URBINO

THE STORY OF A RENAISSANCE CITY

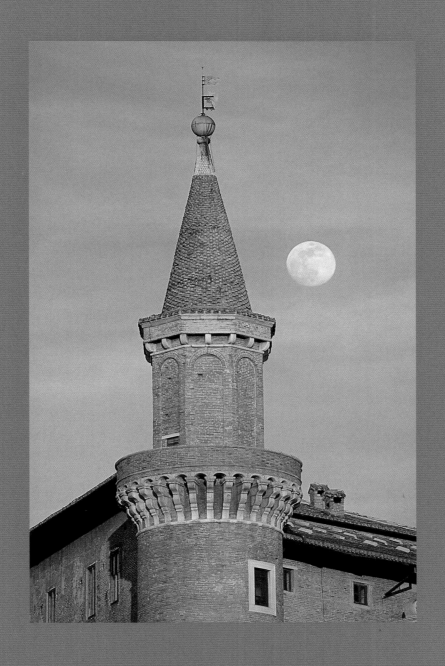

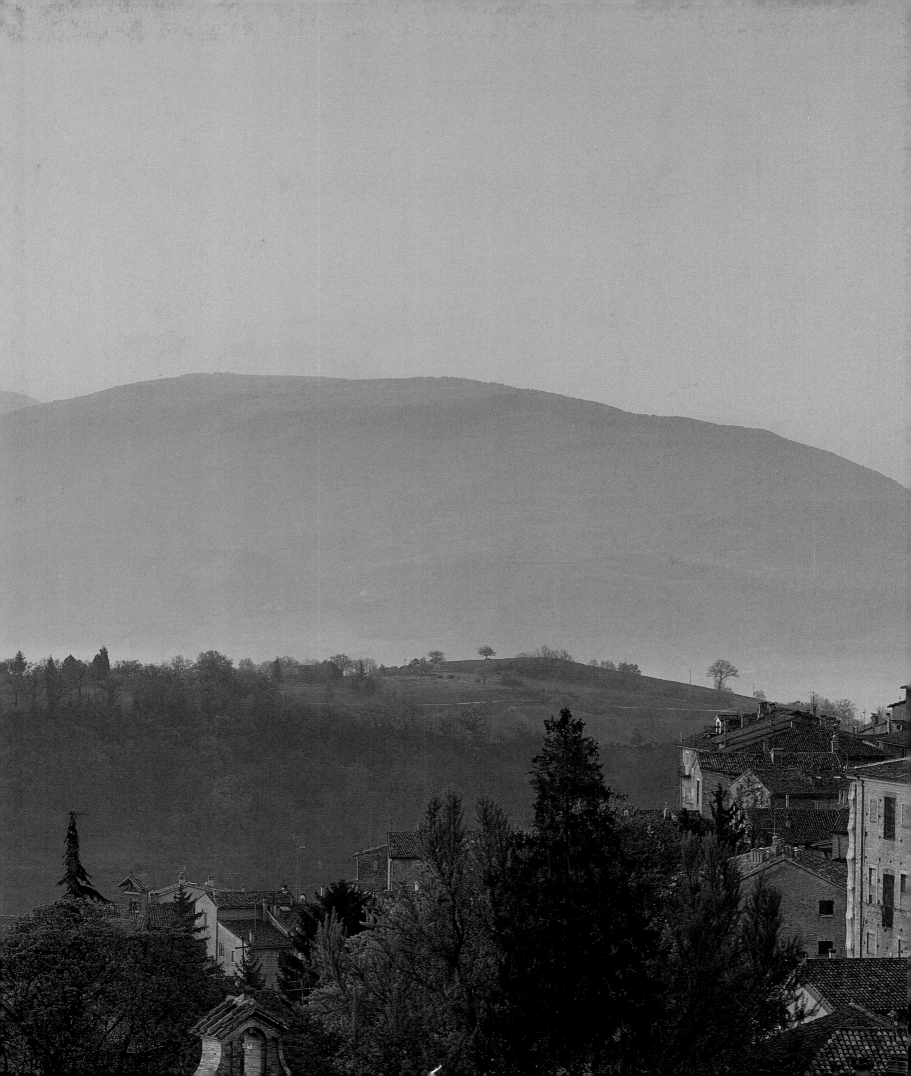

URBINO

THE STORY OF A RENAISSANCE CITY

JUNE OSBORNE

PHOTOGRAPHS BY JOE CORNISH
FOREWORD BY SIR JOHN MORTIMER

THE UNIVERSITY OF CHICAGO PRESS

FOR MICHAEL, MY GUARDIAN ANGEL

The University of Chicago Press, Chicago 60637
Published by arrangement with Frances Lincoln Limited

Urbino: The Story of a Renaissance City
Copyright © Frances Lincoln Limited 2003
Text copyright © June Osborne 2003
Photographs copyright © Joe Cornish, except for those listed on page 208.
All rights reserved. Published 2003
Printed in China

12 11 10 09 08 07 06 05 04 03 1 2 3 4 5

ISBN: 0-226-63763-8 (cloth)

Cataloging-in-Publication data have been requested from the Library of Congress.

⊗ The paper used in this publication meets the minimum requirements of the
American National Standard for Information Sciences—Permanence of Paper
for Printed Library Materials, ANSI Z39.48-1992.

CONTENTS

FOREWORD BY SIR JOHN MORTIMER • 7

INTRODUCTION • 8

1 THE RENAISSANCE IDEAL • 12

2 LOCATION AND THE ROMAN CITY • 20

3 EARLY MEDIEVAL URBINO • 28

4 PRELUDE TO A GOLDEN AGE • 42

5 A LEADER IN WAR AND PEACE • 58

6 THE DUCAL PALACE AND ITS FURNISHINGS • 72

7 FEDERICO AS A PATRON OF LEARNING • 92

8 PAINTING IN FIFTEENTH-CENTURY URBINO • 102

9 LATER DAYS OF THE DUCHY • 122

10 THE ARTS IN THE LATER DAYS OF THE DUCHY • 134

11 THE BOOK OF THE COURTIER • 152

12 OVER THE HILL • 172

APPENDIX: THE KITE • 189

THE MONTEFELTRO DYNASTY • 192

NOTES • 194

BIBLIOGRAPHY • 200

INDEX • 202

ACKNOWLEDGMENTS • 208

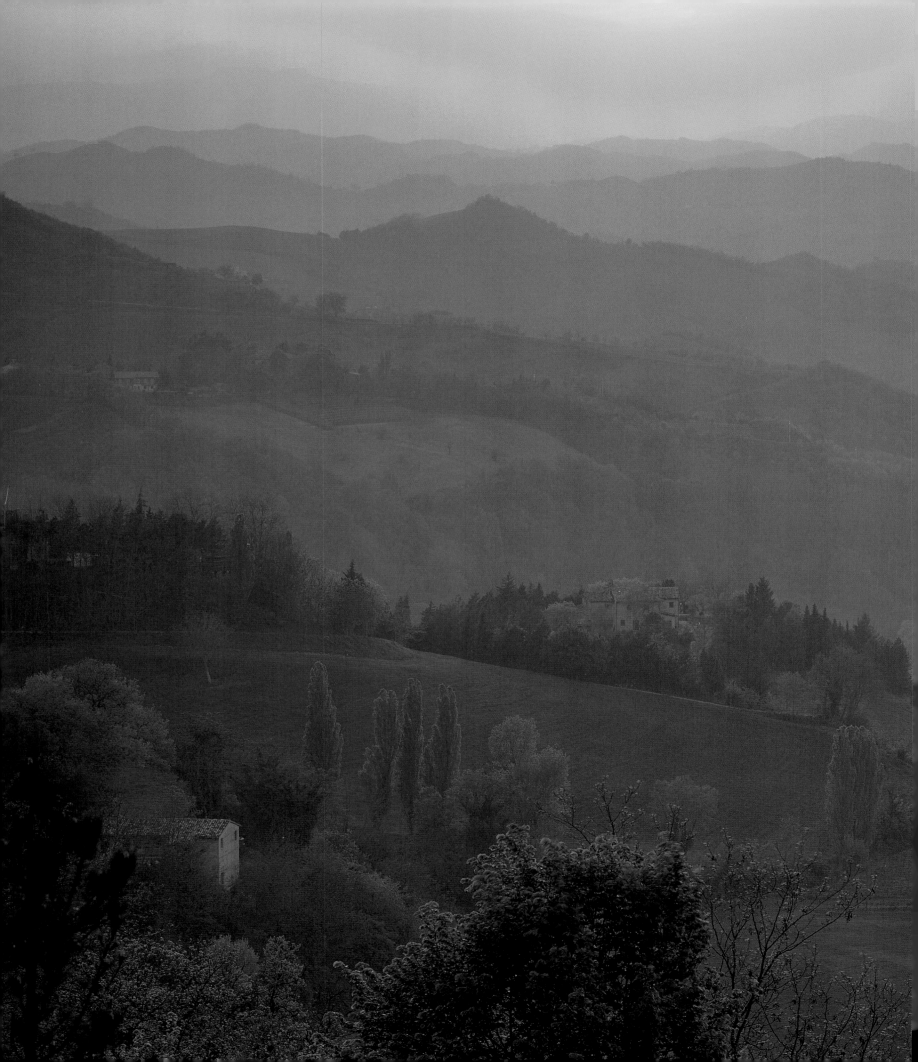

FOREWORD BY SIR JOHN MORTIMER

The best way to approach the Ducal Palace in Urbino is to follow the Piero della Francesca trail. Start at the great frescoes in the church in Arezzo and travel east across Italy, over the Mountains of the Moon towards a distant sea. You can see the pregnant *Madonna*, who used to be housed in a small chapel in a field. You can have your breath taken away by the *Resurrection* in Piero's home town of San Sepolcro. There the great solemn figure rises from the tomb without disturbing the sleeping soldiers. You have one more great picture 'to aim for: the *Flagellation* in the Ducal Palace at Urbino, which some people have called the greatest small picture in the world. But you will find more than a picture; more than many wonderful pictures. You will step into a building which, by its perfect human proportions, will calm your soul and elevate your spirit.

And it was built by a mercenary, a cunning soldier who sold his services to pay for it. It's as though some dubious adventurer, willing to fight in any African tribal war, turned out to be one of the greatest patrons of the arts the world has ever known.

Federico da Montefeltro was unlike any mercenary out of a novel by Frederick Forsyth. His private study in the palace was decorated with portraits of the men he most admired, including Moses, Solomon, Homer, Plato, Aristotle, Virgil, St Augustine, Dante, Petrarch and his old schoolmaster, who had brought him up to love art and literature and the great thinkers. He knew Greek and Latin and learned drawing, music and dancing, as well as fencing and horsemanship. As he set out on his many wars musicians played and poets recited. The money he made fighting was at the service of one of the greatest periods in the arts.

Italy is still a collection of different countries, each with its own dialect, its particular food and wine, and its own great painter, whose masterpieces are still in local churches and chapels. These independent states were continually at war, Florence against Siena, Milan against Venice and the Papacy. Some of these wars were mercifully harmless. As the supreme mercenary, or *condottiere*, of Milan and the Italian League, he met Colleoni, the mercenary in charge of the Venetian forces, at the Battle of Molinella. 'Neither side wavered,' Machiavelli wrote. 'No one fell, a few prisoners and wounded horses being the only outcome of the encounter.'

A leader could find himself in greater peril taking part in a tournament. Piero della Francesca's famous portrait shows Federico's broken nose and hides the eye wounded by a lance. He died of a fever caught in the mosquito-infested marshes of the Po, where two armies were confronting each other. His battles have been forgotten, but his pictures and his palace are still there to proclaim his achievements. If only we could have wars today which made such a great contribution to the arts with so little bloodshed.

So you get to Urbino to greet the Raphael and to puzzle over the mysterious *Flagellation* and to wonder how much the mathematical certainty of the palace's architecture is owed to Piero della Francesca. The city of Urbino, one of the most beautiful in central Italy, deserves a book and June Osborne has done it proud.

It's a book to be read on the Piero trail, or even on a grey, cold day in England, to discover that there is a better world elsewhere.

The Mountains of the Moon. View from near Urbino at sunset.

INTRODUCTION

It began with a picture postcard, my love affair with Urbino. Having read English at Bristol University, and then spent some five years in museum and art gallery curatorship (acquiring meanwhile the Diploma of the Museums Association with specialization in Art History), I was still in my twenties when I found myself working at the Slade School of Art. I was proud to describe my job there as 'dogsbody to Professor Gombrich'.

What an education, and what a privilege it was. The late Sir Ernst Gombrich, surely the greatest art historian of all time, was then Professor of History of Art at the Slade School. One of his tasks was to instil some rudiments of the subject into students who, gifted though they may have been in art as a practical discipline, were not in those days required to have any certificates whatever in general education. Few of them appeared academically inclined, so they needed a little spoon-feeding. Part of my work (as well as cataloguing works of art in the Slade and University College collections, identifying slides and writing Gombrich's letters for him) was to act as an intermediary between the students and the Professor. I made synopses of all his lectures (and the lectures of anyone else, such as Anthony Blunt, who came to speak at the Slade) and distributed these to the students so that they had at least something to hold on to for their exams. They could of course have read Gombrich's *The Story of Art*. Perhaps some of them did.

When the Professor departed on lecture tours, which were usually in Italy, he had the endearing habit of sending me picture postcards from wherever he went. The places were not all unfamiliar to me: Florence I knew fairly well, having spent a month or more there; I had visited Milan and seen Leonardo's *Last Supper*, and with Gombrich's encouragement I went to see the mosaics at Ravenna. But one day a postcard arrived from Urbino, showing the Ducal Palace with its twin towers silhouetted against the sky.

'Now that,' I said to the Professor when he returned, 'looks like a really magical place, and I want to know more about it.'

'Quite right,' he said. 'Immensely important in the field of art history and of civilization generally. You ought to write a book about it. Nobody else has.'

'One day I will.'

Writing a book about Urbino became a sort of trust I owed the Professor. He lent me precious volumes from his own library and answered with unfailing patience my insistent questions, such as:

'Why did Federico da Montefeltro employ an obscure painter like Justus of Ghent when he was rich enough to have anyone he chose? He could have had Piero della Francesca, for instance.'

'He did. But Justus of Ghent painted in oils.'

'How do we know that was the reason?'

'Read Vespasiano da Bisticci.'

'Right.'

'Come to my house in Hampstead and I'll lend it to you.'

So began my many years of study, interrupted somewhat by four more children, but my knowledge of art history was reinforced by an extra-mural diploma at London University. Subsequently I lectured in Art History there and at other universities. Meanwhile, I took every opportunity to learn Italian. This was obviously necessary, as there was virtually nothing written about Urbino in English. I never had any financial support in my studies, and my visits to Urbino had

The Ducal Palace crowns the city of Urbino. Behind the wall to the left of the façade lies the Secret Garden, and in the foreground is the Teatro Sanzio.

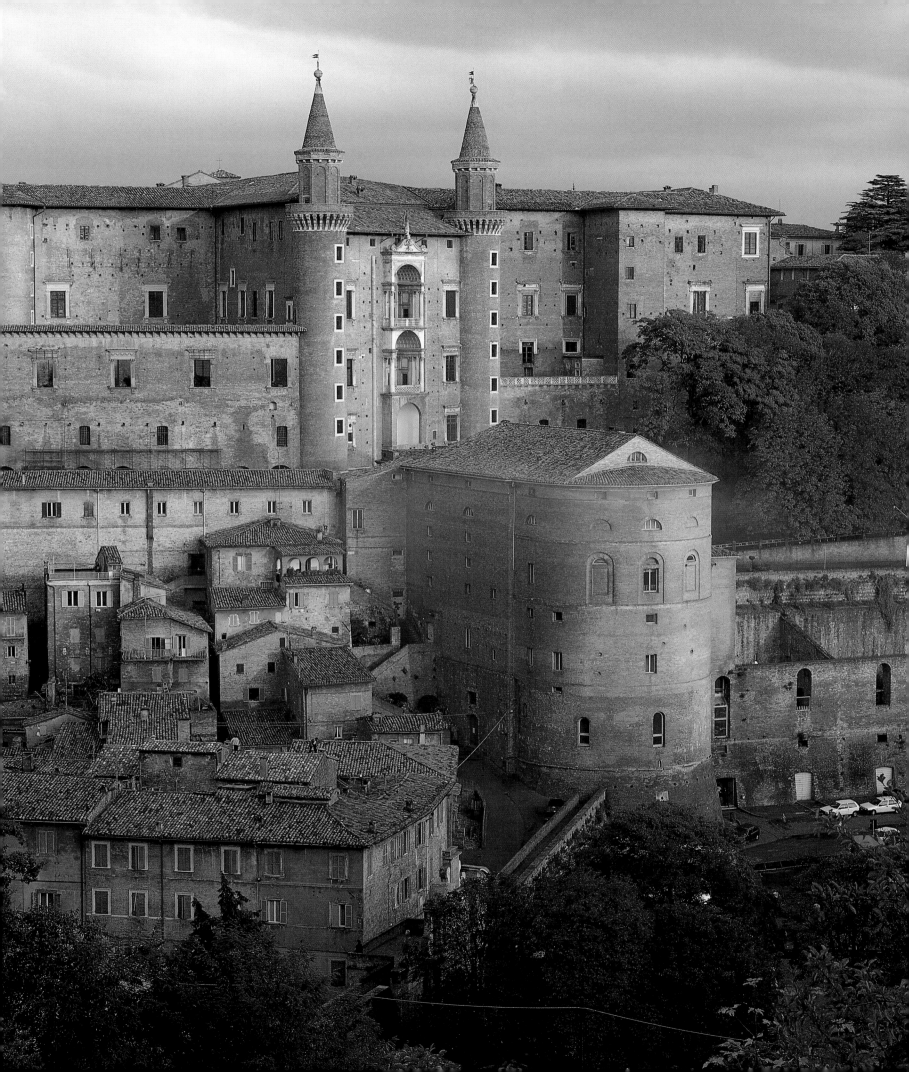

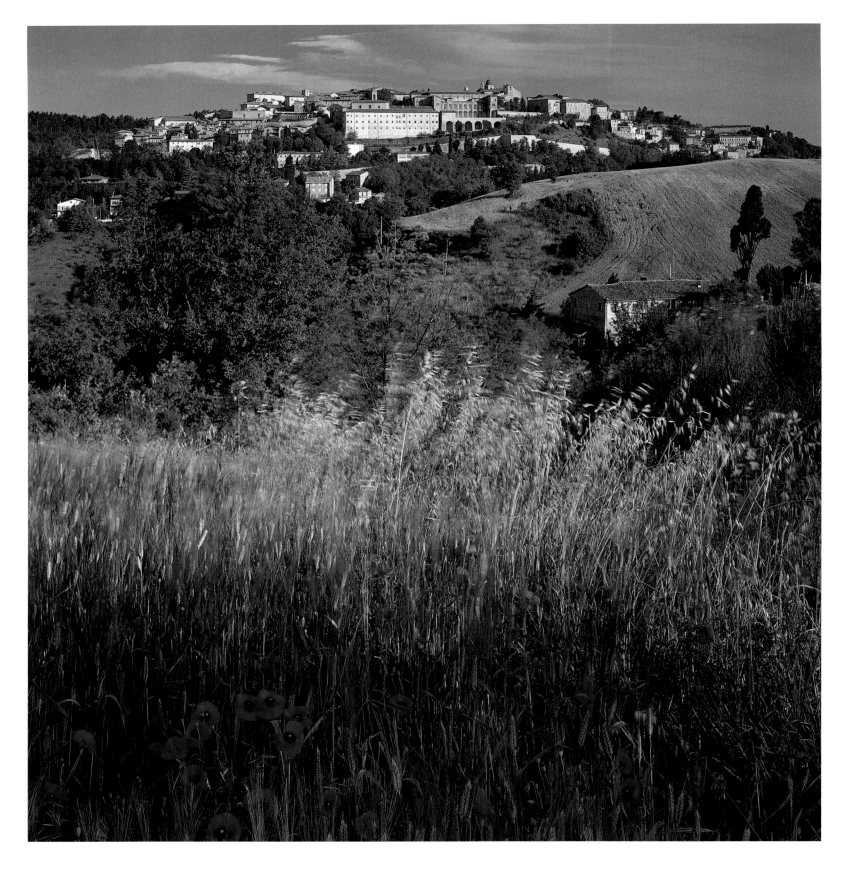

to be funded by undertaking lecture tours, speaking to Anglo-Italian associations the length and breadth of the country.

But every time I arrive in Urbino I exclaim, 'I'd forgotten just how beautiful it is,' and it is not just a superficial beauty, it is the integrity of the place, the feeling that here, at least, the right values prevail.

Gradually I stopped feeling like a mere tourist. Kind friends in Mantua (Cesare and Yvonne Dina) obtained access for me to the state archives in that city, and through the Superintendent there I obtained an introduction to the Dottoresse in charge of the Ducal Palace in Urbino. I arrived with a whole string of questions that I had compiled in my then very indifferent Italian; they answered them patiently and then said, 'You really ought to meet Professor Luni. Veramente il Professore Luni è Urbino.' (Truly, Professor Luni *is* Urbino.) So it was I had this privilege, and the magnificent Professor Mario Luni has been the constant guide to my studies ever since. As head of the Archaeological Institute of Urbino University, he is naturally the leading expert on many aspects of the city's history, especially Roman Urbino. And not only was he kind enough to check my chapter on that subject, but he once took me on a personally conducted tour of some of the lesser-known aspects of the ancient city. He kindly arranges accommodation for me at the university. Recently, he has introduced me to Dottore Savoldelli, President of the Accademia Raffaello, and he too has been unfailingly helpful. Likewise, Dottoressa Valazzi and her colleagues at the Soprintendenza of the Ducal Palace.

Once the writing of the text was complete, the problem was to find a publisher prepared to bring out a book on a subject so little known in this country. It seemed to me I needed all the help and encouragement I could get. Since I knew his delightful novel *Summer's Lease* (which has its climax in Urbino), I approached Sir John Mortimer, with the ultimate happy result that he is writing a Foreword to this book. And John Nicoll, also, I think, a great enthusiast for Urbino, has nobly agreed to publish it, under the imprint of his company Frances Lincoln. He appointed as editor Michael Brunström, who has proved unfailingly conscientious and sympathetic.

John Nicoll and I were looking for the right photographer to embellish the book and both of us, amazingly, suggested the same person, Joe Cornish. Then in order to illustrate the text more faithfully I have presumed to supplement his superb photography with shots of my own, taken over some twenty-five years of joyful visits to Urbino. The photographs are coupled with reproductions of works of art, many of which left Urbino long ago. Thus we are attempting to show Urbino not only as she is now, but as she appeared at the time of her greatest glory. We are trying to recreate the Renaissance. Sir Ernst would have been pleased, I think.

JUNE OSBORNE
April 2003

Distant view of the city from the south-east.

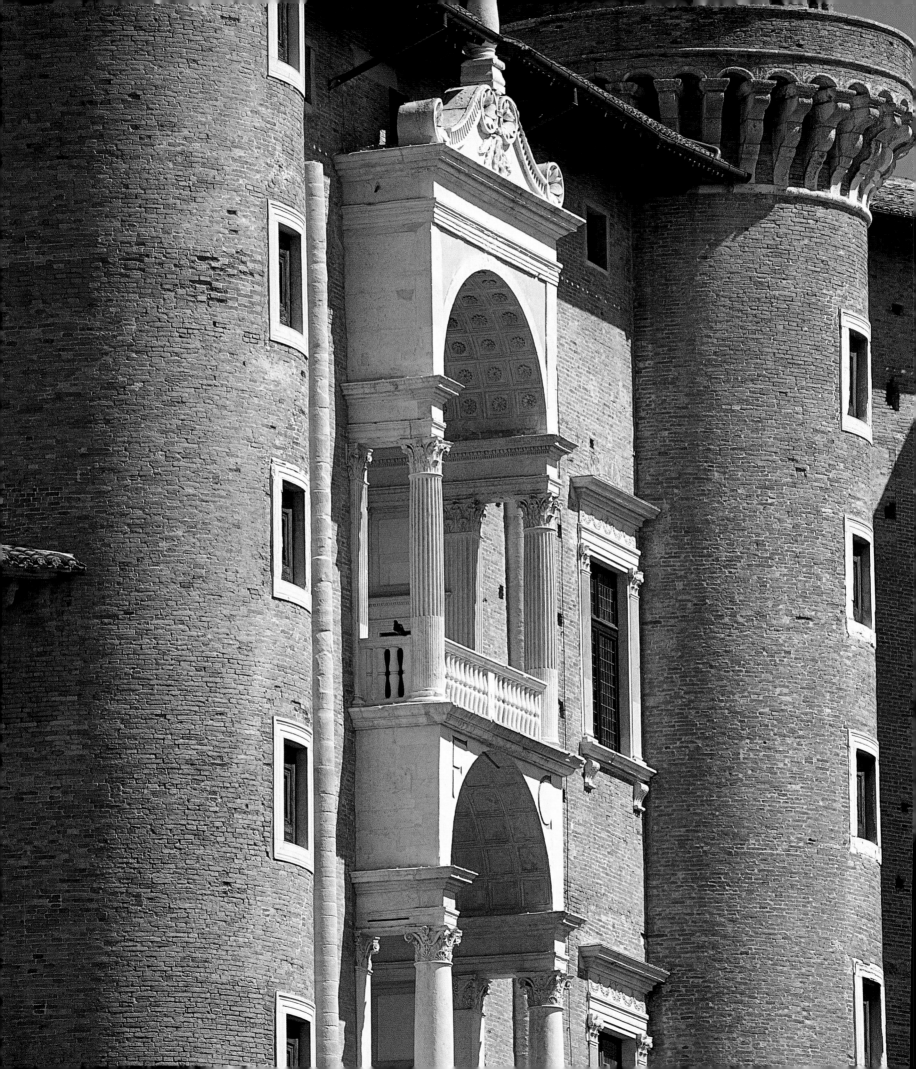

THE RENAISSANCE IDEAL

There was no doubt about it; something stupendous was happening. In fifteenth-century Italy, ideas that had been accepted for centuries were beginning to be questioned. Precedent was no longer enough. Men had a new confidence in their abilities. Problems that had hitherto seemed insuperable were looked at afresh and solved with magnificent daring – as Brunelleschi did in designing a dome to crown Florence's cathedral, a feat that until then nobody had believed possible. This was a time when the whole world of Greek classical civilization was beginning to be opened up. Original manuscripts were arriving from the east; libraries were created in order to house them, and the ancient Greek language was studied in order to understand them. Moreover, there was a new clarity of vision. Man's life expectancy was usually short, it is true, and perhaps this very fact sharpened his perception, and deterred him from wasting a minute. In the field of painting, we only have to think of what Masaccio achieved in a lifetime of a mere twenty-seven years, and Raphael in thirty-seven. Moreover there was no pigeon-holing of culture; people could have expertise in various different fields. A true Renaissance man like Alberti, chiefly remembered today as a very remarkable architect, was also a mathematician, a scientist, a humanist scholar and the author of definitive treatises on the visual arts, all in the intervals of acting as secretary to the Pope. 'Man,' he declared, 'can do all things if he will.' And this was echoed by the philosopher Pico della Mirandola: 'With freedom and honour you should be your own sculptor to fashion your form as you choose.'[1]

Although the word 'Renaissance' had not yet been coined, people were beginning to believe that they were living in a golden age. 'If we are to call any age golden,' wrote Marsilio Ficino,

'MAN CAN DO ALL THINGS IF HE WILL'

Leon Battista Alberti, *Autobiography*

LEFT: The elegant loggias between the massive *torricini* on the west front of the Ducal Palace.
RIGHT: Piazza della Repubblica, still the heart of the city.

it is beyond doubt that age which brings forth golden talents in different places. That such is true of this our age, he who wishes to consider the illustrious discoveries of this century will hardly doubt. For this century, like a golden age, has restored to light the liberal arts, which were almost extinct: grammar, poetry, rhetoric, painting, sculpture, architecture, music, the ancient singing of songs to the Orphic lyre, and all this in Florence. Achieving what had been honoured among the ancients, but almost forgotten since, the age has joined wisdom with eloquence, and prudence with military art, and this most strikingly in Federico, Duke of Urbino, as if proclaimed in the presence of Pallas herself.[2]

As Marsilio realized, civilization could flourish not only in great centres such as Florence, but also in a tiny city such as Urbino.

'On the slopes of the Apennines, almost in the centre of Italy towards the Adriatic, is situated, *as everyone knows*, the little city of Urbino.' So wrote Baldassare Castiglione, in the introduction to *The Book of the Courtier* (*Il Cortegiano*). And it was true; for all its remoteness and small size, everyone did know about Urbino. Not many may have actually visited it, yet it was a place of international repute and a byword for excellence, renowned for that subtle blend of virtues, talents and gracious living evoked by the word 'civilization'.

The whole idea of civilization was closely linked with the concept of a city. In Renaissance Italy cities of any importance

An Ideal City, Piero della Francesca (?). (Ducal Palace, Urbino).

were self-governing states. Therefore they had to be designed primarily for defence. Strong city walls were generally a prerequisite for any quality of life, let alone cultural achievement, among the people dwelling within them. If we look, for instance, at Ambrogio Lorenzetti's painted *Allegories of Good and Bad Government* (in the Palazzo Pubblico, Siena), we find that good government in the city depends largely on the adequacy of the defences; it is only these which permit the dancing within. The city walls, which were frequently Roman in origin, had to be constantly repaired or rebuilt. Failure to do this was to court disaster.

Urbino had the extra advantage of its situation. The same remoteness and difficulty of access that deters weaker-hearted tourists today, built as the city is virtually on the summit of a hill, served in the Renaissance to protect it from armed adversaries.

It might have remained no more than a fortress had it not been for the zeal and talents of one man, Federico da Montefeltro. In his day, wrote Castiglione, he was 'the light of Italy'; yet there were such rival luminaries as the Medici, Gonzaga and d'Este families. It may seem to us strange that this light could shine from so obscure a place and yet be visible throughout the peninsula, but there it was, that was the quality of the man.

'Nor are there lacking today,' continued Castiglione, 'any number of reliable witnesses to his prudence, humanity, justice, generosity and unconquerable spirit, and to his military skill . . . so we can fairly compare him with many famous men of the ancient world. Among his other commendable enterprises, Duke Federico built on the rugged site of Urbino a palace which many believe to be the most beautiful in all Italy.'

This is praise indeed. Castiglione was no mere local boy, praising the exploits of his feudal lord. He had been born near Mantua, and had grown up in the ambience of the Gonzagas; he had studied at Milan University. He was employed by Lodovico Sforza of Milan and Francesco Gonzaga of Mantua before coming into any contact with the Duke of Urbino – and this was not Federico but his son, Guidobaldo, driven out of the province by Cesare Borgia. Castiglione would have seen many other palaces, in Rome and Mantua as well as Milan, and would surely have been aware of those in Venice; so when he suggests that Urbino's may be termed the most beautiful, his evaluation is not based on ignorance.

Castiglione said that Federico's aim was to 'create a city in the form of a palace'. Exactly what he meant by this is not altogether clear. What he did *not* mean was a city imposed dictatorially upon people and landscape: an ideal but impossible city, existing only in the mind, as suggested in the notebooks of Leonardo, and defined by Filarete in his *Treatise on Architecture*.[3] Filarete, whose patron had been Francesco Sforza of Milan (though he dedicated the book to Piero de' Medici) made an elaborate if totally impractical plan for a city by the name of Sforzinda. He conceived a star-shaped city with a regular grid pattern of sixteen streets, leading up to a great central square. On the eastern side of the square would be the principal church; opposite, on the western side, would be a fine palace. On the north side would be the merchants' piazza, with town hall, prison, mayor's palace, mint and tax collector's office; to the south, an extensive market with the house of the captain of police between it and the palace. Also to the south would be the baths and brothels, and to the west the inns and taverns. 'Butchers and shops for fish and fowl,' observed Filarete, 'will be planned later.'

Such a design, had it ever been executed, would have presupposed an entirely empty piece of land with which to start. No pre-existing buildings would have been allowed to survive. The terrain would have had to be essentially flat, and the people subjected to extreme discipline.

Federico da Montefeltro by no means started with a blank page. The essential plan, the true core of the city, had been defined in Roman times. The line of the walls, and even the

pattern of the streets, were left largely as they had been in the Middle Ages. Parts of medieval buildings were incorporated into the structure of his new Ducal Palace, and the swallowtail crenellations (denoting alliance with Papacy rather than with the Holy Roman Empire) can still be discerned. Nevertheless, the changes which took place in the time of Federico da Montefeltro amounted to a transformation.

When one looks at the exterior of the palace today, what immediately catches the eye (apart from the sheer scale of it, remarkable enough on so difficult a site) are its slightly unexpected angles, and the twin towers, known as the *torricini*, which grace the shortest and most elegant of its façades. The tall slim towers rise up to projecting bands of machicolations; these may be classed as a defensive feature. Higher still, they are crowned with conical caps, piercing the skyline. It is these that invest the building with the air of a fairy-tale castle. Between the *torricini* are ranged loggias of extraordinary delicacy, forming a contrast with the rugged mass of the main structure and suggesting the delights contained within.

The Ducal Palace does not reveal its splendours all at once. There is no hint from the somewhat severe interior that one is about to walk into a most beautifully proportioned courtyard, with crisp Corinthian columns, cool arches and an inscription of classically perfect lettering. There is no hint either that among the cool white rooms one will suddenly find oneself in the Duke's intimate study, his Studiolo, panelled with marquetry of exquisite complexity.

The Ducal Palace may be said to reflect the character of the man who commissioned it. One of the most characteristic of all the portraits of Federico da Montefeltro is that in the palace itself, probably originally in the Studiolo, attributed to Justus of Ghent with the assistance of Pedro Berruguete. It dates from 1474–6. The Duke is seated, shown in profile to the left, as in most of his portraits (he had lost his right eye in a tournament). He wears a rich red mantle, and over it an ermine stole with an ermine badge, symbolic of the order of chivalry bestowed on him in 1474 by Ferrante I of Aragon. Under the mantle Federico is wearing a sword and full plate armour; his helmet is placed at his side. On his leg is buckled the Order of the Garter, an honour given to him by Edward IV. Above, on a shelf, rests

a pearl-encrusted mitre, a gift from the Sultan of Persia. In front of the Duke stands his little son Guidobaldo, carrying a sceptre and seemingly weighed down by his jewel-encrusted robes.

The Duke does not look at him. For all his chivalric splendour, for all his trappings as a military leader of considerable international influence and the founder, as he hoped, of a dynasty, Federico is abstracted. He is lost in contemplation of a book: no slim volume, but a weighty tome bound in scarlet. Doubtless it has come from his famous library. For Federico was not only a distinguished military leader, of whom it was said that he never lost a single battle; not only was he the head of an independent city state, and extremely rich – possibly the richest man in Europe – he was also a man of culture. Castiglione's description of Federico's palace continues thus:

> He adorned it not only with the usual objects, such as silver vases, wall-hangings of the richest cloth of gold, silk and other similar material, but also with countless antique statues of marble and bronze, with rare pictures, and with every kind of musical instrument; nor would he tolerate anything that was not most rare and outstanding. Then, at great cost, he collected a large number of the finest and rarest books.

With the palace at its heart, Urbino, in spite of its small size, became a centre of culture whose fame was widely known. Within her walls great men were born: Bramante, whose architecture was to transform Renaissance Rome, and one of the greatest painters of all time: Raphael. It is generally held that Raphael's greatest work is to be found in the Vatican; nevertheless his origins were in this little city, where his father was Court Painter to the Duke, and where his birthplace may still be visited.

It is appropriate, then, that the ducal court of Urbino should be chosen as the setting for Castiglione's *The Book of the Courtier*. In essence, the book defines the ideal Renaissance man, and for that matter, woman. (Women were in many ways dominant in the court of early sixteenth-century Urbino.) Pope Julius II had visited Urbino in the autumn of 1506, and

Duke Federico and his son, Guidobaldo, Justus of Ghent (Ducal Palace, Urbino).

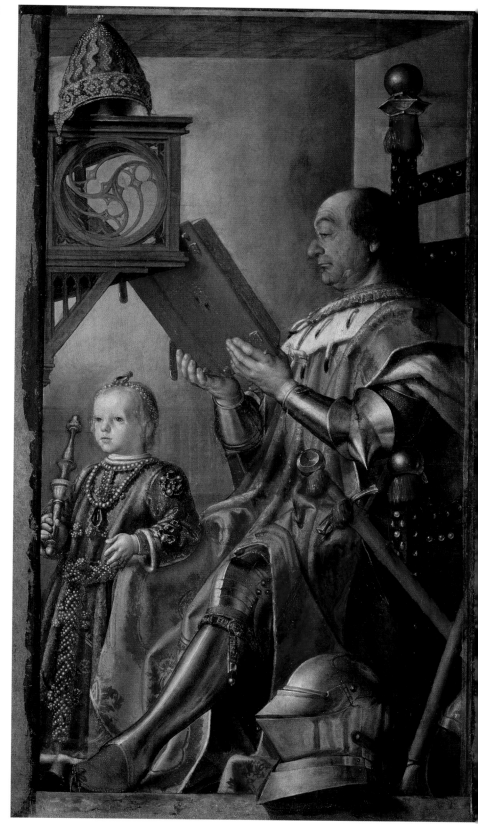

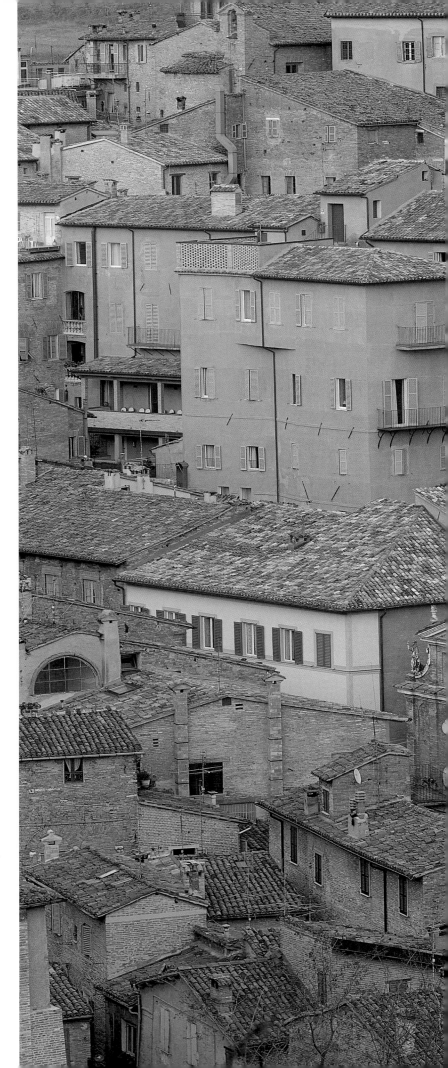

eminent people of his entourage – courtiers, diplomats, clerics, writers, musicians and artists – stayed on there until the following spring. Their conversations, or imaginary conversations, form the basis of the book. They discuss not only how the courtier should behave in matters of etiquette, but also how wide his interests and concerns should be. The topics they consider are as various as the nature of love, the power of music, the precedents of classical antiquity and the relationship that should exist between the courtier and his prince. Castiglione was defining ideals that, even as he wrote, were on the decline in Italy. Yet, within a short space of time, the book was translated into other languages – the first edition in English was Sir Thomas Hoby's of 1561 – and it became immensely influential. In Elizabethan England *The Book of the Courtier* was highly esteemed and widely read. Roger Ascham, who had been tutor to Elizabeth I when she was still a girl, as well as tutor and secretary when she became queen, wrote in his treatise *The Scholemaster* that a young man who read this work with diligence would benefit more from it than from three years' travel in Italy.[4] For the book was held to be an education in itself; it explored ideas upon which the life of a man such as Sir Philip Sidney might be based.

Thus even though, as an independent city state, Urbino did not long survive the death of her most celebrated dukes, its reputation and influence continued. Perhaps this was due in part to the general humanity of the civilization it epitomized. Duke Federico, for all his power and wealth, was not a tyrant. He was open to new ideas, ready to extend his education. He sought, according to his biographer Vespasiano da Bisticci, 'to learn something new every day'.[5] And when Federico was asked what was the most important attribute of a great leader, he replied: 'essere umano' (to be human).

It is this human quality, this sense of scale and proportion, which distinguishes Urbino today and which made it, in its time, a high point in European culture. The city had a quality of greatness. Here, they encouraged aspirations to excellence. For this reason, the story of Urbino deserves to be better known.

Urbino rooftops; citizens' houses cluster below the cathedral and the Ducal Palace.

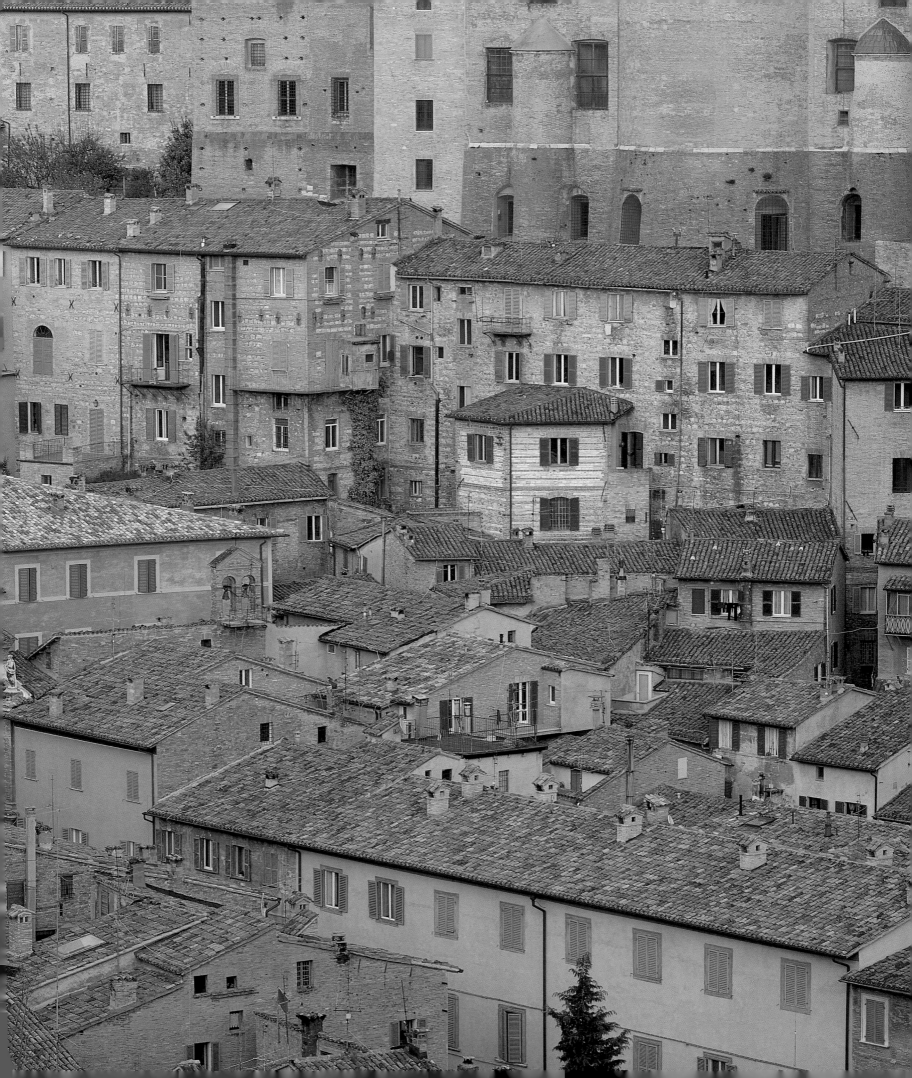

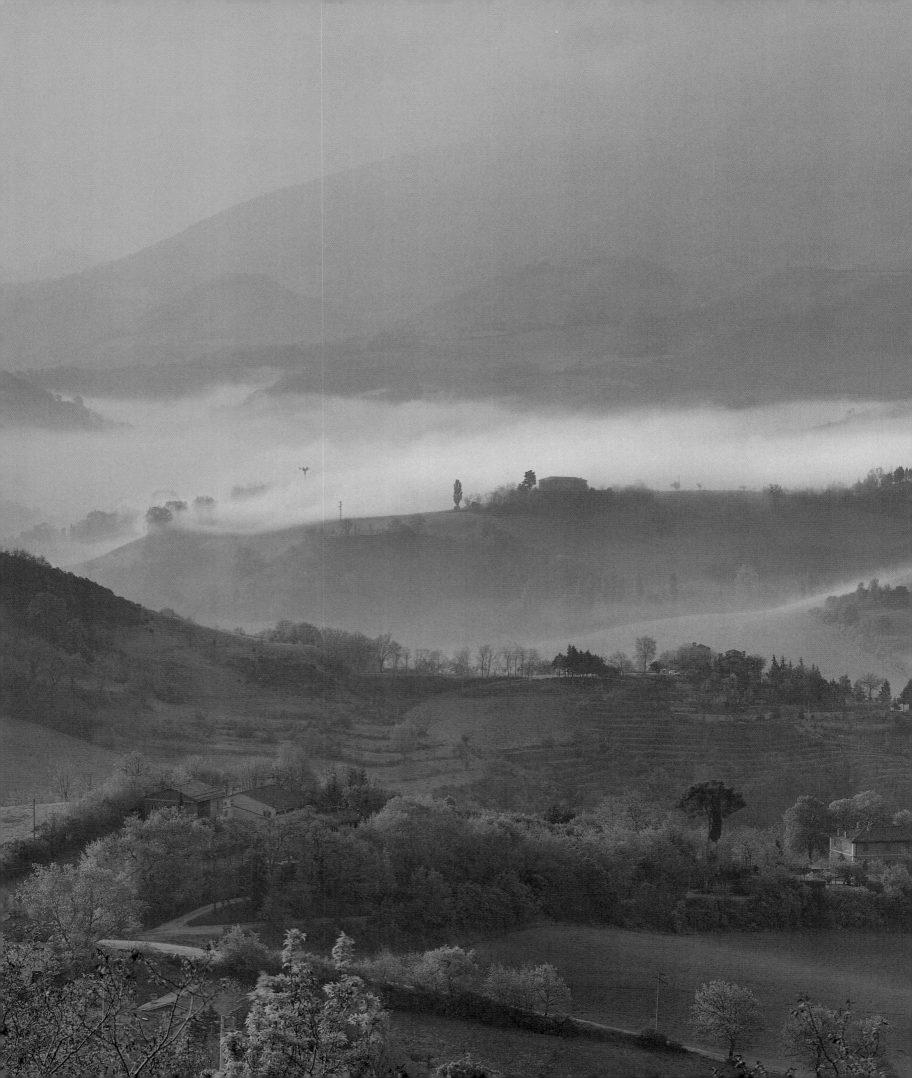

LOCATION AND THE ROMAN CITY

The only description of Urbino to have survived from antiquity is by Procopius of Caesarea, in his *History of the Wars of Justinian.*[1] And although it is, by classical standards, late, the features that it describes are those of its physical situation: features that would have applied to the city equally in Roman times and even earlier.

The form the city was to take and its potential for strategic importance were largely determined by its geographic position. The province lay between two rivers, the Foglia (Pisaurus) in the north-west and the Metauro (Mataurus) to the south-east. Both rivers rise high up in the Apennines and run an almost parallel course to the Adriatic Sea, reaching the coast near the (originally Roman) towns of Pesaro (Pisaurum) and Fano (Fanum). Between the two rivers, whose courses define the principal valleys, the land is a complex structure of smaller valleys and of hills, the Poggio ('mound') on which the city was built claiming a dominant position among them.

The Poggio rises 1,500 feet above sea level and is, as Procopius described, a promontory flanked on three sides by rugged cliffs, and only to the north is there an area of almost flat land offering more gentle access. The promontory is tongue-shaped and not entirely flat, sloping towards the northern side, and there were adequate springs of water. Its geographical features, therefore, rendered the place virtually impregnable, a natural fortress.

It had, moreover, great strategic importance. The River Foglia formed a natural route of communication. The first, Roman, road ran north of Pesaro up its valley along the left bank, rising to the high Apennine pass of the Viamaggio and then descending to the upper reaches of the Tiber. A second

'URBINO IS SITUATED ON A ROUND AND RATHER HIGH HILL, NOT, HOWEVER, PRECIPITOUS NOR INACCESSIBLE FROM ALL SIDES; IT IS ONLY THAT IT IS RUGGED, ESPECIALLY IN THE VICINITY OF THE TOWN, AND IS FAIRLY DIFFICULT OF APPROACH; THERE IS, NEVERTHELESS, AN EASY WAY FROM THE NORTH.'

Procopius of Caesarea, *History of the Wars of Justinian*

LEFT AND RIGHT: Urbino's setting: a mountainous landscape to the south-west.

road ran from Pesaro and followed the valley of the Foglia along the right bank as far as the present-day abbey of S. Tommaso in Foglia, and then rose to follow the ridge leading from Colbordolo to Urbino.

The valley of the Metauro was of even greater importance, and its final stretch became the route of the Via Flaminia. This road, 209 miles long, was constructed by Gaius Flaminius in 220 BC, linking the east coast of Italy with Rome. It starts in Rimini (Ariminum), where there is a fine five-arch bridge begun in AD 14 for the Emperor Augustus and finished in AD 21 for his successor, Tiberius. The gateway to Rimini is marked by a monumental arch[2] (the Porta di Augusto) of an even earlier date, made for Augustus in 27 BC, and at a point three miles along the road is an ancient milestone (Il Terzo). The Via Flaminia continued, more or less parallel to the coast, through Riccione, Cattolica and Pesaro as far as Fano. Here there survives another magnificent gateway (also called the Porta di Augusto), dating from the first decade AD. There are also the remains of a basilica attributed to the Roman architect Vitruvius and described in his *Ten Books on Architecture* (*De architectura*). At this point, the road turned inland, and from Fano followed the Metauro along the left bank, passing through the Roman settlement of Serrungarina (where the surviving remains include cartwheel tracks), then on to Fossombrone (Forum Semprionii), where a considerable stretch of original paving is still visible today, as well as a walled Roman burial ground. From there it turned south into the valley of the River Candigliano, a tributary of the Metauro, through the Furlo Gorge.[3] This was the most dramatic and the most dangerous part of the route.

The Furlo is a mountain pass lying between two peaks: Mount Pagannuccio (3,202 feet) and Mount Pietralata (2,913 feet). The pass itself is about 1¾ miles in length and only 2,073 feet high. Such statistics barely indicate the awesome nature of the place. The Candigliano runs at the bottom of the gorge, with a waterfall dropping 30 feet at the narrowest point. The road (which is still in use today) takes a serpentine route some 100 feet above. It is a miracle of engineering, involving in places cutting into the rock face, in others building long stretches of supporting wall, as well as excavating two tunnels. The larger of these dates from 77–6 BC and was made for the Emperor Vespasian.

With its steep rocky walls descending straight to the narrow road, the gorge was clearly a vulnerable part of the route. It was sometimes considered preferable to use an alternative way. Shortly after Acqualanga, another road went up to the left along the ridge of Mount Pietralata, then descended into the valley of the Metauro in the S. Marino district; from there it headed towards Urbino, continuing in the direction of Pesaro and Rimini. Another road branched off from the Via Flaminia shortly after Fossombrone and followed the Metauro valley in a westerly direction to S. Angelo in Vado, and from there rose to the Bocca Trabaria Pass to attain the upper valley of the Tiber.

Thus Urbino was positioned at an important crossroads, commanding secondary routes linking the great Roman highways. This in itself, together with its proximity to the Furlo Gorge, established the importance of the city.

The name in its present form, Urbino, would appear to mean 'little city', but as has been pointed out, its Latin form Urvinum Mataurense has a different significance.[4] The first part derives from the Latin word *urvus*, a ploughshare, and refers to the shape of the town, elliptical and somewhat ridged along its back. The second part clearly derives from the River Metauro and distinguishes the city from Urvinum Hortense, meaning 'Urvinum of the garden', an ancient centre in inland Umbria near Collemancio.

The area between the two rivers Foglia and Metauro was broadly speaking the extent of the Iron Age territory known as Picenum. It was occupied by a warlike people who made pottery, buried their dead and, by the later period of the Roman Empire, had established an important centre for amber, apparently trading it across the Adriatic Sea.[5]

The Furlo Gorge and the River Candigliano. Through this pass ran the Via Flaminia, the principal route across the Apennines from Rome to Rimini.

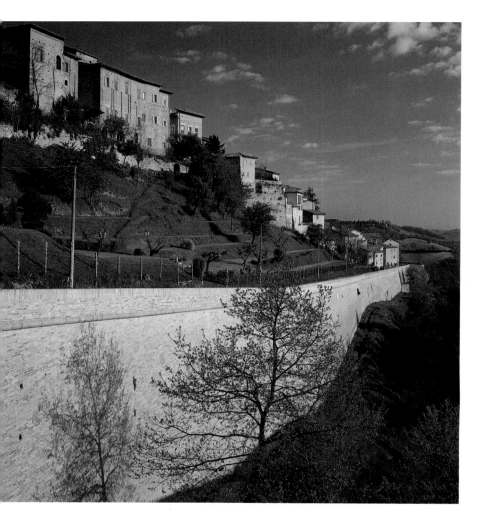

below wall construction known to be of Roman date. At least two Iron Age graves have been discovered in the vicinity of Urbino, and the foundations of huts at nearby Monte Rossano. The likelihood is that Roman buildings were superimposed on the dwellings of the Piceni.

The first mention of Roman presence in the area is the Battle of Sentino (near Sassoferrato) where in 295 BC the Romans, allied with the Piceni, routed the Galli Senoni. A colony was subsequently established at Senigallia (Sena Gallica). Later, in 269–8 BC, the Romans launched a military campaign against the Piceni themselves, and the founding of a colony at Rimini (Ariminum) made it increasingly important to subdue the local tribe and to reinforce Roman presence in the area. Without the Via Flaminia, linking Rome with Rimini, the Romanization of trans-Apennine Italy could hardly have taken place. The final phase in the process of colonization came in 207 BC. At the end of the Punic Wars and the defeat of Carthage, Hasdrubal Barca had crossed the Alps (possibly using elephants) and travelled south in an attempt to join forces with his brother Hannibal. He reached the River Metauro and there suffered a decisive defeat. *Lemprière's Classical Dictionary* (1788) gives a dramatic description of the events.

> He was killed in the battle, but though 56,000 of his men shared his fate, and 5,400 were taken prisoners, only 8,000 Romans were slain. The head of Hasdrubal was cut off, and some days later thrown into the camp of Hannibal, who at that moment was in expectation of a promised reinforcement, and he exclaimed at the sight, 'In losing Hasdrubal, I lose all my happiness, and Carthage all her hopes.'

As Professor Luni has pointed out, archaeological remains have been discovered that establish that there was a settlement at Urbino from at least the fourth century BC.[6] From the siting of the finds it appears that this Iron Age settlement had its centre in much the same place as the Roman town was to be. Pieces of black-glazed Iron Age pottery of the *campana* (bell) type have been discovered in various places on the Poggio, typically in a subterranean layer of blackish earth immediately above the virgin soil. Others have been found in rubble of materials of various periods used laying the foundations of the Ducal Palace, others in the course of works on the Palazzo Diani near the Via Saffi, others on the Poggio immediately

This had happened because letters from Hasdrubal to his brother had fallen into Roman hands and their contents had been divulged, leading to the attack by the consuls Marcus Livius Salinator and Claudius Nero. Subsequently Roman presence in the area was reinforced, with the founding of the colony of Pisaurum, between Rimini and Senigallia, in 184 BC.

The city wall from Via dei Morti, near Porta Sta Lucia. As Procopius observed, Urbino was more accessible from this northern side.

On account of its strategic importance, in *c.* 46 BC, during the consulship of Julius Caesar, Urvinum Mataurense was granted the status of a *municipium*. *Municipia* were founded in areas where Rome had no direct convenient administration, and it was judged better that the people should, with certain provisos, govern themselves. The inhabitants were given Roman citizenship and had their own people's assembly and senate with magistrates. They looked after their own census registers and were responsible for raising taxes and providing troops. In return, they enjoyed certain trading rights and had, except in very major issues, their own legal systems. They had their own *pontifex* (high priest) with jurisdiction in all religious matters. In short, in all concerns except policy, and subject only to occasional visits from the Roman judicial authorities, they were very largely autonomous.

Thus while the population of the villages around were involved mainly in agriculture, the city itself was a considerable administrative centre. Consequently there were a great number of public buildings – a basilica, baths, theatre and temples – concentrated in the centre. There was an Office of Works, with a superintendent at its head, in charge of the construction of all of these, and controlling the craftsmen, masons, carpenters and smiths engaged in the labour.

The encircling walls of Urvinum Mataurense were constructed between the third and second centuries BC and followed the lie of the land at the extreme edge of the escarpment. On the west side they ran from the present Via Piave to the south, under the hanging gardens of the Benedictine monastery and the buttresses of the Ducal Palace's Secret Garden, through the gate of the Castellare and along the wall of the Palazzo Arcivescovile. On the east side the line of their foundations is less certain, but they seem to have run from the church of S. Paolo, along the side of Via S. Girolamo, beneath the monastery of Sta Chiara, continuing to the site of the Palazzo Passionei-Paciotti. Then they passed the Via Budassi (where remains of their structure still survive) just below the Casa de Pretis and from there turned towards the

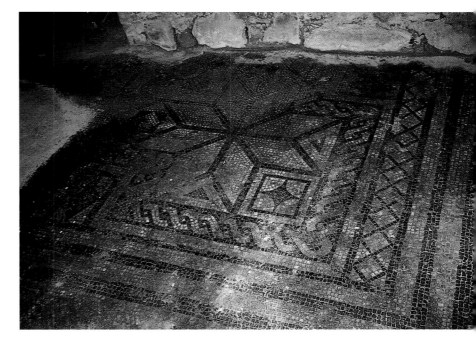

Porta Maia. Here stood the principal gate of the city. In 1985, stretches of Roman wall amalgamated in the later (medieval) structure were observed to have survived in six places.[7] They consist of *opus quadratum*: large blocks of spongy-textured local travertine, each measuring about 30 by 24 inches, set in parallel courses according to the dry-stone-walling method.

Within the compass of the walls on the single hill of the Poggio, there were two main streets. The Cardo Maximus ran from the present Via Saffi by its junction with the Via Piave (where in the walls of the Casa Brandani the remains of an ancient gateway have been found) to the Porta Maia, which was the main way into the city, by the present Via Vittorio Veneto. This was crossed at a right angle by a second street, the Decumanus Maximus, running from the Castellare to the western end of the present Via Veterani; there was a gateway, a Porta Decumana, at either end of it.

This is not to say that the whole conurbation was enclosed within this narrow compass. Towards the end of the Republican period there seems to have been an extension of the city along the gentler slopes to the north. The remains of a large Roman

Roman mosaics below the house that belonged to Polydore Vergil. Much of Urbino was built in layers – Roman below, then medieval, then Renaissance – so it is characteristic that there should be Roman remains beneath the palace of an eminent Renaissance family.

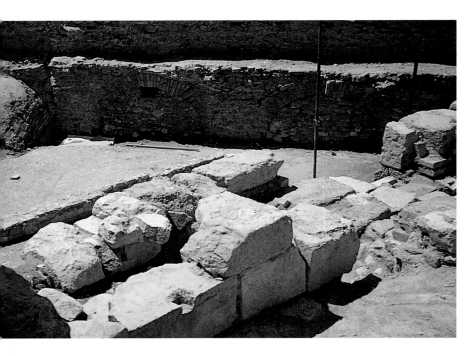

by the Roman magistrate Gaius Vesidienus Bassus, but it is not known whether it fed the Fonte del Leone or a lily pond; in either case it would have supplemented the natural resources of spring water.

When Rome gave Urvinum Mataurense the status of a *municipium*, that implied a degree of trust, combined surely with a recognition of the city's virtual impregnability. Tacitus, in his *Annals*, tells of the struggle between Vespasian, who held Urbino, and Vitellius, who tried in vain to conquer it. The Roman walls were in all probability still intact when Procopius wrote his description in the sixth century. The famous Byzantine general Belisarius, whose adviser he was, made a lengthy siege of the city in AD 538 against two thousand Goths. The Emperor Theodoric had in the previous century established a garrison there, and this had to be eliminated before Justinian's army could advance on Rimini and Ravenna.

A graphic description of the siege of Urbino is to be found in Robert Graves' novel *Count Belisarius*. Graves is not invariably accurate, but his account is worth reading. Abandoned by his colleagues Narses and Bloody John – they had regarded the situation as hopeless; Narses had gone on to Rimini and Bloody John to raid the coast beyond Ravenna – Belisarius, we are told, constructed a series of penthouses on wheels, forming a sort of cloister. From this he hoped that some assault might be made on the city's defences:

cistern, found in 1956, are still visible under the church of S. Sergio beside the Via Raffaello, and there is manuscript evidence[8] that in 1718 the remains of a Roman drainpipe were discovered during the construction of the Palazzo del Collegio. These indicate that on the second hill to the north there were at least isolated dwellings and very possibly whole suburbs: *burgi extra moenia*, districts beyond the walls.

Inside the walls, however, stood the principal civic buildings. The remains of the theatre, dating from the first century BC, were excavated in 1972, and may be seen by the side of the present Via Domenico. It stood on the Decumanus Maximus near the junction with the Cardo. It consisted of a semi-circular auditorium, facing a rectangular *scaenae frons*, similar but on a smaller scale to the surviving Roman theatres at Aspendo, Leptis Magna and the Marcellus Theatre in Rome. Also from the Republican period, a cistern (found in 1964 in the Cortile Seminario), a baths building and the remains of houses with mosaic pavements have been discovered. An aqueduct was built in the mid-second century

> Belisarius was left to press the siege of Urbino with 1,800 men. The 2,000 Goths of the garrison, aware of what had happened, laughed and jeered at him. But the cloister was soon in position, while his best archers, perched on a scaffolding behind and protected by a screen, picked off the sentries on the battlements.
>
> Though the miners worked vigorously, by the third day they had not yet dug down to the foundations of the wall, and the rams, swung in unison, still made no noticeable impression on it. Then the Goths succeeded in pushing down a whole merlon upon the roof of the cloister. It broke through, but killed nobody, for the

ABOVE: Excavations at the old University building, Via Saffi.
RIGHT: Map of Urbino from 1708 showing gateways and monastic foundations. The name Urbino is derived from the Latin 'urvus', meaning a ploughshare, and the walled city retained the same shape long after Roman times. Most of the gateways likewise remained unchanged, as did the crisscross pattern of the principal streets.

archers on the scaffolding gave warning in time. Belisarius reckoned that it would be two months at least before the wall collapsed, and made no secret of this to his remaining officers. Judge then of his surprise, and ours, when on the fourth day, having been strangely quiet for the two preceding days, the Goths of the garrison appeared between the embrasures of the battlements with their hands raised in token of surrender. By midday the terms had been agreed upon between Belisarius and their commander, and Urbino was ours.

The reason for this sudden capitulation was, we have on authority, a lack of water. Graves gives an ingenious explanation for this: Narses, having departed to hold Rimini,

had struck a spring of water and diverted it in order to water his horses. By altering its natural course he had left dry the spring at Urbino.

Whether or not this is true, it seems clear that the walls, and therefore perhaps some of the structures within them, had remained virtually intact. In the western quarter of the city, set above a declivity even more precipitous than it is today, and commanding a view across the surrounding province, had in Roman times been grouped the forum and the fine public buildings, both secular and religious – in short, the heart of Urvinum Mataurense. The pattern had been set. It was on the same site on which the principal structures of the medieval city and the towers of the Renaissance palace were to rise.

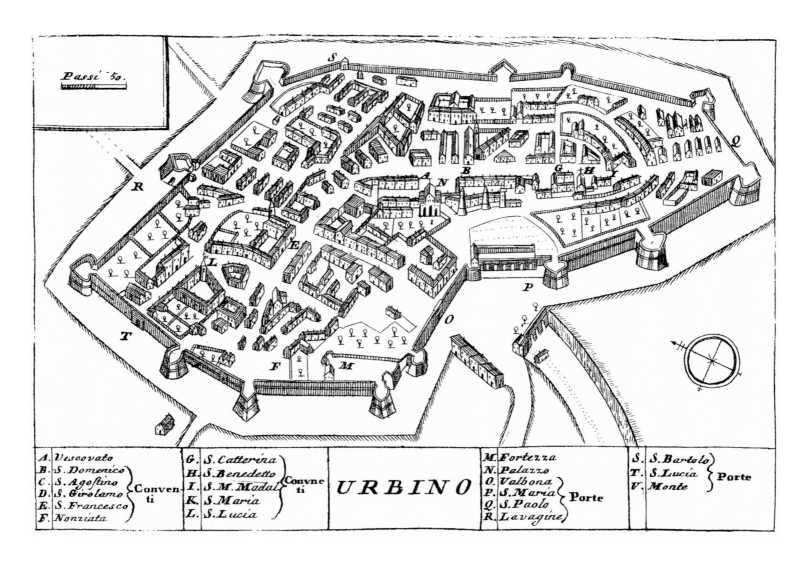

A. Vescovato		G. S. Catterina			M. Fortezza		S. S. Bartolo	
B. S. Domenico		H. S. Benedetto			N. Palazzo		T. S. Lucia	Porte
C. S. Agostino	Conventi	I. S. M. Madal.	Convneti	**URBINO**	O. Valbona		V. Monte	
D. S. Girolamo		K. S. Maria			P. S. Maria	Porte		
E. S. Francesco		L. S. Lucia			Q. S. Paolo			
F. Nonziata					R. Lavagine			

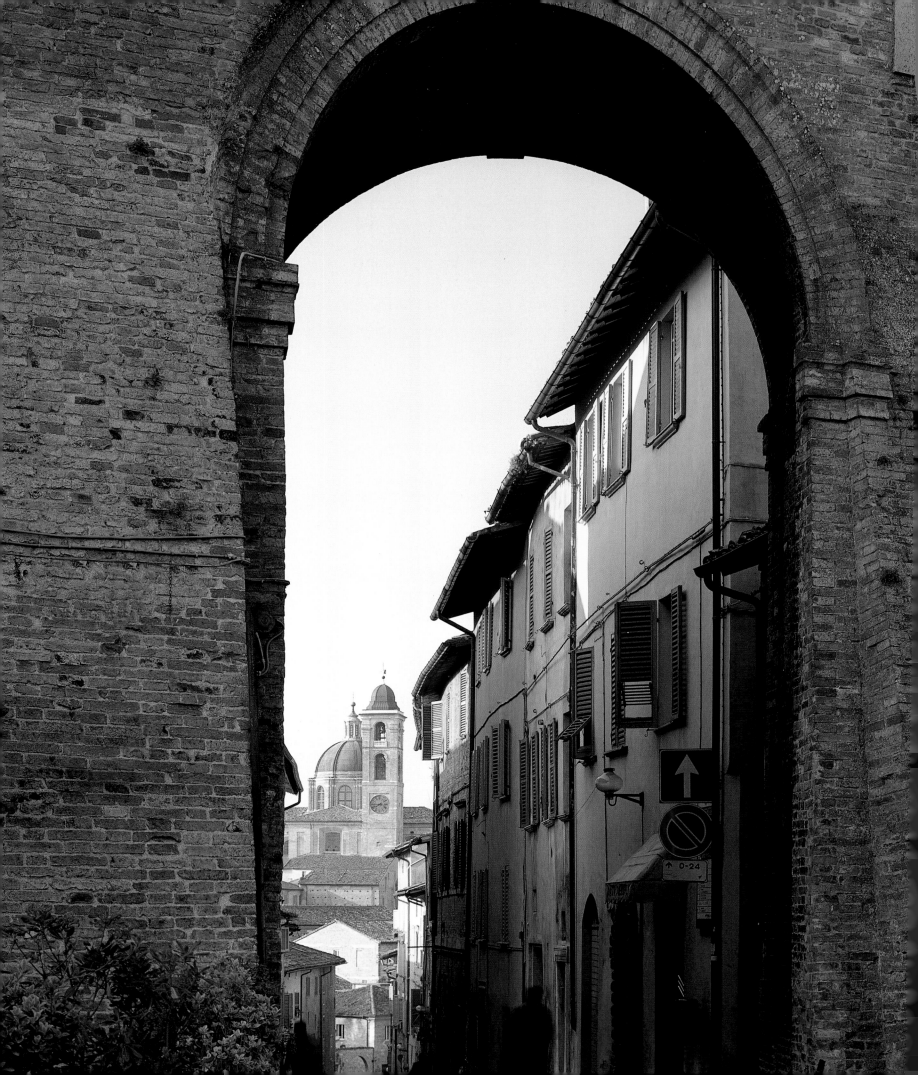

EARLY MEDIEVAL URBINO

From being an outpost of the Roman Empire, Urbino became a bishopric, at first under the sway of Byzantium. Then, threatened by the Lombards from eastern Germany, who from the beginning of the eighth century occupied all the surrounding territory, the city came increasingly under the control of Rome.

Urbino – together with Jesi and Gubbio, the five towns along the Adriatic coast between Rimini and Ancona (Pentapoli), and the city of Ravenna – had been ceded to the Church by Charlemagne. The Emperor handed these lands over to the Papacy, binding his beneficiaries to him with promises of loyalty, in exchange for military service and collaboration.

It may seem incredible, but it is nevertheless accepted almost beyond dispute that the enormous political power exercised by the popes from the time of Charlemagne onwards was based on a forgery. A document known as the Donation of Constantine (*Donatio Constantini*) concerns an alleged gift from Constantine the Great, the first Christian emperor, to Pope Sylvester I (314–35). In gratitude for his supposedly curing him of leprosy and converting him to Christianity, Constantine was said to have granted the Pope and his successors for all time not only spiritual supremacy over the other great patriarchs, but temporal dominion over the whole of western Europe, and in particular Italy. However spurious the document, it was accepted unquestioningly; to doubt it would have been judged utterly heretical. Based on an apocryphal fifth-century *Life of Saint Sylvester*, the document is now thought to have been written at some date between 750 and 800, and to be of either Roman or Frankish authorship. Its authenticity was unchallenged until the scholar Lorenzo

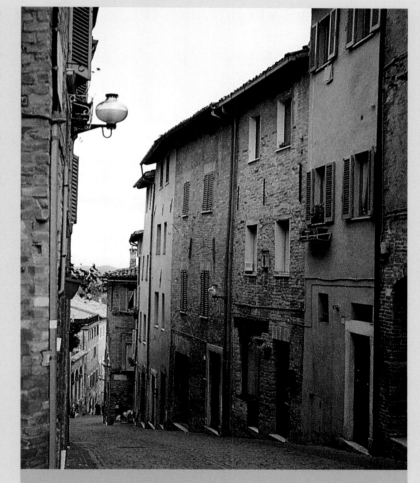

'I WAS OF THE MOUNTAINS THERE, BETWEEN URBINO AND THE YOKE WHENCE TIBER POURS'

Count Guido da Montefeltro,
in Dante Alighieri's *The Divine Comedy: Inferno*, Canto XXVII

LEFT: Porta Sta Lucia. This was originally the main entrance to the city, because access from outside was less steep. Through the arch can be seen the Via Bramante.
RIGHT: The Via Raffaello, descending steeply from the present Piazzale Roma down to the church of S. Francesco, retains some of the quality of a medieval street.

Valla questioned it in 1440, and from the twelfth century onwards the popes wielded it as a weapon of immense power. Worldly ambitions could be theirs on a scale never envisaged by St Peter. Not only could they threaten their enemies with excommunication, they could also know that the threat would be taken with the utmost seriousness.

Enjoying papal protection, as she did for much of the Middle Ages, Urbino appeared to hold the high ground, morally as well as geographically. The Bishop and Chapter of the city were among the greatest landowners of the area. They founded numerous parish churches and chapels in the surrounding district, widening the territory under the control of the Church. Clearly, though, when it came to administration, the Church needed the assistance of the laity.

A feudal system was introduced. Initially, the territory of Urbino was divided mainly into the possession of the Brancaleoni, Carpegna, Castel d'Elci, Dadei, Faggiolini, Feltri Gaboardi di Macerata Feltria and Olivieri families. But it is above all with the name of Montefeltro that the city came to be associated.[1]

The origins of the Montefeltro family appear to have been German. They seem to have descended from the counts of Carpegna (whose loyalty was to the Emperor). One branch of the family retained the castle of Carpegna; one took that of Pietra Rubbia; the third, the youngest branch, who were the Montefeltro antecedents, the castle of Montecopiolo, north of Carpegna. Montecopiolo was a small stronghold set in high rugged land bristling with such turrets. 'For I was of the mountains there, between Urbino and the yoke whence Tiber pours,' declares Guido da Montefeltro to Virgil in Dante's *Inferno*, Canto XXVII.

The Montefeltro family prospered, gained control of the bishopric and became the most powerful rulers in the region. They were given the title of Counts of Montefeltro and the first whose name we know for certain was Montefeltrano (*c*.1135–1202). Because of his military prowess he gained control over the whole diocese, and won the recognition of the Holy Roman Emperor Frederick I, Barbarossa (*c*.1122–90). He is recorded as being constantly with the imperial troops and at the side of the Emperor's heir Henry, whether at Perugia, Siena or Bologna. He established himself at the rocky fortress of S. Leo, a virtually inaccessible eagle's nest commanding the Marecchia valley; and to civilize this dizzy place he founded, in 1171, its cathedral, which took thirty years to build. Montefeltrano was succeeded by his sons, Buonconte (1170?–1242) and Taddeo (1180?–1251).[2] These two further strengthened the position of the Montefeltro family, and it was finally on them that Emperor Frederick II, in 1226, bestowed the overlordship of Urbino. In order to explain how the Emperor considered himself empowered to do such a thing, a few words of explanation are perhaps needed concerning the confrontation between the Guelfs and the Ghibellines.

The name Guelf is derived from Welf, the family name of the dukes of Bavaria; the name Ghibelline from Waiblingen, the castle of the Hohenstaufen dukes of Swabia. The Guelfs were, in general, supporters of the territorial ambitions of the Papacy, and the Ghibellines supporters of the Holy Roman Emperor. Conflict between them did not really begin until the turn of the twelfth to thirteenth century, when the Guelf supporters of Otto, second son of Henry the Lion, were contesting with those of the Ghibelline Philip of Swabia for control over central Italy. However, a strong Papacy in the person of Innocent III (1198–1216) pronounced that the pope had a right to intervene in such disputes and to bestow the imperial crown on the man who would best defend the Church. He declared in favour of Otto, and had him crowned Otto IV. When Otto invaded Sicily and southern Italy, however, the Pope excommunicated and deposed him.

Matters came to a head during the reign of Frederick II (1194–1250), nephew of Philip of Swabia. In 1220 he was crowned emperor by Honorius III, successor to Innocent III. A mild and gentle character, Honorius had been Frederick's tutor; and he crowned him on the condition that he would undertake a crusade. The next pope, Gregory IX, nephew of Innocent III, was a much tougher character. He accused Frederick of having failed in his obligation by abandoning the Sixth Crusade – although in fact he had been seriously ill at the time – and excommunicated him. Frederick nevertheless went ahead with the crusade in June 1228, with the supreme success of capturing Jerusalem. He was, however, still

excommunicated, and continuing belief in the Donation of Constantine meant that this was not a matter to be taken lightly. Frederick won a decisive victory over the Lombards at Cortenuova in November 1237 and was aiming at control of all central Italy including Rome. Pope Gregory tried to set up a rival king, declaring Frederick to be a blasphemer; Frederick called for a general council to judge the Pope. He invaded the Papal States, imprisoning two cardinals and threatening Rome itself. At this point, the aged Pope died, leaving the Ghibelline party clearly in the ascendant.

Then came the problem of choosing a new pope. The cardinals (all but the two who were still in prison) were shut up in dire conditions by the powerful Roman senator Matteo Rosso Orsini until they could reach the necessary two-thirds majority. This was finally achieved in favour of the ancient and ailing Celestine IV. Doubtless they guessed that he would not last long, and his death only a fortnight later allowed a breathing space. The Holy See was vacant for eighteen months, following which the Curia chose the Genoese lawyer Innocent IV.

Meanwhile, Frederick II was still looking to have his excommunication lifted, and drafted a treaty according to which he would return the Papal States in exchange for this. The Pope, however, did not trust him; he sailed secretly to his native city of Genoa and settled in Lyons. There he attempted to depose the Emperor. Frederick questioned the Pope's authority to do such a thing. Innocent exploited the powers that he believed were vested in him by the Donation of Constantine, establishing the Inquisition and the use of torture, and attempted to raise a crusade against Frederick. But on 13 December 1250 the Emperor died, to be succeeded by his second son, Conrad. There followed a Guelf–Ghibelline dispute over the Kingdom of Sicily. On the death of Conrad, Frederick's illegitimate son Manfred became regent. At first, Manfred acknowledged the Pope's supremacy, but in November 1254 he rebelled, and routed the papal troops near Foggia. The news of this defeat reached the Pope as he lay dying in Naples.

From all this confusion emerges a see-sawing of power, first one side and then the other being in the ascendant. The small cities of Italy – who were in any case constantly on their guard against neighbouring towns, an armed truce being as much as they could hope for – found it necessary to align themselves with one great power or the other, declaring themselves loyal scions of the Emperor or faithful sons of the Church. They may in fact have been disillusioned at times with both, but they had to act shrewdly for their very survival. Battlements began to be raised displaying the merlons (swallowtails) of the Ghibellines or the right-angled crenellations of the Guelfs. Allegiance depended more on pragmatism than on principle, and might shift within the same family from one side to the other. Thus it was with the Montefeltro of Urbino.

When, on 31 January 1226, the people of the city were required to accept Counts Buonconte and Taddeo da Montefeltro, sons of Montefeltrano, as lords of Urbino, various stipulations were made. In order to placate the people, it was agreed that there should be a general pardon and that duties previously enforced should be observed, and although the Counts gained immediate control over the city, a three-month period of grace was allowed to ease the transition. The Montefeltro prudently agreed to this, pardoning the citizens of all offences and not exacting any punishment.

Initially, all was peaceful. The Holy See was acting as a moderator between the various groups in the city, as it also did in the neighbouring districts. On 2 March 1235 Pope Gregory IX sent the Patriarch of Antioch into Romagna in order to make peace between the different factions: Ravenna, Forlì, Rimini and Forlimpoli on the one hand, and Cesena, Faenze, Urbino and Cervia on the other. The situation, however, was complicated because the Montefeltro owed their power to Ghibelline patronage and, two months after the advent of the Patriarch, Buonconte was fighting at the side of the imperial leader, defending Ravenna against Faenza. Taddeo (who, on the death of Buonconte, came to be recognized as the head of the family) joined the Emperor's crusade to the Holy Land.

With the election of Innocent IV to the Papacy in June 1243, much stronger measures were taken against the Ghibelline faction. He roundly condemned Taddeo as 'noble by birth but ignoble in actions carried out against the Church'. On the

death of Taddeo, Buonconte's son Montefeltrano II succeeded, and among the new count's brothers was Ugolino, Bishop of Montefeltro. Writing to Ugolino, the Pope bitterly attacked his late uncle Taddeo, together with his supporters Bisaccione da Pignano, Guido da Cerreto and Tiberto son of Guitone, for having been followers of the excommunicated Emperor Frederick. The Pope was equally harsh in his condemnation of Ugolino's brother Montefeltrano. He then wrote to the citizens of Jesi and Recanati saying that he knew how they had been oppressed under imperial rule. He said that by way of reparation, the victims should be given the goods of the tyrants, naming in particular among the latter Count Montefeltrano II who had 'betrayed the Church of Rome and incited others to betray her'.

After the Battle of Parma in February 1248 and the collapse of imperial power, various nobles previously Ghibelline went over to the other side. Among these had been Taddeo, Count of Montefeltro and Urbino. His defection to the Guelf party caused a profound crisis in the family, Ugolino and his brothers (one of them a Franciscan friar) remaining loyal to the Ghibelline tradition. When Emperor Frederick died, Innocent IV wrote to the Bishop of Ravenna asking him to try to persuade Bishop Ugolino and his brothers to observe obedience to the Church of Rome. An uncertain truce was achieved.

Count Guido (1220–98), son of Montefeltrano II, was described by Giovani Villani, a contemporary chronicler from Perugia, as 'the wisest and subtlest man of war of his time in all Italy'. He is the subject of Canto XXVII in Dante's *Inferno*. While still young, Guido had married a girl of the Ghiaggiolo family, who were 'residents' of the archbishopric of Ravenna and very considerable landowners. (Their estates, extending from the middle and high valleys of the Bidete to the Mount of Forlì, included the castles of Ghiaggiolo, Chisercoli and Valpondi.) Through the early death of his father-in-law, Guido had become head of his wife's family and had inherited all their possessions; he thus became involved in the administration of Forlì. He served in Frederick II's army as commander of the Forlì contingent, first at the siege of Faenza in 1240 and then at the battle of Parma. Meanwhile, the death

of his own father Montefeltro further distanced him, virtually cutting him off from his own family. In 1259 he took over Urbino, swiftly gained control over the mountainous districts around and, at the Battle of Montaperti, assured the Ghibellines dominion over all of central Italy. He defended Forlì against French troops sent by Pope Martin IV, only to be driven out three years later when that city, in common with most of Romagna, made terms with the Papacy. In 1282, the city of Urbino was besieged by Papal troops under Anguillara. Guido was defeated and taken prisoner. Exiled and excommunicated, he later became reconciled with the Church and entered the Franciscan order. Nevertheless, in Dante's *Inferno* he is relegated to the Eighth Circle, as he went on to advocate treachery to the Pope as a means of subduing the fortified city of Palestrina.

In central Italy the Middle Ages may have been a time of conflict, yet it was also a period of great monastic foundations. Already in the early eleventh century, Urbino's cathedral had been built, consecrated in 1021 by Bishop Theodoric and dedicated to the Virgin; it was located at S. Sergio. In 1056, Mainardo was invited by the Church to take over the Bishopric of Urbino, and he set about building a new and more spacious cathedral, changing its location to Sta Maria Rocca in the administrative heart of the city. He dedicated it himself to the Virgin of the Assumption and S. Crescentino. We know little about its form and structure, and very little either about how it appeared after further work, amounting perhaps to a rebuilding, was carried out at the end of the fourteenth century. (Only a small fragment of fresco survives from this date, by the Altar of the Conception.)

In Urbino, the monastic foundations, sited as they were at three equidistant points, gave the city a certain stability. The first to be established was the Dominican friary. The Dominicans had come to settle in Urbino as early as the second decade of the thirteenth century; consequently they were allowed a privileged position at the very heart of the city, near the palace and the town hall. Their special relationship with the Church was enhanced in 1297 when Pope Boniface VIII issued a bull giving various benefits to the order in Urbino. The church of S. Domenico was sited halfway along the main street that

runs through the city like a spinal column. The other monastic buildings stood 885 feet away on either side of it.

The friary of S. Agostino was founded in 1225 at the southern tip of the Poggio, in an area outside the first medieval walls but close to the city gate (Porta Mondelce). Via S. Agostino is one of the small streets leading off the present-day Via Saffi. The presence of the friary stimulated further development in this area, and a new district grew up around it.

The third order to be established in Urbino was that of the Franciscans. Their friary was built in 1286 on the site formerly occupied by the Benedictines. It was located on the northern side of the city, near the Pian di Mercato (today's Piazza della Repubblica), alongside the steep slopes of the road now called the Via Raffaello. Consequently it enjoyed the benefits of being near the heart of the commercial city. The Franciscan order was then of quite recent origin (St Francis had died at Assisi in 1226 at the age of forty-five, and two years later was canonized by Pope Gregory IX) and it was especially favoured by the Montefeltro family. It probably influenced Bishop Ugolino, and certainly his brother Taddeo was a member of the order. Even Count Guido, towards the end of his life, became a cordelier – an extreme gesture of repentance, the cordeliers possessing no money, walking barefoot and wearing a simple robe tied at the waist with a cord.

While not every member of the ruling family went to such lengths, nevertheless the Franciscan friary enjoyed their patronage. It became one of the greatest institutions in Urbino, and early in its history the Studio del Convento was founded, later to become the Public Grammar School. By the sixteenth century this had become absorbed into the university as the School of Philosophy and Theology of the Convent of S. Francesco.

Thus there were three main centres looking after the spiritual needs of the city and influencing its development.

The expansion of Urbino outside the original city walls was very closely linked to the religious foundations. The

Pagina Confimationes of 1069, in which Bishop Mainardo handed over the administration of all the estates belonging to the diocese, gives an idea of their extent. At various times since the Dark Ages these estates had been ceded to the Church in exchange for protection. Thus the whole area outside the walls belonged to the Church, and although the estates were now handed over to lay administration to allow for the expansion of the city, it was the ecclesiastical authority that remained the landlord.

Originally, the old Roman wall largely defined the limits of the city, and developments outside it were sparse and scattered. But between the eleventh and thirteenth centuries

Ghibelline merlons on the Ducal Palace. The swallowtail shape of the medieval crenellations is just discernible in the brickwork, between the later windows of the palace.

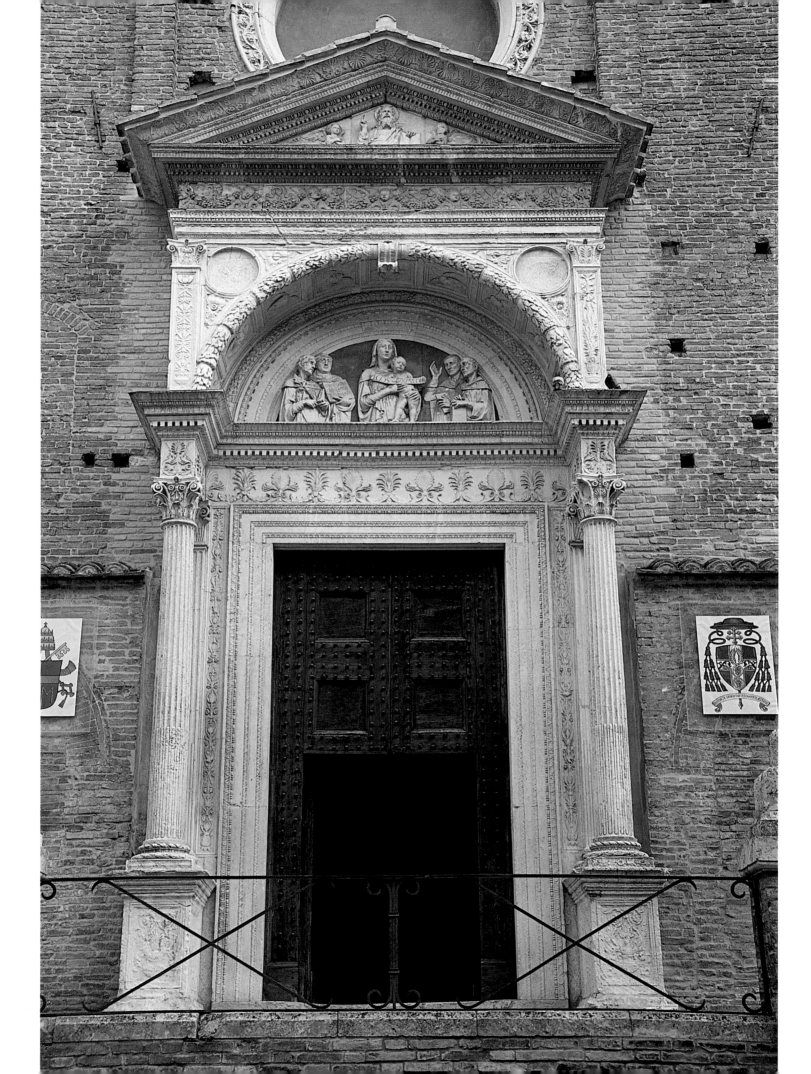

there was considerable development, bringing increasing urbanization to previously rural areas.

The development happened largely to the north, along the line of the Via Raffaello, following a line through the Porta Maia up to the second hill. This was an important axial route, connecting Urbino with Pesaro to the east, Rimini to the north and Montefeltro to the north-west. It was also the point at which the city had been most vulnerable to attack: the second hill being the higher, its occupation by enemy troops could give them the advantage.

When a new wall was constructed, it included the northern development, and extended to the summit of the second hill.[3] The exit here was through the Porta del Monte. To the south of the city, the wall ran along the valley side parallel to, then joining up with, the old Roman one. To the east, the steep natural gradient of the land, together with a manmade ditch, made the curtain wall formidably strong.

Some building was done at this time outside the city walls, but close enough to them to enjoy some protection. An example is the area either side of the Via Saffi; the medieval city extended outside the Porta Mondelce in a series of little streets running either side of the principal road and parallel to the tongue-shaped line of the wall. To the north-east of the Porta Mendelce the *sportello* was opened up – a little wicket gate for the use of pedestrians.

It is difficult to be precise about the dates and the exact lines of the walls built successively to defend the city, since medieval custom was to re-use ancient materials, and if the line of the Roman wall still seemed to be what was required at a particular point, then it could be used again, at least as a foundation.

The plan of the medieval city was in essence little changed from that of the Roman one, divided into quarters by the prevailing street pattern. What was new was the Pian di Mercato, a spot which even today forms a natural and popular meeting place, the Piazza della Repubblica.

The story of medieval Urbino, however, was not entirely one of quiet and uneventful development. Despite Count Guido's temporary reconciliation with the Papacy, the Montefeltro family's allegiance had always been primarily to the Emperor. Moreover, their favouring the Franciscan movement was not something that would necessarily endear them to the Pope, poverty and humility as exemplified by the life of St Francis being a far cry from the worldly splendour that seemed to have been afforded by the Donation of Constantine.[4] Under Clement V (1305–14) the Papacy had moved to Avignon, which then belonged not to France but to the Angevin King of Naples, but this did not at all mean that they had relinquished territorial power in Italy.

Count Guido's successor was his son Federico; he inherited a troubled overlordship. In 1320–21, he found himself at the head of a revolt among the people of the Marches, Umbria and Romagna against the forces of the Curia. The papal armies in the Marches were under the command of Pandolfo Malatesta, Lord of Rimini. He was trying to obtain control of Cagli and Fano, as well as Urbino itself, and was assisted by Urberto, Count of Ghiaggiolo, Paoluccio della Fagiola and Lippaccio and Andrea di Osimo. The Ghibellines under Federico held a conference at Bagno di Romagna, and assistance to their cause was offered by troops from Arezzo, Lucca and Pisa. These troops made a surprise attack on the forces of Pandolfo Malatesta, but with the support of the Bolognese, the Riminese army made a successful counterattack, and they spent the summer camping at Montefabbri, at the very gates of Urbino. The Pope wrote praising those of Rimini, Pesaro, Cesena and Gubbio who had supported the papal army against the so-called tyrant Federico.

At this stage, Federico left his sons and his cousin Speranza to defend Urbino while he himself went to Umbria to look after matters in Spoleto, for in the early part of 1321 it seemed

Porch of the church of S. Domenico (opposite the Ducal Palace). The Domenican Order established a friary here in the early thirteenth century. The medieval church was partially rebuilt in Duke Federico's time (see page 89) and the porch ornamented with a lunette by Luca della Robbia (c.1400–82). (The original lunette is now in the Iole suite of the Ducal Palace.)

that, in spite of Pandolfo's counterattack, he still held the advantage. But things were becoming increasingly difficult for the Montefeltro faction, partly because of their diminishing resources, partly because of the Malatesta strategy of concentrating their forces at the weakest point: the border between the Marches and Umbria. Moreover the Pope was exercising enormous pressure to induce local rulers to 'take up the Cross' and oppose Federico and his allies, whom he labelled 'heretics and idolators'. He issued a bull, which was sent to all the bishops and abbots in the papal lands (including, it appears, the Bishop of Salisbury), enumerating their villainies. It asserted that they had seized the treasure left in the church of the basilica of St Francis, that they held the Bishop of Osimo prisoner and that they had 'blasphemously set up a confraternity in the name of the Blessed Virgin' in order to try and impose their will on the people of Urbino. For those who resisted them, the Pope granted indulgence – remission from punishment for sin – for a year. Meanwhile Francesco Bishop of Rimini sent messages from the Pope to the people of Florence, Bologna and Perugia, encouraging them to send soldiers to fight against the 'heretics'. And even in Urbino, Brother Lorenzo

da Mondaino was empowered by the Pope to establish beyond doubt the nefarious nature of Federico, thus undermining loyalty among the citizens.

Conditions in the city became more and more difficult. Count Federico felt obliged to return, and arrived in Spoleto to find all the strongholds around the city already in enemy hands, and the citizens largely hostile. He took refuge in the main tower on the Monte where his sons were already besieged. The Guelf armies entered the city in ferocious mood. On 2 April 1322 Federico, with his son Guido, appeared to the people and in vain entreated mercy; immediately they were both assassinated. In the words of Giovanni Villani, 'the people of Urbino in this year rose up against Count Federigo di Messer Guido da Montefeltro their overlord . . . and the populace in fury killed him and his son.'

Among those directly involved in stirring the insurrection, Antonio Orso was promoted from the Bishopric of Rimini to that of Florence, and later took refuge in the Curia at Avignon; Brother Lorenzo da Mondaino, who had incited the people against Federico, was made Bishop of Ragusa.

Urbino was left in chaos. In the words of the chronicler Federico Veterani, 'In the year 1323 the city of Urbino fell into the hands of the enemy and the walls were destroyed from their foundations; she was deprived of her country district and of honours, laws and privileges, by the enemies of the Holy Roman Emperor.'

The surviving members of the Montefeltro family took refuge in neighbouring castles: Federico's other sons at Castel d'Elci, Cagli and Mercatello, and his cousin Speranza at S. Marino. From these mountain strongholds they raised military help from Arezzo and Fabriano, and launched an attack to try to repossess Urbino. At first the city resisted, but the discontent of the people was such that they ultimately prevailed. Count Speranza, with the support of soldiers provided by the Bishop of Arezzo, also from Fermo and Fabriano, re-entered Urbino together with his nephew Nolfo, the eldest of Federico's surviving sons.[5]

ABOVE: The old name for the Piazza della Repubblica was Pian di Mercato, and a street market is still held here outside the church of S. Francesco.
RIGHT: Campanile of the church of S. Francesco. The Franciscan movement was a powerful influence in Urbino.

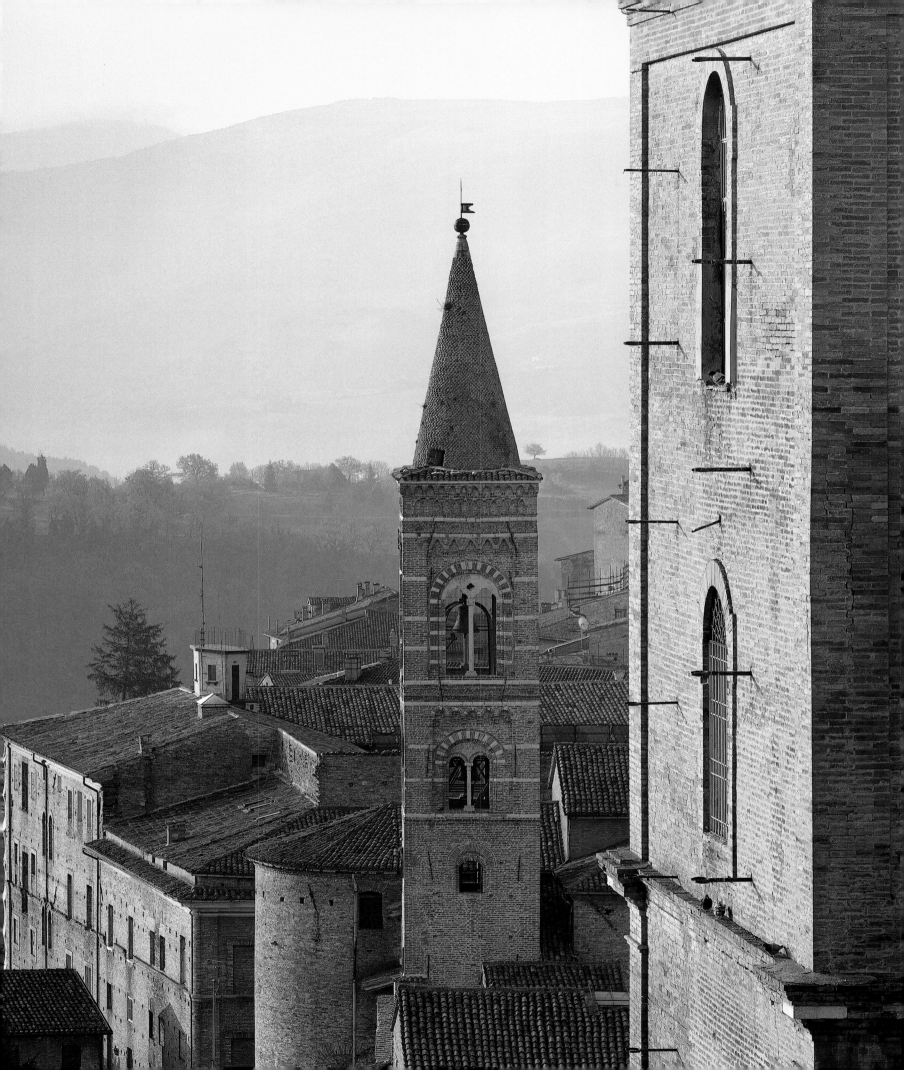

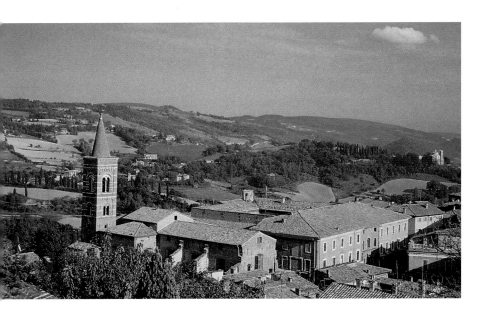

Similarly urged on by the formidable Bishop of Arezzo (who was later censured by the Pope for giving armed support to the excommunicated lords), the former rulers of Fermo, Fabriano and Osimo were reinstated in their domains. They ranged themselves together in a league, the Amici della Marca (Friends of the Marches), with Count Speranza as their captain, their opponents still headed by Pandolfo Malatesta of Rimini.

In the end, however, it was hardly possible to sustain opposition to the Church. In 1353, the Papacy, still at Avignon, gave the Spanish cardinal Egidio Alvarez Carillo d'Albornoz (after whom the Fortezza Albornoz at Urbino is named) the task of restoring former possessions to their control. The Montefeltro were invited to give the cities of Urbino and Cagli back to the Church. Nolfo and his brother Enrico met up with Albornoz at Gubbio. On the one hand they agreed to recognize the authority of the Church; on the other, they were granted *custodia civitatis* (custody of the state) over both Urbino and Cagli. On the death of Nolfo in 1365, Paolo Montefeltro succeeded as count; but then Albornoz, who had always been a moderating influence, suddenly died in 1367. Two years later Urbino was taken over by Pandolfo Malatesta, and Paolo was stripped of power and humiliated. The cities of the Marches were asked to raise taxes to pay papal foreign mercenaries. It was at this point that the people of Urbino rose in revolt, and on 21 December 1375 they acclaimed Antonio da Montefeltro, the grandson of Nolfo, as Lord of Urbino and Cagli. He remained in control for more than twenty-five years. At last the city was able to achieve some stability.

Throughout this chequered history, what is noticeable is the growing power of the people. To be successful, an overlord had to rule with their consent. Even in the early times when Urbino was ruled nominally by bishops, they had the lay Consiglio degli Ottimati (Council of Distinguished Men) to advise them, composed of representatives from the city's leading families. Gradually the people freed themselves from the jurisdiction of the Church, gaining greater autonomy. From this Consiglio was derived the new civic authority, or Comune.

The city had always relied on the produce and resources of the outlying area. These lands were run according to a feudal system by the local lords of the manor under the general jurisdiction of the Church. Gradually their power was transferred to that of the Comune. In return, the Comune looked after their security as best it could, undertook building works and improved the condition of the roads, thus providing an effective market for their produce. Acts of submission of varying severity were imposed on the lords of the manor: they were required to pay taxes, to swear loyalty to the Comune and sometimes to reside for part of the year in the city. The inhabitants of Viapiano, for example, were required (in a document of 1219) to become citizens of Urbino in perpetuity and to swear loyalty to the city. What we find therefore is that with urbanization of the outlying areas, power became increasingly centralized.

At the head of the Comune was the Potestas (Supreme Judge). He was assisted by the Sindacus (Council), by the Chief Procurator, by the Priores (Magistrates) and by the

Church of the 'Scalzi' (barefoot or Carmelite friars), seen from the public gardens by the Fortezza Albornoz.

notaries specializing in different aspects of the law. These included, for instance, the Notarius Camerarii (Privy Notary), the Notarius Malefiteorum to deal with criminal cases and the Notarius Iudicis Minoris to deal with petty cases. There were also the guardians of the city walls and boundaries, and of ditches and springs. In addition there were the Sindaci Castrorum et Villarum, subcommittees to administer affairs in rural areas.

The centre for local government was sited in the same area as it had been in Roman times. The Palazzo del Comune, or town hall, seems to have stood on the south side of the main square, now called Piazza Duca Federico. Nothing of it remains above ground, and the only evidence we have is from documents. As in Roman times, the city was divided into *quadre* (quarters). These were Vescovado in the north-west, Pusterla in the north-east, S. Croce in the south-east and Porta Nova in the south-west. Each had its own representative, a notary and sometimes its own militia. One can imagine there may well have been a certain rivalry between them; citizens would identify with one quarter or another. Each, however, was subordinated to the central Comune.

We know very little about the physical appearance of medieval Urbino, and almost equally little about the lives of her inhabitants. It was decreed that the only activity carried on by the people of the outlying districts should be farming, and that all the produce should be brought to the city to be sold. The main market for goods from the countryside, especially livestock, horses and cattle trading, was just outside the city walls by today's Porta Valbona on the spot still known as the Mercatale. In the Middle Ages, however, there was also a new market in the middle of the city, at the Pian di Mercato. This was little more than a widening out of the street, but it provided an important trading centre, being so easily accessible from every part of the city, and it encouraged the siting of craftsmen's workshops along the adjoining roads.

It was here that the first of the confraternities started up: the brotherhood of Sta Maria della Misericordia di Pian di Mercato, founded in 1265. This was the organization so roundly castigated by Pope John XXII in 1321. It was followed in 1318 by the confraternity of S. Croce, in 1350 by that of S. Giovanni Battista and Corpus Domini. In 1362 the confraternity dell'Umilità was founded, and in 1398 that of Spirito Santo (Holy Spirit).

These were charitable organizations. The most important of them was the earliest one, the confraternity of Sta Maria della Misericordia. It was set up by a hundred citizens, without the use of public funding, its initial aim being the rescue and care of abandoned children (rather like the Ospedale degli Innocenti in Florence). Later, with generous donations from the nobility, especially the Paciotti of Montefabbri, the confraternity was able to build a hospital for the sick. Thus the confraternity became not only a considerable landowner, on account of bequests made to it, but also the principal charitable organization in the city. And while it would be an exaggeration to say that medieval Urbino was a welfare state, yet there was some hope of help for the needy. There was some sense of compassion.

Urbino was never a large city, and at no time did the population rise above more than a few thousand. Yet it was a lively place, where in normal circumstances trade prospered under a well-organized government. The new families coming to live in the city brought new vitality, new ideas. Gradually the Guelf–Ghibelline dispute began to subside. There was a declining belief in the infallibility of the Papacy, and at the same time a preference not to be ruled by the Empire either. Urbino was beginning to achieve her identity; in some ways pragmatic, prepared to make alliances where expedient, in other ways idealistic, touched by the spirit of St Francis. And we can detect, in the mid-fourteenth century, the growing importance of the people themselves, the beginning of a search for the ideal city state.

We can detect, too, signs of a proto-Renaissance, at least in the field of literature. By the time of Count Nolfo, both court and city had been enriched through marriages, especially by the dowry of 6,000 gold ducats brought by Teodora of the powerful Gonzaga family of Mantua. Military alliances, first with Siena and then with Perugia, followed by links with Verona, all helped to widen the horizon for the Montefeltro and their subjects, and the young princes took to visiting

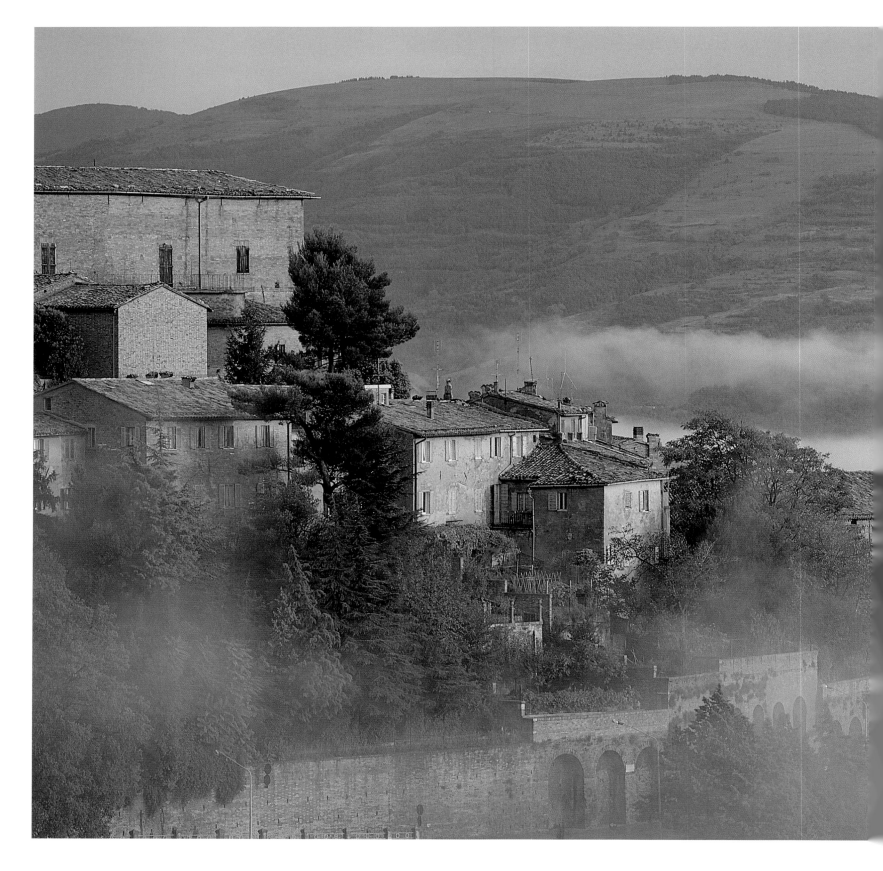

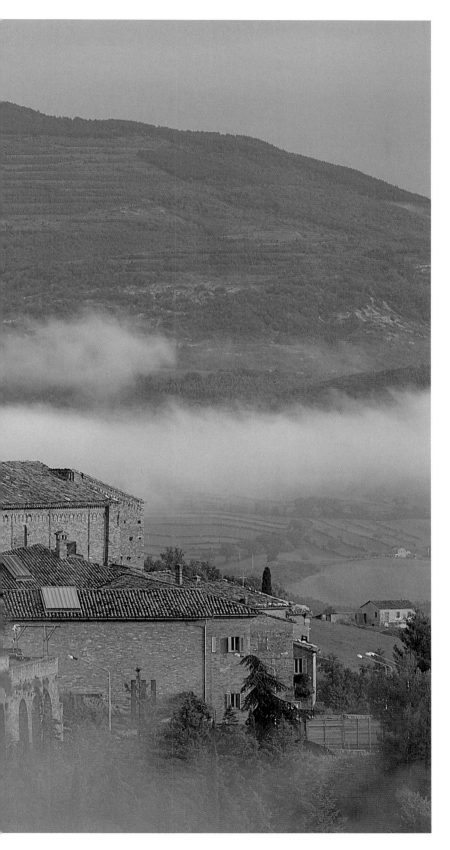

foreign courts. In Verona the court of the Scaligeri was an especially lively place, and it was here that the virile Count Galasso (1350–98) met his future bride Ghidola Malaspina. It was here too that an impoverished poet, Fazio degli Uberti (probably born in Pisa and an adherent of the Scaligeri) had the misfortune to fall in love with the same girl. Ghidola was sent to Urbino to be married and the exiled poet also travelled to the city and met her once again, but her status was now far above his.

His poem describes his journey to Urbino, the 'misty sun', and the bittersweet joy of their reunion (making delicate play on her surname, which means 'wicked thorn'):

> Nell' ultima città ch'e qui nomata
> trovai quel vago sol, trovai la rosa
> che sopra Luni de' mali spini e nata.

> In that last-named city
> I found that misty sun, I found that rose
> Born from wicked thorns beyond the moon.

He goes on to compare himself to Achilles arriving at the gates of Troy. His passion can never end in happiness, for Ghidola is not for him; the rose is hedged about with thorns. In Fazio's plaintive and lyrical verse we find the first glimmerings of a Renaissance dawn.

Misty dawn at the fringe of the city.

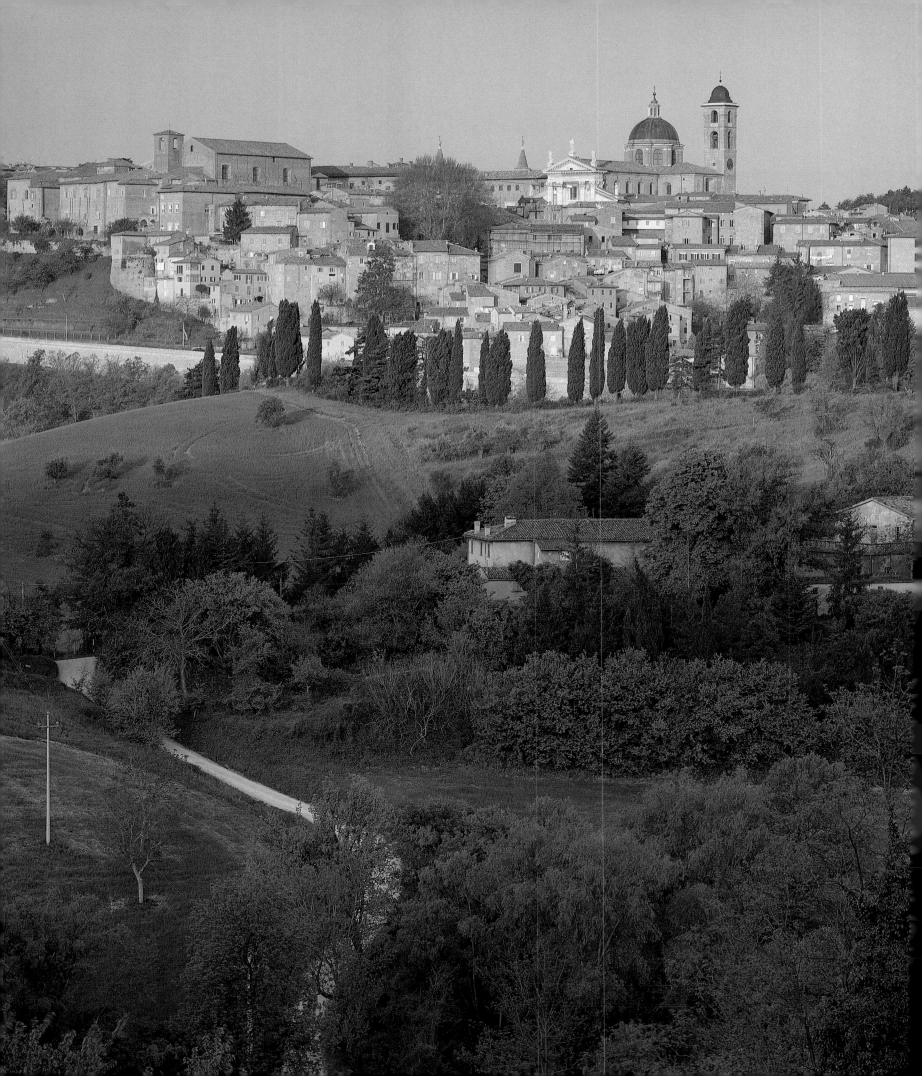

PRELUDE TO A GOLDEN AGE

The city of Urbino could easily have remained poor and obscure, whether well governed or not. She had few natural resources, the land was not particularly fertile and communications were difficult. She was not, like Venice, a great trading post between east and west. She could not, like Genoa, send out merchant-venturers to capture wealth from the New World. Nor was she, like Florence, a commercial centre with a thriving cloth trade, and an incomparable banking system built on the golden florin and expanded by the medieval equivalent of travellers' cheques. Urbino admittedly had a fine defensive position, rendering her strategically important in time of war. The city is placed in surroundings of incredible beauty among the foothills of the Apennines, but beauty alone does not engender prosperity. And the prosperity that made possible the founding of a remarkable centre of culture would not have occurred had it not been for the Montefeltro family tradition of becoming *condottieri*.

In these days we are accustomed to think of war as, to say the least of it, impoverishing: a phenomenon that destroys cities, decimates the population, lays waste the countryside and costs a great deal of money. It may seem strange to us that in certain circumstances and for certain people, war could be converted into a lucrative business, but this was the case in fifteenth-century Italy.

The custom was for powerful leaders, such as popes, dukes and emperors, to employ professional mercenary captains to do the fighting for them; these were called *condottieri*. Cities could meanwhile continue with their everyday trade and commerce. Although taxes might have to be raised, workshops could still be kept busy, feast days

'A MILITARY LEADER WHO KNOWS LATIN HAS A GREAT ADVANTAGE OVER ONE WHO DOES NOT'

Vespasiano da Bisticci, *The Vespasiano Memoirs*

LEFT: View of the city from the north-east.
RIGHT: Painted memorial to Sir John Hawkwood, Paolo Uccello (Duomo, Florence).

observed, frescoes and sculpture commissioned. There would be leisure for scientific invention, for the discussion of philosophy, for the writing of books. Nor was there the danger that the ruler himself, or his heir, might be killed in the conflict, disturbing the equilibrium of the realm.

The history of fourteenth- and fifteenth-century Italy was by no means free of violence, but when one compares it with that of England and France during the Hundred Years War (1337–1453) – which left France devastated and England deeply in debt (largely to Italian bankers) and in a state of political confusion that culminated in the Wars of the Roses – all one can say is that, while in certain parts of fifteenth-century Italy a Renaissance was possible, in the countries to the north it was not.

When major wars ended, there must have been unemployed and often unfunded soldiers left over – Germans, Swiss and English. Some of the more enterprising of these became *condottieri*. The Swiss Guards in the Vatican are an interesting survival from this custom.

One of the most celebrated and successful of the breed was an Englishman from Essex, by the name of Sir John Hawkwood, known in Italy as Giovanni Acuto. It is said that he fought at the battles of Crécy (1346) and Poitiers ten years later, and he was knighted by the Black Prince for his valour. For such a man, warfare must have become a way of life; possibly he knew no other trade. So when, after these victories, there was a lull in hostilities amounting it seemed to a peace, Hawkwood decided, instead of returning to Essex, to become a gentleman of fortune. By 1359 he was in command of a troop of lancers in Gascony. Three years later he turned up in Italy, fighting for the Marquis of Monferrato. He soon had at his command The White Company, a troop of 3,000 well-trained soldiers, armed mainly with lances and bows. For thirty years, Hawkwood's services were at the command of various masters, but in the latter part of his life he worked exclusively for Florence. When he died in 1394 aged nearly eighty, the Florentines awarded him a state funeral, and he would have been given a tomb in the cathedral, except that Richard II wrote asking for his body to be returned to England. Instead of a tomb,

a fresco was commissioned from Paolo Uccello in 1436, showing the intrepid warrior on horseback.[1]

Clearly a successful *condottiere* could be showered with honours. Jacob Burckhardt, in his book *The Civilization of the Renaissance in Italy* (1860), relates the story, perhaps apocryphal, of a *condottiere* who fought so bravely on behalf of a certain city (reputed to be Siena) that the people could not think of any reward grand enough to bestow on him. So they decided, 'Let us kill him and make him our patron saint.'

Mercenary captains were not always held in such esteem. They were often distrusted, for they owed no long-term allegiance to anyone. They might enter a city's territory threateningly and exact blood money if they were not employed immediately. They were independent soldier-princes, not upholding any particular cause other than their own personal wealth and self-aggrandizement. Their characters ranged from the downright wicked to the surprisingly pious. The Papacy might on occasion condemn them (as Urban IV did in 1364), even excommunicate them, yet not infrequently it used them for its own ends.

The *condotta* (contract) was an agreement drawn up between the captain and the power employing him. It was usually a contract for a set period of time or for a particular engagement, and when it was terminated it was quite in order for the captain to go over and fight on the other side. The contract would stipulate the standard of equipment to be used. Specially bred and trained war-horses were to be required, more than one for each cavalryman, and compensation was to be paid for any horses lost.

Condottieri were noted for their fearlessness and ruthlessness, and they were frequently suspected of using their trade to further their own ends rather than those of their employers. Machiavelli accused them of arranging 'soft' battles.[2] Certainly there was sometimes a tendency to rationalize war. If one adversary was clearly of superior strength to the other, there was little point in putting the matter to the test and incurring unnecessary bloodshed; it was much more sensible to arrange a treaty with the more favourable terms allowed to the stronger. Alternatively,

peace could be bought by taking hostages and exacting ransoms. This did not exactly fit in with chivalric ideals, and in fact came closer to Falstaff's opinions on Honour: 'Who hath it? He that died o' Wednesday. Doth he feel it? No.' (*Henry IV* Part I, V, i). Particularly successful *condottieri* might even be offered money for *not* fighting on the opposing side.

Before the end of the fourteenth century it came to be realized that the employment of foreign mercenary captains was too expensive and unreliable, and moreover that the Italians themselves were missing out on a profitable source of revenue. So indigenous *condottieri* began to emerge. The first seems to have been Alberico da Barbiano, who founded his Company of St George in 1378. When he died, half of his troops were taken over by the formidable Braccio Fortebraccio (1368–1424), otherwise known as Braccio di Montone. He was from an impoverished noble family of Perugia; from being a freelance soldier he had enriched himself sufficiently with loot and prisoners' ransoms to take command. In 1414 he became Captain General of the Church, and used the army nominally belonging to the Pope to conquer Perugia for himself. A current rhyme ran:

> Braccio valente
> Vince ogni gente.
> Papa Martino
> Non val un quattrino.

> Clever Braccio
> Conquers everybody.
> Pope Martin
> Isn't worth a farthing.

Renowned for his ruthlessness, Braccio was finally defeated at the Battle of Aquila by a Neapolitan force under Francesco Sforza and died of his wounds.

A blend of negotiation and soldiery fostered the fortunes of the Montefeltro family. The son of Count Antonio (see page 38) was Guidantonio da Montefeltro (1378–1443).

While still a young man he was entrusted with matters of government while his father was away in Milan in the service of the Duke. With the protection of the latter, Urbino became a place of refuge for those menaced by the power of Florence.

The fine defensive position of the city meant that there was little to fear from neighbouring powers, but to ensure peace and safety in a wider context it was necessary to keep on good diplomatic terms with the Papacy. Shortly after his father's death, Guidantonio sent lawyers to the Curia to arrange the payment of certain dues to the Church, with the result that on 22 May 1404 the young count was invested as a papal representative.

The standing that this gave him enhanced his relations with other states, and in particular persuaded the mighty Florence (always a Guelf city) to support Count Guidantonio against the rival claims of, for instance, the powerful Ubaldini family. In February 1406 the new pope, Innocent VII, wrote to the Count confirming the protection granted by his predecessor. Only four years later, however, by which time there was another pope, Alessandro V, Guidantonio found himself excommunicated. This was because he had helped Ladislas of Durazzo to become King of Naples. However in 1417, Cardinal Oddo Colonna, formerly Bishop of Urbino, was created Pope Martin V. (His election ended the schism in the Church; the antipope John XXIII fled, and the two successive antipopes had little following.) Pope Martin rescinded the excommunication, met Guidantonio in Mantua in 1418 and created him Duke of Spoleto. In his profession as *condottiere*, Guidantonio had previously been fighting against Braccio Fortebraccio, but in March 1420 the Pope called Guidantonio to Florence to reconcile him with his former adversary, and presented him with the Order of the Golden Rose.

Guidantonio's first marriage was with Rengarda Malatesta of Rimini. After twenty-six years of childless marriage, she died in 1423, and soon afterwards Guidantonio married Caterina Colonna, daughter of the Pope's brother Lorenzo Colonna. She came with a

handsome dowry of 5,200 gold florins, but more significant, perhaps, was the strong alliance thus formed with Pope Martin V. She made her ceremonial entry into Urbino on 4 March 1424.

Meanwhile there had been feuding with the powerful Brancaleone family who were in control of the mountainous lands of the Massa Trabaria and the upper reaches of the Metauro valley.

On 7 June 1422 Guidantonio's illegitimate son Federico had been born, destined to become the most celebrated of all the Montefeltro family. In 1424 Guidantonio seized Castel Durante (now Urbania) and other fortresses, and on the death of Bartolomeo Brancaleone he arranged for the betrothal of Bartolomeo's daughter Gentile, aged about seven, with his two-year-old son Federico.

This required a dispensation to be obtained through the Bishop of Urbino from Pope Martin V, as Federico and Gentile were related, although not very closely. Gentile's paternal grandmother was Agnese, daughter of Federico di Nolfo, and hence Guidantonio's aunt. The dispensation was granted on 11 October 1425, and in consequence of the betrothal Federico became heir to Brancaleone's estates.

After eight months' marriage to Caterina, Guidantonio's hopes of a legitimate heir showed no signs of being fulfilled. So on 27 November 1424 he had the little Federico brought from the abbey of Gaifa, high in the mountains where he was being kept hidden, to the city of Urbino, where he was declared the rightful heir.

According to the bull of legitimization issued by Martin V, Federico was the son of Guidantonio da Montefeltro and an unknown woman. Among the papers kept in the State Archive in Florence, together with the bull, is a document reporting that Federico's mother was a young court lady from Gubbio, Elisabetta degli Accommanduci. However, out of respect for her good name and in order not to perturb Guidantonio's wife Rengarda Malatesta, who was seriously ill, this was not made public at the time.

Much later, in 1444, the Malatesta of Rimini tried to discredit Federico by denying his paternity. This Federico was to refute in person: 'They say that I am the son of Bernardino degli Ubaldini, and not of him whom, without a word of a lie, I hold to be my father.'

As soon as Guidantonio's new wife Caterina found herself pregnant, she seems to have taken against young Federico, regarding him as a possible threat to her own children. So he was sent away from the court and spent the next eight years remote from the court, in the care of Giovanna degli Alidosi, widow of Bartolomeo Brancaleone, and in the company of his young fiancée. His father was naturally enough looking for legitimate heirs from his new marriage. The first child Raffaello lived only one day, but amid great rejoicing a second son, Oddo Antonio (or Oddantonio), named after his maternal uncle Oddone Colonna, was born on 18 January 1427.

Guidantonio's fortunes, however, fluctuated once more. In 1430 he was defeated at Lucca by Niccolò Piccinino – one the most successful of all *condottieri* (see page 52) – and returned to Urbino only to hear of the death of his wife's uncle, Martin V, on 20 February 1431. The next pope, Eugene IV, a Venetian, was a bitter enemy of the Colonna family, and disapproved of the way the late Pope had lavished territorial possessions on his nephews. Guidantonio found himself out of favour and so went over to the other side. He entertained the Emperor Sigismund, who was returning to Germany after his coronation in Rome, and on 1 September 1433 both Guidantonio and Oddantonio were knighted by him.

Guidantonio had been allied with the *condottiere* Francesco Sforza, Duke of Milan, against Eugene IV, but now he was obliged to make his peace with the Pope. The guarantor of this peace was Venice. Consequently the Count had to send his son Federico to 'La Serenissima' as a hostage. He was handed over to Andrea Donato, a Greek lawyer, to be escorted to Venice.

For a boy reared among remote mountaintops, the city must have been a revelation. In the 1430s Venice had perhaps twenty thousand inhabitants, and ruled also in the mainland as far as Verona. At this time, before the capture of Constantinople by the Turks in 1453, she was the supreme trading centre between east and west.

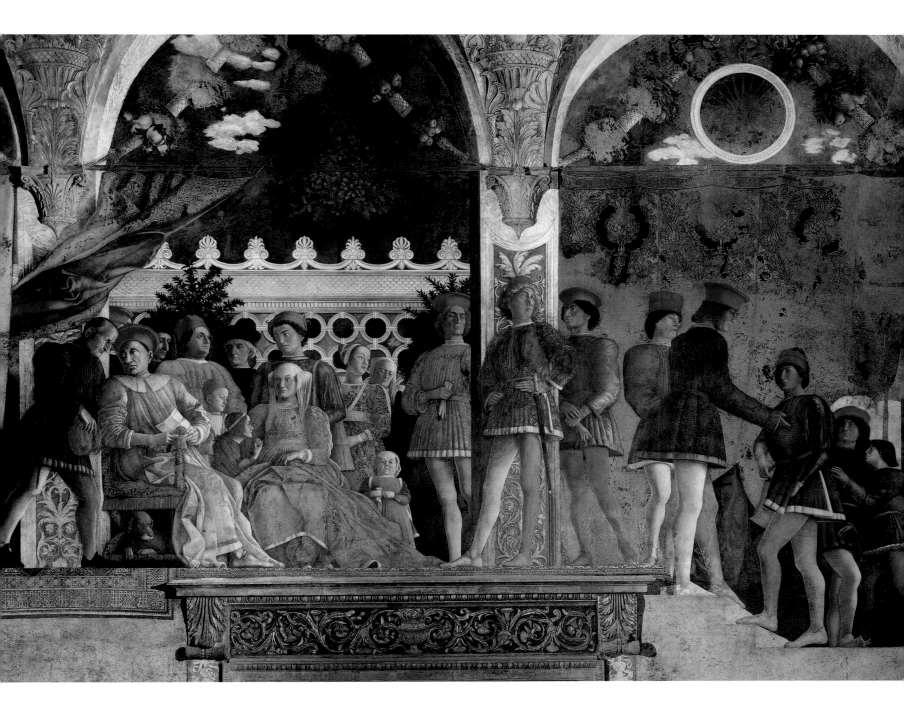

Architecturally, this was the great period of the Venetian Gothic style, exemplified by the delicate arcading of the Doges' Palace[4] and the newly completed Ca' d'Oro, and the mosaics recently designed by Paolo Uccello for the Baptistry of St Mark. It must have been a place of scintillating beauty and a source of wonder to the boy.

While trading with the Levant may have enlarged Venice's horizons, it also brought with it the ever-recurring scourge

The Court of the Gonzaga in Mantua, fresco by Andrea Mantegna (Ducal Palace, Mantua). Federico da Montefeltro was fortunate to be welcomed by the Marquis Gianfrancesco Gonzaga, and educated alongside his children. Gianfrancesco was succeeded by his eldest son Ludovico, who is seen holding court in Mantegna's painting.

of plague. For fear of infection – a real enough fear, as it is estimated that a single fifteenth-century epidemic carried off two thirds of the population – the Doge Foscari agreed that Federico should be allowed to move to the court of the Gonzagas, the ruling family of Mantua.

The head of the family at that time was the Marquis Gianfrancesco Gonzaga. He is said to have been at times irascible, at other times magnanimous. His wife, Paola Malatesta, religious and very capable, seems to have been influential with him. Federico stayed in Mantua for two years, and had the great good fortune to be educated with the Gonzaga children at the Ca' Zoiosa (House of Joy), the school of Vittorino da Feltre (1378–1446).[4] The chief authority on the life and work of this remarkable man is Francesco Prendilacqua's *La Vita di Vittorino da Feltre* (1774).

Vittorino deserves recognition as one of the greatest educationalists of all time. Although essentially self-taught (lacking the funds to be anything else), he was very experienced in both mathematical studies and classical literature. He had been in Padua teaching rhetoric when in 1423, aged forty-five, he was invited to teach the Gonzaga children. The request came from Gianfrancesco, but was perhaps prompted by Paola. The exact location of the Ca' Zoiosa is difficult to determine, but it was certainly a boarding school, as an inventory

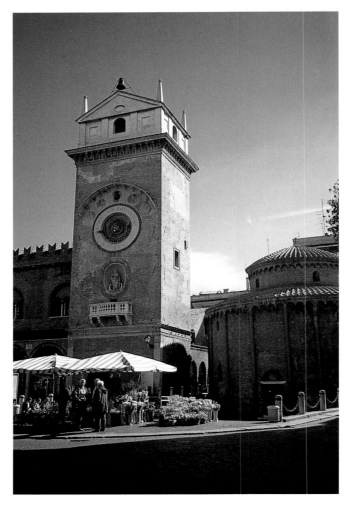

drawn up afterwards included many beds as well as other furniture.[5] Vittorino ran the school for twenty-two years.

Vittorino would brook no interference from the parents and made himself responsible for his pupils' physical as well as intellectual well-being. The curriculum included classical authors, such as Virgil, Cicero and Demosthenes, rhetoric and dialectic, languages, philosophy, religion, mathematics and athletics. He did not encourage luxury or self-indulgence in his pupils; he himself dressed simply in a tunic of goatskin, unlined in summer and with a layer of sheepskin in winter.

Vittorino's pupils numbered about seventy; remarkably, there were girls as well as boys in the school, and some free places for the poor children of the city. The official purpose of the school, however, was primarily to educate the young princes. Among them was Ludovico, the son of Gianfrancesco; he was to become the second Marquis of Mantua, and his face is familiar to us from Mantegna's portrait of him in the Camera Dipinta (or Camera degli Sposi) in the Ducal Palace in Milan. When he first started at the school, he is said to have been coarse, fat and heavy in movement. Vittorino imposed a simple lifestyle on him, and in a few months he was quite elegant. Within a few years he was culturally enlightened enough to become the patron of both Mantegna and Alberti.

Clocktower in the Piazza Erbe, Mantua, with a clock designed by Bartolomeo Manfredi.

His bride was Barbara of Brandenburg (1422–81), who came to Mantua to marry Ludovico when she was not yet twelve. (She was a rather podgy girl, if we are to judge from Mantegna's painting.) It was a matter of marriage first and education afterwards; she also attended the Ca' Zoiosa. There were other Gonzaga princelings at the school: Carlo (1417–56) was reputed to be one of the best pupils. He was tall and thin – too thin, Vittorino thought, so he fed him up with extra bread. There was also the short-lived Gian Lucido (1423–48), of whom there is no portrait – he is said to have been a scholar – and Alessandro, who was 'deforme molto', a hunchback – he is probably the figure talking to Ludovico in Mantegna's fresco.

Then there was Cecilia Gonzaga (1426–51), described by Prendilacqua as 'alta, bella, regale di figura e de volto, molto eccellera per cultura e virtu, degna di un sposa nobile e grande,' that is, tall, beautiful, regal in face and bearing, distinguished for culture and talent, worthy of a great and noble husband. She was never to acquire one, however (see page 50).

There was also Bartolomeo Manfredi, an intellectual, devoted to astrology. He was sometimes called Manfredi deli' Orologio because he designed the clock on the tower in the Piazza Erbe, constructed in 1473.

However, it is Federico da Montefeltro whom Prendilacqua singles out for special praise:

He was distinguished by the greatness of his spirit and intellect, and also physically he was most attractive, handsome and elegant. The nobility and regality of his appearance promised one whose kingly majesty was beyond expression. And I do not know another person characterized by such chaste modesty, fitting for his nobility of soul; full of dignity and kindness, tall in person; nature could not have created any being more elegant or more distinguished.

Federico never forgot his teacher, and Vittorino's portrait by Justus of Ghent[6] was included in a gallery of illustrious men that was later made to adorn his Studiolo in the Ducal Palace at Urbino (in such company as Homer, Virgil and Euclid). Vittorino was sometimes known as Magister Pelicanus; his emblem, as appears on the back of his portrait medal by Pisanello, being the Pelican in its Piety. There is a theory that Vittorino can be identified in the court scene of Mantegna's Camera degli Sposi as the grey-haired old man wearing a cap.[7] He preferred to count himself a citizen of Mantua rather than of Feltre, and he was buried in the Church of Sto Spirito. A tablet was put up in 1978 to mark the sixth centenary of his birth. It reads: 'Vittorino Rambaldoni da Feltre per La Sua Fede

Tablet to Vittorino da Feltre in the church of Sto Spirito, Mantua.

nell' Uomo e nell' Educazione' (For his faith in man and in education.)

How fortunate Federico was to have such an upbringing. As it turned out, he was far more fortunate than his half-brother Oddantonio, Guidantonio's legitimate son. Oddantonio was no doubt made much of, and was only six when he was knighted by the Emperor Sigismund, then staying in Urbino. His mother Caterina commissioned the painter Ottaviano Nelli to portray him with a horse; the little boy seems to have had a passion for horses. When he was about ten he wrote to the city of Siena to ask if he could send his charger to take part in the famous Palio, and safe conduct had to be arranged, in fact, for two horses. The whim must have involved considerable expense.

Caterina Colonna died in the autumn of 1438, and the following year his father decided that the eleven-year-old Oddantonio should marry Cecilia Gonzaga, who was twelve, one of the pupils at the Ca' Zoiosa. Girls were expected to do what they were told in these matters, but Cecilia said she would rather be a nun. Meanwhile Oddantonio still seemed far more interested in horses; on 25 February 1439 he wrote to Cosimo de' Medici and his son Piero from Gubbio concerning a Barbary courser. Had the marriage taken place it would have brought great political advantages, especially to the Montefeltro, who would have made alliances with both the Gonzaga and Malatesta families. They could also have gained control of Fossombrone by using money from the bride's dowry to buy it from its lord Galeazzo Malatesta (Cecilia's uncle). So the parents pursued the matter with all diligence. (The negotiations are covered by a fascinating series of letters, now in the State Archive at Mantua.) The Marquis wrote that the girl would come to Urbino to be married 'anche se avesse mandarvela legata', that is, even if she had to be tied up to be sent there. Oddantonio – this is one of the few episodes that redound to his credit – did not want to force an unwilling bride, and he wrote to this effect to the girl's mother Paola on 16 October 1442. On 3 November he wrote again 'ne absolvo di chalchuna promessa', absolving her of any promises. The promises of course had been made not to her but to the Marquis. Although in the end Cecilia was persuaded by Vittorino da Feltre and others that it was her duty to agree to the marriage, her father finally gave in, and Cecilia entered the convent, garlanded with zenevrio.

Count Guidantonio, downcast at the failure of the match, was doubtless anxious to placate the Malatesta family. So he sent Oddantonio nobly escorted to Rimini to be their guest for the four days of the fair of S. Giuliano; great feasts were held in his honour. Meanwhile his half-brother Federico, having spent two years in Mantua (where he too was knighted by the Emperor), returned to his native country. At Gubbio on 2 December 1437, as his father had wished, he married Gentile Brancaleone. She was nearly twenty-one and he was only sixteen.

Young as he was, Federico realized that the only future for himself and, as it was to prove, for his dynasty, lay in feats of arms. Therefore, while keeping up his academic studies, he undertook military training: riding, soldiery and swordsmanship – at which he was, according to Bernardo Baldi, 'mirabilmente disposto e desideroso'.[8]

His military skills were first put to the test in the matter of securing his nephew's inheritance. Federico's sister Aura, who was also illegitimate, had been married to Bernardino degli Ubaldini; he died on 24 May 1437, naming his little son Ottaviano as his heir. The inheritance included 800 horses, which had been left, on foreign land, in Lombardy. Federico was required to collect these – but since funds were short the thing had to be done as economically as possible. He achieved the difficult mission most efficiently, riding via Forlì, where he dined at the court (on 31 May 1438), on his way to Milan, where he made an eloquent speech in front of Duke Filippo Maria Visconti. The exercise was in diplomacy as well as in military skills.

San Leo. Federico won military distinction by capturing this seemingly impregnable fortress.

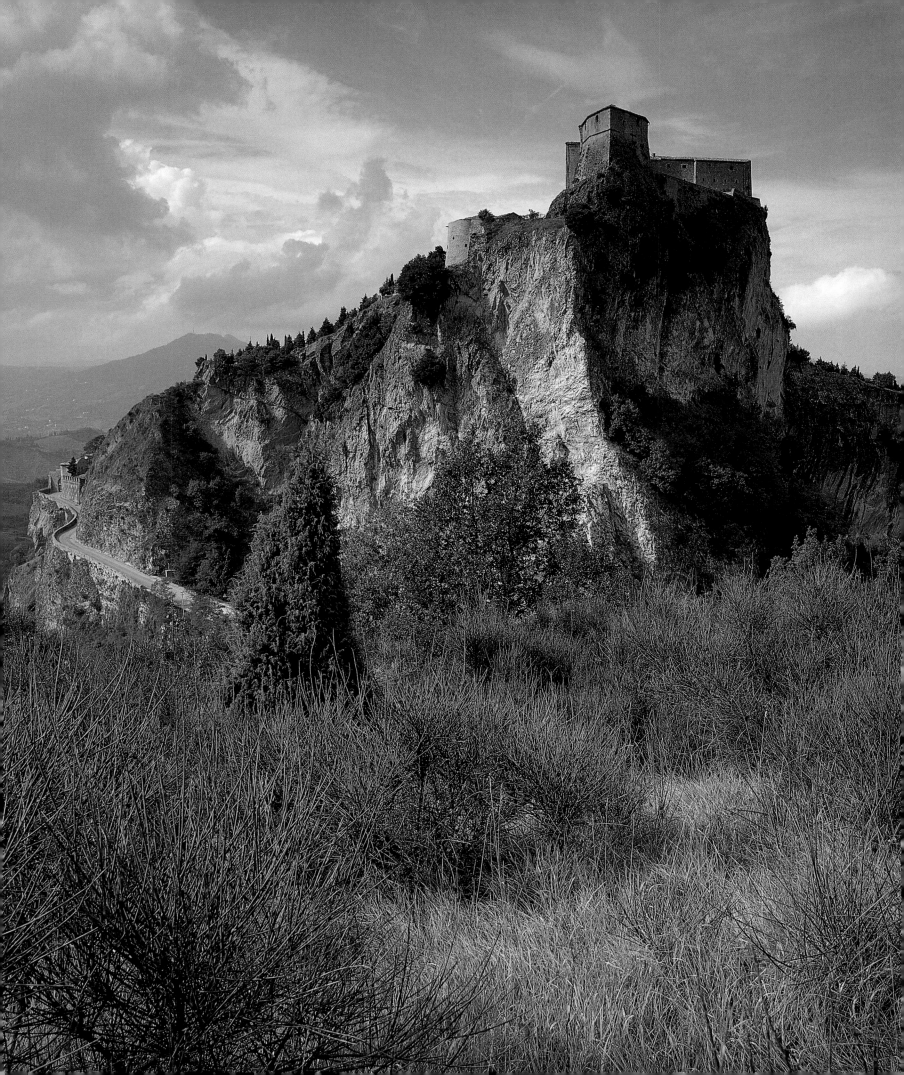

He rejoined his wife briefly at Easter the following year, but then had to go back to Lombardy to assist his father in renewed warfare against the Malatesta. Domenico Malatesta had seized three Montefeltro castles (Castel d'Elci, Senatello and Faggiola) and Federico was successful in regaining these.

At this point, the customary Montefeltro–Malatesta scrapping had to be suspended because they were caught up in the conflict between the great powers: Milan on one side, supported by Naples, and Venice and Florence on the other. It was a complex and stormy situation prompted by the opposing forces of the Council of Basle (1431) on one side, and on the other the Papacy in the person of Pope Eugene IV, who had fled from Rome to Florence in 1434, leaving almost all Italy to become a battleground for the *condottieri*.

The two great mercenary captains of the time were Francesco Sforza and Niccolò Piccinino. Francesco Sforza (1401–66) was the son of a military commander, and when his father was killed in battle he took over his leadership, working principally for Duke Filippo Maria Visconti of Milan, and eventually succeeding to the dukedom himself. Piccinino (1386–1444) had risen from humble beginnings to join the troop of Braccio Fortebraccio (see page 45), taking command of it after Braccio died. He was first employed by Florence; later, after 1426, we find him fighting for Filippo Maria Visconti against Florence and Venice.

Whether they were fighting under the captaincy of Piccinino, or after his death, that of Francesco Sforza, the traditional enemies of the Montefeltro were always the Malatesta of Rimini. The antagonism reached its peak between Federico da Montefeltro and Sigismondo Pandolfo Malatesta (1417–68).

The Malatesta had gained control of Rimini at the end of the thirteenth century when Malatesta da Verrucchio expelled the Ghibellines.[9] During the fourteenth and early fifteenth centuries the family was active in the wars of the Visconti family of Milan, and after the death of Gian Galeazzo Visconti, Carlo Malatesta became Governor of Rimini, while his brother Pandolfo was for a while

(1404–21) in control of Bergamo and Brescia. Sigismondo (1417–68) was one of the three natural sons of Pandolfo, and, like Federico, he was legitimized by Pope Martin V. He lived as a *condottiere* for thirty years, fighting for whichever side was paying him.

Feuds between families could be suspended for their general good. A truce between the Montefeltro and the Malatesta was confirmed, at least for the time being, by the betrothal of Domenico Malatesta, Lord of Cesena, with Violante da Montefeltro, daughter of Guidantonio and Caterina Colonna. Both families now supported Niccolò Piccinino, who was fighting on behalf of the Duke of Milan against Florence and the Sforza. For Piccinino, the territory around Urbino was a place where his armies could recoup their strength. However they were soundly routed at the Battle of Anghiari on 29 June 1440, after which Sigismondo Malatesta went over to the other side – thus endangering the small towns of the Marches such as Pesaro and Fossombrone. In April 1441, Federico, with a force of 200 cavalry and 300 infantry, rushed to their defence. In the summer there was more trouble in the mountainous area around Montefeltro. Almerigo dei Brancaleoni seized various castles belonging to the Count of Urbino. Again Federico went to defend his father's lands; he had the support, oddly enough, of Domenico Malatesta of Cesena, who remained loyal to the Milanese faction, even though it meant he was on the opposite side to his brother Sigismondo. Federico was wounded in a fight against Sigismondo near the fortress of Campi, but in less than a month was back in battle to engage in the most celebrated military action of his youth: the taking of the almost impregnable rock of San Leo, on 22 October 1441. The next day he wrote with confidence to his allies at San Marino: 'Have no doubt that we shall have pressed forward as far as Rimini within eight days.'

But it was in no one's interest to prolong the struggle, and since it was now clear that the Montefeltro were in the ascendant, Francesco Sforza intervened as peacemaker. He drew up a document decreeing that all the castles taken by Sigismondo Malatesta should be restored to the

Montefeltro. On 2 June 1442 the truce between the two families was further strengthened by the marriage of Domenico Malatesta and Guidantonio's daughter Violante.

Federico's military prowess in restoring the family fortunes must have been some comfort to his father, whose health was in decline, and must have atoned a little for the shortcomings of Oddantonio. Towards the end, Guidantonio relinquished the life of a *condottiere* and assumed the habit of a Franciscan friar, perhaps as a mark of penitence (*condottieri* never being quite sure of their fitness for heaven). The Count died in the early hours of 20 February 1443. His tomb, carved in low relief in the pavement of the old church of S. Donato in the monastery of S. Bernardino, outside the city, shows him clothed as a friar. His hands are crossed over his knotted girdle, his head is cowled and flanked by heraldic shields and a long sword lies at his side. He was mourned, it was said, throughout Italy. 'Non fu mai principe più clemente e giusto' (Never was there a prince more kind and just) was his epitaph.[10]

Shortly before his father's death, Oddantonio had been made a papal representative by the exiled Eugene IV. Since Sigismondo Malatesta was now fighting on behalf of Francesco Sforza, the Pope was anxious to have some political support in the Marches; he found the new Count quite easy to bribe. Siding completely with the Pope, Oddantonio did nothing to defend his family lands; on the contrary: in March 1443 he was persuaded to sign a truce with Sigismondo and to hand over to him the territory of Montalboldo, which his father had only recently acquired.

In exchange for this, the Pope invested him as a duke. Oddantonio went to meet him in Siena where he was staying, in the Palazzo Maliscotti, and the investiture took place in the cathedral. He wore mourning clothes for his father, but over these he wore a splendid gold cloak reaching from shoulder to floor. He prostrated himself at the feet of the Pope, who made him a Knight of St Peter and girded him with a sword. In return Oddantonio promised,

on behalf of himself and his heirs, perpetual loyalty to the Holy See, and swore to defend the Church's lands whenever required – also to give a white palfrey to the Pope every year on St Peter's Day.

There were great celebrations to welcome the new duke when he returned to Urbino. Medals, known as *piccioli*, were struck in his honour, bearing the badge of S. Crescentino on one side and Oddantonio in Gothic letters on the other. Feasting continued throughout the spring.

S. Bernardino, the mausoleum of the Dukes, was erected next to the old church of S. Donato. (The interior is illustrated on page 103.)

So far, Oddantonio's rule had been characterized by much expenditure and, on his part, very little of that military activity which was the one way to put money into the coffers. He was, however, at the siege of Roccacontrada, lending support to Niccolò Piccinino who was fighting on behalf of King Alfonso of Naples. Also present was his half-brother Federico.

Whether it was Federico's influence or not, Oddantonio decided to improve his education, and invited a classicist and orator from Siena by the name of Agostino Dati to come to Urbino to be his tutor. He probably did not stop to think of the impossibility of travelling across the snowbound Apennines in the middle of winter; when Dati finally arrived it was the end of April and the Duke was no longer there.

At the encouragement of Domenico Malatesta, a contract of betrothal was being drawn up between the young Duke Oddantonio and Isotta, sister of Leonello d'Este, the Marquis of Ferrara. He was sixteen, she eighteen. It appeared to be a useful alliance with the very powerful, and traditionally Guelf, Este family. Leonello himself was getting married to Maria d'Aragona, daughter of the King of Naples; Oddantonio was invited to the wedding, and this gave him a chance to meet his own bride. He returned to Urbino to take up his studies with Agostino Dati, described by Bernardo Baldi as 'the greatest orator, historian and humanist of his time'.

It is difficult to assess the character of Oddantonio. Some said he was generous, some called him cruel. He seems to have had all the outward graces; according to Baldi he was 'full of light and lively colour, with fair hair and princely bearing'. On his own initiative, he engaged an excellent tutor. It must also be remembered that he never lived beyond his teens, so that today we would regard him as a boy rather than a man. At the same time, he was undeniably weak and lacking in judgement. With Italy divided into two great camps, it was clearly a mistake to align himself in perpetuity with one side or the other, and an exiled, shortly to be deposed, pope was hardly the best of allies. It may be that Oddantonio was over-indulged as a boy. He had a

cosseted childhood compared with that of his half-brother. It may be that he felt completely lost after the deaths of first his mother (1438) and then his father (1443) and was too ready to listen to those who flattered him. During his brief rule he became increasingly unpopular in the city of Urbino. For one thing, it seems he was not much of a soldier, and far more ready to sell or give away what had been Montefeltro territories than fight to defend them or acquire new ones. In this he was thought to compare very unfavourably with Federico. Furthermore, he was vain and hopelessly extravagant; there was a fear that the state itself was endangered on account of the debts he ran up – 'debito de molti migliaia de ducati'.[11]

Meanwhile the entire papal faction, with which Oddantonio had allied himself exclusively, was being threatened by Sforza's armies. At the Battle of Monteluro in 1443 there had been a confrontation between the two great leaders: Piccinino and Francesco Sforza reinforced by Malatesta. Piccinino was defeated; most of his army retreated to Fabriano and Federico rushed to Pesaro to protect it from Sigismondo Malatesta. Piccinino stayed just one evening in Castel Durante, where he was nobly entertained by Federico, then retired to Lombardy, leaving his son Francesco to command his armies in his place. Francesco Piccinino suffered a decisive defeat at Montolmo, and Niccolò died of dropsy soon afterwards.

This left Francesco Sforza the supreme military commander in Italy. Up to then he had been employed principally by Filippo Maria Visconti of Milan, and in 1443 he married the Duke's daughter Maria (to become Duke of Milan himself seven years later). With Piccinino dead, and Sforza clearly in the ascendant, Federico decided to support him – especially as Malatesta was defecting from his cause. Federico was at the defence of Pesaro when he was told of his half-brother's death.

Oddantonio had been becoming more and more unpopular. He had two advisers in particular, Manfredo dei Pii – who was apostolic pronotary – and Tommaso di Guido dell'Angelo of Rimini. Both men were held to be thoroughly unscrupulous, and both were almost unanimously detested

by the citizens of Urbino, but the young Duke would hear no ill of them. The conspiracy seems to have been made with the general support of the citizens and with the connivance of people outside as well. In the night of 22–23 July 1444, the assassins broke into the palace and hacked young Oddantonio to death. He was aged seventeen years, six months and four days.

Federico rode with amazing speed from Pesaro to Urbino, and was at the gate of the city the next day. It is difficult to avoid the conclusion that he was forewarned in some way; it was necessary for him to be on the spot quickly in order to prevent confusion from becoming anarchy.

He arrived at the Porta Lavagine, but was not admitted until he had agreed a full pardon for his half-brother's assassins. This was the first of many conditions with which he had to agree. The rest mainly concerned the alleviation of taxes and the revocation of exemptions so that the burden was shared equally, the use of one third of all fines for the maintenance of public buildings, legislation regarding salt and the appointment of city administrators for short terms only as a precaution against insurrection and corruption. Public appointments were also to be made of two physicians and a schoolmaster.

Oddantonio was buried in the tomb of his ancestors, solemnly but without any great mourning. It was only in Ferrara that there was any expression of grief; elegies were written to console his widow Isotta. She herself died in 1456.

There are some who hold that Federico ordered his half-brother's death. On the one hand, he must have understood

that this bold measure was probably the only way of saving the situation – Oddantonio's rule having been characterized by unwise alliances, illiberal expenditure, loss of territory and dearth of income, and the whole state of Urbino being in danger. On the other hand, Federico's personal position was precarious. Despite the bull of legitimization from Pope Martin V, he might not be regarded as the undisputed heir; there were also the claims of, for instance, Violante, legitimate daughter of Guidantonio, and her husband Domenico Malatesta. Thus the assassination could well have had other consequences. To have contrived it himself was probably too dangerous a game to play, even supposing that Federico (who was always regarded as a virtuous man) could have squared with his conscience the crime of fratricide.

He may, however, have known of it. Later, he was to commission from Piero della Francesca the small and intensely enigmatic painting of *The Flagellation of Christ*, which still hangs in the Ducal Palace. The identity of the three standing figures on the right has long been a matter of dispute, but there is a theory that the fair-haired youth represents Oddantonio. It would thus be a memorial, or expiation, made at the command of one who was to be called 'The Light of Italy'.

The tomb of Guidantonio da Montefeltro in the church of S. Donato. He is portrayed as a Franciscan friar.

COUNT FEDERICO'S CONCESSIONS

In the name of God, amen; to the honour and worship of the indivisible Trinity, of our Lord Jesus Christ and his mother the glorious Virgin, of the blessed Crescentius, and of the whole triumphant heavenly host. These underwritten are certain articles, conditions, and concessions made, published, concluded, and consented to between the illustrious and potent lord our Lord Federico da Montefeltro, Count of Urbino, Durante, and various other places, and the inhabitants and community of the city of Urbino, on the 23rd of July, in the year of our Lord 1444; the seventh indiction, and the right of Pope Eugene IV.

First. That your Lordship is not to bear in remembrance, against such as have committed them, the injuries and offences inflicted during this revolution on the person of Oddantonio late Duke of Urbino, and others, nor in any way, or on any pretext, to punish or avenge them publicly or secretly; further, that you are understood to forgive and take under your protection all who may be compromised in these crimes.

Answer. We consent, and shall observe all that we promised at our entry.

Second. Further, that the Lords Priors of the city of Urbino shall, in time to come, be appointed every two months, as heretofore, and shall enjoy the privileges, exemptions, and dignities conceded to them by law, except the custody of the registers; and shall be empowered to remit sentences and punishments for injuries done, and to administer the duties of the Lord Podesta of this city on extraordinary occasions as he may direct; each prior to have a salary of fifteen ducats (at forty bolognini to the ducat), payable monthly.

Answer. We again consent and approve; but their authority and privileges shall be those possessed during the time of our father of happy memory; and their salary of fifteen ducats to each in monthly payments shall include the whole period of their service.

Third. Further, as the house of the priors was in old times that now used as the great hall for the supreme court, your Lordship shall deign to concede to them, in compensation for it, that new building near the episcopal cemetery, or some other residence convenient for the despatch of public business; and this the more, as their present dwelling is going to ruin.

Answer. So be it, until their old house be repaired.

Fourth. Further, seeing that the ordinary assessment, which was of old three shillings in the pound, has been raised to five and a half, without the sanction and consent of the people, – a very greivous and insupportable exaction, reducing the soil to sterility, whereby many communities have been dispersed, and threatening further evils, – that your Lordship shall condescend to lower it to four shillings a pound, in order to relieve the poor and needy, as well in this city as throughout the state.

Answer. Be it so.

Fifth. Further, that your Lordship would deign to revoke all donations made since the death of the Lord Guidantonio, in order the better to provide for your outgoings and expenses.

Answer. Be it so.

Sixth. Further, that your Lordship would deign to revoke all immunities and exemptions granted to any individuals or communes, on the plea of nobility, or on any other pretext, so that no one now or henceforth may be exempt from assessments, warding, or other public burdens, real or personal.

Answer. So be it; but reserving all exemptions granted by our father of happy memory.

Seventh. Further, that your Lordship would condescend to approve the citizens deputed to watch and ward, with the customary pay; and that your Lordship may not intromit (as has been the case heretofore) with the warding moneys, nor receive any sums or contributions for that purpose.

Answer. Be it so.

Eighth. Further, that one third of all fines for convictions and damages shall be paid over to the master of works, for repair of the city walls and other public edifices, according to law and usage; and that your Lordship will deign to renounce the power of bestowing gratuities out of that tierce, seeing that a decree of the Lord Guidantonio, of felicitous memory, is still in force, prohibiting such gratuities or misapplications.

Answer. Be it according to that decree, and this although the payments be made before sentence, or by way of composition.

Ninth. Further, that your Lordship would condescend, for the maintenance of this city and state and its inhabitants, to ask from them no further contribution, nor to impose on them any loan, restraint, or other burden beyond the ordinary assessment as above.

Answer. So be it, except in a case of necessity.

Tenth. Further, that every three months a chamberlain should be

elected and his notary be boxed [*inbussolari*] for this community, as provided by the statutes, and with the usual salaries.

Answer. We shall delegate a chamberlain for a competent period; as to the notary, let it be as asked.

Eleventh. Further, that the notary of the military and the chancery notary of sentences be boxed, with the same salaries and emoluments as heretofore.

Answer. Be it so.

Twelfth. Further, that the quarter of salt be revised, and restored to its proper weight of thirty-five pounds, in order to remove numerous complaints as to this, and that it be sold for the customary price.

Answer. Be it so.

Thirteenth. Further, that the podesta reside constantly in the city, and that his office last six months, with the usual honours; also that your Lordship should agree never to re-appoint any podesta, and that, at the termination of their official services, he and the other officials should render account to the priors of this city, the statutory allowance being paid to the persons employed to pass their accounts, and to the notary.

Answer. Such is our intention, reserving our freedom therein; but the accountants and notary shall have the usual salaries: as to the podesta's jurisdiction, we consent that it shall not be renewed beyond a year.

Fourteenth. Further, that your Lordship deign to select two good, competent, and skilful physicians, to be paid a salary from the community, and be bound to visit and prescribe for all persons within the city and countship paying imposts, and for all others, at some fee or emolument, including your Lordship's family.

Answer. So be it; but let them be held to visit indiscriminately all citizens, our household included.

Fifteenth. Further, that there always be in this city a schoolmaster, with an excellent and well-qualified rehearser, at the customary salary.

Answer. Be it so; be it so.

Sixteenth. Further, that the camp-captains of this community be citizens or inhabitants of the countship.

Answer. Be it so.

Seventeenth. Further, seeing that many merchants and others, passing with their effects, have and do refuse to take the road by Urbino, or through this state, in consequence of the great and enormous tolls, that your Lordship would agree to these tolls being paid as under the old laws in the time of Count Antonio of happy memory.

Answer. Let the same regulations be observed as in the time of our sire of good memory; be it so.

Eighteenth. Further, seeing that many citizens of Urbino are creditors of the Lord Guidantonio of most happy memory, and of his son and successor Oddantonio, some for merchandise and other goods supplied to them, or by their order; some for obligations and engagements incurred by their command; that your Lordship would condescend and will that these be paid out of their effects.

Answer. It will be our endeavour to arrange that they be satisfied in so far as possible, but we do not hereby intend to commit ourselves further than we are legally bound.

Nineteenth. Further, that two suitable and qualified citizens of Urbino be chosen to the office of appassatus for this community, their appointment to last two years, and to be regulated thereafter as found convenient.

Answer. We agree as regards ourselves, but, as other interests are involved, let justice be observed.

Twentieth. Further, that your Lordship would condescend to depute for the priors a clerk for their business, not from those employed in chancery.

Answer. The communal clerk may suffice for this.

FEDERICUS FELTRIUS, *manu propriâ*

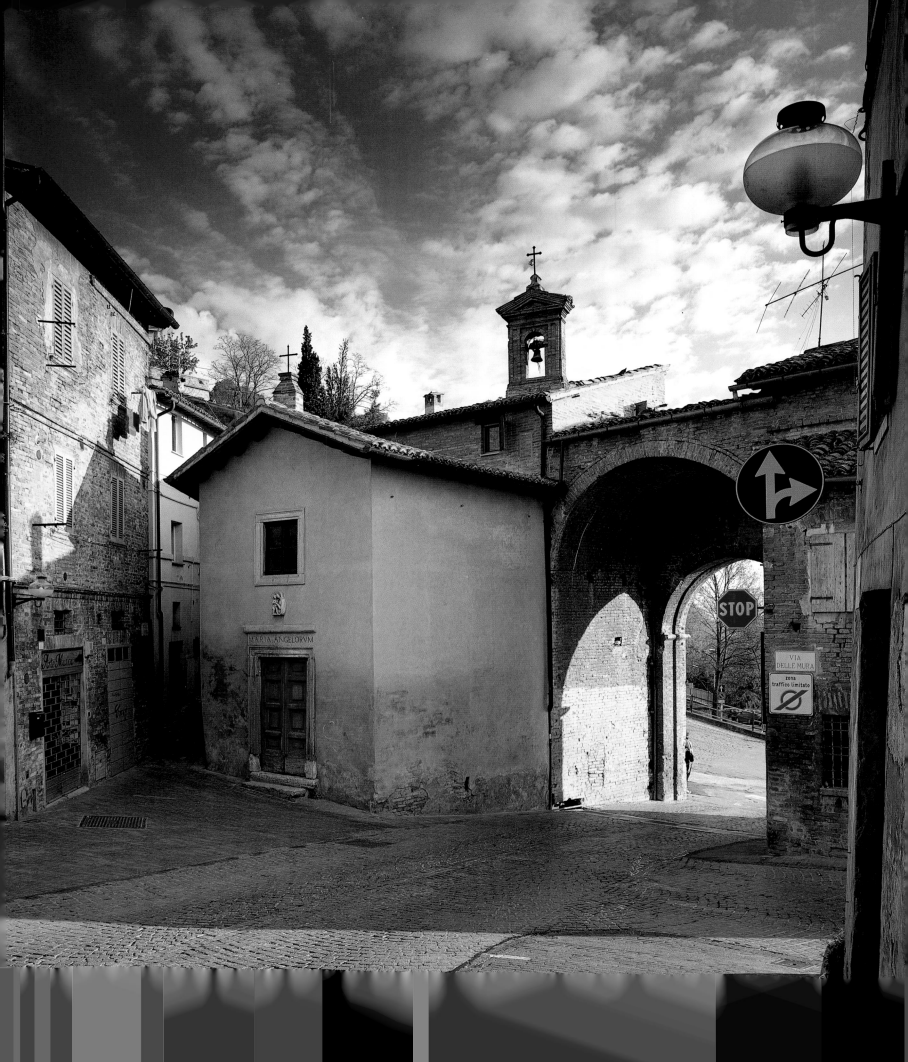

A LEADER IN WAR AND PEACE

There was no doubt about the joy with which the people of Urbino greeted Federico when he assumed power in July 1444.

A manuscript illumination in the Vatican Library, possibly by Valerio da Pesaro, illustrates the scene.[1] The young Count, mounted on a white horse, arrives at the Porta Lavagine to be greeted by the Bishop and eminent citizens, carrying a rich canopy ornamented with the arms of Urbino and of S. Crescentino, the town's patron saint. Ebullient crowds cluster on the city walls and in the foreground is an enthusiastic little dog with its tail curled into a spiral. Federico himself sits very upright; he is dressed in red and gold and his dark hair is surmounted by a scarlet cap.

The illumination, however, is not necessarily reliable as an indication of how the Count looked at the time. The earliest portrait of him that has been identified is on the frescoed walls of the Oratory of S. Giovanni in Urbino.[2] It is thought that these frescoes were commissioned in honour of the memory of Federico's foster mother Giovanna Alidosi, who died in 1446, and whose daughter Gentile he had married in 1437. The artist is thought to be Antonio Alberti of Ferrara. The fresco shows a somewhat bull-faced young man with a decisive profile, his nose still straight; he wears the customary red cap and a cloak of the same colour over plate armour. His hair, oddly enough, is golden. According to the description given by Bernardo Baldi:

He was of medium, or rather less than average height, with strong and muscular limbs, his complexion rather pale; on his face smiles mingled with seriousness and severity; his nose was fairly prominent and aquiline. In his youth he had quite a wide forehead, that with increasing age and baldness appeared bigger.

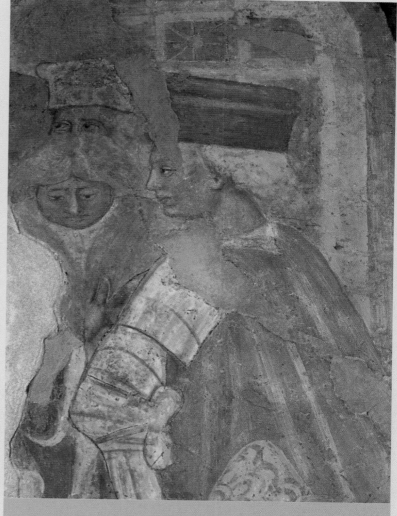

'HE WAS EVER CAREFUL TO KEEP INTELLECT AND VIRTUE TO THE FORE, AND TO LEARN SOME NEW THING EVERY DAY'

Vespasiano da Bisticci, *The Vespasiano Memoirs*

LEFT: The Porta Lavagine. Federico had to wait outside this gateway until he had agreed to the concessions required by the citizens in order to ensure good government.
ABOVE: The earliest known portrait of Federico, in the frescoes by Antonio Alberti of Ferrara at the Oratorio of S. Giovanni.

The truth is, we have no clear idea of how Federico looked when he was young, that is to say, before the injury that ravaged his features in 1451. This was in a tournament fought as a manly exercise and for reasons of prestige. In a bout against Guidangolo de' Ranieri, Federico lost his right eye from a glancing blow from a lance, which also broke the bone of his nose. It left the young prince desperately ill and he was lucky to survive. After that, almost all the portraits made of him, and commissioned by him, show him in profile to the left. Apart from this, he seems to have rejected any attempt to flatter him, but chose to be shown, like Cromwell, 'warts and all'. The prime example is Piero della Francesca's double portrait, in which he is shown with his second wife Battista Sforza, their triumphs depicted on the back (see pages 114–17). In all the portraits of the mature Federico, except the balding ones of his later years, he is shown with dark and rather curly hair. His features are prominent, the chin rounded and firm, the lips pursed in contemplation, the nose is long and often appears hooked because of his injury, the one eye that is visible is somewhat hooded and shadowed, the eyebrow lifted, suggesting an enquiring mind. Frequently he is shown wearing a scarlet cap, which is either cone-shaped, or a squat cylinder widening out to a flanged crown.

As for his character, the best witness must be Vespasiano da Bisticci, because he wrote as a contemporary and knew Federico personally. On the other hand, it must be remembered that he was also an employee; he had enjoyed the fruits of patronage, and his *Commentary on the Sayings and Doings of the Most Invincible Federigo, Duke of Urbino* was dedicated to the Duke's son Guidobaldo. If there were any flaws in the man's character, Vespasiano was unlikely to point them out.

'Messer Federigo,' Vespasiano asserts, 'had many praiseworthy qualities, and another such character, virtuous in every respect, the age could not produce.' He was a man, we are told, who never went back on his word once he had promised something. He spoke ill of nobody. He was the most approachable of leaders, and constantly made himself accessible to his subjects, treating them as if they were his own children. When he was in Urbino, which was not as often as he would have wished, for much of his life was taken up with soldiering,

everyone could speak to him at any hour of the day, when he would listen to all with the utmost kindness, remarking that this gave him no trouble. If there was anything he could do for them, he would see to it, so that there might be no need for them to return, and there were few whose business could not be dispatched on the same day, in order that no time might be lost. And should he mark that anyone amongst those who desired to address him might be shamefaced, he would call him up, and encourage him to say what he would. His subjects loved him so greatly for the kindness he showed them that when he went through Urbino they would kneel and say 'God keep you, my Lord,' and he would often go afoot through his lands, entering now one shop and now another, and asking the workmen what their calling was, and whether they had need of aught. So kind was he, that they all loved him as children love their parents.

It seems that Federico also had a choleric nature, but knew how to keep his temper under control. Vespasiano says he

Medallion showing Federico's arch-enemy, Sigismondo Malatesta (Tempio Malatestiano).

preferred people who did not boast, but who behaved with modesty, as he did himself. He kept to a simple diet and ate no sweetmeats; the only wine he drank was made of pomegranates, apples or cherries.

Clearly Federico was no ordinary despot. Almost inevitably one compares him with his rival Sigismondo Malatesta of Rimini, and it is tempting to pronounce that while the former was incredibly virtuous, the latter was irretrievably wicked. Jacob Burckhardt, in *The Civilization of the Renaissance in Italy*, sums up the Lord of Rimini thus: 'Unscrupulousness, impiety, military skill and high culture have been seldom combined in one individual as in Sigismondo Malatesta. . . . The accumulated crimes of such a family must at last outweigh all talent, however great, and drag the tyrant into the abyss.'

Certainly a ruthless and impetuous man, Sigismondo acquired a reputation for vice and brutality (it was suspected that he had his first two wives murdered so that he could marry Isotta degli Atti), but this may be largely on account of the defamation of his character by Pope Pius II at the time of his excommunication in 1461. Whatever the truth of it, the Lord of Rimini was nevertheless a Renaissance prince; he was patron of artists such as Piero della Francesca, Filippo Lippi and notably Leon Battista Alberti, who was a thoroughly enlightened man and the greatest architect of his day. From him Sigismondo commissioned the austerely classical S. Francesco, part church, mainly museum, better known as the Tempio Malatestiano.[3] So though he may have been cruel, brutal and unscrupulous, it would be wrong to regard Sigismondo as uncultured.

Federico's assumption of power did not go without challenge, but he considered himself the rightful heir and, seeking a lucrative *condotta*, the young Count offered his services to Pope Eugene IV. Although the general custom was that only males should succeed to power, it was never specifically stated that females and their descendants were

not eligible, and the heirs of Violante, eldest daughter of Guidantonio and Caterina Colonna, had a rival claim. With the Colonna family urging him to question the legitimacy of Federico's overlordship, the Pope decided to decline the request for a papal *condotta*; on the other hand, he agreed to the young Count's offering his services to Francesco Sforza. Thus with the Pope's blessing Federico was aligned with the man who, since the death of Piccinino, was the greatest captain and one of the greatest landowners in all Italy. Sforza controlled nearly the whole of the Marches and Umbria, and enjoyed financial support from both Florence and Venice.[4] In allying himself with him, Federico was enormously strengthening his own position as the new overlord of Urbino.

Sigismondo was alarmed and frankly jealous. He detached himself from Sforza and sought to arrange a *condotta* with King Alfonso, Pope Eugenio and the Duke of Milan. He sent a long letter to Sforza with a libellous attack on Federico, in which he claimed that Federico had been

The Tempio Malatestiano – part church, part museum – in Rimini, commissioned from Alberti in 1450, but never completed. It was designed to encase the old gothic church.

constantly defaming Sforza and working against his interests whenever possible.[5] He accused him of cowardice, and said that 'he had never been amongst his men either in peace or in war'. He called him a fellow of 'pocchezza e pusillanimita' (small-mindedness and pusillanimity), and accused him of having seized control of the state with utter lack of reverence either to God or to his ancestors. Furthermore, he alleged that his 'shameful way of life' was causing quarrels in Sforza's army. The letter goes on to sing Sigismondo's own praises

Federico was not going to take these insults lying down, and he replied in terms of similar invective. Sigismondo, he wrote, was a wife-killer, traitor, thief and blasphemer, and the son of a low-living fellow from Bergamo. Thereupon Sigismondo issued a challenge and the challenge was accepted. But the two never actually came to blows, for at that moment news came of the handing over of Pesaro – after the weak rule of Galeazzo Malatesta – not to the Malatesta, as Sigismondo had hoped, but to Count Francesco's brother, Alessandro Sforza. Meanwhile the little town of Fossombrone, halfway between Urbino and Pesaro, was ceded to Federico. Sigismondo had to nurse his resentment in silence. At the same time the standing of the young Count of Urbino was greatly enhanced, both as a military captain and as a political power.

Federico's contemporary biographers, such as Vespasiano da Bisticci and Pierantonio Paltroni,[6] emphasize his prowess as a military commander. To us today this may seem one of the less interesting aspects of this very remarkable man. On the other hand, it was on his success as a *condottiere* that his own prosperity and that of his people depended. Without it, the building of ducal palaces, the commissioning of works of art, the making of a great library, the patronage of writers, scholars and musicians – in brief, all that high pinnacle of achievement we call the Renaissance in Urbino – could never have happened.

Round the entablature of the Cortile d'Onore in the Ducal Palace of Urbino runs an inscription in Latin:

FEDERICUS URBINI DUX MONTISFERETRI AC
DURANTIS COMES SANCTAE RO
ECCLESIAE GONFALONERIUS ATQUE ITALICAE
CONFEDERATIONIS IMPERATOR HANC DOMUM A
FUNDAMENTIS ERECTAM GLORIAE ET POSTERITATI
SUAE EXAEDIFICAVIT. QUI BELLO PLURIES
DEPUGNAVIT SEXIES SIGNA CONTULIT OCTIES
HOSTEM PROFLIGAVIT OMNIUMQUE PRAELORUM
VICTOR DITIONEM AUXIT EIUSDEM IUSTITIA
CLEMENTIA LIBERALITAS ET RELIGIO PACE
VICTORIAS EQUARUNT ORNARUNTQUE.

This inscription records that 'Federico Duke of Urbino Standard Bearer of the Holy Roman Church and head of the Italian League began this house from its foundations to his own glory and posterity's.' It goes on to emphasize his justice, mercy, generosity and piety, stating how he was victorious in all his battles.

Another contemporary biographer of Federico was Pierantonio Paltroni. Paltroni was born probably in the first decade of the fifteenth century. His father had been a councillor in the court of Count Guidantonio and by 1434 he had followed him into public life. His life of Federico was undertaken, he said, not because the writing would be 'adorned with eloquence and embroidery, but ornamented only with the remarkable works of his Excellency, and only with the truth . . . no one who reads it will find it departs from the truth as it is based on first hand knowledge.' He declares that the Duke (Federico had that status by the time the life was written) was fit to compare with any of the heroes of antiquity, 'both for his feats of arms and for his special wisdom in governing'. Moreover, this was a man 'gifted in knowledge, eloquence, liberality, magnanimity and remarkable and unrivalled humanity, kindness and mercy'. He calls him 'really splendid and magnanimous in all his works', blessed with every virtue and gifted by God; his rival had not been seen for more than two centuries. 'Non solum fuit bellator intrepidus, sed nunquam victus et fide incorrupta', that is, he was not only a fearless warrior, but never defeated and of incorruptible faith.

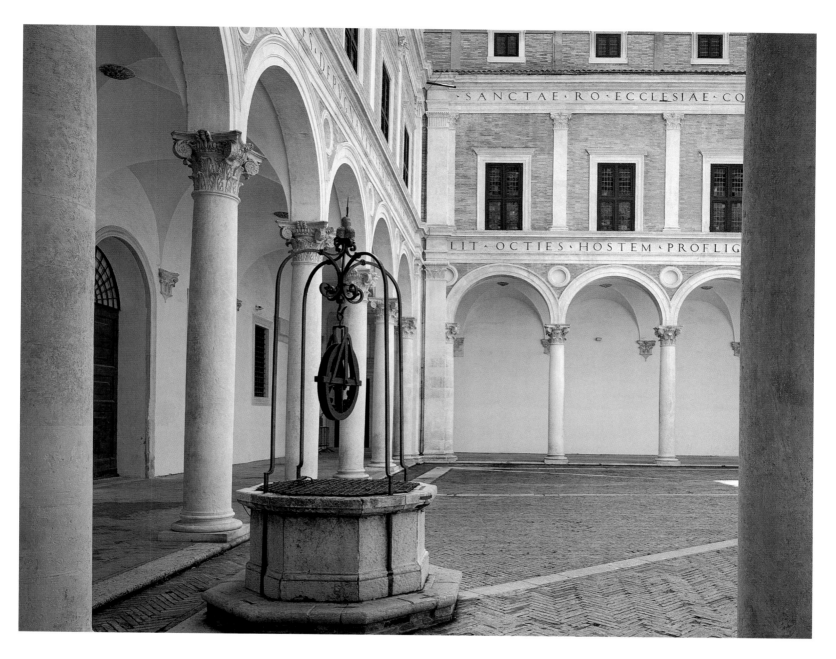

The Cortile d'Onore in the Ducal Palace. Round the entablature runs a Latin inscription extolling the virtues of Duke Federico.

This praise is echoed by Vespasiano. 'Messer Federigo had many praiseworthy qualities, and another such character, virtuous in every respect, the age could not produce.' He said of his prowess as a *condottiere*, that he 'triumphed less by his sword than by his wit'.

FEDERICO AS A MILITARY LEADER

Federico needed all his wits about him during the campaigns of 1446. The powerful armies of Pope Eugene, led by Sigismondo Malatesta, were contesting Sforza rule in the Marches; Urbino, as the weakest point, was under particular

victory. 'Even if he wins ten battles,' he opined, 'Signor Sigismondo will meet a doom-laden conflict.' His downfall ultimately came in the autumn of 1463 with the surrender of Senigallia to the papal forces under Count Federico. Subsequently Sigismondo's possessions were reduced to just Rimini, without its *contado*. All his lands in Montefeltro, Pietrarubbia, Maiolo and Pennabili went to Federico, who had already taken over Castel Durante, the territory of the Brancaleoni. Not only were Federico's lands extended, his fame, power and prosperity were established.

Sigismondo died on 4 September 1464. The following year saw the death of Francesco Sforza from dysentery. Federico was left almost the only powerful military leader in northern Italy. But though Captain General of the Italian League, he sometimes had to tread carefully, as when his help was enlisted by Milan against the ambitions of Bartolomeo Colleoni of Venice, for example.[8]

The victory that won Federico his greatest international renown, however, was the Battle of Volterra in 1472; he was fighting on behalf of Lorenzo de' Medici of Florence. Volterra had been under Florentine domination since 1361, but because of its remoteness, its high rocky position and the independent spirit of its people, the city to a large extent ran its own affairs. But when in about 1470 an alum mine was discovered in the area, it assumed a new importance. It is estimated that a third of the population of Florence were occupied in the cloth trade.[9] Wool was imported, much of it from England (Cotswold wool was particularly prized), and the finishing and dyeing was done in Florence. The colours came from various sources, some of them local (yellow from the crocuses of S. Gimigniano, for instance), but alum was needed to fix them. Until the mid-fifteenth century this was imported from Phocea on the Gulf of Smyrna; then a mine was discovered at Tolfa near Civitavecchia in the Papal States, finally one at Volterra. The Florentines did not want to leave this very valuable resource in the hands of the local company that had been formed, and Lorenzo was determined to control the price. The protest of the Volterrans was interpreted as revolt, and Federico was called upon to put it down. This he did effectively enough, and the besieged city

was sacked unmercifully by the troops; Federico said afterwards that he had been unable to stop them. It was not perhaps the most edifying of his campaigns, but it certainly brought him renown.

There was feasting for days. Princely gifts were showered on him by the Florentines; they included a helmet fashioned in silver and gold by Antonio de Pollaiuolo, ornamented with mythological figures of Hercules and the Chimaera, and valued at 500 ducats.[10]

Federico and the court of Urbino became famed not only in Italy but throughout Europe. Because of his prowess as a soldier, the Ducal Palace came to house a distinguished military academy and noblemen sent their sons there to be trained. In 1474 Ferrante I of Aragon bestowed on Federico the knightly order of the Ermellino (ermine), and on 18 August of the same year Edward IV of England honoured him with the Order of the Garter. Three days later, the Pope made him a Duke and confirmed him as Standard Bearer of the Holy Roman Church.

It was just at the time of the Florentine celebrations over the victory at Volterra that Federico heard that his wife Battista Sforza (1446–72) was critically ill. He had married Battista on 10 February 1460 when she was about thirteen years old, little more than a third of his age. The young lady had been educated in Milan, together with her erudite cousin Hippolyta Maria; she was very eloquent in Latin rhetoric, and used to be detailed to welcome important visitors, even delivering an oration before Pius II. She is described in the chronicle written by Giovanni Santi (the painter Raphael's father, who was both court painter and court poet) as 'A maiden with every grace and virtue rare endowed/That heaven at intervals on earth vouchsafes,/In earnest of the bliss reserved on high.'

Her chief function in the court of Urbino, however, was to produce an heir for Federico. To begin with there was a succession of six daughters (of whom the eldest, Elisabetta, born in 1461, was betrothed, aged ten, to Roberto Malatesta who had succeeded as Lord of Rimini). No son arrived until 1472, when Guidobaldo was born. But Battista, worn out with all this childbearing, survived his birth by only a few months. She died at Gubbio.

The lives of Renaissance princesses may have been full of pageantry, and sometimes of learning, but were probably lonely, their lords being so often away, and too frequently regrettably short. All Italy mourned Battista; her memory is kept alive today through the paintings of Piero della Francesca (see page 114).

FEDERICO'S COURT AND HIS WAY OF LIFE

With his frequent absences from Urbino, Federico had early learnt to delegate. When Urbino first became allied with Florence and Venice, he chose as administrator a Petrarchan poet by the name of Angelo Galli. He placed great faith in Galli, who became one of his right-hand men. But the man for whom he came to have the greatest regard was Ottaviano, the son of his sister Aura.[11] Ottaviano Ubaldini, says Vespasiano, 'had his full confidence, by reason of the great affection which subsisted between them', to the extent of entrusting to him the management of state affairs.

With maturity and with a growing reputation for invincibility, Federico came to be offered pensions simply for keeping the peace. For this purpose he was given 6,000 ducats a year by the King of Naples alone, and by the end of his life his peacetime income had grown to about 65,000 ducats. He was one of the richest men in Europe, and was able to live in some state.

Dennistoun, in his *Memoirs of the Counts of Urbino*, compiled a list of the members of Federico's court (see following page).[12] The 'camel-leopard' was a giraffe. In most courts of any standing, at least one exotic beast was kept, sometimes a pride of lions, sometimes a whole menagerie. Federico also had provision for about three hundred horses, but these were not just for display.

Dennistoun points out that the list he compiled is not entirely complete, as there must have been in addition an almoner, as well as heralds, librarians and servants for the noblemen. Among the great men who frequented his court were Giovanni della Rovere (the Pope's nephew and Prefect of Rome, to whom Federico's second daughter Giovanna was betrothed in August 1474), Giulio and Francesco Orsini (the Orsini were a very powerful family in Rome), Ranuccio and Angelo Farnese (the Farnese became rulers of Parma and Piacenza in the sixteenth century), Girolame and Pierantonio Colonna (the Colonna came from Rome and were a powerful Ghibelline family; Pope Martin V was a Colonna, and Agnesina, Federico's fourth daughter, married Fabrizio Colonna, Lord of San Marino), Andrea Doria (the celebrated Genoese admiral and statesman) and Gian Gacomo Trivulzio (a highly educated military commander in Milan; after his victory at Marignano he commissioned an equestrian statue of himself, never realized, from Leonardo da Vinci). That such distinguished men should undertake considerable journeys to come and stay at the palace in Urbino is evidence enough of the status of its owner.

Vespasiano da Bisticci estimated that the household totalled about five hundred in all. He stressed how well ordered it was, almost monastic in character. 'There was no romping or wrangling, but everyone spoke with becoming modesty.' The military academy was run by a gentleman of Lombardy who had himself been trained by Federico, and the training given was greatly valued. Federico was always ready to acknowledge those from whom he had learnt. Vespasiano relates that one day when he was in Milan, he was talking to Duke Galeazzo, who remarked 'Signor, I would fain be always at war, with you to back me, then I should never be worsted.' Federico replied, 'What I know of warfare, I learnt from his Excellency Duke Francesco your father.' At this object lesson in modesty, Galeazzo was left speechless.

Battista's daughters were all still very young when she died. The girls were kept in a separate wing of the palace in almost complete solitude; there was to be no romping with all these eligible young men in the military academy. They were visited only by Ottaviano, Federico's trustworthy nephew, and by their little brother. When Guidobaldo came to visit them, Vespasiano reports, 'those in attendance remained outside, going to the waiting room till he should return'. Their surviving half-brother Antonio was not apparently allowed to come; there is a suggestion that he was not to be trusted.

THE CONSTITUTION AND NUMBERS OF FEDERICO'S HOUSEHOLD AND COURT

Counts of the duchy, and from other states	45
Knights of the Golden Spur	5
Gentlemen	17
Judges and counsellors	2
Ambassadors and secretaries	
[at Naples, Rome, Milan and Siena]	7
Secretaries of State	5
Clerks in chancery [or public offices]	14
Teachers of grammar, logic and philosophy	
[including Maestro Paolo, astrologer, and Gian Maria Filelfo]	4
Architects and engineers	
[Luziano, Francesco di Giorgio, Pipo the Florentine, Fra Carnevale and Sirro of Casteldurante]	5
Readers during meals	5
Transcribers of MSS. for the library	
[besides many abroad]	4
Chaplains	2
Choristers of the chapel	3
Singing boys	5
Organists	2
Workers in tapestry	5
Fencing-masters for the pages	2
Dancing-masters	2
Apothecary	1
Master of the Palace Keys	1
Chamberlain	2
Master of the Household	1
Treasurer	1
Chamber attendants	5
Pages	22
Carvers and sewers	3
Stewards of the Buttery	4
Storekeepers	2

Purveyors	3
Grooms of the Chamber	19
Table waiters	19
Footmen	31
Cooks	5
Various menial servants	8
Masters of horse and purveyors of the stable	5
Servants under them	50
Keeper of the Bloodhounds	1
Keeper of the Camel-leopard	1
Total household of the Duke	317
Captains in constant pay	4
Colonels of infantry	3
Trumpeters	6
Drummers	2
Master-armourers	3

HOUSEHOLD OF COUNTESS BATTISTA AND HER CHILDREN

Ladies in waiting	7
[After the Duchess's death, Madonna Pantasilea Baglione, sister of Brozo Baglione of Perugia, was made governess to the princesses]	
A great many female attendants.	
Elderly and staid gentlemen	6
Servants of Prince Guidobaldo when a child	7
Total establishment, so far as enumerated	**355**

Little Guidobaldo was at first given two tutors. Then a young man was employed to teach him Greek and Latin, and 'was expressly charged by the Duke to let him have no traffic with young folk, in order that he might at once assume the grave temperament which nature had given him.' One gets the impression that Guidobaldo was a delicate child who received a somewhat cloistered and one-sided education. Meanwhile his elder half-brother Antonio 'devoted himself to arms and was of excellent carriage'.

Both princes were, in different ways, reflections of their father. Federico had his own self-discipline, riding out every day at dawn, eating a frugal diet and keeping the doors open at mealtimes. He was a devout man, good-humoured, and showed clemency for all offences except blasphemy. Vespasiano relates how he went about the city with only a few attendants (and those unarmed), and spoke to ordinary people simply and directly:

> Once I saw him go to the piazza on a market day, and ask of the men and women who were there how much they wanted for the wares they were selling. Then, by way of joking, he added 'I am the Lord and never carry any money; I know you will not trust me for fear you should not be paid.' Thus he pleased everybody, small and great, by his good humour. The peasants he had spoken to went away so delighted that he could have done with them whatever he wished, and when he rode out he met none who did not salute him and ask how he did.

In summer he rose early and went riding among the green hills surrounding the city – a landscape which must have looked very much as it does today – returning in time to hear mass. If it was a feast day he went to mass in procession, with a crowd of gentlemen and servants, making a round of all the great churches of the city. After mass, he gave an audience in the garden until it was time for his meal. While he ate, there was a reading in Latin, usually from Livy's *Histories*, but from a religious work by perhaps Thomas Aquinas or Duns Scotus if it was Lent. Afterwards he would be willing to give further audiences before going to his study to conduct his affairs or

to listen to more readings. Then he would attend vespers followed by further audiences and, if he had time, visit the nuns in the convent he had built at Sta Chiara; or he would go to S. Francesco where there was a fine view:

> There he would sit while thirty or forty of his young men, after stripping to their doublets, would throw the lance either at the apple or at the twigs in marvellous fashion; and the Duke, when he marked a want of dexterity in running or catching, would reprove them, in order that they might do better. During these exercises anyone might address him; indeed he was there for this end as well as any other. About the hour of supper the Duke would bid the youths put on their clothes. On returning to the palace it would be time for supper, and they would sup as I have already described. The Duke would remain for a time to see if anyone had aught to say, and if not he would go with the leading nobles and gentlemen into his closet and talk freely with them. Sometimes he would say 'Tomorrow we ought all to rise early and walk in the cool. You are a set of boys and prone to lie a-bed. You say you will come, but you will do nothing of the kind, and now good night.'

Federico was both shrewd and kindly in his dealings with people. It was brought to his notice that a certain merchant who had supplied goods to the household was making an excessive profit. But the Duke said that he 'would not have made this profit if he had not been highly deserving' and that he was indebted to the merchant 'who had trusted him, when he was poor and just come into his possessions, with five or six thousand florins when no one else would have lent him a single one.'

On one occasion he found himself arbitrating in a family quarrel. A fairly well-born subject of his had chosen a wife from a similar background, but subsequently took against her, to the fury of her family who were threatening vengeance Strife could easily have followed, but Federico spoke to the young man: 'If I desired you to become a relative of mine, would you not consent, having regard for my station? Would it not seem to you a desirable relationship?' The young man said it would not be fitting, the Duke being of much higher

rank. Then the Duke said, 'But will you not pay regard to something which satisfies me?' The young man said that of course he would. Then the Duke said, 'I think very highly of this young woman for her virtue and goodness, as if she were my own daughter; so you are becoming a relative of me, and not of her family.' Thus the young man was forced to agree to the marriage. Then, says Vespasiano

> he took her with the good wishes of all. The Duke took them both by the hand, wishing them good luck, and saying that their relationship with him began from that hour, that he wished them always to bear this in mind, and in all their needs to make use of him. He gave them a noble marriage feast and they both went away highly pleased.

Moreover, we are assured, the marriage worked.

Vespasiano admired the way that Federico dedicated himself to the welfare of his state. With the wealth amassed from his success as a *condottiere*, together with his good government, prosperity came to Urbino. In the words of Vespasiano, 'The country he ruled was a wondrous sight; all his subjects were well-to-do and waxed rich through labour at the works he had instituted, and a beggar was never seen.'

ABOVE: The convent of Sta Chiara, built by Federico, who would visit the nuns here.
RIGHT: The façade of the Ducal Palace, seen from the Viale Fratelli Rosselli.

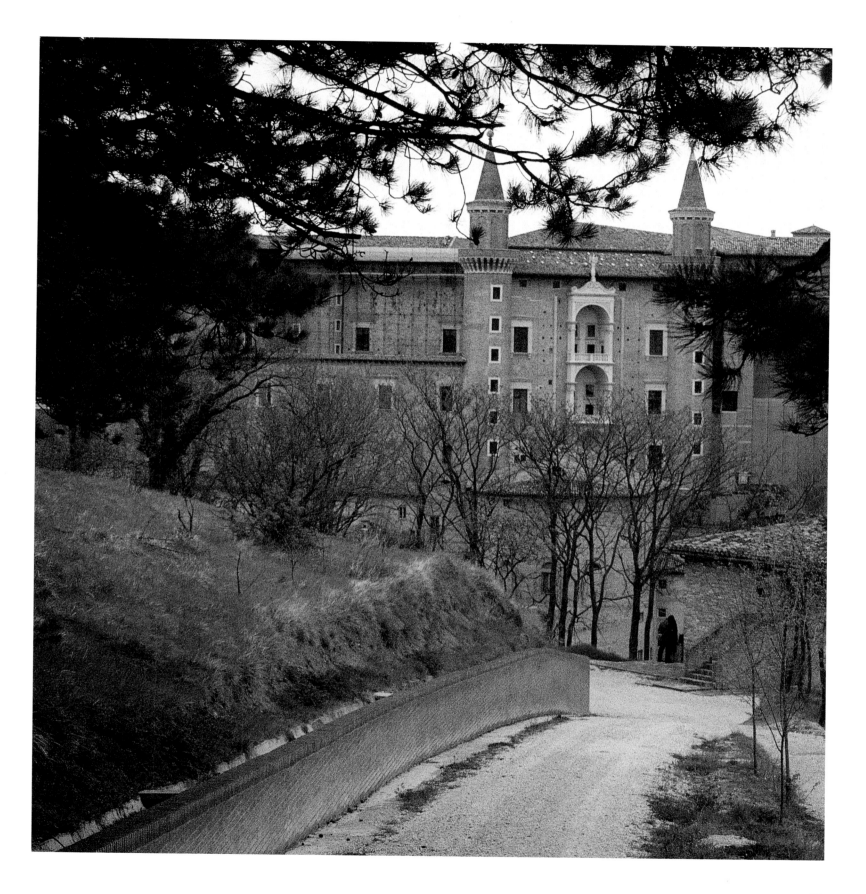

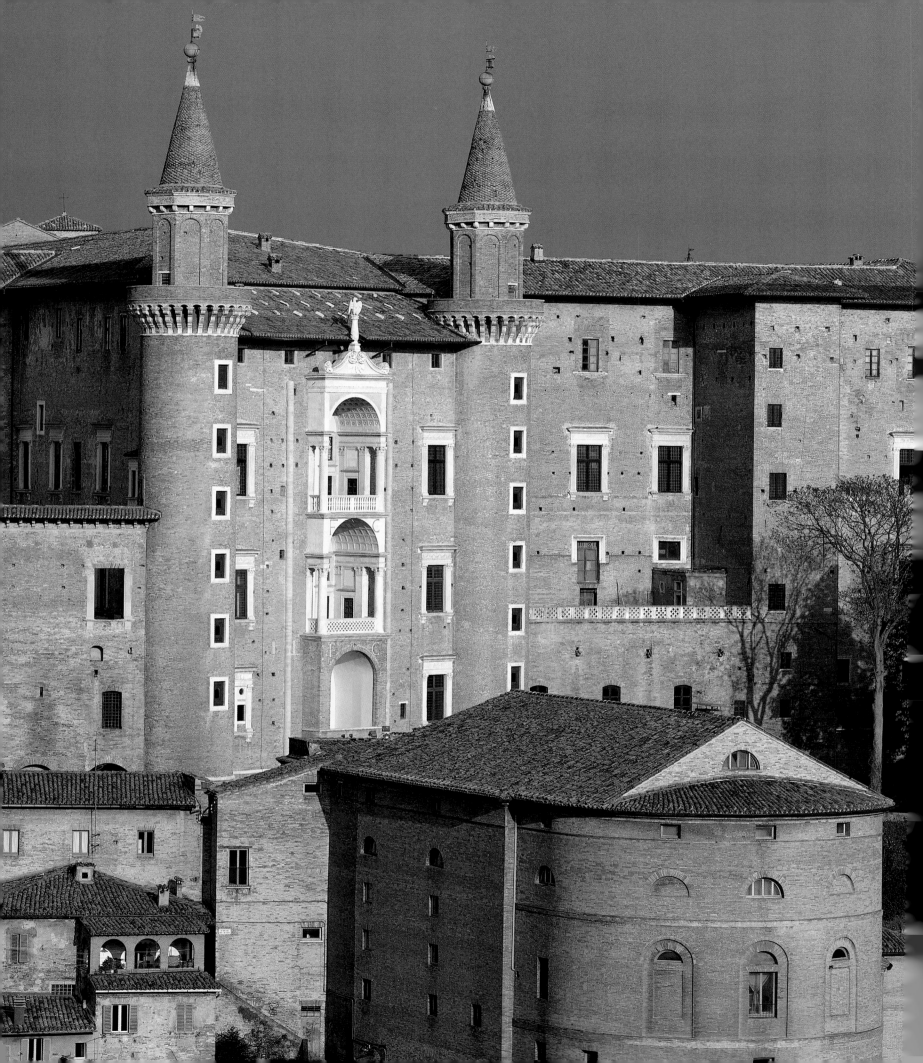

THE DUCAL PALACE AND ITS FURNISHINGS

'A HOUSE IS A LITTLE CITY'
Leon Battista Alberti, *The Ten Books of Architecture*

When Federico da Montefeltro was asked what quality above all others distinguished a great leader of men, he replied 'essere umano', that is to say, to be human or humane; perhaps one might add another interpretation: to be humanist. With his skill in fighting and diplomacy, he had become one of the richest men in Italy, possibly one of the richest in all Europe.[1] ('Eighty thousand florins is a good price simply for staying at home,' remarked Vespasiano da Bisticci.) He was anxious to use the proceeds of war to foster the arts of peace.

The building of a great palace to house the court and, at the same time, to convey both the magnificence and the modesty of the man was clearly a supreme priority. 'Men of public spirit rejoice when you have raised a fine wall or portico,' wrote Leon Battista Alberti and, as for the architect, 'It is the business of architecture, and indeed its highest praise, to judge rightly what is fit and decent. . . . To build in such a manner that the generous shall commend you, and the frugal not blame you, is the work of a prudent, wise and learned architect.'[2]

Federico was by no means one of those patrons who simply finds the money, commissions an architect and then takes no further interest in the proceedings. According to Vespasiano da Bisticci, no one of the time, whether noble or commoner, had such thorough understanding of architecture. 'Though he had his architects about him, he always first realized the design and then explained the proportions and all else; indeed, to hear him discourse on it, it would seem his chief talent lay in this art; so well he knew how to expound and carry out its principles.'

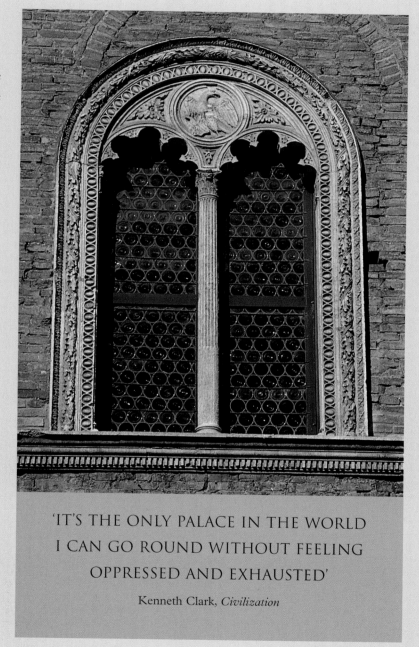

'IT'S THE ONLY PALACE IN THE WORLD I CAN GO ROUND WITHOUT FEELING OPPRESSED AND EXHAUSTED'

Kenneth Clark, *Civilization*

LEFT: The distinctive façade of the Ducal Palace with its *torricini* and ranged loggias.
RIGHT: An elegant fifteenth-century window on the east front of the Iole Suite. The Iole Suite, or Palazzetto, was the first part of the palace to be completed.

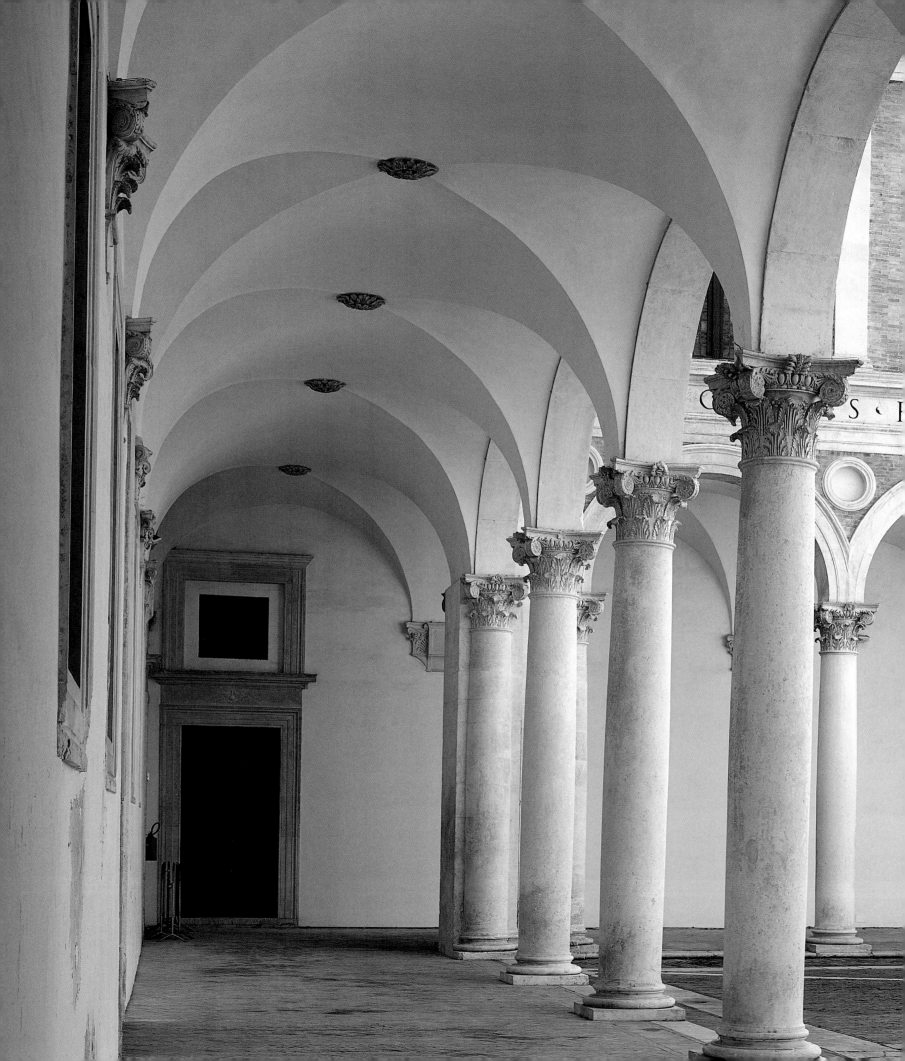

These principles were probably based primarily on the ideas of Alberti, with a bow also to classical precedent in the writings of Vitruvius. Richly bound copies of the treatises of both architects were to be found in Federico's library, and Alberti was a frequent and welcome visitor to Urbino.

Leon Battista Alberti (1404–72) came from a Florentine merchant family. Though illegitimate, he was given a superb education, studying in Padua and then at the University of Bologna, where he achieved a doctorate in law. He travelled in France, Belgium and Germany, and on his return to Italy made a study of the ruins of ancient Rome. He wrote treatises on painting and sculpture as well as architecture. Indeed, the ideal education that Vitruvius had proposed for an architect reads very much like the story of Alberti's life:

> The architect should be equipped with knowledge of many branches of study and varied kinds of learning. . . . Let him be educated, skilful with the pencil, instructed in geometry, know much history; have followed the Philosophers with attention, understand music, have some knowledge of medicine, know the opinions of the jurists, and be acquainted with astronomy and the theory of the heavens.[3]

Alberti's treatise, *The Ten Books of Architecture* (*De re aedificatoria*) dates from about 1450, the year he left uncompleted the Tempio Malatestiano at Rimini. (His other notable buildings include the Palazzo Rucellai in Florence, and the churches of S. Sebastiano and S. Andrea in Mantua.) Like Vitruvius, he stressed the importance of a thorough education:

> Him I call an architect who, by sure and wonderful art and method, is able, both with thought and invention, to devise, and with execution to complete all those works which can with the greatest beauty, be adapted to the uses of mankind; and to be able to do this, he must have a thorough insight into the noblest and most curious sciences.

The Cortile d'Onore, a supreme example of Renaissance harmony, with its carved Corinthian capitals.

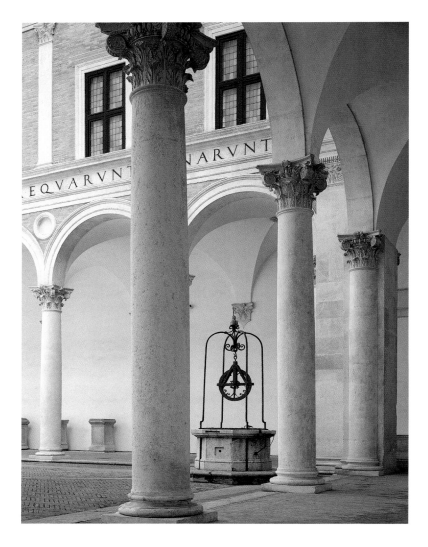

Whether or not Alberti had intended to dedicate his treatise to Federico – it was not printed until 1485, after they were both dead – here was a man after the Duke's heart, one who combined vision with practicality.

The building of a great palace in Urbino was clearly a necessity. It was not the only Montefeltro palace – there was another one in Gubbio, for instance – but Urbino's was to be the greatest. The five hundred or so people in Federico's court could hardly be boarded out throughout the town; and besides, this great lord, now an international power, required a fine building in order to express his magnificence. The Duke

had already proved himself, over and over again, as a war leader; there was no need for a castle, as the Malatesta had in Rimini; the walled city was a fortress in itself, and Federico, making himself constantly accessible, showed that he had little to fear from insurgents.

The choice and preparation of the site were not matters to be undertaken in haste. 'Do not think,' wrote Alberti, 'that the labour and expense of a building is to be entered into in a hurry,' and, 'If the seat be upon the summit of a hill, either it should be raised where it is not even, or else made level by planing away the top.'[4]

For the Ducal Palace of Urbino, which is built on the lower of two hills (the Fortezza Albornoz is on the higher), it is clear that not only did the site have to be levelled, but deep foundations needed to be dug. In Baldassare Castiglione's *The Book of the Courtier*, an amusing story is put into the mouth of Bernardo Dovizi (Bibbiena). There was in Urbino a foolish old abbot who was present when the Duke was discussing what to do with the great quantity of earth which had been excavated for the foundations of the palace. 'My Lord,' the abbot suggested, 'I have the perfect answer for where it should go. Order a great pit to be dug, and then it can be put there.' The Duke replied, laughing, 'And where will we put the earth that comes out of the pit?' And the abbot said, 'Have it dug so large that it will take both loads.' The Duke tried to persuade him that the larger the pit, the more earth there would be to dispose of. 'Well, make it bigger still,' the abbot persisted.

The story, whether apocryphal or not, certainly illustrates Federico's humanity, his sense of humour and his ability to suffer fools gladly. Meanwhile there was the genuine problem of the surplus earth. This was solved by using it to fill the gorge that lay between the hills. A flat plain was made, held up by great arches of masonry; this is known as the Mercatale – for centuries a market place, today a park for cars and buses.

Alberti recommended leaving all existing structures untouched until it became necessary to demolish them to

ABOVE: Corner of the Cortile d'Onore.
RIGHT: The Grand Staircase, leading from the Cortile d'Onore to the state apartments on the first floor.

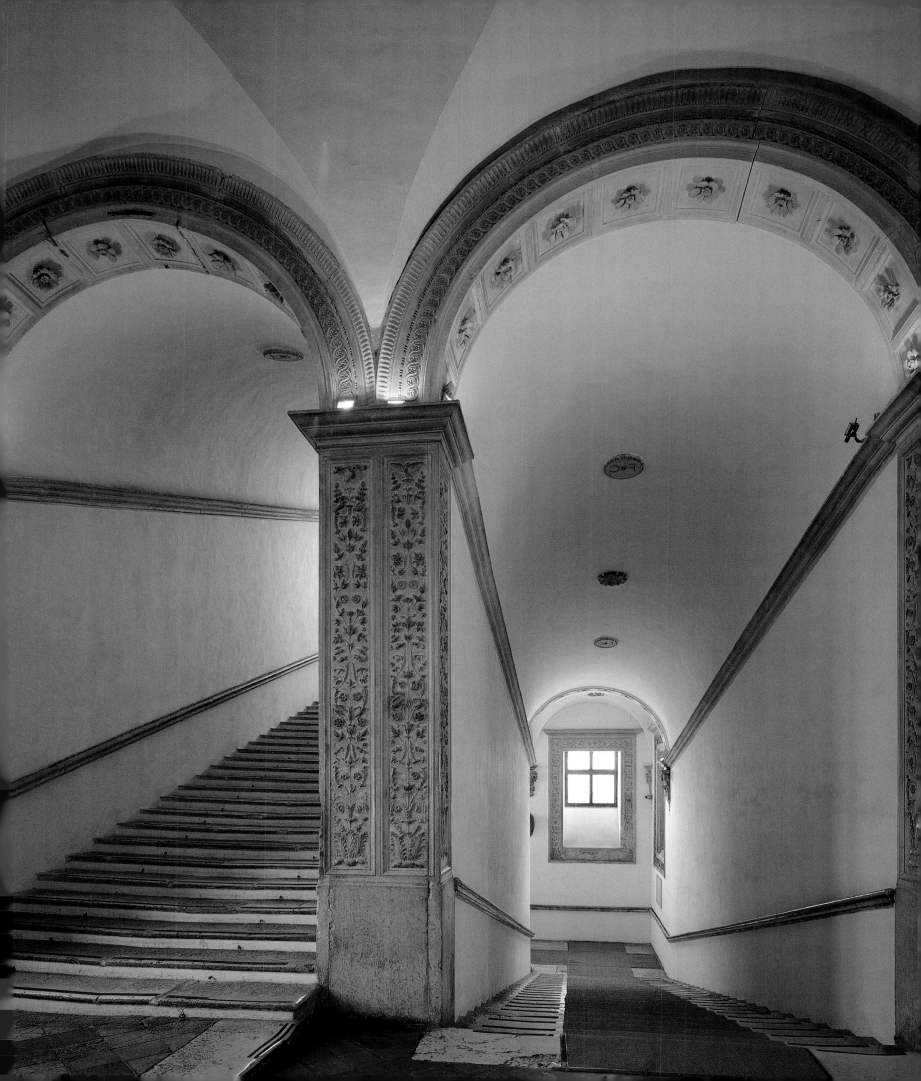

make way for the new building. In this way they could either be used as part of the foundations or even incorporated in the walls. There was already in existence the square block of Count Antonio's palace to the south (dating from before 1404) with two medieval houses slightly to the north of this, and the building known as the Castellare on a site next to the present-day cathedral.[5] These were incorporated into Federico's palace. The total effect was originally still that of a castle, with most of its skyline characterized by battlements in the form of merlons. The oldest part of the Ducal Palace is that known as the Palazzetto della Iole, so called because of its great fireplace with carved figures of Iole and Hercules.[6] On the exterior the architecture is rather severe, but this is counteracted by the delicate arched windows on the *piano nobile* (the first and principal storey) and the frieze in low relief.[7]

It seems pretty clear that the Duke himself was very much involved in the building of the Ducal Palace, but it is not possible to attribute it to any one architect. It was probably a Florentine, Maso di Bartolomeo, who was responsible for the Palazzetto della Iole. Maso was a pupil of Michelozzo di Bartolomeo (1396–1472) who designed the Medici Palace in Florence for Cosimo de' Medici, working in a style of restrained classicism. This part of the Urbino palace is in a similar mode. It contains remnants of frescoes dating from 1450–55 and attributed to Giovanni Boccati; they show men-at-arms (Mucius Scaevola and other heroes of Roman history) in a fifteenth-century version of classical armour. This may have been the Audience Chamber in the older palace.

A completely different style is to be found in the work of the next architect, Luciano Laurana (1420/5–79). Laurana was born in Dalmatia, worked in Mantua for Lodovico Gonzaga, and with his permission was transferred for a few years from Pesaro where he was architect to the court of Alessandro Sforza. The patent granted to him by Federico (dated 10 June 1468, at Pavia) still exists. The original is in Latin; Dennistoun's English translation reads:

> Whereas we, deeming those men to be worthy of distinction and preference who are gifted with such genius and talent as have been in all ages esteemed, especially for architecture founded upon arithmetic and geometry, which, as foremost among the seven liberal arts, and as depending upon exact science, require profound knowledge and great ability, and are therefore highly appreciated by us; and whereas, we, having sought everywhere, but particularly in Tuscany, the fountain of architects, without finding any one really versant and skilful in that profession, and having lately heard by report, and since ascertained by full experience, the learning and attainments of the distinguished Messer Lutiano, bearer hereof; and, further, we, having resolved to erect in our city of Urbino a fair residence, in all respects befitting the rank of our predecessors and ourselves, – have for these causes, selected the said Messer Lutiano as engineer and chief of all those employed upon that fabric, in building, hewing, woodwork . . .

The document goes on to give him complete control not only over the workmen but also over the building funds. Laurana was already employed on the palace when the document was drawn up; probably he had been working in Urbino from 1465/6, and by the date of the patent the façade with the small towers was complete up to the *piano nobile*.

What is remarkable about this patent is the high esteem in which the architect is held; he is deemed to be an intellectual and not just an artisan. And while one tends to associate the document mainly with Laurana, the ideas expressed in it are surely Federico's, and it bears his signature.

Laurana worked in Urbino for about six years, leaving in August 1472. He died in Pesaro in 1479. In Vespasiano's biography of Federico the buildings are listed, but not the architects. It is impossible to be certain about who took

ABOVE: Federico's signature.
RIGHT: Pilaster at the head of the Grand Staircase and entrance to the Iole Suite, the oldest part of the palace.

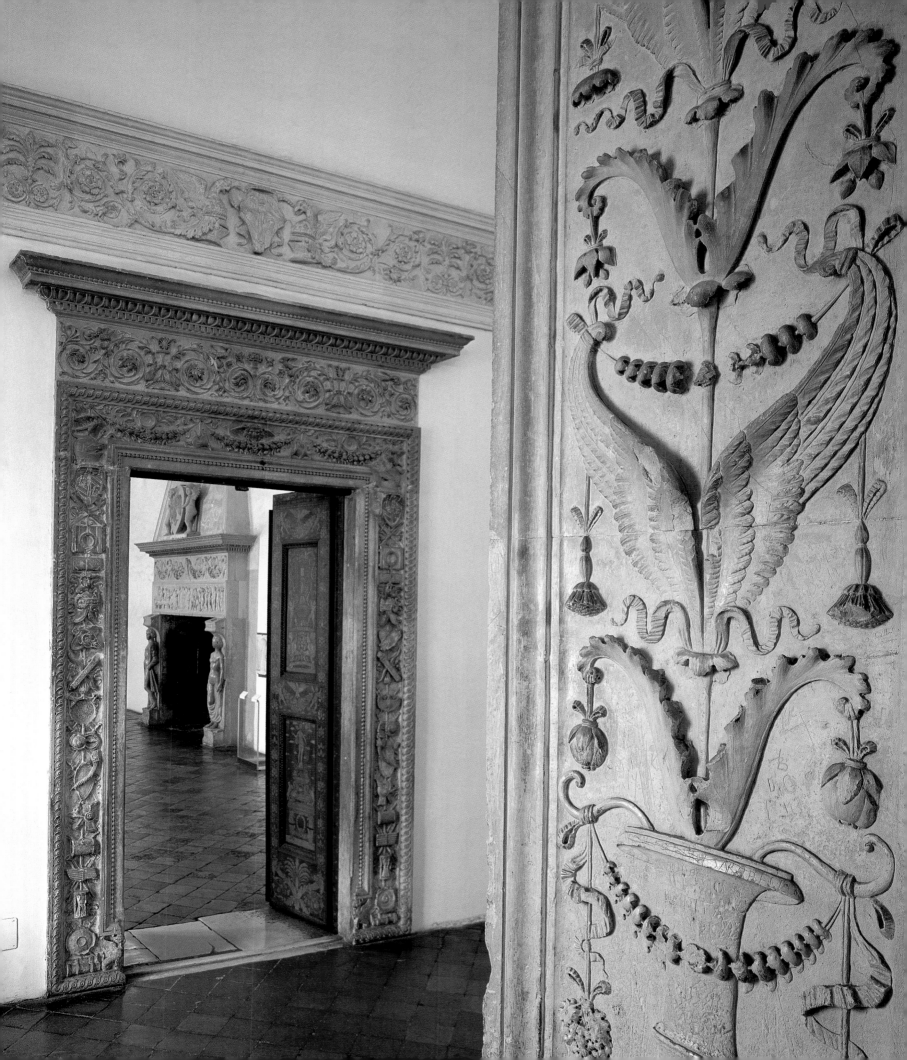

Laurana's place and when, but those whose hands may be seen in the subsequent development of the palace include without doubt Francesco di Giorgio Martini of Siena, and very likely Piero della Francesca as well. Peter Murray suggests that Francesco di Giorgio was responsible mainly for the decoration, or the completion of existing schemes. (This is on the grounds that the one church that is definitely by him, near Cortona, does not have anything like the quality of the palace of Urbino.) According to Cecil Clough,[8] Francesco di Giorgio Martini replaced Laurana by October 1472, then in June 1485 he was ordered to return home to Siena, and worked there for the rest of his life.

Meanwhile Piero della Francesca was already working for the Duke as a painter (see page 113). It has to be remembered that he was also a theorist and the author of two treatises: *On Perspective in Painting* (*De perspectiva pingendi*) and *On the Five Regular Bodies* (*De quinque corporibus regularibus*). He was above all a seeker after harmony. Believing Man to be the measure of all things, he looked for beauty primarily in form,

and only secondarily in ornament. These ideas are wonderfully encapsulated in the painting of *The Ideal City* in the National Gallery of the Marches, (see pages 14–15). Housed in the Ducal Palace, its serene and exquisite harmonies express the dual concept of a city in the form of a palace, and a palace in the form of a city.[9] This same serenity is also to be found in the Cortile d'Onore, the open heart of the palace. Forms are balanced, human in scale, never grandiose or pretentious, and there is little adornment beyond the classical inscriptions and the crisply carved Corinthian capitals.

Federico da Montefeltro was made a duke by Pope Sixtus IV on 21 August 1474. Therefore, a way of dating the different parts of the palace is to note whether they bear the inscription FC, and relate to the time when he was simply a count, or FD – which may appear as Fed Dux – denoting a post-1474 date. One of the earlier parts of the palace to be built is the façade with the delightful *torricini*. These slender, cone-capped towers contrast so dramatically with the cliff-like mass of most of the exterior, and shelter between them tiers of loggias. Here we find the Duke's bedroom and Audience Room, the Sala degli Angeli (named after the frieze of cherubs which adorns the fireplace), the Throne Room, the Grand Staircase which ascends gently and is neither mean nor showy, and the loggia opening on to the Terrazza del Gallo, between the right *torricino* and the square tower which terminates this façade.

According to Rotondi, two different projects are discernible in the building of the palace: one rectilinear and occupying the south-central part, and the other north-central; and it is the latter which is characterized by interesting angles in the exterior architecture – and indeed, interesting concepts in the rooms behind them.

There is a high wall linking the left-hand *torricino* with the Duchess's suite; broken only by three great rectangular openings, it looks forbidding enough from the outside. But behind it, at ground floor level, is the Secret Garden. This was a cool retreat with a central fountain and raised flowerbeds;

ABOVE: The Secret Garden, situated at ground floor level between the Duke's and Duchess's apartments.
RIGHT: The angel fireplace that gives the Sala degli Angeli its name.

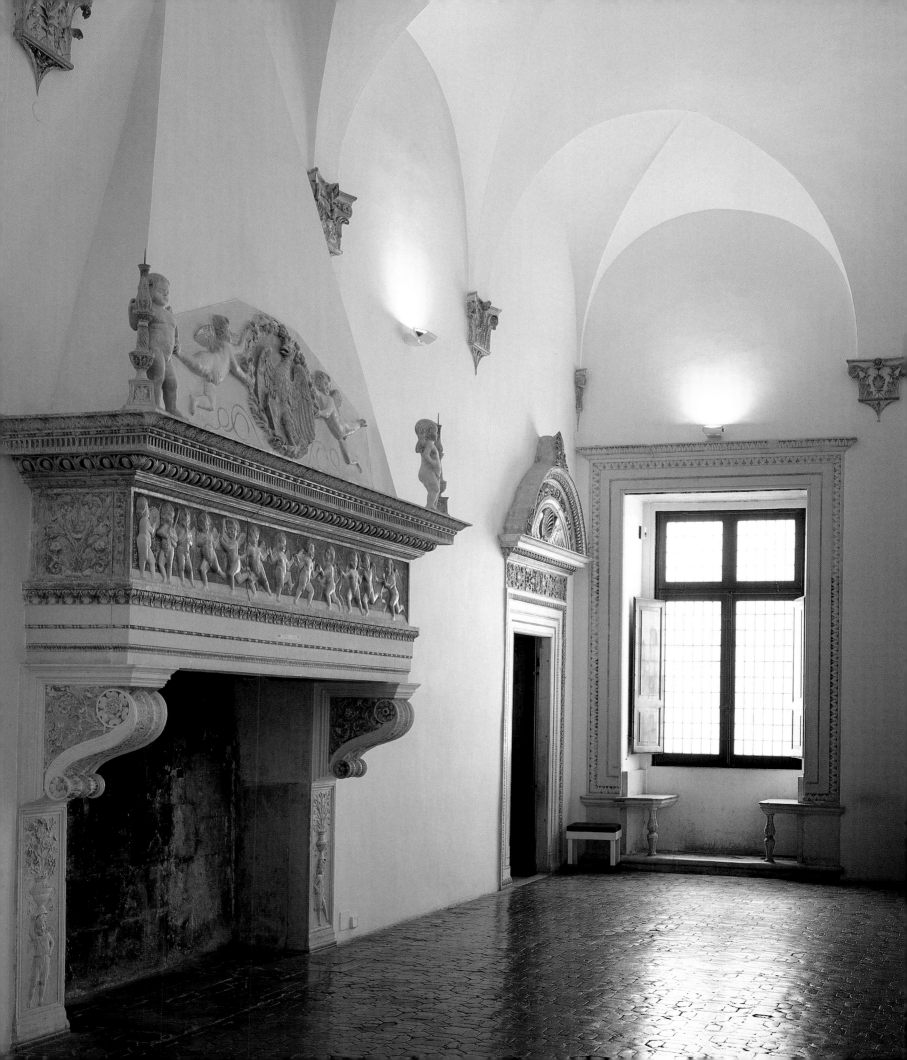

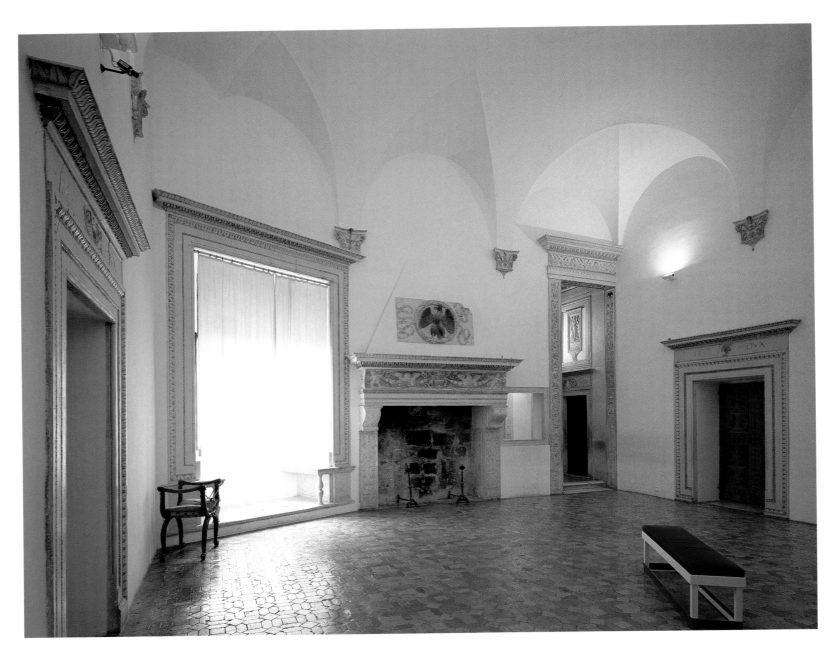

stone seats were placed around, and the walls were covered with ivy and jasmine.[10] Behind this there was a greenhouse, and under it a pit for snow. When snow fell in the winter, it could be brushed down to a store at basement level, where it served as an ice house to preserve food and cool wine in the summer.

The basement floor of the palace was mainly devoted to practical purposes: stabling for horses, kitchens and a pantry, a wine cellar, a cistern for rainwater, the pit for snow, and the luxury of two bathrooms. A helicoidal ramp led to the upper storeys. The main provision of water, so vital for a household

ABOVE: The Audience Room, with the Montefeltro eagle over the fireplace. The tall doorway leads to the Duke's Vestibule which in its turn leads to the Studiolo on the right and the small chapel of Guidobaldo II on the left.
RIGHT: A ramp leads to the basement floor, which was used for stabling, cooking and bathing.

of this size, was from cisterns under the paved floor of the Cortile d'Onore. Small discreet guard chambers were sited by the entrance hall. Service rooms and rooms for guests were mainly on the ground floor; so were the rooms to be used for a theatre. Significantly, both the Banqueting Room and the Duke's library were here, both of them very accessible, the library being just by the entrance hall and the Cortile d'Onore, the Banqueting Room between that courtyard and the garden. The siting of these rooms was indicative of the humanist and trusting nature of the Duke.

The floor above this, the *piano nobile*, housed the most elegant rooms. The Duke's and Duchess's apartments faced each other across the Secret Garden. On the Duke's side there still exists a noble bay window, mounted on consoles carved with FC (as it was completed when Federico was still just a count). It will be remembered that after the death of Battista Sforza, Federico's string of daughters lived in the Duchess's suite in almost complete seclusion. A narrow passageway ran along the top of the high garden wall, linking the Duke's rooms with the Duchess's; there used to be a balcony from the Duchess's apartments giving access to it. But the more usual approach was through the Sala degli Veglie, the room for evening gatherings (memorable as the supposed setting for the conversations that form the basis of Castiglione's *The Book of the Courtier* – see Chapter 11). This room, in turn, led through the state rooms of the Throne Room and the Sala degli Angeli, before reaching the Duke's private apartments. The fireplace in the Sala degli Angeli, with its gambolling cherubs, is the finest of the many fireplaces in the palace, which were admired not only for their appearance, but also for the remarkable fact that they did not smoke.

When we walk today through the series of noble state-rooms, such as the Throne Room, the Audience Room, and the Sala degli Uomini Illustri, probably our greatest delight is in their beautiful proportions and their cool simplicity. On the other hand, we must remember that they were never intended to be so bare. Castiglione, describing the palace in his introduction to *The Book of the Courtier*, said it seemed more like a city than just a palace.

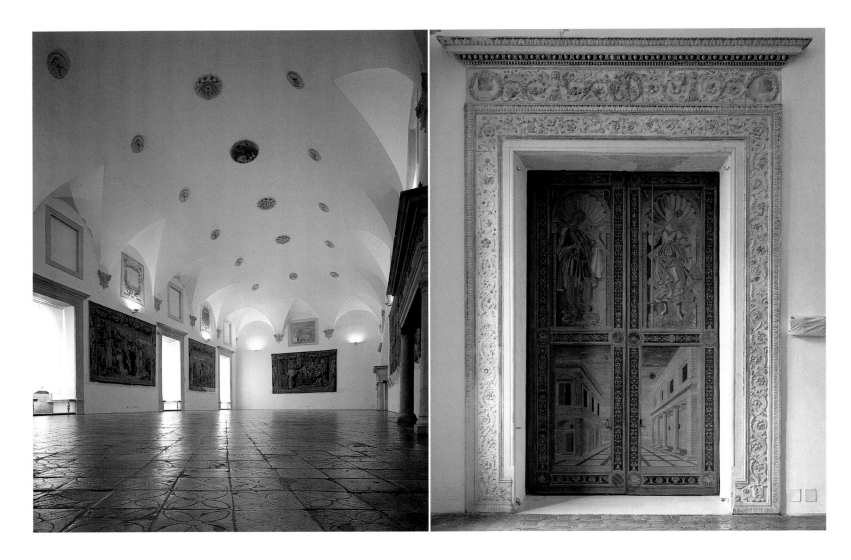

For he adorned it not only with the usual objects, such as silver vases, wall-hangings of the richest cloth of gold, silk and other similar material, but also with countless antique statues of marble and bronze, with rare pictures, and with every kind of musical instrument; nor would he tolerate anything that was not most rare and outstanding.

On tapestries for this palace alone it is estimated that he spent a total of 10,000 ducats. Among the tapestries he commissioned was a set of eleven depicting scenes from the Trojan War.[11] These were made by a Flemish weaver, Jean Grenier of Tournai. The subject itself is significant; great leaders of the Renaissance (especially *condottieri*) liked to identify with the heroes of the classical world, and perhaps

Pope Pius II had succeeded in convincing Federico of the importance of this particular conflict.

After the fall of the duchy, the palace was stripped. The inventories compiled between 1582 and 1631 make rather melancholy reading on the whole.[12] Take, for instance, this list of *cassoni* (marriage chests), usually among the most treasured pieces of furniture:

Three large *cassoni* of walnut, old and outmoded.

A *cassone* of walnut in the lower dressing room, old and decrepit.

A large pinewood *cassone* in the dressing room, old and broken.

Two small boxes of tooled leather, old and broken and
 of little value.

So much ancient and broken furniture, so many hangings of gilded *corrame* (tooled leather); and yet, as one reads the inventories, from time to time one is brought up with a jolt. Suddenly one is confronted with a reference to a masterpiece – a Raphael, a Titian, a Piero della Francesca (recognizable, though in each case the artist is seldom named) – and the encounter seems all the more vivid because one can visualize how the painting would have looked in its original setting.

Federico's bed can still be seen in the palace today, and very impressive it is, almost a room in itself, with gilded pilasters and simulated marble bearing the Duke's insignia, with cherubs' heads and swags and flowering trees. A remarkable survival of fifteenth-century furniture.

Most of the adornments of the palace that can still be seen today, however, are those which could not easily be removed – notably the intarsia that enriches so many of the doorways. In places street scenes are depicted, in others allegorical figures or classical deities. It is not recorded who designed the panels. Rotondi suggests a number of different artists, detecting in some the hand of Francesco di Giorgio, in some Bramante and in others Botticelli.

From the Duke's private apartments, the twisting staircase in one of the *torricini* leads to two tiny rooms below. There are inscriptions in Latin: 'BINA VIDES PARVO DISCRIMINE

FAR LEFT: The Throne Room. There is a stucco relief of the Lion of St Mark on the far wall.
LEFT: Portal leading into the Throne Room from the Sala degli Angeli.
ABOVE: A *cassone* (marriage chest), which belonged to Duke Guidobaldo and Duchess Elisabetta (Victoria and Albert Musuem, London).
RIGHT: Giant candlestick designed for Federico by Francesco di Giorgio Martini (Museo Albani, Urbino).

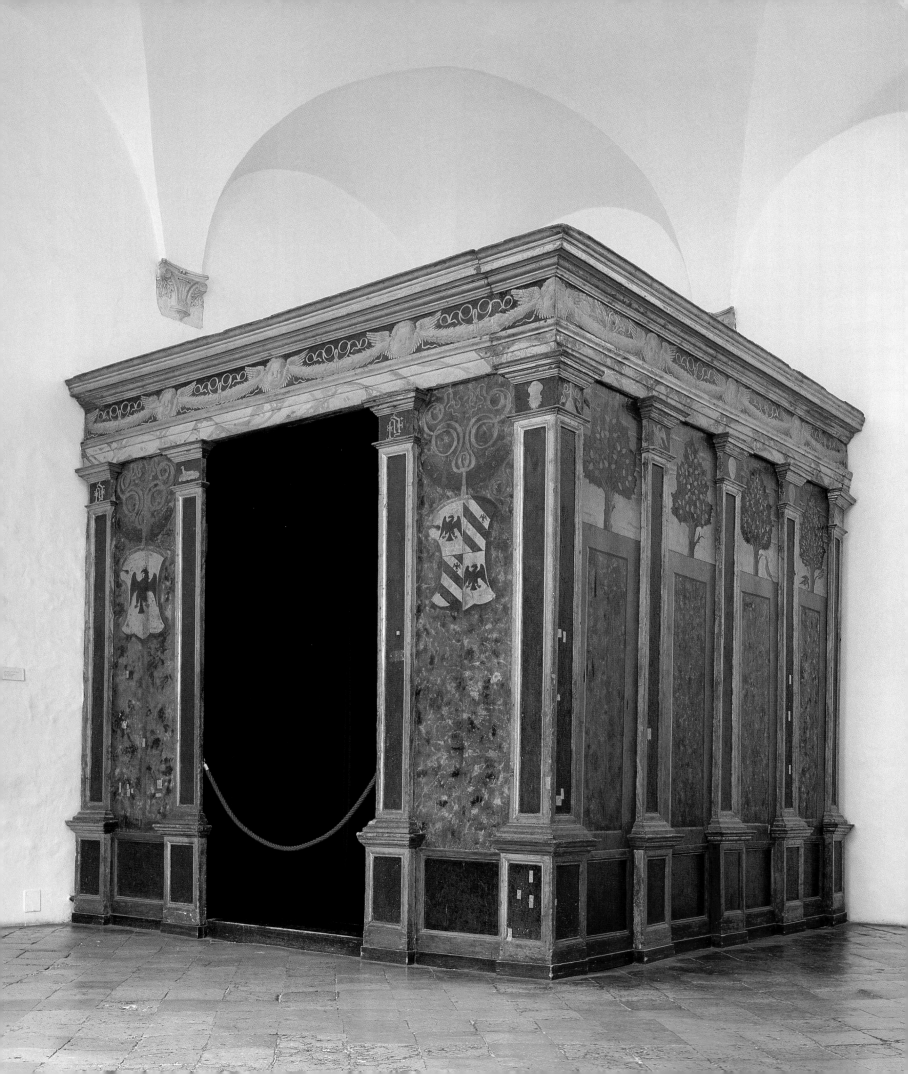

IUNCTA SACELLA/ALTERA PARS MUSIS ALTERA SACRO DEO EST.' (You see two small rooms adjoining with little space between them, one sacred to the Muses, and the other to God.) and 'HAEC QUICUMQUE PETIT MUNDO PIA LIMINA CORDE/HIC PETIT AETERNI FULGIDI REGNA POLY.' (Whoever seeks these holy rooms with a glad heart seeks here the shining kingdom of the immortals.)

These little rooms are among the hidden delights of the palace. One of them is a chapel, the Cappella del Perdono. It is no bigger than a cell, with winged cherub heads on the vaulted ceiling (probably by Ambrogio Barocci) and, on the walls, restrained marble panelling, having the serenity and harmony of a painting by Piero della Francesca or, as Rotondi suggests, showing the influence of Donato Bramante. Whoever's work it was, this is essentially a place of private devotion, almost a reliquary. When the 1582 inventory was made of the contents of the palace, this chapel was found to have contained one of the world's masterpieces, Raphael's *Madonna and Child with St John*, known as the *Madonna della Sedia* (*The Madonna of the Chair*). The painting is now in the Galleria Palatina at the Palazzo Pitti, Florence.[13]

Alongside the chapel, and of equally small size, is the Temple of the Muses. Only the barrel-vaulted ceiling is decorated now, coffered in blue and gold. Beneath it is another inscription: 'QUISQUIS ADES LAETUS MUSIS ET CANDIDUS ADSIS/FACUNDUS CITHERAE NIL NISI CANDOR INEST.' (Whoever you are, may you be present rejoicing in the Muses with an honest heart, because here in Cythera there is nothing but eloquent honesty.)

The walls used to be covered with paintings of Apollo, Athene the goddess of wisdom, and the nine Muses, executed by Timoteo Viti and others, originally set around the walls in adjoining frames of inlaid wood. Only eight of the eleven paintings have survived – gentle, lyrical, slightly melancholy figures – and they are now in the Galleria Corsini in Florence. If we can imagine them as they were, something of Federico's

spirit can be evoked by these two juxtaposed rooms. His religious devotion was undoubted, but it was paralleled by an equally fervent devotion to the arts.

A third great passion was for learning. On the *piano nobile*, occupying the space directly above the chapel and the Temple of the Muses, is the Studiolo.[14] It is situated behind the richest of the loggias between the two *torricini*, but slightly askew, so there is not too much direct light.

The Studiolo lies between the private rooms (bedroom and dressing room) that one would expect any great lord to have and the public apartments (Audience Room and Sala degli Angeli). Although from time to time favoured guests would have been allowed in to admire it, it was essentially a place for solitary meditation and study. More than any other part of the palace, therefore, it seems to reflect Federico's taste and character.

Although there was another such room in the Montefeltro palace at Gubbio, similarly adorned with a scheme of paintings and intarsia, the one at Urbino served as a model for other similar apartments, and survives as the finest and most complete example of an early Renaissance private study.

LEFT: Federico's bed, a small room in itself, has miraculously survived.
ABOVE: Detail from Federico's bed.

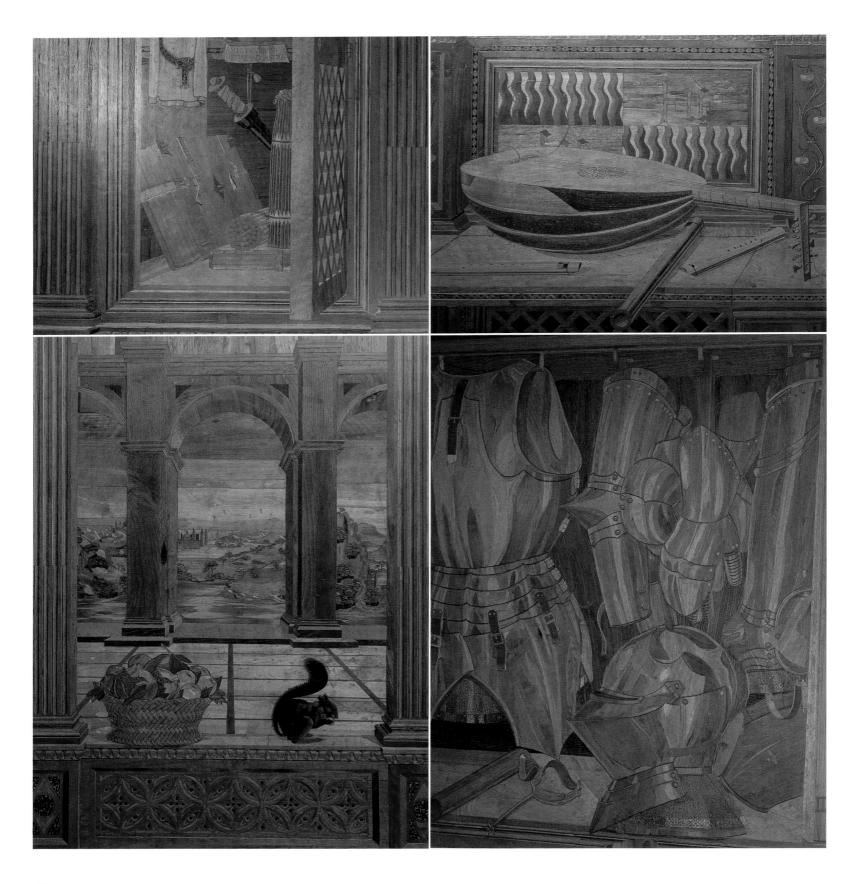

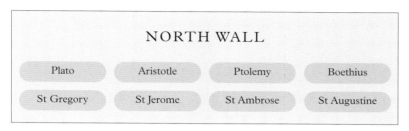

NORTH WALL

| Plato | Aristotle | Ptolemy | Boethius |
| St Gregory | St Jerome | St Ambrose | St Augustine |

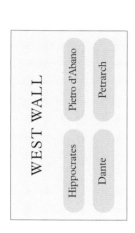

WEST WALL

Pietro d'Abano
Petrarch

Hippocrates
Dante

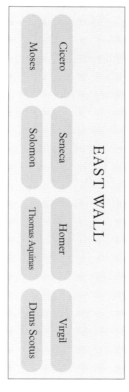

EAST WALL

Moses
Cicero

Solomon
Seneca

Thomas Aquinas
Homer

Duns Scotus
Virgil

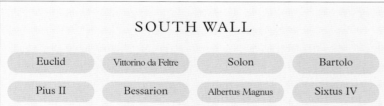

SOUTH WALL

| Euclid | Vittorino da Feltre | Solon | Bartolo |
| Pius II | Bessarion | Albertus Magnus | Sixtus IV |

LEFT: Details of the intarsia work in the Studiolo. The designs reflect some of the Duke's interests – music, military matters and books. Behind the squirrel and the basket of fruit is a representation of the Duke's estates.
ABOVE: Diagram showing the arrangement of portraits decorating the upper walls of the Studiolo.

The room is of irregular shape and small, no bigger than an average suburban sitting room. Its measurements, including the niches are a mere 12 by 11 feet. The lower part of the walls (up to 7¼ feet) is covered by a most delightful *trompe l'oeil*, the upper part with portraits of illustrious men. The whole scheme (according to Luciano Cheles) was probably completed by 1476.

The intarsia and its mellow shades of gold and chestnut brown gives the impression of a princely room cluttered with books, armour, scientific and musical instruments, as if the Duke, engrossed in his studies, had left some of the fretted cupboard doors open. But all this is an illusion, and the walls are actually flat. Above the lower layer we find the *stemme*, or heraldic insignia. Then, in the upper row of the intarsia there are panels of the theological virtues of Faith, Hope and Charity, an organ with its pipes rising to an apex, and a robed figure of Federico himself. In the centre of the east wall, flanked on one side by, apparently, a cupboard full of armour, and on the other by a miniature study with a reading desk, is a section which actually juts out into the room. Here perspective lines lead to the arches of a simulated loggia; in the foreground is a basket of fruit and a squirrel sitting on its haunches nibbling, and in the background is a miniature view of Urbino and the rocky landscape of the *contada*. All this is executed in the different natural colours of wood, so that, despite the intricate detail, there is a sense of harmony and repose. Above the intarsia there were, originally, twenty-eight portraits of celebrated men painted, it is thought, by Justus of Ghent. Federico's choice of portraits will be discussed in the next chapter.

While considering Federico as a patron of architecture we naturally tend to concentrate on the great Ducal Palace of Urbino; but it should be remembered that he started the building of a new cathedral for the city, he arranged for a new façade to be made for the church of S. Domenico, commissioned the building of the convent of Sta Chiara, restored the church of S. Donato and ordered the church of S. Bernardino to be erected next to it. Equally, when we remember how the Duke spent his day, religious observance took an important place among his other preoccupations and was never neglected.

Thus it was only appropriate that portraits of figures connected with religious life should appear on the walls of the Studiolo. There has been a good deal of dispute about the exact order in which they, and the corresponding secular portraits were placed, and also whether any other paintings associated with palace were originally in the Studiolo. In 1631, after the death of the last Duke of Urbino, Francesco Maria della Rovere II, the twenty-eight paintings were ruthlessly cut out and sent as individual pictures to Rome. Fourteen of them were eventually returned to Urbino, and the rest ended up in the Louvre in Paris. In the Studiolo, photographic copies of the latter are now interspersed with the originals, so we can at least assess the general effect.

They are arranged in groups of four; classical and humanist scholars above, biblical figures, theologians and religious poets below.

Clearly this is no random selection of illustrious men. It is not like setting up a series of Roman emperors just as a feature of room decoration. Military heroes, such as would have adorned the walls of the Painted Chamber, are not included here. Just as in the Cappella del Perdono it was faith, and in the Temple of the Muses the arts, here the emphasis is on the intellect.

Like the two rooms below it, the Studiolo is essentially a personal apartment. We feel the presence of Federico here, not only as a patron of architecture, but as a patron of learning. The room has that human, as well as humanist quality that is characteristic of the whole building. But here is the quintessence: civilization in microcosm. In the words of Frederick Hartt, 'All the intellectual refinements of an ideal life were concentrated here, within the confines of a tiny chamber, executed with consummate skill to please the noblest of Renaissance princes. Neither the perfection of this art nor the kind of personality that commissioned it were ever to recur.'[15]

LEFT: The spiral staircase leading down one of the *torricini*.
RIGHT: The Temple of the Muses, dedicated to honour secular art, is situated alongside the Cappella del Perdono.

FEDERICO AS A PATRON OF LEARNING

The Duke of Urbino was a many-sided man, and had, as we have seen, received an excellent upbringing at the Gonzaga court of Mantua. But whereas with some young princes education was a veneer quickly rubbed off in later life, with Federico it was engrained. And since he valued it, he was anxious to pay homage to those thinkers and writers he considered truly great.

For this reason he had his Studiolo adorned with portraits of illustrious men. Referring to the plan on page 89, it will be observed that the lower row are portraits of figures connected with religious life, the upper row pagan or humanist. To the Renaissance mind there was no dichotomy between learning and faith, and any notion that humanism might be linked to atheism would have been held to be totally bizarre. Thus we find that on the north wall, above the four Fathers of the Church – Ambrose, Augustine, Jerome and Gregory – are the Greek philosophers Plato, Aristotle, Ptolemy and Boethius.

Plato (*c*.427–*c*.347 BC), the great Athenian philosopher and founder of the Academy, was the author of the *Republic*, the earliest of all Utopias. Original Greek manuscripts of his work had been coming to Italy, via Constantinople, since about 1400, and Latin translations of them had been made by Marsilio Ficino. Plato's vision of an ideal state was clearly of the greatest interest to Federico.

Aristotle (384–322 BC) was Plato's pupil, and founded a school of rhetoric in Athens. After a spell as tutor to Alexander the Great, he returned to that city in 335 and established his famous Lyceum.

Ptolemy of Alexandria (AD *c*.90–168) was essentially a scientist. It was on his work on astronomy that the Renaissance view of the solar system was based; the earth was

'NO OTHER UNITED AS HE DID, IN HIS OWN PERSON, THE SOLDIER AND THE MAN OF LETTERS, OR KNEW HOW TO MAKE INTELLECT AUGMENT THE FORCE OF BATTALIONS'

Vespasiano da Bisticci, Proem to *The Life of Federico da Montefeltro*

LEFT: Sunburst decoration in the centre of the ceiling of Federico's library.
RIGHT: Some of the illustrious men portrayed in the Studiolo. Top row: Euclid, Vittorino da Feltre, Solon; bottom row: Pope Pius II, Bessarion, Albertus Magnus.

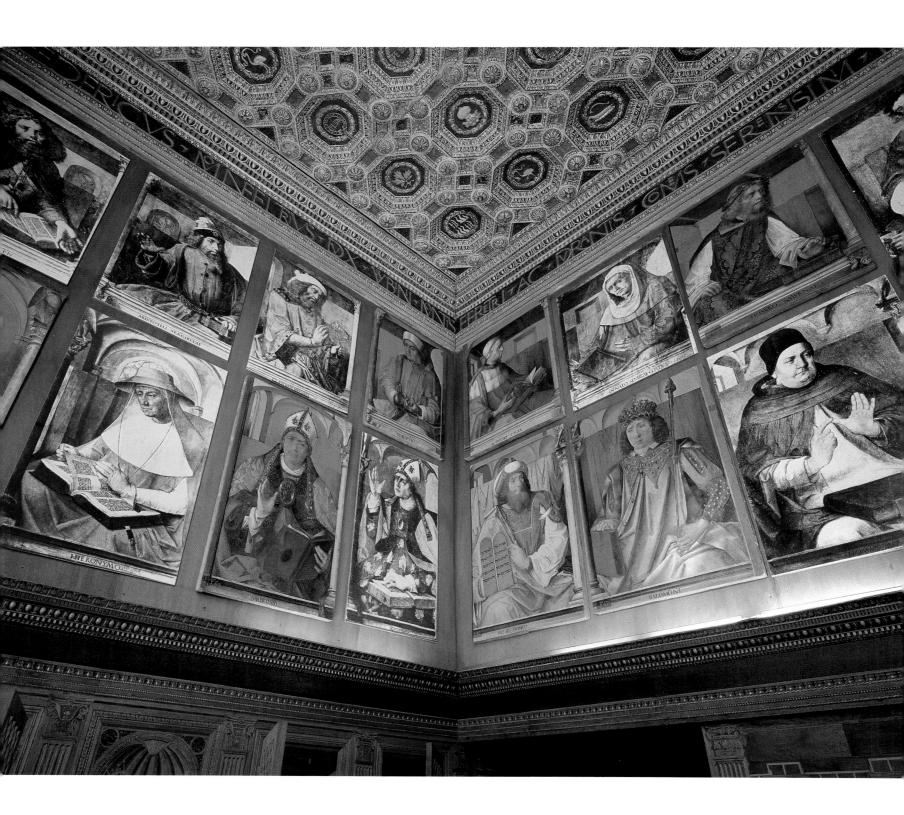

North and East walls of the Studiolo, with portraits of illustrious men. Top row, left to right: Plato, Aristotle, Ptolemy, Boethius, Cicero, Seneca, Homer, Virgil; bottom row, left to right: St Jerome, St Ambrose, St Augustine, Moses, Solomon, Thomas Aquinas.

held to be the centre of the universe and surrounded by eight concentric spheres, the stars being set in the outermost of them. This theory was still held up to the time of Shakespeare, unquestioned except by Copernicus and Galileo, and is certainly what Federico would have believed. He had an original manuscript of Ptolemy's in his ducal library, and kept it in a cedarwood box.

Next to Ptolemy we find Boethius (c.475–524), a Roman administrator under the Gothic king Theodoric, until he fell foul of his overlord and was imprisoned. It was in prison that he turned to writing; his most famous and influential work *The Consolation of Philosophy*, which was translated into Anglo-Saxon by King Alfred, and later into English by Elizabeth I, won Boethius the nickname 'Schoolmaster of the West'.

On the east wall are the lawgivers, the classical Cicero (106–43 BC), and Seneca (c.5 BC–AD 65), and the biblical Moses and Solomon. The latter is portrayed as a richly dressed and bejewelled young king, looking rather like Charlemagne. These were all men who in fifteenth-century eyes were regarded as great administrators of justice, and so of supreme relevance to a ruler such as Federico.

Next to them are, above, the classical epic poets Homer and Virgil. The almost legendary Homer is shown as a blind man, as tradition held him to be. A great deal more is known about Virgil (70–19 BC), the author of the *Eclogues* and *Georgics* (pastoral and bucolic poetry) and, above all, his epic masterpiece the *Aeneid*. He had been born near Mantua, where he was very highly regarded, and still is. Thus for Federico, receiving his formative education at the Ca' Zoiosa in that city, Virgil and his poetry would have been an important part of his culture.

Below the poets are the theologians, St Thomas Aquinas (1225–74), who represents the Dominican Order, and whose writings are still an authority in the Roman Catholic Church, and the persuasive Duns Scotus (c.1265–1308) who emphasized faith rather than philosophy and represented the Franciscans. The fact that both are included in the Studiolo indicates that Federico was aware of there being two sides to the argument. He himself commissioned a fine new façade for the church of S. Domenico, but the Montefeltro family had always had a predilection for the Franciscan movement. We recall how Federico's father had chosen to live his last few months like a Franciscan friar and to be buried in the habit of that order.

On the west wall we find portraits of poets and men of medicine. The Greek physician Hippocrates (c.460–c.377 BC) excelled in the description and diagnosis of diseases. From him derived the theory of the four 'humours' (blood, phlegm, yellow bile and black bile) that throughout the Renaissance were held to influence men's health and their lives generally.

Next to him is the less well known Pietro d'Abano (1257–1315) who translated Hippocrates, and whose own writings on astrology – taken in all seriousness as a science – were to be found in Federico's library.

The poets here are Dante and Petrarch. The great Dante Alighieri (1265–1315), whose masterpiece *The Divine Comedy*, written in Italian rather than Latin as was customary, gave new fluency and power to the language. Petrarch (Francesco Petrarca, 1304–74) by contrast wrote largely in Latin and encouraged the study of the literature of classical antiquity. Very popular in the Renaissance period were his *Trionfi* ('Triumphs') and *Canzionere* ('Lyrical Poems'); in the ducal library Federico had a copy of the two works bound together in one volume.

On the south wall several of the portraits are of clerics. There are the two popes, Pius II and Sixtus IV, and the theologian Albertus Magnus (1206–1280), who was a Dominican, and the teacher of Thomas Aquinas. Above him is Solon (c.640–559 BC), the Athenian lawgiver and poet, and next to Solon, Bartolo da Sassoferrato (1314–57), another lawgiver, much esteemed by Federico; all of his works (affirms Vespasiano da Bisticci) were to be found in the Duke's library.

Several of the men portrayed were known personally to Federico. He had met Pope Pius II in 1459; Pius regarded him as the ideal Christian leader, while Pius was regarded by Federico as the ideal Pope; moreover they shared a love of classical learning and literature. During his papacy humanists felt that the triple tiara was worn by a man with an enlightened

sense of values, and to Federico it seemed that he had an ally in high places.

The other pope shown here is Sixtus IV, whose pontificate was 1471–82. He was an almost exact contemporary of Federico's, and would have been Pope at the time the portrait was painted. Though a somewhat worldly man (he was involved in the Pazzi Conspiracy against the Medici in Florence), he did much for art and architecture in Rome; it was he who commissioned the Sistine Chapel.

Next to Pope Pius is the astonishing Johannes Bessarion (1395/1403–1472), a Greek, with Emperor John Palaeolagus VIII; his aims were firstly to protect Constantinople from the Turks, and secondly and even more ambitiously to reconcile the Western and Eastern churches of Christendom. He might have succeeded had it not been for the opposition of the Byzantines. Then after the fall of Constantinople in 1453, Bessarion went to Germany to try and rouse up a crusade. But his lasting significance in the whole story of the Renaissance lay in his introducing Greek ideas and literature into Western Europe. At his death he was to leave six hundred manuscripts to the library of St Mark's in Venice.

Bessarion had come to the court of Urbino in 1453, and was much impressed by the hospitality he received, and by the erudition of Federico's elder natural son, Buonconte.

Above Pius II we find the celebrated mathematician Euclid, wearing flowing robes and poising a pair of dividers. Euclid's work became known throughout Europe, in particular his *Elements*, which introduced theorems, and became the basis of geometry textbooks for generation after generation.

Looking towards Euclid, whose *Elements* would certainly have been on the curriculum of his school, is Vittorino da Feltre (1378–1446).

It is both moving and appropriate that Federico should have made his old teacher the tribute of including him among the 'Uomini Illustri'. (Vittorino and his Ca' Zoiosa are discussed on pages 48–9.) In having him portrayed in the Studiolo, Federico was not only acknowledging how much he owed to him personally, but recognizing his significance as one of the greatest teachers of all time.

Such were Federico's heroes, lay and religious. They represent virtually the whole state of learning as it appeared to one of the most enlightened men of the Renaissance. Grouped together are the Fathers of the Church, humanist prelates, philosophers and lawgivers, theologians, doctors, educationalists, rhetoricians and mathematicians, and the great poets both of antiquity and the Middle Ages.

It is interesting how differently they are portrayed. We notice straight away that with only two exceptions (Moses with the Tablets of the Law and Ptolemy with his armillary sphere), all the portraits include books, whether closed, signifying a work achieved, or open, like Plato's or Cicero's, signifying a matter for discussion or, as with many of the clerics, being referred to as a text for contemplation.

The ancient Romans appear as sober humanist scholars; the Greeks are long-haired and bearded, dressed in exotic, somewhat oriental costumes; Moses similarly, yet Solomon in his coronation robes looks almost Carolingian. Saints Gregory, Ambrose and Augustine are shown in their full canonicals, as naturally are Pius II and Sixtus IV; St Jerome and Bessarion are in their cardinals' robes. The two Italian poets are crowned with laurel wreaths, and Vittorino da Feltre wears the very simple garments that he did in real life.

It will be noted how many of the notable scholars and poets of the Middle Ages, Petrarch for example, took an interest in discovering the works of antiquity. This interest was shared by the Montefeltro family. An early humanist, Ciriaco di Pizzicolli (1392–1452), who came from Ancona and was constantly curious about ancient inscriptions, visited Urbino on his way from Rimini to his native city, which meant making a special detour from Pesaro.[1] The reason for the visit was to inspect two inscribed tombstones that had been discovered within the city walls. One of them (lost since at least the nineteenth century) commemorated a soldier, Lucius Petronius Sabinus, and the other was dedicated by the community to Gaius Clodienus Serenus. In his tour of inspection Ciriaco was accompanied by Federico's father, Count Guidantonio, and by his half-brother Oddantonio; so these tombstones would have been known also to Federico.

A painting in the British Royal Collection, attributed to Justus of Ghent and dating from 1497 or 1480, shows Federico da Montefeltro with his son Guidobaldo and others listening to a lecture in Latin.[2] The speaker, a solemn bearded man dressed in black, stands at a lectern; he is probably Antonio Bonfini da Patrignone. Federico sits upright, concentrating, his features slightly pursed. He wears a red cap; on his knee he balances a heavy volume and on the shoulder of his heavy velvet cloak can be seen the badge of the Order of the Garter. His son Guidobaldo aged seven or eight stands beside him, trying to take an intelligent interest. Behind them are the other auditors, who can be identified as Cesare Odasio, Ottaviano Ubaldini della Carda (Federico's erudite, favourite and trusted nephew) and his son Bernardino; more men hover in the doorway.

Some of them may seem a little bored, but Federico is all attention. Vespasiano da Bisticci, in the Discourse to his *Lives of the Illustrious Men of the Fifteenth Century*, wrote, 'In this age all the seven liberal arts have been fruitful in men of distinction, not only in Latin, but also in Hebrew and Greek; men most learned and equal to the best of any age.' Many, he goes on to say, are no longer known because there was no one to write about them.

Clearly the scholars needed to receive enough to live on. According to Cecil Clough, the rewards for scholars at the court of Urbino were by no means as generous as those given to artists; on the other hand, scholars who were given free accommodation in the palace and had the privilege of using the Duke's library may have felt reasonably well rewarded with little cash in addition. Then there was the extra inducement that Federico had friends in high places; patronage from him might in turn lead to patronage from the Pope.

Among those scholars who came to Urbino was Paul of Middelburg, mathematician and astrologer. The first time he arrived was on a visit, having then a lecturing post at Padua University. In 1480 he wrote an astrological work and dedicated it to the Duke. He was, according to Vespasiano, court astrologer, also responsible for giving instruction in arithmetic and geometry.

Gianmario Filelfo, son of the more celebrated Francesco Filelfo of Tolentino, was a learned Greek scholar, and Poet Laureate. He came to Urbino in about 1476, and was employed teaching Latin and Greek to the Duke's son Guidobaldo. It seems he felt he was inadequately paid, for he told the Marquis of Mantua (for whom he went on to work afterwards) 'I have a lot of expenses, with sixteen to feed.' But he was a difficult man to please, apparently.

Other scholars did not actually join the court, but sent their manuscripts to Federico in the hope that he would afford them patronage if they should need it in the future (the Cardinal Bessarion was one such, and the Florentine humanist Cristoforo Landino) or perhaps simply in order to feel appreciated, to make contact with someone who appreciated their qualities and their writings.

Vespasiano da Bisticci was full of praise of the Duke as a patron of learning; writing of Pope Nicholas V and King Alfonso, he added:

> In addition to those two princes must be named a worthy successor, the Duke of Urbino, who, having followed their example in honouring and rewarding men of letters, became their protector in every respect, so that they were all wont to fly to him in case of need. Thus, to help them in their labours, he paid them well for their work, so that he gained immortal fame by their writings. But when there was no longer a Duke of Urbino, and when neither the Court of Rome nor any of the other courts showed any favour for letters, they perished, and men withdrew to some other calling, seeing that, as I have said, letters no longer led to profit or reward.

Vespasiano da Bisticci, a Florentine bookseller, was vitally important as a go-between between Federico and the humanists and scholarship generally. Bisticci was a small village just outside Florence, and Vespasiano was in fact very much more than a bookseller. Printing was in its infancy, and many collectors (including Federico da Montefeltro) preferred to have their books handwritten, and often beautifully illuminated. Vespasiano employed a large number of scribes to satisfy this demand. It was an exciting time for those interested in learning; manuscripts by Greek authors

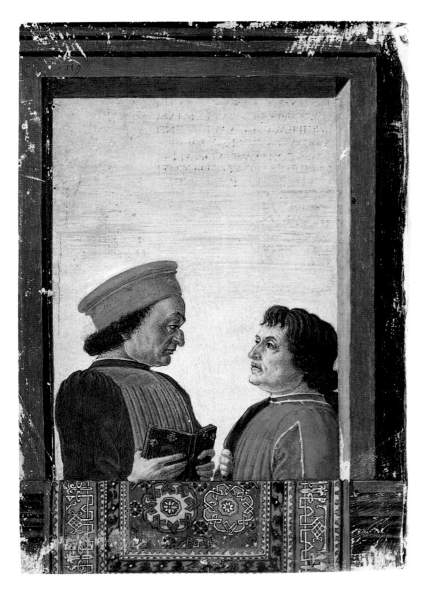

scratch to a collection of more than a thousand volumes, some five hundred or more were commissioned from this workshop. It is estimated that the total cost of the books was over 30,000 ducats, and the Greek scholar Agapito, assisted by Lorenzo Astemio of Macerata, a Latin scholar, was appointed to look after them. These two were succeeded by Federico Veterani, who had been a copyist.

Some of the books were presentation copies. For instance, there was a manuscript of Cristoforo Landino's *Disputationes Camaldulenses* of 1472, written in Florence by, probably, Gabriel de Pistorio and illuminated by Francesco d'Antonio del Chierico.[4] It is now in the Vatican Library, still in its original stamped leather binding. It is inscribed to Federico as 'Prince', and it bears a pasted-in frontispiece showing Federico, with his unmistakeable profile, holding a book and in conversation with another man, who may or may not be Landino.

The library contained a wide range of volumes. Among the humanist works there was a beautifully inscribed and illuminated copy of *The History of the Florentine People* (*Historia Florentius Populi*) by Leonardo Bruni (1370–1444), translated from Latin into Italian by Donato Acciaiuoli. The first folio of the text was rewritten later, and the opening page is decorated with portraits of leading rulers and *condottieri*, together with the arms of Federico as Duke of Urbino (the illumination is attributed to Francesco Rosselli). Another beautifully decorated volume contains the collected works of Poggio Bracciolini (1380–1459), the first part of which describes the archaeological sites of the city of Rome. A profile picture of Bracciolini appears in the initial M on the first page, and at the base of this are the arms and initials of Federico while still only Count of Urbino.[5]

Federico had in his library copies of the works of the great Italian poets. A richly decorated Dante's *Divine Comedy* was made for him in Urbino in 1478–82, the scribe being Matteo Contugi of Volterra and the illuminators Giugliemo Giraldi and others (completed by an unknown artist in the

were arriving in abundance from Constantinople, and there was a demand for these either in the original language or translated into Latin. Vespasiano's *bottega*, or workshop, became a meeting place for scholarly travellers, and he came to know them personally.[3] Vespasiano supplied texts in Greek, Latin and Hebrew to Pope Nicholas V for the Vatican Library, books to Cosimo de' Medici for the Laurentian Library in Florence, to Alessandro Sforza and the Cardinal of Portugal. And as for Federico's library, which was built up almost from

ABOVE: Federico with (probably) Cristoforo Landino, from the frontispiece to *Disputationes Camaldulenses*, a manuscript in Federico's library. RIGHT: A page from the collected works of Poggio Bracciolini, an illuminated manuscript made for Federico when he was Count, not yet Duke.

POGGII·FLORENTINI·AD·NICOLAVM·QVINTVM
SVMMVM·PONTIFICEM·DE·VARIETATE·FORTVNE
LIBER·PRIMVS·INCIPIT·FOELICITER

VLTA QVONDAM PACE
ac bello preclara ate Ninum assiriorum
regem fuisse arbitror. que scriptorum
inopia nulla ad nos eorum traducta cog
tione uetustas assupsit. Feliciora postmodu
excutere secula. quoru res lumen litera
rum nacte splendorem suum ad posteros
trassuderunt. Magnam igitur utilitate
afferre mortalibus historia censeri debet.
& plurimi extimaadam. beneficio cuius tum dicta. tum facta superio
rum haud quaquam obliuione hominum sepulta ad hec usq. tenpo
ra magna ex parte propagata sunt. Hec diligens custos. & fida. prete
ritorum memoria dicenda est. hec sola illustrium uirorum facta
uirtutesq. nostro in conspectu ad imitandum proponit. hec detestatur
uitia. & docet uitanda. huius ope preterita representantur nobis. &
que uetustas solet delere. reddit tanquam recentia. Nullus quippe
priscas. & abetate nostra remotas excellentum uirorum gestas res nosset
nisi literarum monumentis. & historie munere in luce hominum
uersarentur. Accessit enim ad earum memoriam scribentium labor
& industria. que illa ab interitu uendicarent. Siqua uero commenda
tione historia digna est. hec nostra est profecto. in qua fortune insta
bilis fauor describitur. & meuertendis que extulit pernicacia. Appe
tunt sane omnes ferme. que uidentur ampla. ac speciosa fortue dona
inq. eis potiundis tantum studii opereq. inpertiunt. ut uirtute atq. omi
bonarum artium cura posthabita. ueluti ceci sequantur ea. que lubri
ca. ac fallacia esse multorum exempla docuerunt. Quo igitur ina
nis multorum ambitio. atq. insana dominandi cupido paulum copnat

F C

seventeenth century). The scribe had worked first for the Gonzaga in Mantua, then for Federico; he moved to Ferrara after the Duke died. It is recorded that 130 ducats were put aside for the illumination of the manuscript, which includes not just conventional ornamentation but dramatic scenes from the narrative, set against rocky backgrounds.

Written on parchment by the same scribe was Federico's copy of the *Trionfi* and *Canzoniere* of Petrarch. This was richly illuminated by Bartolomeo della Gatta, and the initials FD appear within the Garter (an honour conferred on Federico by Edward IV in 1474). The triumphs, for instance that of Chastity, drawn by unicorns, are reminiscent of those on the back of the double portrait of Federico and Battista Sforza painted by Piero della Francesca (see pages 116–17).

Federico's great Bible, written in Florence in two volumes in 1476–8 and illuminated by a number of skilled artists, is a work of exquisite detail and consummate beauty. Such books were not just texts for reference, they were works of art in their own right. The richness of the decoration symbolized the value placed by Federico on the words contained.

The library stands empty today, but in Federico's time was carpeted and furnished with benches and tables. The books were bound in velvet or leather, and were grouped according to subject; on the left were geography, poetry and history, on the right religious works, law, philosophy and mathematics. Above the books, in their appropriate order, were paintings of the Seven Liberal Arts, attributed to Melozzo da Forlì.[6]

More volumes were added from the collection of Ottaviano Ubaldini after his death in 1498. Printed books were added in the time of Federico's son Guidobaldo. Then the library suffered considerable depredations at the hands of Cesare Borgia. Guidobaldo restored it as well as he could, and by the time of Francesco Maria della Rovere, the last Duke, it had been enlarged to about 1,800 manuscripts,

and thousands more printed books. Forced to flee to Urbania, the latter took the contents of the library with him. Then in the seventeenth century they were transferred by Pope Alexander VII to the Vatican. The result is that, although the books are no longer in their original setting, the collection is more intact than might otherwise have been the case.

If Federico da Montefeltro were to be remembered only on account of his Library, that alone would have been an outstanding achievement. While personal prestige might have been part of the reason why he collected books, he nevertheless loved them. The library he built up, it was agreed, excelled even that of Humphrey Duke of Gloucester, who earlier in the century had gathered together the nucleus of what was to be the Bodleian Library in Oxford.

'At great cost,' Baldassare Castiglione summed up in *The Book of the Courtier*, 'he collected a large number of the finest and rarest books, in Greek, Latin and Hebrew, all of which he adorned with gold and silver, believing that they were the crowning glory of his great palace.'

He had built up what was probably the finest library in Europe.

Federico's library today, empty but still evocative.

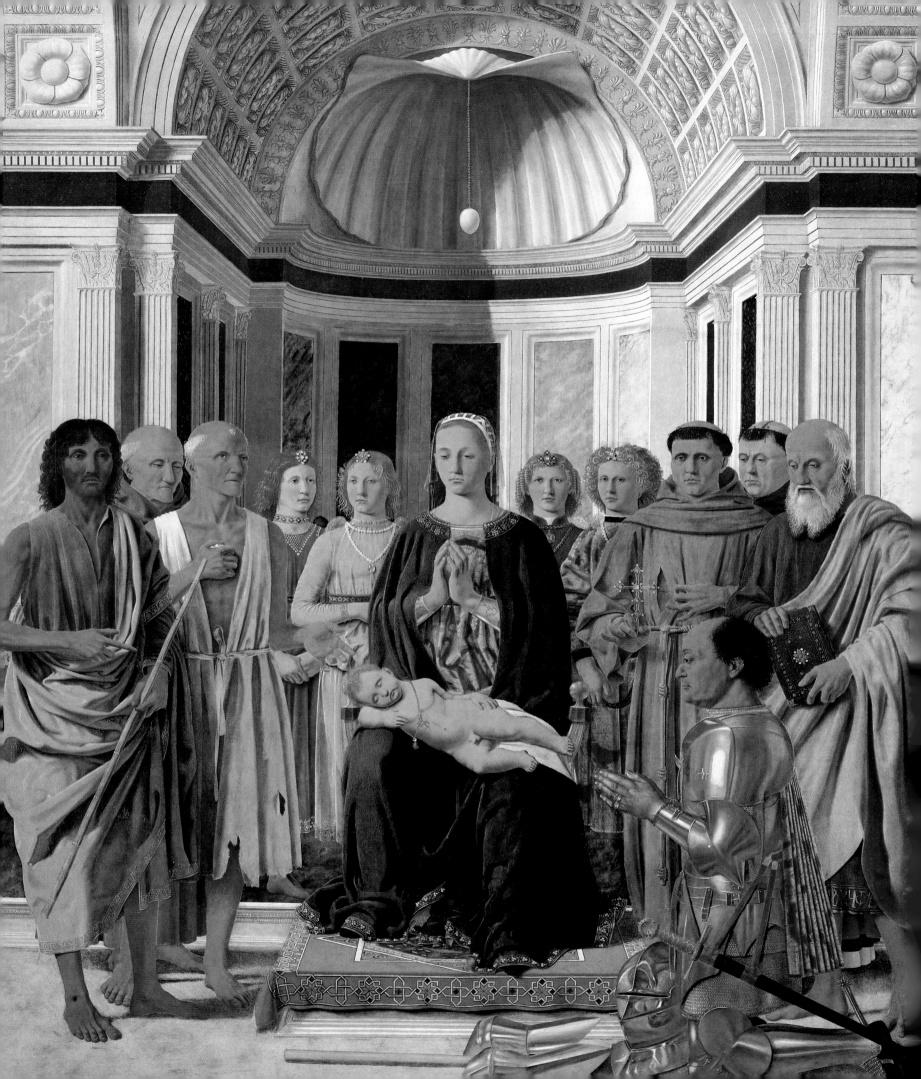

PAINTING IN FIFTEENTH-CENTURY URBINO

In the fifteenth century painting was never numbered among the liberal arts; nor was the profession of the artist very highly regarded.

The Craftsman's Handbook by Cennino Cennini[1] defines the practices and the disciplines of a busy *bottega*, where commissions of all sorts were undertaken and where no distinction was made between the 'fine' and 'applied' arts. Apprentices were expected to make themselves familiar with all processes: grinding colours, laying down and moulding in gesso, gilding and varnishing, as well as drawing, and painting in fresco and tempera. To those entering the profession Cennini advised humility:

> Submit yourself to the direction of a master of instruction as early as you can; and do not leave the master until you have to. ...Then you will find if nature has granted you any imagination at all, that you will eventually acquire a style individual to yourself, and it cannot help being good; because your hand and mind, being always accustomed to gather flowers, would ill know how to pluck thorns.

Although these words were written the other side of the Apennines, they nevertheless define the tradition regarding painting which would have existed in Urbino, as in every other Italian city where there was patronage for the arts. 'Art' was indistinguishable from 'craft', and the generic term 'artist' was never used: men might work in more than one medium, but they were known as painters, sculptors, metalworkers, goldsmiths and so forth, not as artists.

It was quite common for painters to travel widely in search of lucrative commissions, and thereby enhance their

'PIERO DELLA FRANCESCA'S CREATIONS BROUGHT HIM SO MUCH CREDIT THAT HE WAS EMPLOYED BY THE DUKE OF URBINO'

Giorgio Vasari, *Lives of the Artists*

LEFT: The altarpiece by Piero della Francesca now in the Brera, Milan (discussed on pages 117–19).
RIGHT: The church of S. Bernardino, Urbino, built to house Piero's altarpiece.

renown. Andrea Mantegna (1430/1–1500) however, once appointed court painter by Ludovico Gonzaga in 1460, remained firmly ensconced in Mantua for almost the rest of his life. But such was his fame that Duke Federico was said to have made a visit to that city in 1482 with the express purpose of seeing Mantegna's work. This is related in the *Rhyming Chronicle* of Giovanni Santi, who was poet, painter and, one suspects, Jack-of-all-trades in the court at Urbino.[2]

'Great the delight it gave him to admire Mantegna's wondrous paintings, splendid proofs of his high genius.' Santi goes on to define just what attributes were to be found in Mantegna's work which made him worthy of such praise: his power of design, his craftsmanship, colour, understanding of perspective and grasp of the third dimension. Then he lists other eminent painters of the fifteenth century; first the Flemish, among them Jan van Eyck and Rogier van der Weyden; among the Italians are Masaccio, Uccello, Gentile da Fabriano, the Pollaiuolo brothers, Domenico Veneziano, Piero della Francesca, Filippo and Filippino Lippi, Ghirlandaio, Botticelli, Melozzo da Forli, Antonello da Messina, and

> Also two youths, equals in age and love,
>
> Da Vinci and Pietro from Pieve,
>
> Perugia's sacred limner.

In other words, Leonardo and Perugino. If this was the accepted hierarchy, why, one may ask, did Federico so frequently employ the relatively unknown Justus of Ghent? Vespasiano da Bisticci said that it was because he painted in oils, which indeed he did; yet painting in oils was by then a skill known to many Italian painters, so we must look for additional reasons. Many of the finest artists of the day, including Mantegna and almost certainly Piero della Francesca, worked extremely slowly, and perhaps Federico needed more of a 'jobbing' painter, who would work fairly swiftly and to order, would not cost too much, and would be prepared to complete schemes of appropriate portraiture to decorate the rooms of his palaces.

Justus of Ghent (Joos van Wassenhove, called Giusto da Guanto in Urbino) was a Flemish painter whom we first hear of in 1460, when he was made a member of the Antwerp Guild of Artists. Moving to Ghent some four years later, he became a friend of Hugo van der Goes, which is interesting because of that artist's *Portinari Altarpiece*. This large triptych of the Nativity was commissioned for the Hospital of Sta Maria Nuova in Florence by Tommaso Portinari, who was a merchant working in Bruges for the Medicis. Dating from 1475–6 and now in the Uffizi, it proved to be a major influence of northern art upon Italian, not only because it was painted in oils, but because of its realism and psychological insight. Similar qualities were to be found to some extent in Justus's work. Having visited Rome in the late 1460s, Justus was in Urbino by 1472 and working for Federico da Montefeltro; his great work *The Communion of the Apostles*

ABOVE: A modern bust of Justus of Ghent in the Piazzale Raffaello.
RIGHT: *The Communion of the Apostles*, Justus of Ghent (Ducal Palace, Urbino).

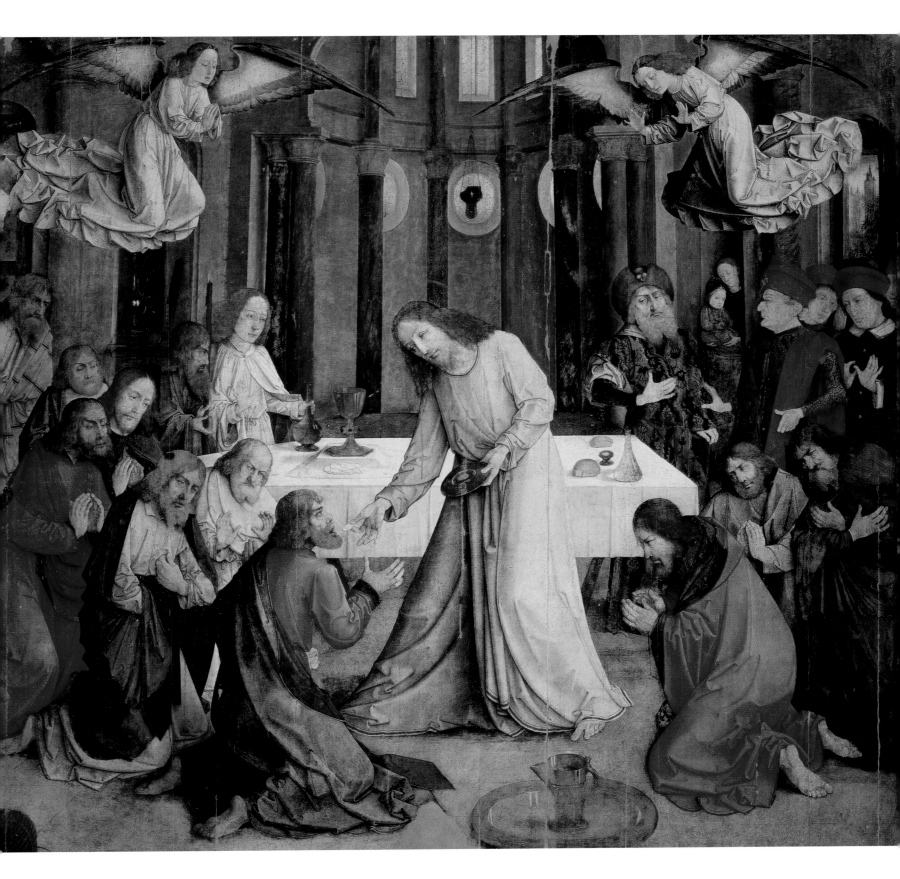

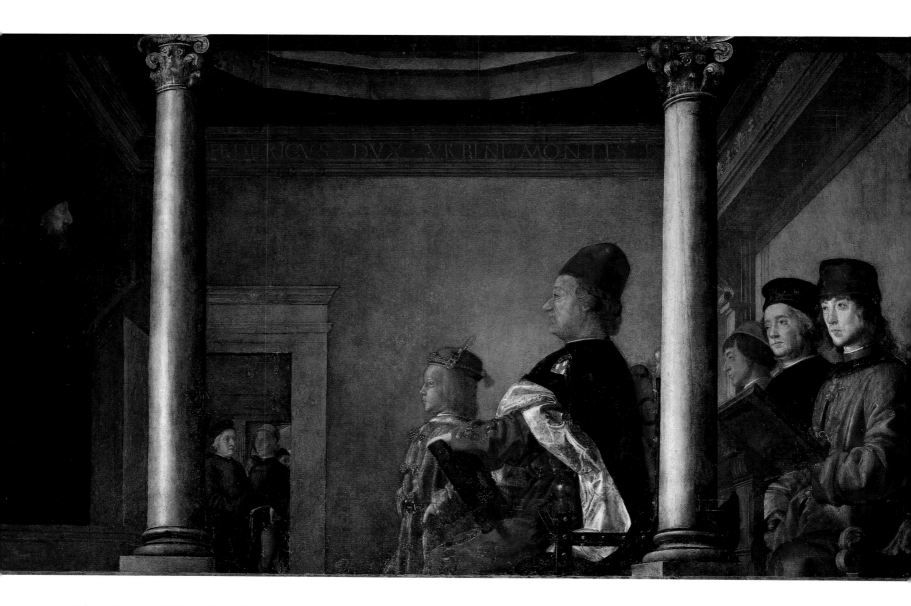

dates from 1473–4. In this remarkable composition the swaying lines of the stooping Christ, the drapery that envelops the apostles and the frenzied convolutions of the angels' robes contrast with the rigidity of the architectural background and the firm horizontal of the communion table. Towards the right is to be seen the anxious profile of Federico (the painting dates from shortly after the death of his wife Battista Sforza), and behind in the doorway a nurse hovers, clutching the infant Guidobaldo. The tension among the mortals on the right hand side of the painting is expressed in the agitated pattern of their hands. The colours are extraordinary: an arrangement of soft mauves, tawny browns and white, contrasting with luminous carmine; they seem to prefigure the Mannerist palette of such artists as Pontormo.

Also attributed to Justus of Ghent are the portraits of famous men painted for the Studiolo (see previous chapter). There is, however, a possibility that some of

Federico and his Son Listening to a Lecture, Justus of Ghent (Royal Collection, Hampton Court).

them may be by a Castilian artist named Pedro Berruguete, of whose Italian career we know little, except that he is probably the 'Pietro Spagnuolo' who was employed in the Ducal Palace in 1477. Eight years later he was back in Toledo. He was made court painter to Ferdinand and Isabella and died in 1504.

The identity of artists being in general held of little account, it is equally difficult to be absolutely sure of the attribution of other paintings held to be by Justus of Ghent,

such as the double portrait of Federico and his son, which is still in the Ducal Palace (see page 17), and the painting, now at Hampton Court, of the two of them, in the company of courtiers, listening to a lecture (opposite). Part of the problem is that Justus of Ghent was never accorded that immortal renown granted to the greatest of Italian artists. The fate of the Hampton Court painting, which was probably done for the palace at Gubbio, is symptomatic. The panel seems to have been lost without trace until

ABOVE LEFT: Modern bust of Bramante in the Piazzale Raffaello.
ABOVE RIGHT: *Christ at the Column*, Bramante (Brera, Milan).

about 1845 when it was discovered, covered in soot and grease, by Vitale de' Tivoli and his brother, in a villa near Florence. Since the painting was on a solid piece of poplar wood, the owners of the villa were thinking of turning it into a breakfast table and had contacted a joiner who started preparing the back of the panel with this in mind.[3] But the brothers consulted the art expert Cavalascelle, who thought that it could well be a valuable painting; and for the price of a replacement table top, the panel changed hands. It was then subjected to a rather ruthless cleaning, the curling paint-layer being laid down with a hot iron, and the whole picture being rubbed for days with breadcrumbs.

Nothing is heard of Justus of Ghent after about 1480; he seems to have slipped into that oblivion which was the fate of most painters. It was perhaps to avoid a similar fortune that Donato Bramante (Donato di Angelo, c.1444–1514), turned from his original career as a painter, and became renowned as one of the most celebrated Renaissance architects. He was born at Fermignano, just outside Urbino, but we know tantalizingly little about his work as a painter. He was no doubt trained in Urbino and subsequently employed in the decoration of the Ducal Palace, but there is no work that can with confidence be ascribed to his early years. It has been suggested that he had a hand in the design of the little church of S. Bernardino, a mile or so outside the city, but there is no more than stylistic evidence for this. By 1477 he was in Bergamo, painting frescoes, then in Milan, still working as a painter. His few surviving paintings are enough to show that it was not because of lack of talent that he turned from

his initial career. The works by him at the Pinacoteca di Brera in Milan, particularly his *Christ at the Column* and his *Man at Arms* (a fresco fragment of a man who appears to resemble Federico's half-brother Oddantonio) show high seriousness and serenity reminiscent of Piero della Francesca, and an interest in the antique shared by Mantegna.[4] In 1499 Bramante left Milan for Rome, where he received papal patronage and set about the rebuilding of St Peter's. But the work which best epitomizes his achievement as an architect is the small but utterly perfect S. Pietro in Montorio in Rome (known as the Tempietto), built on the supposed site of the martyrdom of St Peter. Raphael, who went to Rome at his suggestion, paid him the tribute of including him as Euclid in his fresco *The School of Athens* in the Vatican.

The intention was for Paolo Uccello to paint the whole of the altarpiece of *The Communion of Saints*, but he completed only the predella. Paolo, who was born in Florence in 1397 and died in the same city in 1475, came to Urbino at the end of his working career. His name was actually Paolo di Dono; but he adopted the nickname Uccello, meaning a bird. (Vasari in his *Lives of the Artists* relates that he was a man of gentle nature and was very fond of animals, birds in particular.) As a youth he worked in the *bottega* of Ghiberti (the creator of Florence's 'Golden Gates of Paradise'), and there he would have been trained in a number of skills. At different stages in his career he worked not only as a painter but also as a mosaic artist (in 1425 he went to Venice to work on mosaics for St Mark's), and as a designer for marquetry, decorative work and

stained glass. In 1436 he completed the equestrian portrait of the English *condottiere* Sir John Hawkwood (see page 43). Located in the Duomo, Florence, this is done in *trompe l'oeil* as if it were carried out in stone, and involved intricate problems of perspective. The science of perspective was indeed one of Uccello's main preoccupations. Vasari relates how, despite his wife calling him to bed, he would stay up all night studying it, exclaiming, 'What a wonderful thing perspective is!' In Vasari's opinion he would have done better concentrating on the drawing of the human figure. Three great panels depicting the Rout of San Romano (Niccolò da Tolentino's victory over the Sienese in 1432) were painted for the great hall of the Medici Palace in the Via Larga in Florence; these survive in the collections of the National Gallery, the Louvre and the Uffizi, and again demonstrate Uccello's involvement with perspective and ambitious foreshortenings. They have a decorative, toy-like quality as if the battle were a jolly encounter fought out between rocking horses. Uccello was, it seems, a prolific artist, yet curiously little of his work has survived. In Padua he painted a series of Giants, in Florence a Battle of the Dragons and Lions (for the Medici Palace), and the Four Elements symbolized by animals for the Palazzo Peruzzi; all these are lost.

Towards the end of his working life, in 1465, we find him in Urbino. He was commissioned by the confraternity of

Corpus Domini to paint an altarpiece on the subject of the Holy Sacrament: *The Communion of Saints* (which, as we have seen, was completed by Justus of Ghent), and below it, the predella of *The Profanation of the Host*, illustrating the bitter perils of sacrilege. This was the only part he completed, it is not perhaps the most endearing of his works, being expressly anti-Semitic. This is in a way surprising in the setting of Urbino, where Jews were accepted more readily than in many places and were vital to the city's commerce.[5] Uccello cannot however be held accountable for the subject of the predella, which would almost certainly have been determined by the confraternity.

ABOVE: The Jewish family cowers in dismay as soldiers batter on the door (second scene from *The Profanation of the Host*, Paolo Uccello).
BELOW: The complete sequence of scenes.

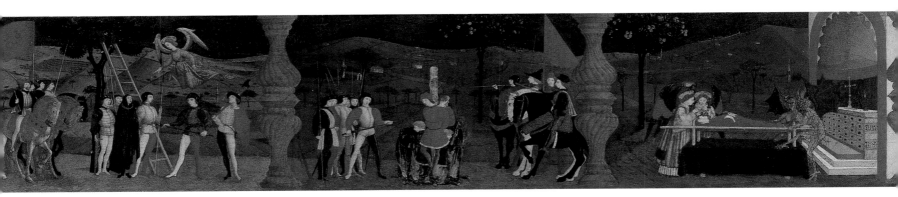

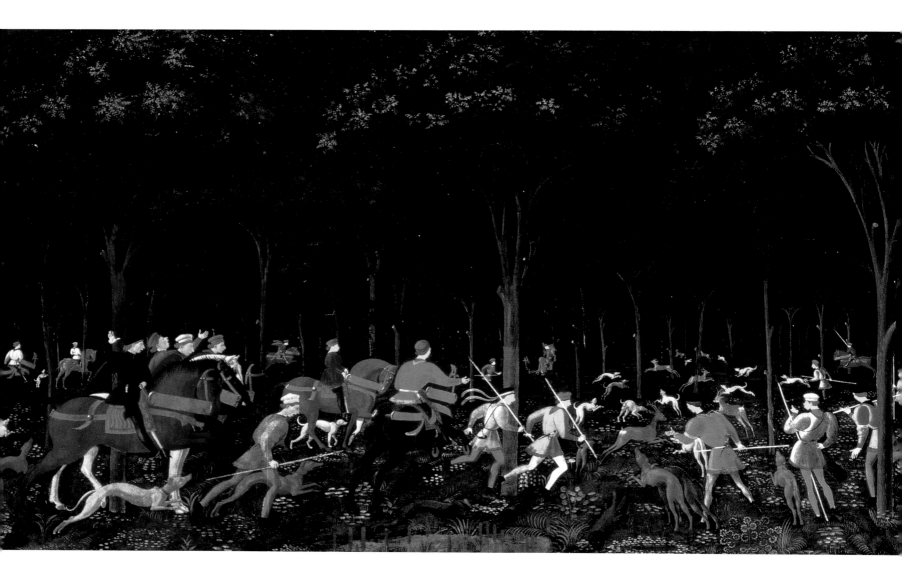

The narrative is told in six narrow panels, the figures mainly in crisp profile, and the predominating colours are ochre, black and vermilion. In the first, a woman sells the consecrated wafer to a Jewish merchant. In the second panel, the Jew has attempted to cook the wafer; blood pours out of it and runs into the street, his family stand dismayed while soldiers batter at the door. The floor is aslant, in crazy perspective, as if there were an earthquake; the outside wall of the house seems unnaturally thin and flimsy; it will not withstand the battering for long. The third panel shows an expiatory procession, all the figures in profile, some in richly figured brocade, slowly moving towards an altar; in the background is a rolling landscape beneath a crescent moon. In the fourth episode, the woman, dressed in black, has been seized by the soldiers (most of whom wear parti-coloured hose) and is about to be hanged from a tree; a group of horsemen with a red flag stand on the left; above, an angel flutters, silhouetted against the night sky. In the fifth panel, we see that an even worse fate has been planned for the Jews. The whole

The Hunt in the Forest (1468), Paolo Uccello, now in the Ashmolean Museum, Oxford, but very possibly painted for the Ducal Palace in Urbino.

family has been condemned to be burnt at the stake. In the final scene, the woman's body lies on a bier before the altar while two devils dispute with two angels over her soul; in the background the hills are barren under the night sky, but the tree is laden with fruit.

It is not a very likeable story; there is scant justice in it and no mercy at all, an extreme expression of transubstantiation. With its night settings, it has a weird fantasy quality, and seemingly trivial misdemeanours have the direst consequences.

From the same period derives the altogether delightful *Hunt in the Forest* (now in the Ashmolean Museum, Oxford). It is a matter of debate whether it was painted for the Medici court in Florence, or for Duke Federico while Uccello was in Urbino. Certainly it would have been created for the court of some civilized lord. There is an entry in the inventory of 1599 that the first room of the Duchess's apartments had contained '101. Item un quadro antico d'una caccia' (an old picture of a hunt). It is mentioned again in an inventory of 1651, and approximate dimensions are given. It has been suggested that, rather than being a panel from a *cassone* (marriage chest), the picture is a *spalliera*, a piece to be hung at shoulder level.[6] All fifteenth-century secular painting is rare, and *spalliere* are especially rare; they would have been found only in palaces.

The painting, which was done on a panel of poplar, is a late work of Uccello's, and resembles in style *The Profanation of the Host*. It would be delightful if evidence could one day demonstrate that this entrancing work, with its mysterious wood, rushing horsemen, capering hounds and dancing deer, did indeed come from Urbino.[7]

There is a portrait in the Metropolitan Museum, New York, of the pert yet calm profile of a young girl in a brocaded dress, her forehead plucked and her fair hair strained back into a pearl-strewn coif. She is represented against a black ground. Though it has sometimes been attributed to other painters such as Veneziano, it is thought that the painting is more likely by Uccello and if so it would belong to this same late period. There is a further suggestion that the girl represented may be Federico's eldest daughter Elisabetta.[8] Elisabetta was born in 1461 and was betrothed when she was ten to Roberto Malatesta, Lord of Rimini. A somewhat later portrait, in the Thyssen Collection, Lugano, is thought to represent her little brother Guidobaldo, at the age of six or seven. Again, it is in profile, and has the same precise delineation of the features. It is, however, not by Uccello; it is from the hand of Piero della Francesca.

Piero della Francesca (1415–92) was born in the remote Tuscan town of Borgo San Sepolcro, which has a similar position to Urbino, perched on the foothills of the Apennines, but on the western side. As he spent much of

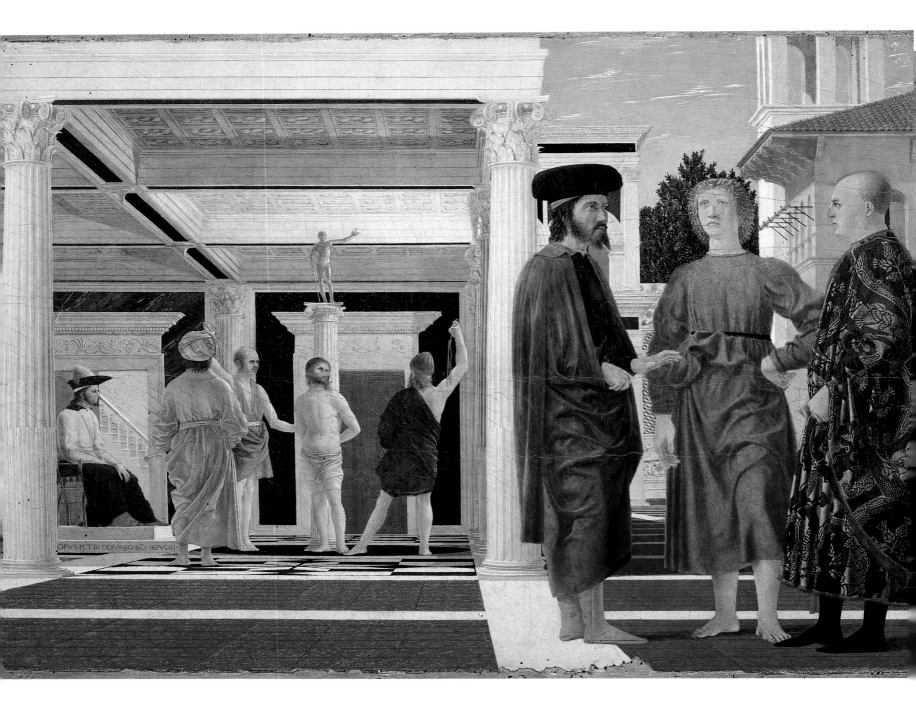

his life in his native town, Piero's work was almost forgotten for hundreds of years and it was not until the beginning of the twentieth century that he was 'rediscovered' as one of the finest artists of his time. His work is distinguished by its simplified forms, symbolic use of colour, serene light, and an unparalleled feeling of timelessness.

We know little about his origins. There is a reputed self-

The Flagellation of Christ, Piero della Francesca (Ducal Palace, Urbino). This small and enigmatic panel is one of the very finest treasures in the Ducal Palace.

portrait in the scene of the meeting of King Solomon with the Queen of Sheba in the Arezzo frescoes; he has a black hat and an apprehensive expression. He was it seems the son of a cobbler, Benedetto dei Franceschi, and he is first heard of working in Florence alongside the older painter Domenico Teneziano executing frescoes, now lost, for the church of S. Egidio. Leaving Florence in about 1445, he was commissioned by the Compagnia della Misericordia of his native town to paint a polyptych. On this he spent over ten years.

The Baptism of Christ, in London's National Gallery, dates from the same early period; it was painted for the priory of S. Giovanni Battista at San Sepolcro. On the other hand, *The Nativity* in the same gallery is a late work, which remained for a long time in the painter's family.

Piero's greatest undertaking was the sequence of frescoes on *The Legend of the True Cross*, painted for the Church of S. Francesco in nearby Arezzo, between 1452 and 1459.

Piero travelled widely in search of further patronage. Sometime before 1450 he had gone to Ferrara to work for Lionello d'Este; in 1451 he was in Rimini painting a memorable profile portrait of Federico's rival Sigismondo Malatesta (with his dogs), kneeling in front of his patron saint, Sigismondo of Burgundy. We know that Piero was in Rome in 1459-60, and sometime between 1460 and 1470 he painted the moving composition of the *Madonna del Parto* in the hill-village of Monterchi,[9] and the impressive *Resurrection* at Borgo San Sepolcro.

Interspersed were several visits to Urbino, where Federico da Montefeltro became his most valued patron. One of the first works Piero did for him is also perhaps the most enigmatic: the small panel of *The Flagellation of Christ*, which hangs in the Ducal Palace.[10]

This little painting has been the subject of much research and speculation: when was it painted, and what was its significance? The figure of Christ is tied to a free-standing pillar, between two assailants; the flogging ordered by a man in a turban, and watched by Pontius Pilate; the scene takes place in a squared-off open arcade with a black and white marble floor, flanked by large Corinthian pillars. The right-hand one of these, just beyond the centre of the picture and reminiscent of the actual pillars in the Cortile d'Onore of the Ducal Palace, serves as a frame to the group of three figures on the right. They all appear twice the height of those in the flagellation group, and they appear detached in place and time: a fair-haired youth standing between a bearded man in travelling costume and an old man in rich brocade. There has been much debate over their identity and hence their significance.

It is generally accepted that the fair-haired youth represents the assassinated Oddantonio, as he has similar features to the only known portrait of the young man.[11] Carlo Bertelli, in his work on Piero della Francesca, suggests that the painting was done in Cesena for Violante da Montefeltro, in memory of her brother, and came to Urbino as a gift. But there is no documentary evidence for this, and as Violante always resented Federico's rise to power, there was no reason for her to be so generous.

Another theory, put forward by Fabrizio Lollini, is that the *Flagellation* is an anti-Jewish painting, like Uccello's *Profanation of the Host*.[12] But it seems far more likely that Federico commissioned it in expiation, or self-defence against any possible implication in his half-brother's death. It is suggested that Oddantonio (who resembles more than one of Piero's angels in his other paintings) is shown as an antitype of Christ. The richly dressed older man, who bears a resemblance to Solomon in the *Meeting with the Queen of Sheba* in Piero's Arezzo frescoes, can be equated (as tradition has it) with Federico's father, Count Guidantonio. And the bearded man in travelling clothes may represent John VIII Paleologus, who came over to Italy to attempt to bring about a union between the Greek and Roman churches, as proposed at the Councils of Ferrara and Florence, and to wage a crusade against the Turks. Maria del Poggetto points out that it is a Turk who, with his back to us, orders the flagellation of Christ. The proposed unification of the Christian church never took place, and Constantinople fell in 1453; possibly the whole painting

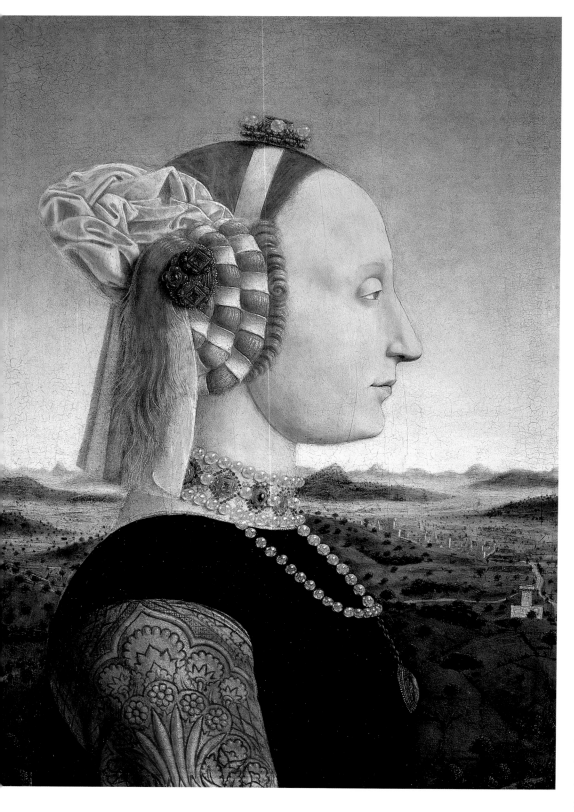

Battista Sforza (c. 1472), Piero della Francesca (Uffizi, Florence).

refs to this event, and was executed in the following year, 1454, ten years after the death of Oddantonio.

The bearded man has his hand raised to forestall any act of homage. Maria del Poggetto thinks that it is Oddantonio who is offering to make an obeisance; to my mind it is Guidantonio who is about to gather up his robes for this purpose, while his son remains aloof and otherworldly. The little red flowers in the background – Oddantonio is perhaps holding one of them – may be symbolic of the blood of the Crucifixion, and his carmine robe symbolic of the Passion. It is in any case a work of great mystery and intensity.

John Mortimer in his delightful novel *Summer's Lease*, which has its climax in Urbino, desribes it as 'undoubtedly the greatest small picture in the world'.

Our mental image of Federico and his second wife Battista Sforza is almost certainly based on Piero's remarkable double portrait in the Uffizi. They are shown in profile, facing each other against a hilly landscape with its outlines continuing from one picture to the next. On the reverse are their triumphs, Battista's triumphal car being drawn by unicorns and Federico's by white horses. Again, an extensive landscape pimpled with little hills continues from one to the other, and below there are Latin inscriptions.

Federico's triumph may be translated as: 'This illustrious man is borne in splendid triumph, he whose bravery, equal to that of the world's greatest generals, is commemorated by everlasting fame, as he nobly holds the sceptre.' And under Battista's triumph are the words: 'She who

showed moderation in times of prosperity now enjoys the praise of all men, in the reflected glory of her mighty husband's great achievements.'

It was appropriate that Federico should be celebrating a triumph, having just fought a famous victory on behalf of the Florentines. He came back to find that Battista, having recently given birth to their long-hoped-for son, was on her deathbed; so there are grounds for saying that she merited a triumph also.

On the top of the simple cart, Federico is shown seated in full armour, and he is being crowned by an angel or winged victory. In front of him ride the four cardinal virtues – Justice, Prudence, Fortitude and Temperance (these were listed by Plato in his *Republic* as the qualities required for the good running of a city state) – while a winged cupid, symbolizing love, drives the horses. The unicorns, symbolic of chastity, pulling Battista's chariot are also driven by a cupid. She herself is clothed in red and gold, and is accompanied by four females: the virtues of Faith, Hope and Charity, together with the shrouded figure of a nun or *duenna* – could this possibly symbolize death?

Although the Uffizi catalogue dates the work to 1465–70, there is a strong argument for believing it to have been painted just after Battista's death in 1472.[13] It is partly based on the appearance of the Duchess; she married when she was about fourteen, and was only twenty-seven when she died. The painting is likely to have been commissioned either as a wedding or as a commemoration piece and in the portrait

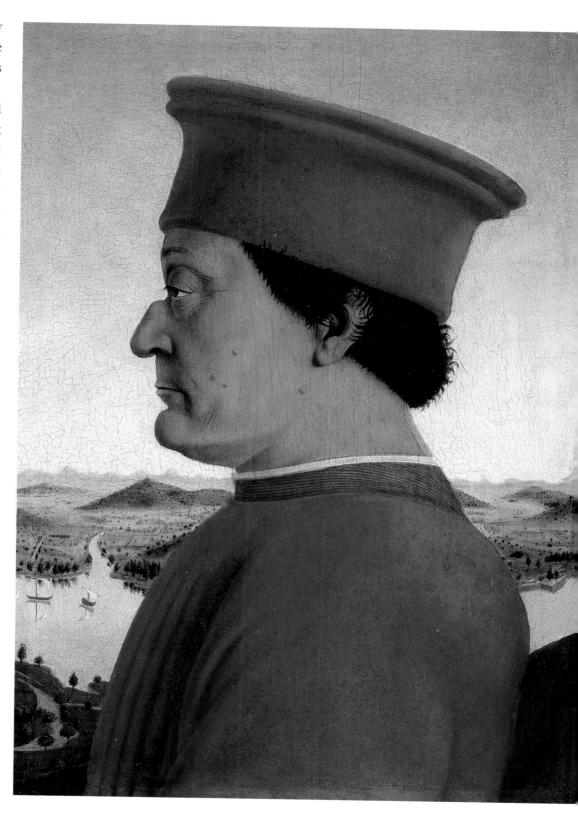

Federico da Montefeltro (c. 1472), Piero della Francesca (Uffizi, Florence).

115

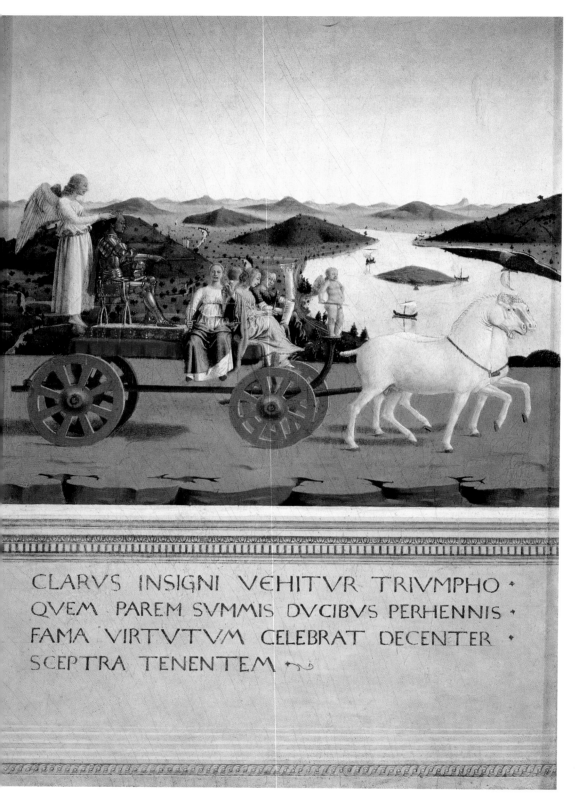

CLARVS INSIGNI VEHITVR TRIVMPHO ·
QVEM PAREM SVMMIS DVCIBVS PERHENNIS ·
FAMA VIRTVTVM CELEBRAT DECENTER ·
SCEPTRA TENENTEM ᴂ

Triumph of Federico da Montefeltro (reverse of his portrait), Piero della Francesca (Uffizi, Florence).

she looks far more like a twenty-seven-year-old than a young teenager; moreover the face has the waxen pallor and precision of a death mask – from which indeed it may have been taken. The characteristic profile of Federico, on the other hand, has a ruddiness and vigour which are very much of this world (every wart is noted, every hollow and shadow on the skin); the head contrasts with the pearly sky beyond, rather than merging into it as Battista's does. Further evidence of a later date is to be found in the inscriptions; it will be noted that while Federico's is in the present tense, Battista's is in the past, like an obituary notice.

The idea of a double portrait of husband and wife was a new one in the fifteenth century. As Cecil Clough has pointed out, there seems to be a precedent in the bronze medallion designed by Matteo de' Pasti in 1446, celebrating Sigismondo Malatesta and Isotta degli Atti. On the other hand, a double portrait painted in oils, as this is, with the sitters' triumphs on the back of the panels, is something rare enough to be termed unique. Probably it has always been in a double frame, and it is likely to have occupied a prominent position in the Ducal Palace, such as the Throne Room. 'One of the most telling representations of Renaissance man,' wrote M. Salmi in his book *La Pittura di Piero della Francesca* (1979).

Piero's *Madonna of Senigallia* (also known as *Madonna and Child with Two Angels*) is an evocation of stillness and serenity. It came from the little coastal town of Senigallia, which became part of the Montefeltro province, though it may have

been painted in Urbino, where it hangs today in the Ducal Palace. It is a domestic scene, set in the cool grey interior of a house; on the shelves of an alcove stands a basket of linen, light streams through the shutters into a further room. The Virgin stands with downcast eyes, quietly caressing the toes of the Christ Child. She is humbly attired in a rose-coloured dress, her hair covered in a white coif; only her mantle, of an intense, almost peacock, blue, contrasts with this quiet symphony of pinks and greys.

The child, who has an oddly adult face, lifts a hand in blessing; he wears a coral necklace (coral was said to ward off evil) and carries a white rose, symbol of purity. On either side of the Virgin stand two fair-haired angels, one in palest blue with his arms crossed, staring fixedly ahead, the other, almost feminine in pink, watches the Christ Child. Painted in tempera, the scene is homely, devoid of any ostentation; there are no haloes. All is tranquil contemplation.

The great altarpiece that is now in the Brera, Milan (see pages 102, 103) but was executed for the church of S. Bernardino just outside Urbino, is Piero's last known painting. Towards the end of his life, Piero stopped painting and turned to his other great enthusiasm, geometry. The *Brera Altarpiece* is a far more formal work than the *Madonna of Senigallia*. It is an early example of the genre which became known as *sacra conversazione*, although the saints are silent and no conversation is taking place. The painting is, in Hendy's words, 'the most profound expression of silence ever painted in Europe'.[14]

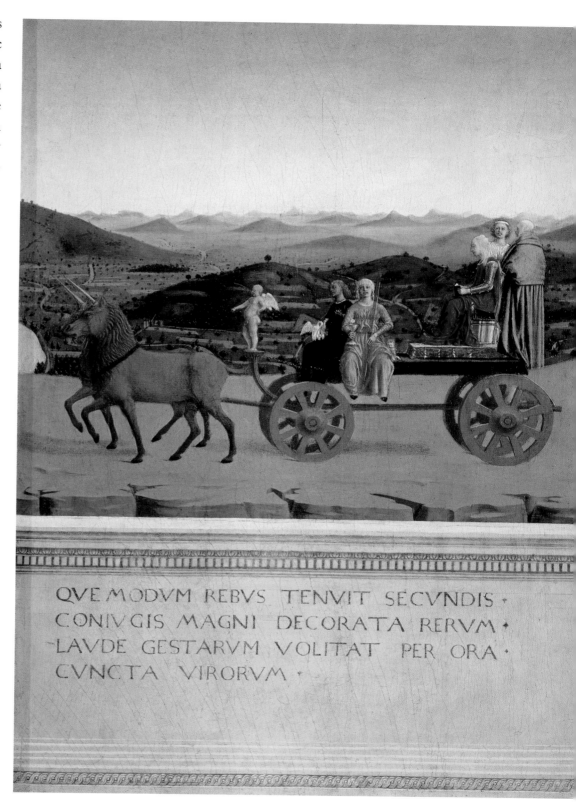

Triumph of Battista Sforza (reverse of her portrait), Piero della Francesca (Uffizi, Florence).

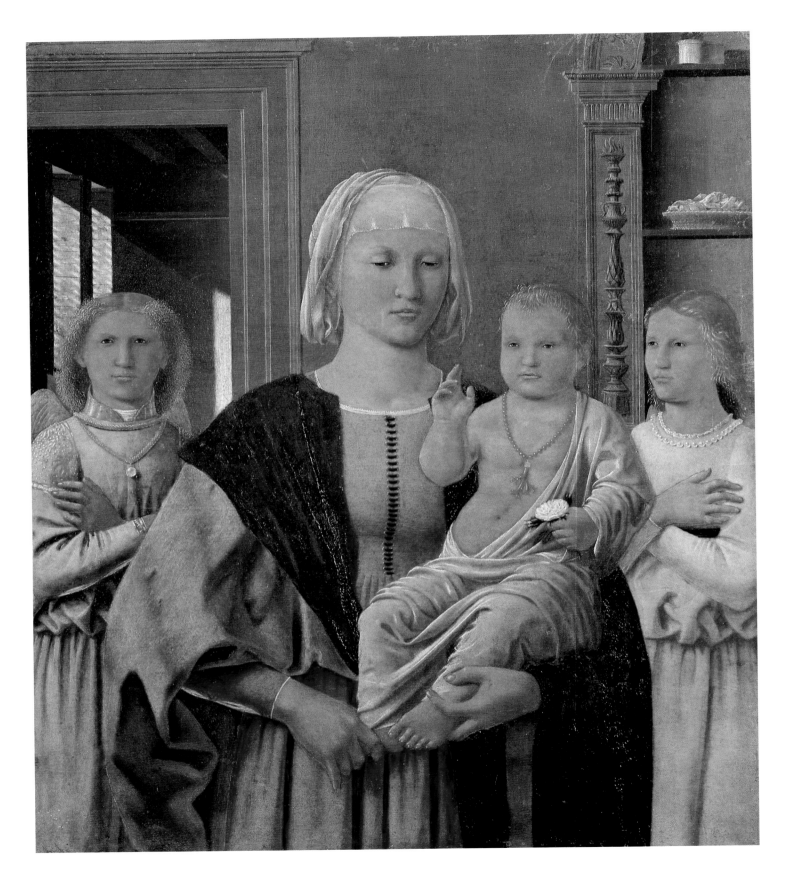

On a small dais in front of an arched recess sits the impassive Madonna, her hands together in prayer, while on her knee lies, or rather sprawls, the Christ Child, an inert defenceless form protected only by the coral round his neck. Around the Virgin are grouped six saints: to the left, St John the Baptist and St Jerome, with St Bernardino's head visible between them, and to the right St Francis and a bearded saint, possibly St John the Evangelist, holding a book, and between them we can see the head of St Peter the Martyr. At the back of the group stand four silent angels. Meanwhile in the foreground is Federico, not looking at the Madonna, but kneeling in prayer. He is, as ever, in profile, and he wears full armour except for his helmet and gauntlets, which lie on the ground before him.

Behind the figures, the tympanum of the apse is in the form of an inverted scallop shell, and from this, directly over the Virgin's head, is suspended an ostrich egg.

The painting is somewhat smaller than it was originally, having been cut on all four sides. There is a theory that it was originally much higher and that the ostrich egg (rather than the Virgin's head) was in the centre of the picture; this seems unlikely, as it would unbalance the picture, both visually and iconographically. Federico's hands are painted very realistically in a different style, almost certainly by another artist.

Both the date and the significance of the painting have been much debated. According to medieval bestiaries, the ostrich digs a hole for her egg and leaves it to hatch on its own. Thus it was argued that an ostrich egg symbolized virgin birth (or, one might have thought, inadequate parenting). On the other hand, the egg may equally signify creation or resurrection. Also, the ostrich was one of the Montefeltro emblems. There is a theory that associates the painting with the death of Battista Sforza and the birth of her son, but this seems rather far-fetched; at whatever date the altarpiece was made – and most critics suggest a date of about 1475 – it is difficult to equate the Child (who to some extent resembles the Christ of a Pietà) with Guidobaldo.

Philip Hendy suggests that the painting was done after the death of Federico (that is, after 1482) and at the same time that the church was being built. His theory is that the hands were done by somebody else because Piero della Francesca suddenly went blind at this point. To my mind, however, it seems rather improbable that, in the course of painting the altarpiece, the artist would have left the Duke's hands to the very last.

Vasari in his *Lives of the Artists* maintains that Piero did go blind before he died, which was in the autumn of 1492; though when he wrote his will, with his own hand, in 1487, he stated that he was 'sound in mind, intellect and body'. Certainly there was nothing wrong with his mind, and it was in order to exercise it, and as he said, save his brain becoming torpid through inactivity, that he wrote his work on geometry *On the Five Regular Bodies* (*De quinque corporibus regularibus*). This won him considerable renown as a mathematician, and he dedicated it to Federico's son Guidobaldo. His treatise on perspective, *De prospectiva pingendi*, he had already dedicated to Federico.

As for the *Brera Altarpiece*, it remains a compelling work. Solemn and inscrutable, it is embued with the spirit of meditation. If it is a memorial to Federico, it is a fitting and moving one, executed by an artist who was esteemed in his time as 'the prince of contemporary painting and architecture'.[15]

Meanwhile at the ducal court was Giovanni Santi (born 1440/5 and died 1494 in Urbino), a gentle, amiable figure who, eclipsed by the glory of his son, was never until recently given serious consideration as a painter in his own right.[16] He was born in Colbordolo, between Urbino and Pesaro, and in 1450 his family moved into the city in order to evade the dangers threatened by Sigismondo Malatesta. Little is known of Giovanni Santi's early career. He seems to have been trained in the circle of Piero della

The Madonna of Senigallia, Piero della Francesca (Ducal Palace, Urbino) – a contemplative and serene Madonna in a domestic setting.

Francesca. Then between 1474 and 1480 he appears to have been away from Urbino, probably travelling to Rome, Florence and Venice and gaining knowledge of the new developments in painting and architecture in those cities. Praised by Pietro Zampetti as 'il primo pittore urbinate' (the first painter from Urbino), he cannot be dismissed as merely a provincial artist. After his return in 1480 he married Magia di Battista Ciarla, and in the following years he was painting frescoes for the church of S. Domenico at Cagli: an *Entombment*, a *Sacra Conversazione*, with the *Resurrection* above, and an *Annunciation*. These two last demonstrate a particular delight in perspective. From later in the l480s date the panels executed for Fano (on the coast, south of Pesaro), including a *Visitation*, still to be seen at the church of Sta Maria Nuova, and a *Madonna* enthroned with saints, including Roch and Sebastian, who were invoked against the recurring threat of plague. There is another *Madonna with Saints*, with angelic choir above, in the mountain village of Frontino, in the convent church of Montefiorentino. It commemorates Carlo Oliva, Count of **Piagnano**, who kneels in prayer to the right of the group; there is an affinity here with Piero's *Brera Altarpiece*.

In the National Gallery of the Marches in the Ducal Palace of Urbino there are a number of Giovanni's works of different dates. Perhaps the most impressive of them is a pair of canvases done for the church of S. Francesco in the city. One shows Tobias and the Angel, a graceful and harmonious composition with the Archangel Raphael guiding the boy's tentative footsteps. The other is a dignified figure of St Roch, as usual demonstrating his plague sore; he is arrayed as a pilgrim, carrying his staff, and standing against a rocky landscape. The paintings, which are of similar size, both signify journeys, and the protection to be sought by travellers. While they have something of the elegance of, say, Perugino, they have at the same time an earthier quality. And while Giovanni's

St Roch, Giovanni Santi (*c*.1435–94), (Ducal Palace, Urbino). St Roch (S. Rocco) was a saint traditionally invoked in times of plague.

work may never have reached the heights that his son's did, it was doing him scant justice to describe him, as Giorgio Vasari did, as 'a painter of no great eminence in his art'.

Raffaello Sanzio, the incomparable Raphael, was born in Urbino on Good Friday, 6 April 1483. The house his father had bought there was in the street which rises steeply to the north from the central market place, now called Via Raffaello.[17] The house is pleasant and unassuming, cool,

reticent and white-walled. In the bedroom where Raphael is said to have been born there is a mural painting of the *Madonna and Child* (see page 136); this may be a very early work by the master, or else it is by Giovanni Santi. And in the courtyard may still be seen the stone on which the boy Raphael ground the paints for his father.

LEFT: Modern bust of Giovanni Santi in the Piazzale Raffaello.
RIGHT: The stone on which the young Raphael would grind paints for his father.

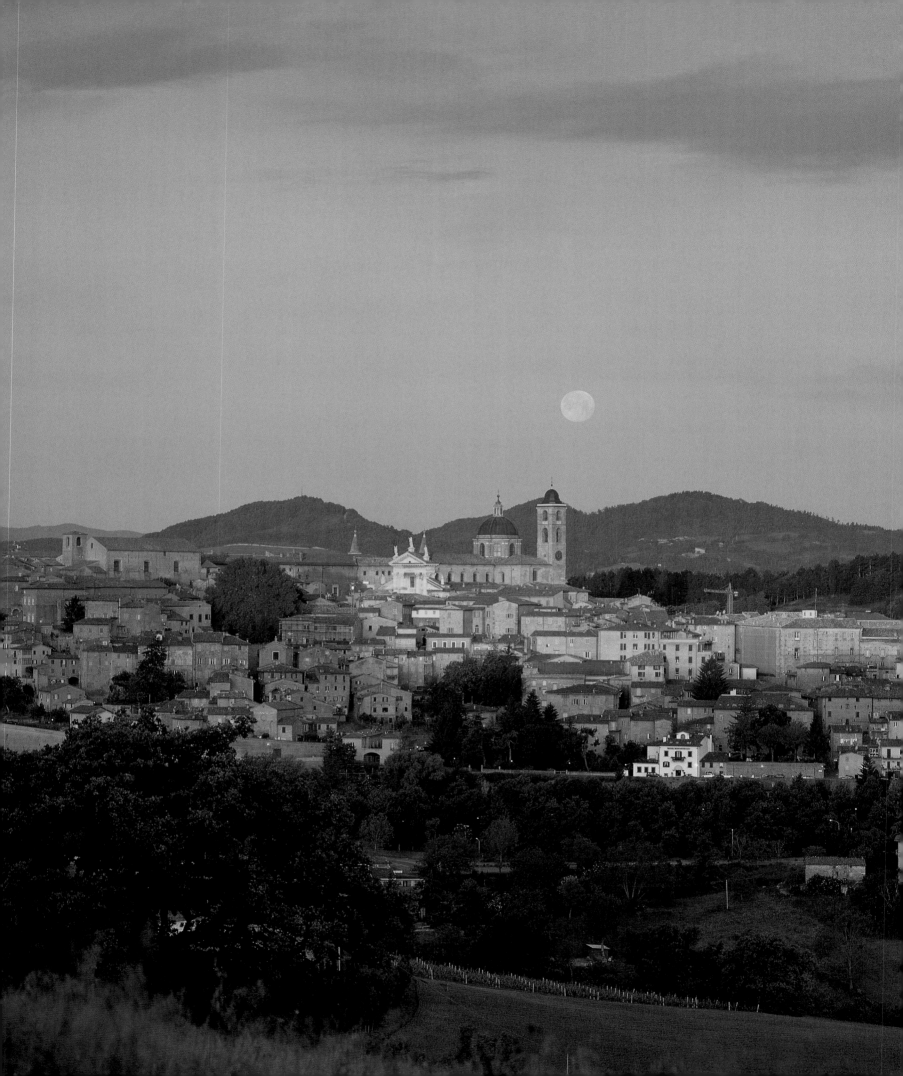

LATER DAYS OF THE DUCHY

The year before Raphael was born, the great Duke Federico died.

He had been by no means fit when he set out on his last campaign. He was lame, and looked older than his years, but, determined as ever, he was commanding the armies in support of the Duke of Ferrara (Ercole I, 1431–1505) against the Venetians. The dispute was over the possession of Polesine, a small town on the River Adige. The marshy lands between that river and the Po were notoriously unhealthy and, with the increasing summer heat, sickness spread rapidly among the troops. In June 1482 Federico himself succumbed to marsh fever and was forced to abandon the field; he was carried in a litter to Ferrara to seek refuge with the Este family. But his condition further deteriorated throughout the summer, and on 10 September he died. His half-sister Violante, who had been married to Domenico Malatesta of Cesena, and was now Abbess of the Convent of Corpus Christi, was at his deathbed.

His body was taken to Urbino, where his funeral was attended by princes and ambassadors from all over Italy. Bernardo Baldi relates how his corpse was taken to the church of S. Francesco, and not buried but embalmed and propped up at the side of the high altar in an open wooden coffin. He was dressed in a tunic of crimson satin, scarlet hose and the customary red cap, with a long satin robe and his sword at his side. Baldi, on seeing it over a hundred years later (his account was written in 1603), said that the body was still 'whole, uncorrupt and like a wooden effigy covered with skin which was still pale and taut – not at all terrifying or alarming'.[1] Similarly it was hoped that the Duke's spirit would live on; but inevitably there followed a time of transition. Guidobaldo was only ten when his father died.

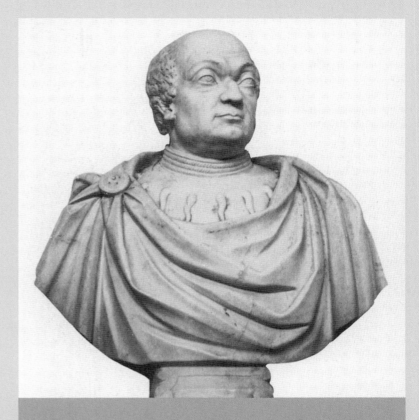

'WHEN THE DUKE FAILS,
ALL THINGS FAIL'

Federico Veterani of Urbino, *Tribute to Baldassare Castiglione*

LEFT: Moon over the city of Urbino.
RIGHT: Marble bust on Federico's monument (erected in 1620) in the church of S. Bernardino.

Federico's funeral oration was given, appropriately enough, by Ludovico Odasi of Padua, who was tutor to Guidobaldo and was skilled in both literature and horsemanship. The boy had early shown his aptitude as a scholar in classical studies. It will be remembered he was taught Greek by Gianmario Filelfo (see page 97). Guidobaldo's first master, however, was Giorgio Benigni, a cleric from Ragusa (Dubrovnik), and in a letter to the senate of his native city, he defined his function as to lead the boy 'towards a moral life and the practice of piety'.

Ludovico Odasi was employed not so much for his talents in literature as an instructor in military disciplines. From his earliest years Guidobaldo had been encouraged to take all sorts of physical exercise – running, jumping, riding, dancing, playing ball – but now came a further toughening up and the regime included wrestling, swimming, and above all riding. Although never at the best of times robust, at this Guidobaldo was especially skilled.

Federico had nominated as the boy's guardian the excellent Ottaviano degli Ubaldini, the son of the Duke's sister Aura, and an intelligent and high-principled man. He now headed a Regency Council and supervised the running of the state. However, they were not entirely easy times, for the prosperity of Urbino had always rested on military prowess, and although there were many brave young captains who had trained under him, the death of Federico left a vacuum. Urbino became politically isolated.

There was the dynasty to consider. Marriages were a matter not of individual choice, but political alignments. For a small duchy, it was clearly advantageous to be united with powerful allies, and a substantial dowry was always useful. When he was only two and a half years old, Guidobaldo had been betrothed to Lucrezia d'Aragona, daughter of King Ferdinando of Naples. This however came to nothing, and the next, and definitive, betrothal was to Elisabetta Gonzaga (1471–1528), fourth of the six children of Federico, Marquis of Mantua.[2]

Guidobaldo was accounted very good-looking as a youth, 'bello come un amorino' (as handsome as a cupid), in the opinion of the poet Pietro Bembo (see page 157). He was also held to be generous, affable and intelligent. He was adding new books to his father's library and, as a fine horseman, he had already embarked on a career as a *condottiere*. The King of Naples, now allied with Pope Sixtus IV, had given him the command of 100 men-at-arms and 30 lancers, and he was accorded an allowance of 10,000 ducats. Thus in his teens he appeared an entirely eligible bridegroom.

Elisabetta was also called beautiful, but this was true perhaps only compared with others in her family; at least she had not inherited her father's hunchback, a deformity that was unfortunately recurrent in the Gonzaga family. (The girls who were afflicted with this were almost inevitably sent off to be nuns.) Elisabetta's elder brother Federico became Marquis on the death of his father in 1484, and he married the remarkable Isabella d'Este, who was to become an influential and close friend of her sister-in-law.

Italian Renaissance princesses had almost no choice in their destiny. If they were unattractive or in some way deformed they were expected to take the veil. Otherwise, many of them were married off when they were little more than children, and then the perils of childbearing often made their lives pathetically short. Elisabetta's sister Maddalena, for instance, was married in her teens to Giovanni Sforza, Lord of Pesaro, only to die with the birth of her first child. Her widower then had a short-lived marriage with the young Lucrezia Borgia. Beatrice d'Este, Isabella's sister, was married at sixteen to Ludovico II Moro, aged almost forty, and she died in childbirth aged twenty-two. For these high-born girls marriage almost always meant parting from their family, perhaps never to meet again. They were frequently betrothed as children, and seldom met their husbands before their actual wedding day. So despite all the lavish dresses, fine jewels and sudden adulation, they can seldom have entered into marriage without trepidation.

Guidobaldo da Montefeltro, Raphael (Uffizi, Florence). Painted on a wooden panel in 1506–8, this shows the Duke at the end of his short life. He appears anxious and unwell.

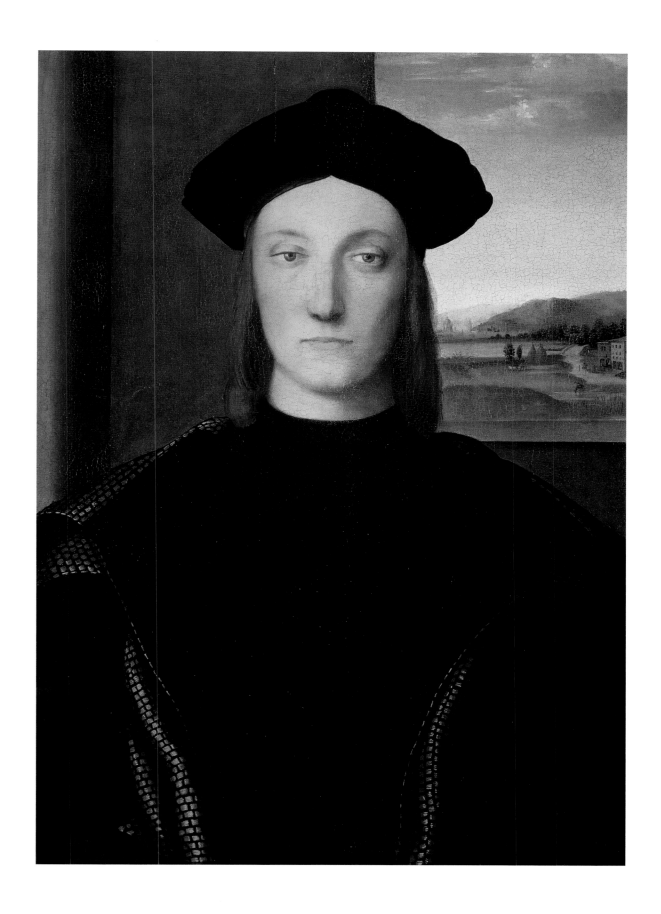

As a bride, Elisabetta was furnished with magnificent jewels: a necklace with thirteen diamonds, fourteen rubies, fifty-two pearls, a pendant of sapphires with an enormous pearl, also 300 small pearls and 500 large ones. But when, early in 1488, Cardinal Ottaviano degli Ubaldini arrived in Mantua ready to escort her to Urbino, the girl was ill and unable to travel. So Guidobaldo took the very unusual step of coming to Mantua himself. In the Ducal Palace there, he was taken to see the Mantegna paintings in the Camera degli Sposi, and also the famous canvasses depicting *The Triumph of Caesar*.[3] He was understandably impressed by these, though less so by the architecture, which by no means measured up to the Ducal Palace his father had built in Urbino. He also sailed in a boat on the Mincio, but it made him seasick.

By the early summer Elisabetta's health had much improved and she was able to undertake the journey to Urbino, where she was welcomed with great rejoicing. It soon became clear, however, that her handsome young husband was impotent. The fact was at first kept secret. What her own reaction was is not recorded; it is possible there may have been some sense of relief. In any case she seems to have had a genuine affection for him, and her loyalty was unswerving.

When he was eighteen Guidobaldo reached his majority and was no longer under the control of Ubaldini. He was a conscientious and kindly young man, and he took his responsibilities seriously. As his father had, he walked in the city every day to listen to his subjects' requests, and then discussed them in council the following day. He was an intelligent patron; Cristoforo Landino dedicated his edition of the Roman poet Horace to him, and in the painting by Jacopo di Barbari of the mathematician Luca Pacioli (now in the Capodimonte Museum, Naples), Guidobaldo may well be the young man who looks on thoughtfully at the friar's side.

While Elisabetta was from time to time afflicted with stomach pains, and would go and take the waters at Viterbo, Guidobaldo at first seemed healthy enough. But when he was about twenty he began to limp, his legs swelled up, and by the time he was thirty his body was misshapen and wasted. He did his best to fight against this mysterious illness, described at the time as gout, but surely something much more serious, like rheumatoid arthritis.

In 1492 the great Lorenzo the Magnificent died, also of what was called gout; in the same year came the news of the election of the Borgia pope, Alexander VI. Both these events were ominous not only for Urbino, but for the whole of Italy.

The Borgia, or Borja, family were originally Spanish, from Valencia, and first appeared in Italy at the time of Alfonso of Aragon's conquest of Naples in 1443. Rodrigo Borgia, who became pope under the name of Alexander VI, was probably the most self-indulgent pontiff ever to sit on the throne of St Peter. He had a number of illegitimate children. His favourite was the notorious Cesare (1475–1507), whose mother was Vanozza dei Catanei. Cesare was officially legitimized when little more than a boy and was made a cardinal; but this was reversed in 1498 when he decided to give up the Church for a military career. He was able to gain the promise of French support in his campaign to subjugate the cities of Romagna and bring them under papal control. Ruthlessly efficient, utterly pragmatic, he was much admired by Machiavelli, who used his career as the basis of *The Prince*. There was such a strong anti-Spanish prejudice throughout much of Italy that it is difficult to judge the Borgia fairly. But Cesare was undoubtedly cruel, as witnessed by his heartless massacre of the *condottieri* at Senigallia (see page 132) and his equally heartless treatment of his own family. As for his sister, the pretty, fair-haired Lucrezia, it is strange how later generations gave her a reputation for wickedness. She was far more sinned against than sinning, simply a pawn in the game, and her latter years in Ferrara were devoted to good works.

Because of her husband's infirmities, Elisabetta seems to have been granted more independence than most young wives. As time went on she was revealed as the stronger character. Always an admirer of her sister-in-law Isabella d'Este and no doubt missing her home city of Mantua, where the court was livelier, Elisabetta finally arrived in the spring of 1493 and stayed there nearly a year. Her visit was prolonged because by the summer Isabella found she was pregnant, and Elisabetta wanted to be there for the birth.

The baby was a girl, called Eleonora, or Leonora, after Isabella's mother.

Guidobaldo came to join his wife in Mantua and in January they set off for Urbino, where they were greeted by a crowd of 4,000 people, including singing boys and ladies and gentlemen on horseback. In the spring of 1494 Isabella paid them a return visit, on her way back from Loreto.[4] Fascinated by Gubbio, which she saw on the way, she was even more impressed by Urbino; she wrote back to say that the palace, 'richamente guarnito de tapezarie, apparamenti et argenti de credenza' (richly ornamented with tapestries, furnishings and services of silver) surpassed her expectations. What was more, she told her husband, it was a fine and civilized court, and government was carried out humanely, responsibly and with the support of the people. Clearly the young Duke was striving to keep up the standards set by his father.

The next ceremonial visit was by Lucrezia Borgia (the Pope's daughter by his mistress Vanozza). She was only thirteen and she was going to marry Guidobaldo's cousin Giovanni Sforza, lord of Pesaro. The bridegroom was recently widowed after the death in childbirth of Elisabetta's sister Maddelena. The wedding took place in Rome; the bride was magnificently attired and came with a huge dowry. All the Pope's children were there, also his new mistress, known as Giulia la Bella. After two months Giovanni returned to Pesaro, the marriage not yet consummated. When in May of the following year (1494) he finally decided to collect his bride, they stayed in Urbino on the way. Guidobaldo and Elisabetta tried to make them welcome but they stayed only a single night, and left in pouring rain; there was a general impression that all was not well with that marriage.

Despite his poor health, Guidobaldo was allied as a *condottiere* to the Aragon family of Naples, and was training his men in the mountains. The first of the French troops of the ambitious Charles VIII entered Italy in September 1494. This caused serious division among the great families. The Estes of Ferrara and the Sforzas of Milan were strongly pro-French; the Gonzagas as yet uncommitted. Francesco (Elisabetta's brother and Isabella d'Este's husband) was invited to enter the service of the King of Naples. Realizing that this would make

enemies of the Sforzas, he finally turned the invitation down, after which he was invited to lend his support to the French. Had he done this, Elisabetta would have had her husband fighting on one side, and her brother on the other. Meanwhile Count Giovanni of Pesaro, having ostensibly left the Sforzas' contingent, was offered by the Pope (on whose favour he depended) a command of pro-Aragon troops. However, he was still linked with Ludovico Sforza – so he had great scope for double-dealing.

Then news reached Pope Alexander that his daughter Lucrezia was critically ill. He wrote and requested her immediate return to Rome, and also that of his mistress Giulia. Giulia, however, had already left Pesaro, with the idea, she said, of rejoining her husband Orsino Orsini, who was claiming his wife back. It was an immensely rich situation, and highly embarrassing for the Pope. Giulia agreed to return to Rome, but was captured by French troops. The Pope had to pay a large ransom of 3,000 soldi before she could continue her journey.

While Guidobaldo was away, Elisabetta, with Ubaldini to advise her, was left to govern Urbino. News came sporadically of events in the rest of Italy: that Charles had 30,000 or 40,000 men, and, it was said, 800 women with him (reputedly bringing venereal disease); that in Milan Gian Galeazzo Sforza had suddenly and mysteriously died, and Ludovico il Moro had assumed the title of Duke; that Ludovico's young wife Beatrice (Isabella's sister) had given birth to a second son, Francesco; that Piero de' Medici had been forced to flee from Florence (never to return); and that Elisabetta's sister Clara had unexpectedly turned up in Mantua. On 22 February Charles VIII entered Naples, which was in a sense a bridge too far, though at the time he met with no resistance. General consternation about this led to the formation of a new League, supported by both Emperor Maximilian and the King of Spain, with the aim of heading him off on his return. Charles was in any case moving rapidly north again; at Fornovo he encountered the League's troops headed by Elisabetta's brother Francesco. This was counted a victory for the League, and Francesco was much fêted in Mantua, where Elisabetta joined him for the celebrations.[5]

Meanwhile Guidobaldo was looking for a *condotta* that would bring profit. In the summer of 1495 he was asked by the Borgia pope to fight alongside Don Juan, Duke of Gandia (the Pope's son, newly returned from Spain) in a campaign against the Orsini. Juan had no military experience, and acting as his second-in-command was not easy.

Elisabetta was obliged to go to Mantua in 1496 on account of her sister Clara's husband being critically ill. Then came Isabella's second pregnancy, resulting again in a girl. The following year Isabella's sister Beatrice died in childbirth; Ludovico il Moro, despite having various mistresses, was devastated. To add to all these troubles, Elisabetta received the news that Duke Guidobaldo had been wounded and then taken prisoner. With Guidobaldo incapacitated, the army had been left in the hands of the totally inept Don Juan and had been routed by the Orsini, who were now perilously near Rome. Don Juan had escaped unscathed and was making merry at the Roman carnival.

Elisabetta approached the Pope via an ambassador to ask for assistance in the freeing of her husband, who was being kept in the fortress of Seriano. The Pope assured her that she would soon see her husband safe and sound, but in fact he did nothing. Ubaldini wrote to say that she was mistaken in expecting help from that quarter. The Borgia pope, he believed, was not to be trusted. 'If Judas sold Christ for thirty pieces of silver, this man would sell him for twenty-nine.' Elisabetta had to find some other means of saving her husband and the Montefeltro dynasty.

She therefore sold her jewellery and silver, raising the sum of 40,000 ducats, and sought the assistance of other princes. Ludovico il Moro promised that Guidobaldo should be freed whatever the cost, and finally in April 1497 he was. Elisabetta hurried to Urbino so that she was there to join in the celebrations occasioned by his return.

Then in the summer came the news that Don Juan had been assassinated; his body with nine stab wounds was dragged out of the Tiber. Guidobaldo was among those suspected; so was Giovanni da Pesaro; so were the Orsini. But the guilty man was never identified. It was very likely Juan's own brother, Cesare, who in the Pope's eyes could do no wrong. There were rumours of incest between Juan and Lucrezia; the matter was never resolved.

There were certainly problems with Lucrezia's marriage. Giovanni da Pesaro, she alleged, was impotent, which was why the union had never been consummated. Giovanni did little to improve his position by fleeing from Rome. A rather embarrassing visitor, he turned up in Urbino on his way to Pesaro. Elisabetta and the rest of the Gonzagas resented the imputation that Giovanni was impotent because it touched the honour of her late sister Maddalena. They offered another lady of the Gonzaga family to be Giovanni's third wife, in order to demonstrate his virility. Giovanni himself – who finally took refuge in Milan – maintained that the Pope lusted after his daughter Lucrezia himself, and that was why he wanted the marriage annulled.

A new marriage was planned for Lucrezia, this time with Alfonso, Duke of Bisceglie (the illegitimate son of King Alfonso II of Naples). Lucrezia seems this time to have been genuinely happy; they had a son Rodrigo, who was baptized in the Sistine Chapel. Cesare, despite having contracted the *mal francese*, made a princely progress to France, and married Charlotte, sister of the King of Navarre. But by the end of 1499 there was a fearful atmosphere in Rome, strife between the followers of the Borgia and those of Aragon, and general suspicion of poisoning. And in the smaller states there was growing fear of Cesare who, with the Pope's money and support from the French, was assembling an army ready to attack and annex them.

In Urbino meanwhile, as it was now clear that Guidobaldo would otherwise have no heir, he decided to adopt his nephew Francesco Maria della Rovere, who was then nine years old; Francesco Maria was the son of his sister Giovanna who had married Giovanni della Rovere. Guidobaldo told the Pope of his intention, and received no objection. Cesare was now attacking Imola and Forlì, and in the end overcame them, despite valiant resistance by Caterina Sforza; then he marched on Pesaro.

As the year 1500 was exactly a millennium and a half since the birth of Christ, it was designated a Holy Year, and despite solemn warnings from her brother Francesco, Elisabetta

decided to go to Rome. She stayed in the castle of Marino just outside the city; this was the home of Guidobaldo's sister who had married into the powerful Colonna family, and with this protection she was able to visit the churches. They were dangerous times. Caterina Sforza was imprisoned in the Castel Sant' Angelo, and Ludovico il Moro had been captured by the French.[6]

In May that year a Gonzaga heir, Federico, was born, but because of the perilous situation Elisabetta remained in Urbino. The following month the Vatican was dramatically struck by lightning. Ceilings collapsed, masonry fell, and everyone thought the Pope had been killed; but he was discovered, covered with dust but still alive, sitting on his throne beneath the baldacchino. It was while he was convalescing in the care of his daughter Lucrezia and her husband Alfonso that Alfonso was attacked, first seriously injured, and then murdered in his bed – probably on the orders of Cesare. Lucrezia was grief-stricken, and it was a year before the Pope persuaded her to marry again.

Giovanni of Pesaro was now seriously menaced; the Pope was threatening to excommunicate anyone who tried to help him. He is said to have applied to Guidobaldo for assistance or advice, and Guidobaldo could not help him without bringing down ruin on his own head. He advised him to bear the situation with patience and await better times. So Giovanni left the city and took refuge in Mantua, while Cesare rode into Pesaro, dressed in cloth of gold and crimson satin. He was attended by a procession of merchants, musicians, poets and prostitutes, and had among his suite his inventor of war machines, Leonardo da Vinci.[7]

In Urbino it was a time of anxiety, and also sorrow. The news came that Guidobaldo's natural brother Antonio (the young man who excelled in the martial arts but who in Federico's day was not allowed near his half-sisters) had died of dropsy. He had married Emilia Pia da Carpi;[8] and together with her children she was adopted into the court at Urbino, and became a close friend of Elisabetta's – she features

Lucrezia Borgia, from a fresco by Pinturicchio decorating the Borgia apartments in the Vatican.

prominently in the conversations that are immortalized in *The Book of the Courtier* (see Chapter 11).

Cesare's movements were watched with trepidation. His next attack was against the town of Faenza which, under its young leader Astorre Manfredi, put up a heroic resistance. Cesare paused from warfare in order to celebrate carnival time in Urbino. One can imagine he was not an entirely welcome guest, but on the other hand the Montefeltro did not dare offend him. Knowing Cesare's reputation, there was a genuine fear that Duke Guidobaldo might be assassinated. Cesare however contented himself with pursuing one of Elisabetta's protégées, a young girl from Mantua who was engaged to be married to a Venetian captain. She resisted Cesare when he was in Urbino, only to be kidnapped on the way to her wedding. Despite her cause being taken up by the Gonzaga and the Venetians, as well as the Montefeltro, she disappeared without trace.

All this time Faenza had been in a state of siege and now with the spring Cesare once more attacked, and the city was finally overcome. Its leader Manfredi was taken to Rome and imprisoned in the Castel Sant' Angelo.[9] At this stage Cesare temporarily relinquished his campaign in the Romagna in order to deal with affairs in the south, where France and Spain had resolved to take over the Kingdom of Naples between them. King Federico d'Aragona took flight, ending up in France an exile, though honourably treated. For Urbino it was a temporary respite.

Now a third marriage was being planned for the hapless Lucrezia Borgia, this time with Alfonso d'Este, brother of Isabella and heir to the Duchy of Ferrara. Such a marriage would bring Ferrara under Borgia control without the need for an actual conquest. The Duke of Ferrara (Ercole I) was understandably reluctant about this doubtful honour being imposed on his son, being all too aware of what had happened to Lucrezia's previous husbands. He demurred, protesting that the Emperor Maximilian was against it, and held out for at least a good financial settlement. Lucrezia's dowry was settled at the huge sum of 100,000 ducats, and Ferrara's tax payable to the Church was reduced from 4,000 to only 100 ducats annually.

It was decreed that this third marriage of Lucrezia's was to be celebrated with the utmost splendour, not just in Rome and Ferrara but in all the princely courts the wedding procession would pass through. The Montefeltro were expected to offer hospitality to Lucrezia and her numerous suite on their way to Ferrara, and the Pope requested Elisabetta to accompany her there.

There still survives a contemporary account of life at the court of the Borgia, written by Johann Burchard who was Master of Ceremonies there. Since he held that position, he could not be wholly frank about what was going on; on the other hand he was admirably placed to describe the ceremonial. Celebrations in Rome lasted from September 1501 until Christmas.[10] Lucrezia was now aged about twenty; she wore a dress of gold brocade worth about 300 ducats (£3,000) and was presented by the bridegroom's brother, acting as proxy, with an impressive collection of jewellery, valued at 8,000 ducats.

As the time for her departure drew nearer, the prospect for the bride cannot have been one of unmixed joy; for one thing, it meant leaving not only Rome but her two-year-old son Rodrigo. However she put a brave face on it, and was commended for her modesty, beauty and integrity. It was arranged that the wedding party should progress through Gubbio and Urbino, then through lands that had already been conquered by Cesare. For the Montefeltro to be obliged to offer hospitality to some hundreds of people was a considerable expense; and besides, Elisabetta had to be accoutred and attended in the lavish way thought appropriate. She wore a dress of black velvet with gold fringes as, accompanied by Emilia Pia and a large group of courtiers, she came to meet Lucrezia at Gubbio.

When the immense party arrived in Urbino, there were two days of festivities at the Ducal Palace. Lucrezia was much admired for her beauty, elegance and wit, as well as her costume, the like of which had not been seen before. The dancing of her jesters was also applauded. Then the vast procession moved slowly on, stopping at Pesaro and Rimini, and eventually (some days later than expected) arriving in Ferrara. Here the young couple met for the first time.

Having left their husbands behind – Guidobaldo in Urbino and Francesco in Mantua – but attended by a number of the nobility, Elisabetta and Isabella left Ferrara in February when the festivities came to an end. Rather than return straight home, they visited Venice, which impressed them enormously; 'piu meravigliosa di Roma' was Elisabetta's opinion.

At the end of March they returned to Mantua. At the end of June they were in Porto Mantovano when, to their astonishment, Guidobaldo suddenly turned up, dishevelled and with an escort of only four men. They were appalled to hear that he had lost the overlordship of Urbino.

The Duke himself had trusted Cesare as if he were his own brother. But Cesare's troops had been lurking outside the city, and had been armed and fed by some of Guidobaldo's courtiers. One of the Duke's secretaries treacherously opened the city gates, and in rode Cesare like a conquering hero at the head of his troops. He was furious to find that Guidobaldo was not there. He had been forewarned and had escaped, taking with him his little nephew Francesco Maria. He sent the boy into the protection of his uncle, Cardinal della Rovere (later to be Julius II), and for his own part was lucky to escape with his life. With these two still alive, Cesare felt that his tenure of Urbino was by no means secure. He had the treacherous secretary executed, and proceeded to ransack the palace, removing pictures, sculptures, manuscripts and the celebrated tapestries.

In Mantua, Francesco could not contain his fury at what had happened to his brother-in-law. Isabella was altogether more cunning and tried to negotiate with Cesare. Would he at least restore the dowry of Emilia Pia? Would he spare the courtiers who had been loyal to Guidobaldo? Would he be prepared to exchange for something else a marble Venus and a sculpture of a sleeping cupid? This sculpture was thought to be of Roman origin, though actually by Michelangelo.[11] Isabella used the argument that Cesare 'was not much interested in antiquity and therefore other things will please him just as well.'

Isabella managed to wheedle the cupid out of Cesare and put it in her studiolo. Though she was sympathetic, she was also concerned to feather her own nest; she was at least able to keep negotiations open. For the truth was that Cesare, with the backing of his father the Pope, was now so powerful that not even the King of France dared oppose him openly. The latter was in Italy, and the two met at Pavia. Although at first relations between them appeared cordial, Louis was cautious; Cesare was talking of attacking Bologna, in which case he could be a threat to the French.[12] Guidobaldo, along with Francesco, had also gone to Pavia to plead his cause with Louis XII; he was instructed to go back to Mantua where 'his affairs would be dealt with.' Isabella was advised by Francesco not to trust Cesare, to welcome Guidobaldo, and, oddly, 'to allow the Duke to go to bed with the Duchess and do what he pleases.' A strange command, suggesting that Guidobaldo's impotence, which he and his wife had always tried to keep secret, was now widely suspected.

It was reported in Mantua that Cesare had asked Guidobaldo if he wanted to become a priest; obviously he could not do this without his wife's consent. There was talk of the marriage being dissolved – Elisabetta would then be free to marry again, perhaps to a French nobleman; but she remained loyal to Guidobaldo and would not hear of it. Guidobaldo offered to go into voluntary exile in Venice; Cesare ordered Francesco to ask Elisabetta if she would remain in Mantua, but she felt that her husband would be in more danger without her and so accompanied him there.

On his return from Pavia, Cesare stopped at Ferrara where his sister Lucrezia, having just given birth to a stillborn child, had caught a fever and was critically ill. However, she recovered, and retired temporarily to a convent.

Widespread dissatisfaction against the Borgia came to a head in Montefeltro territory, and there was news of a revolt, starting in the fortress of San Leo. Aided by the Orsini and the Vitelli, the men rose with shouts of 'Feltro! Feltro!' Guidobaldo felt obliged to depart from Venice, leaving Elisabetta behind, and sailed to Senigallia, where his sister Giovanna lived.[13] He arrived in a poor state of health, but when he had more or less recovered, he rode across the province to join the rebels in San Leo. Amid great celebrations, he rode at their head into the city of Urbino.

When one thinks of the difficulty of the terrain – the journey involved crossing the Apennines twice – it was not surprising that when he reached the Ducal Palace he retired exhausted to bed. He stayed there for some days, acknowledging the homage of the people.

The ever-wily Cesare was unlikely to let matters rest there. He reassembled his forces at Pavia, and bribed the *condottieri* (even the Orsini) with promises of help against their enemies if they would adhere to his side. Guidobaldo found his position untenable and was forced to give up Urbino; however his life was spared, and he was allowed to keep certain fortresses. For two months nothing was heard of him. The question of the annulment of his marriage and his becoming a cardinal was raised again.

Meanwhile Cesare rapidly captured Senigallia, and invited the *condottieri*, to whom he had promised such great things, to come there to a conference. When they arrived, they were escorted to their rooms and slain by Cesare's soldiers.

For Elisabetta alone in Venice there was still no news of her husband. The months of exile had greatly reduced their circumstances. She had sold most of her jewels and feared for his life. She told her brother, the cardinal Sigismondo, that if Guidobaldo wanted to be a priest she would be content to return to Mantua; in fact it was necessary to keep his name alive in order to protect him. At the end of January, Guidobaldo, in poorer shape than ever, finally turned up in Venice. They were desperate days.

Then, in the heat of the following summer, there was an outbreak of malarial fever in Rome. The Pope and Cesare were invited to a banquet given by a cardinal, and afterwards they both suddenly fell ill. Cesare just managed to survive, but Alexander Borgia died on 18 August 1503. It is possible that they had been poisoned. The Pope's body blackened and swelled so much that it could not be got into a coffin.

Guidobaldo went back once again to Urbino. Baldassare Castiglione relates how he entered the city to shouts of joy and waving of olive branches; people of all ages came out to meet him; blind old men came forward, asking him to touch them; there was singing and dancing with tambourines. Elisabetta meanwhile stayed in Venice waiting for the situation to resolve itself. Cesare, after all, was still alive. The new pope, Pius III (a nephew of Pius II) was chosen as a comparatively neutral candidate, and one who would not last long. He had in fact planned some much-needed reforms, but he died a mere ten days after his coronation on 8 October 1503. He was succeeded by the Borgias' great rival, Giuliano della Rovere, who was more of a warrior than a priest. His election in Nobember 1503 meant much greater security for the Montefeltro.

Cesare found himself a virtual prisoner in the Torre Borgia constructed by his father. Having given up his fortresses in the Romagna and armed with a safe conduct from the Pope, he left Rome and travelled south. He was captured by Ferdinand of Aragon and imprisoned in Naples; then he fled to Spain. Meanwhile Louis XII of France deprived him of his French possessions. Eventually he escaped to Navarre, and died in March 1507 trying to suppress a rebellion against the king of that country.

Meanwhile it had taken time to realize that the terrible Cesare was no longer the threat that he used to be. With the election of Julius II, uncle to Guidobaldo's adopted heir, it was now safe for Elisabetta to leave Venice and join her husband. Guidobaldo invited loyal Venetians to escort her as she sailed to Ravenna and then rode to Urbino, the city she had not seen for nearly two years. She arrived in early December 1503. Four thousand people came out to greet her, waving olive branches and shouting 'Feltro, Feltro, Gonzaga, Gonzaga!' It took her three hours to cover the short distance from the city walls to the palace, so great and so enthusiastic was the crowd.

Guidobaldo had Cesare's promise that he would restore the ducal library and give back the works of art that he had appropriated. The only exception was the set of tapestries of the Trojan War, which Cesare said he had already given away. As for *The Sleeping Cupid*, which Isabella d'Este had acquired, and which was now ornamenting her studiolo, she refused to part with it, saying she had it as a gift from her sister-in-law in recognition of the hospitality she had been given in Mantua. Whether true or not, it was difficult to argue with that.

The new Pope approved of Guidobaldo's adoption of Francesco Maria as heir to the Duchy of Urbino. The next question was to re-establish the dynasty by finding him a suitable bride, and the choice fell on Eleonora (or Leonora), eldest child of Francesco Gonzaga and Isabella d'Este. She was preferred to either of her younger sisters, Ippolita and Livia, because the marriage would not be so long delayed. (The younger sisters were placed in a convent.) In fact, Eleonora was only eleven years old when the betrothal was celebrated in March 1505. She had not yet met her future husband; Julius II was anxious to avoid any suggestion of nepotism, and would not pay the expenses for Francesco Maria to visit his bride in Mantua.

Elisabetta's brother Sigismondo was made a cardinal, and her husband Guidobaldo was increasingly in favour with the Pope. He and his nephew visited Rome; they were present at all the important ceremonies, and were at the Pope's side when he gave audience.

Julius, allied with both France and Germany, decided to lead a campaign himself to drive the Bentivoglio out of Bologna. On the way they would make a visit to Urbino. In the summer of 1506 the news reached the city that he was coming, together with thirty cardinals. Each cardinal would be accompanied by his suite, and would require sixteen beds and stabling for fifty horses. Elisabetta naturally wanted the Pope's room to be especially grand. She wrote to Isabella to ask if she would send 'qualche paramento de panno d'oro et de seta et de tapeti' (furnishings of cloth of gold and silk and carpets); but her sister-in-law – whose family in Ferrara were being riven by internal strife, brother against brother – sent

only a few jewels and two sets of bed-hangings, one of crimson damask and one of gold brocade.

The papal favour that a visit from Julius II implied brought with it a degree of material prosperity and considerable international prestige. With his poor health, and the changing political climate, Guidobaldo was never as rich as his father had been. Still, he received a fair salary as Captain General of Venice, and it was generally held that his support counted for something.

Thus it was that Henry VII of England decided to present him with the Order of the Garter. Admittedly his reason for doing so was not entirely altruistic (as when Federico had received that honour from Edward IV). It was on account of Catherine of Aragon. The death of Henry's elder son Prince Arthur had left his bride a widow; and the King was anxious to obtain a papal dispensation to enable Catherine to marry his second son, Henry (later Henry VIII).[14] So he sent his envoys (Sir Gilbert Talbot, Richard Beer Abbot of Glastonbury and Robert Sherborne Deacon of St Paul's) to congratulate the Pope on his election. While it was hardly possible to present His Holiness with a chivalric order, it was quite acceptable, and might well prove influential, to bestow one on the Duke of Urbino.

In the Pope's train came many of the most gifted and intelligent men in all Italy. It was a brief Indian summer, after the tempestuous days of the Borgias. Urbino became once again a Renaissance city, a centre where the arts could flourish.

Pope Julius II. Uncle to Guidobaldo's adopted heir Francesco Maria della Rovere, he made a brief but memorable visit to Urbino in September 1506 (see page 153).

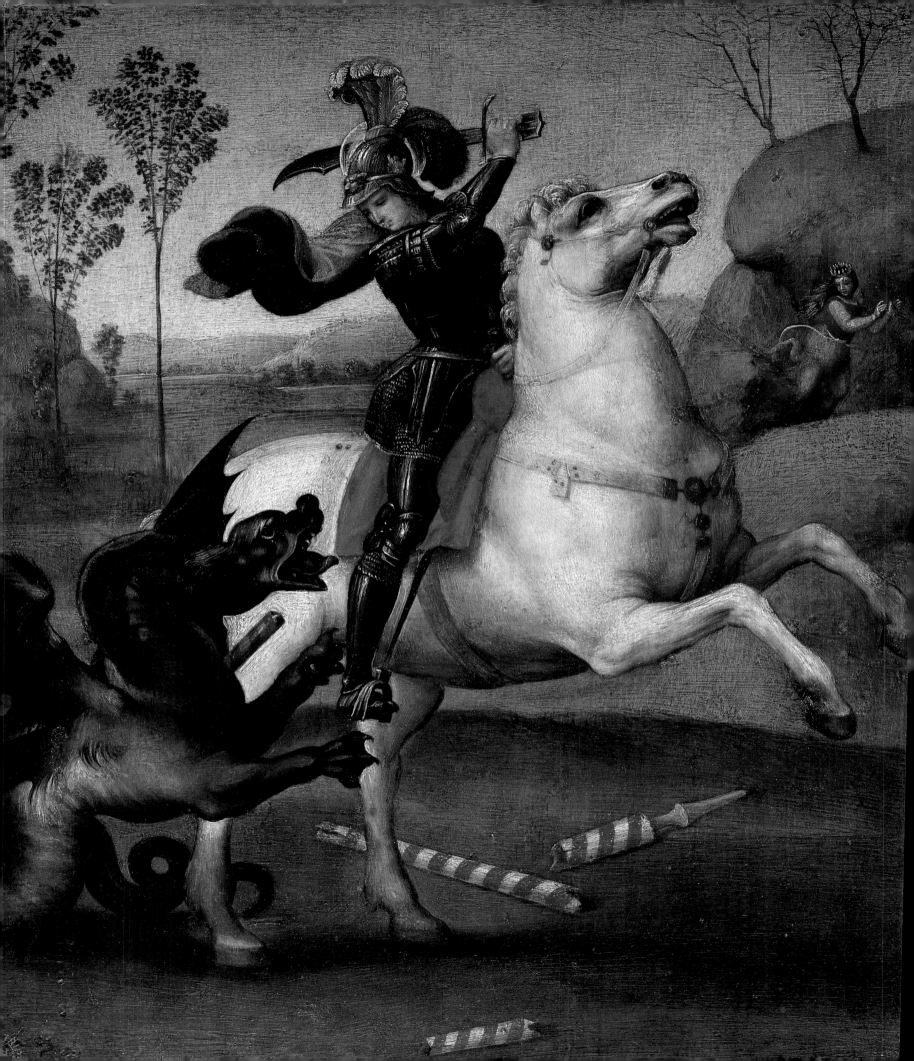

THE ARTS IN THE LATER DAYS OF THE DUCHY

What cared Duke Ercole, that bid

His mummers to the market-place,

What th' onion-sellers thought or did

So that his Plautus set the pace

For the Italian comedies?

And Guidobaldo, when he made

That grammar school of courtesies

Where wit and beauty learned their trade

Upon Urbino's windy hill,

Had sent no runners to and fro

That he might learn the shepherds' will.

W. B. Yeats, from 'To a wealthy man who promised a second
subscription to the Dublin Municipal Gallery if it were proved the
People wanted Pictures'

PAINTING IN URBINO

In exchange for being given the Order of the Garter, Duke Guidobaldo sent to Henry VII the first Raphael painting ever to be seen in England. This was in June 1506, but the painting dates from about two years earlier; it represents, very fittingly, St George and the Dragon. The panel, which is now in the Louvre, Paris, depicts an athletic young saint in full armour and mounted on a rearing horse, his right arm with sword upraised ready to slash at the gasping dragon, whose neck has already been pierced by a lance. The rest of the broken red and white lance lies in pieces on the ground. In the background to the right of the picture runs the terrified princess; there are slender feathery trees to the left.[1]

'RAFFAELLO, ONE OF THOSE POSSESSED OF SUCH RARE GIFTS THAT IT IS IMPOSSIBLE TO CALL THEM SIMPLY MEN, BUT RATHER, IF IT IS ALLOWABLE SO TO SPEAK, MORTAL GODS, WAS BORN IN THE FAMOUS CITY OF URBINO IN ITALY, IN THE YEAR 1483, ON GOOD FRIDAY, AT THREE O'CLOCK OF THE NIGHT.'

Giorgio Vasari, *Lives of the Artists*

LEFT: *St George and the Dragon*, Raphael (Louvre, Paris), the first painting by Raphael to be seen in England.
ABOVE: Dining room in the house belonging to Giovanni Santi, where his son Raphael was born, in the Via Raffaelle, Urbino.

Raphael's first master in the art of painting was undoubtedly his father Giovanni Santi. It is strangely moving to see the stone where the boy ground the paints for him. Giovanni Santi had remarried, after the death of Raphael's mother Magia in 1494, to Bernardina, daughter of a goldsmith called Pietro di Parte. Then three years later Giovanni himself died; at which time his son was only eleven or twelve years old. It seems likely that Raphael continued his apprenticeship under Timoteo Viti, otherwise known as Timoteo of Urbino.

Timoteo Viti (1469/70–1523), who was born in Urbino, had probably been a pupil of Giovanni Santi. He did some training as a goldsmith, then went on to study painting under Francesco Francia in Bologna, returning to Urbino in 1495. He is recorded as having painted *Apollo and the Muses* for the Temple of the Muses in the Ducal Palace, a work that was much admired by Vasari when he saw it in 1548.² Timoteo Viti's sensitive yet slightly archaic style is represented in the collection at the Ducal Palace by his painting on canvas *Trinity between St Jerome and the Blessed Colombini*. There is also a panel of stained glass designed by him, with an Annunciation above, heraldry and cherubs below (see page 156).

A colleague of Timoteo's was Girolamo Genga (1476–1551), architect, painter and stage designer. He was born in Urbino, and his house was near the Porta Sta Lucia. He was also a musician and, according to Vasari, a very pleasant character. He studied with Luca Signorelli, and then (like Raphael) with Perugino, concentrating particularly on the art of perspective. After that he went to Florence and Siena, working alongside Pandolfo Petrucci until 1512.³ Then he returned to Urbino to work for the court, alongside

Timoteo Viti. As many of the commissions seem to have been for ephemeral things, such as triumphal arches and the caparisons of horses, little of his work survives. But he is accredited with designing the top floor of the Ducal Palace, also probably the Chapel of the Sepulchre in the cathedral.

Paintings by his hand are fairly rare, but in the Uffizi, Florence, there is a *Martyrdom of St Sebastian* – the saint is tied to a tree and posing elegantly while his assailants take aim. It is essentially a decorative picture; the clever foreshortening of the figures show a command of perspective which was to stand him in good stead when it came to designing for the stage (see pages 149–50), which was probably his greatest achievement.

In 1500, when he was seventeen, Raphael went to Perugia to work under Pietro Perugino, whose style strongly influenced him at this time. It is said that he was sent there by his uncle Simone Ciarla and his guardian Don Bartolommeo.

In the Royal Collection at Hampton Court Palace there is a small, beautifully preserved painting of a youth, just head and shoulders, set against a softly contoured landscape and a clear summer sky. The front of his tunic is fastened with two buttons and if these buttons are inspected with a magnifying glass they will be found to bear the inscription RAFFAELLO on one and URBINUS on the other, indicating that this is a self-portrait by Raphael. According to the catalogue (*Early Italian Pictures in the Royal Collection*) it dates from about 1506. But if one considers the boyish plumpness and warm colour of the cheeks and the fullness of the lips, and compares the painting with the self-portrait in the Uffizi (also said to date from around 1506) with its melancholy air, sallow

ABOVE: *Madonna and Child*, painted on the wall of the room where it is said Raphael was born. It is either a very early work of his, or by his father Giovanni Santi.
RIGHT: Self portrait by Raphael as a very young man (Royal Collection, Hampton Court).

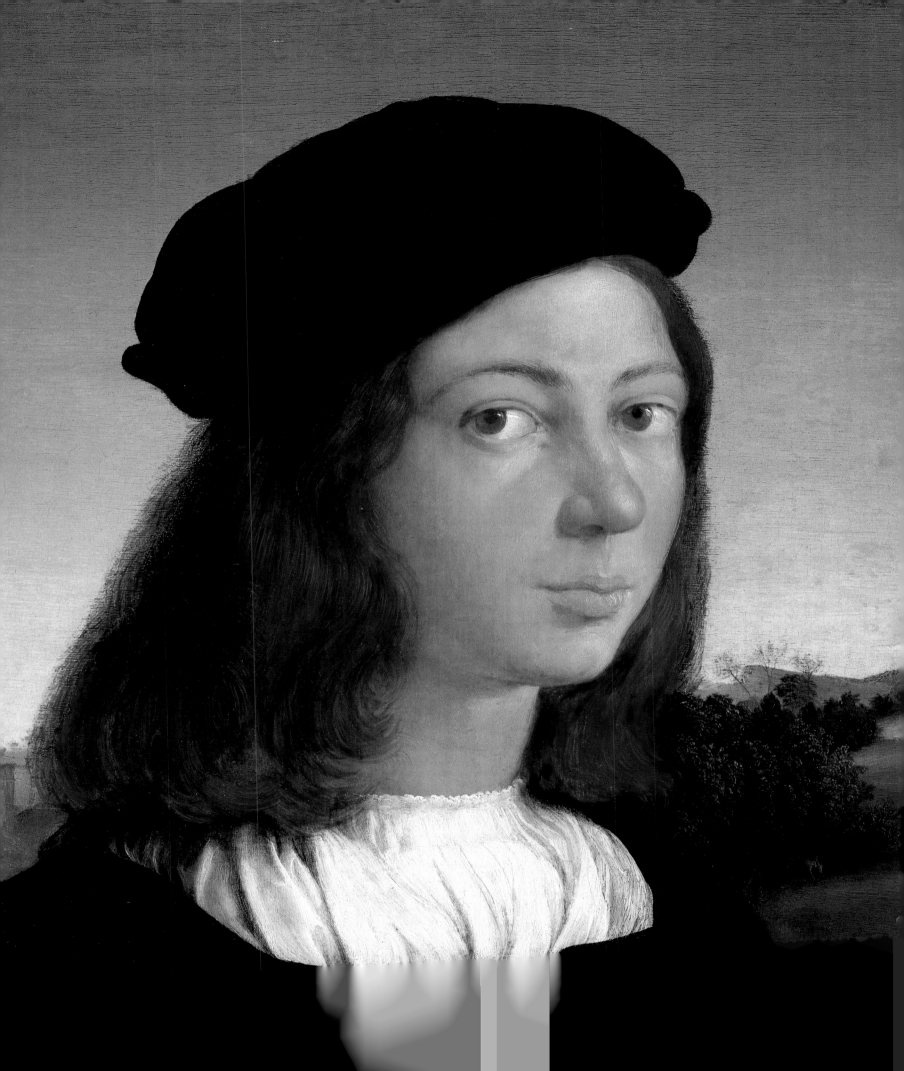

complexion and rather sunken cheeks, one is forced to conclude that the Hampton Court painting is considerably earlier, perhaps painted when the artist was no more than an adolescent, possibly when he was still living in Urbino.[4]

It was no doubt fortunate for Raphael that he had moved out of the city at the time when it fell into the hands of Cesare Borgia, for the Montefeltro were traditionally his good patrons.

Under Perugino, Raphael worked very much in the manner of his mentor. The *Sposalizio* (*Betrothal of the Virgin*) in the Brera Gallery, Milan, shows clearly the influence of the older painter, and at the same time (if we compare it with Perugino's version of the subject in Caen) by how much the younger artist surpassed him. After that came what is known as Raphael's Florentine period; from this time dates the *Madonna della Seggiola* (*Madonna of the Chair*) which used to hang in the Cappella del Perdono in the Ducal Palace. In fact Raphael never had a permanent home in Florence, but was very much aware of artistic developments in the city. He was influenced in particular by the work of Leonardo – as is shown by his Madonna paintings and portraiture (such as the painting known as *La Muta*, which can seen in the Duchess's apartments in the Ducal Palace of Urbino) – and to some extent by Michelangelo as well. With the encouragement of Bramante (see page 108), to whom he may possibly have been related, Raphael went to Rome in 1508, where he painted *The Triumph of Galatea* for the Villa Farnesina (1511) and was commissioned by Pope Julius II to paint the first of the papal apartments, known as the Stanza della Segnatura. Raphael's work in the Vatican Stanze, which he continued for Leo X, was the summit of his all-too-short career.

The dying Bramante having nominated him as his successor, on 1 August 1514 Raphael was appointed chief architect of St Peter's. Then four years later he was entrusted by Leo X with the responsibility of being Inspector of Antiquities in Rome. Through this appointment he became aware of the intricacies of the Golden House of Nero ornamentation known as *grotteschi*; he used similar designs to enrich the corridors of the Vatican.[5]

It was in 1514 that he wrote to his friend Baldassare Castiglione in Urbino concerning his thoughts about ideal beauty:

As for the *Galatea*, I should consider myself a great master if it had half the merits you mention in your letter. However, I perceive in your words the love you bear me, and I add that in order to paint a fair woman, I should need to see several fair women, with the proviso that your lordship will be with me to select the best. But as there is a shortage both of good judges and beautiful women, I am making use of some sort of idea which comes into my mind. Whether this idea has any artistic excellence in itself, I do not know. But I do strive to attain it.

ABOVE: *Madonna della Seggiola*, Raphael, now in the Palazzo Pitti, Florence.
RIGHT: The Cappella del Perdono, where the *Madonna* used to hang.

Raphael died, greatly mourned on his thirty-seventh birthday. Although he had moved away from his native city, it seems that Raphael continued to think of himself as a native of Urbino. His portrait of a girl known as *La Fornarina* (the baker's daughter), who was probably the artist's mistress, bears on her upper arm a bracelet inscribed RAPHAEL VRBINAS.[6]

By the time, after the fall of Cesare Borgia, Guidobaldo had been restored to his duchy, Raphael had returned to Urbino and did portraiture at the court. His painting of Elisabetta Gonzaga is a small work in tempera on wood, dating from 1502–3. Together with the portraits of Guidobaldo, and young Francesco Maria della Rovere, it hangs in the Uffizi Gallery, Florence. The Duchess's portrait is waist-length, and she wears a striking black dress, relieved with a broken stripe in gold (one wonders if it is the costume she wore for Lucrezia's wedding).

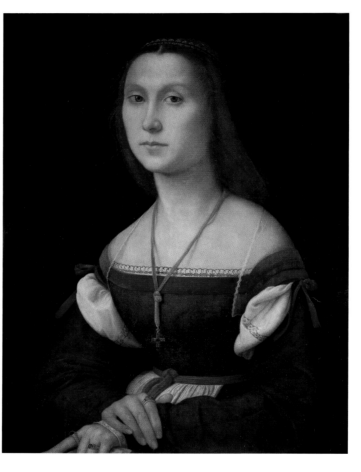

Her face is rather long and sad, as if she had endured much – which indeed she had. Her cheeks are rounded and not without colour, and she is portrayed full-frontal against a blue afternoon sky, the light just catching a jagged rock in the otherwise gentle landscape behind her.

The slightly larger portrait of Guidobaldo is more melancholy in mood, and is a few years later in date. It is thought to have been painted between 1506 and 1508 (the year of his death). The Duke is clad in almost entirely unrelieved black, and the painting is again in tempera on wood. The background is mainly an undefined greyish interior, though a landscape is visible through an aperture.

Guidobaldo stares fixedly ahead, his face thin and drawn, his hair lank; he has the look of one not long for this world.[7]

In the same gallery is a small portrait of a youth, also done in tempera, dating from 1503/4; he is dressed in carmine with a fur-lined cloak, and is thought to be the Duke's nephew, Francesco Maria della Rovere. If this is the right identification, the sitter is thirteen or fourteen years old – which is probably credible; though the face is full of nervous tension, the hands are those of a boy.

Also in the Uffizi are portraits of Francesco Maria della Rovere and his wife Eleonora Gonzaga by Titian, painted in 1536/8. It is difficult to say whether the Raphael portrait shows the same person as the rugged bearded character painted by Titian more than thirty years later.

One cannot by any means claim Titian (Tiziano Vecellio, *c*.1489–1576) as an artist hailing from Urbino. Essentially he was a Venetian, but at the same time he was a nationally – even internationally – known figure, at home in many courtly and intellectual circles. He did portraits of the Emperor Charles V and of the Pope, he painted mythological subjects for the Duke of Ferrara and for the King of Spain and he counted Bembo and Aretino amongst his friends. The canvas of *The Last Supper* in the Urbino Gallery was originally part of a processional banner. The lovely *Venus of Urbino*, now in the Uffizi, is a comparatively early work, painted for Duke Guidobaldo II in 1538. It shows the influence of Giorgione (whose pupil Titian had been), and is related to that master's *Dresden Venus*, but Titian's reclining goddess is no innocent nymph sleeping in a wood, but a self-aware young lady gazing

LEFT: *La Muta*, Raphael (Ducal Palace, Urbino).
ABOVE: *The Institution of the Eucharist*, Federico Barocci (Duomo, Urbino).

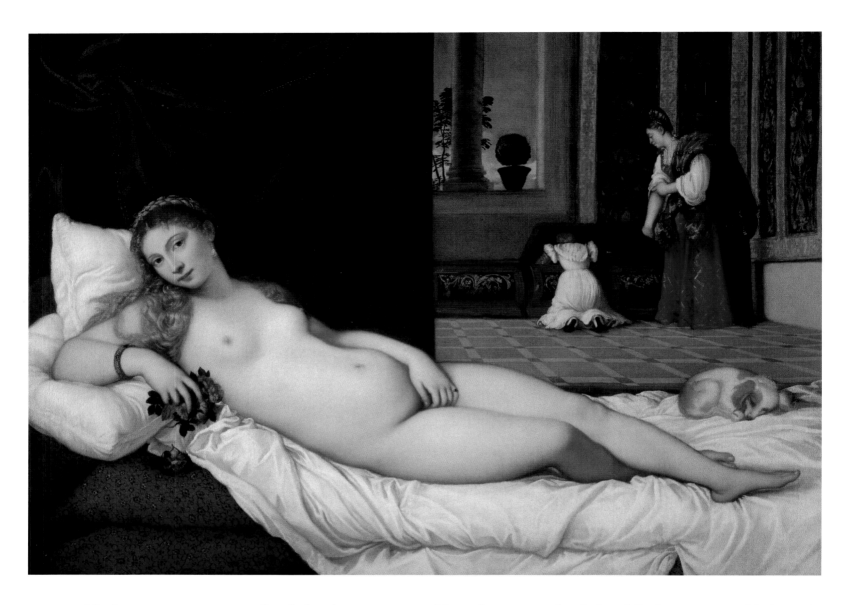

at you while her servants rummage for clothes in a cassone. Clearly in this courtly circle, there was now patronage for distinctly secular subjects.[8]

While Titian cannot be claimed as more than an occasional visitor, Federico Barocci (Federico Fiori, *c.* 1535–1612), both born and dying in Urbino, was very much a native of the city. Early in his career he made two visits to Rome, but apart from that he was firmly rooted in Urbino. His work was considerably influenced by Raphael and Correggio; at the same time his greatest compositions, such as the *Madonna del Popolo* in the Uffizi (1579), and *The Institution of the Eucharist* (1603–7) in the Urbino Gallery show him to be an artist of great originality;

his works are never harsh, but full of movement, with dramatic massing of light and shade. In addition he was a pioneer in the art of pastel drawing. He would have been better known in his lifetime had he not (in the words of the great seventeenth-century art critic G. P. Bellori) 'languished in Urbino', for by then its heyday as a city state was over.

MAIOLICA

The art of maiolica was closely allied to that of painting on wood or canvas; in fact it was primarily painting, rather than

the three-dimensional creation of pots. To begin with, however, the pottery was often intended for use, as drug jars, storage jars and dishes, and the function of the decoration was to enhance the form. Then it came to be realized that here was a superb medium in its own right, one that made possible the creation of original pictorial designs or, later, the reproduction in miniature of famous works of art.

The same technique was common to what in France was called 'faïence' (after Faenza), to what in Holland and England was called 'delft'. In Italy it was termed 'maiolica' (from Majorca, where it was thought the art originated). The body of the pot was made in fine earthenware clay and fired at a temperature of about 1,800 degrees Fahrenheit. After this initial firing the wares were dipped into a tin-enamel glaze, consisting of potash, sand and oxides of lead and tin. This was allowed to dry and then it was painted with colours derived from metals: a range of blues could be obtained from cobalt, yellow from antimony, orange from antimony with the addition of iron, green from copper, purple or brown from manganese. Then there was a second firing at a somewhat lower temperature. What was special about the technique and what was so much admired in the Renaissance was the clarity and brilliance of the colours. It needed great skill on the part of the painter, however, to predict the finished effect; for what he actually took on to his brush would be greyish or brownish or dun-coloured, and it would not be until the second firing that the colours were revealed. If it was

desired to have a metallic lustre effect on the top (a particular speciality at Gubbio), silver or copper oxides were painted on, and the wares fired a third time.

Maiolica was therefore essentially a painter's art (even Raphael designed plates, and so did the Urbino artist Girolamo Genga),[9] but a painter with the technical expertise of the ceramics workshop. It was precise and detailed work; it is perhaps not accidental that at about the time when the art of illuminating manuscripts was in decline, the art of the maiolica painter had its finest hour.

By the mid-sixteenth century, Urbino with its surrounding area had become a pre-eminent centre, one can even say *the* pre-eminent centre for Italian maiolica.[10] The great period began in about 1520 with the exquisite work of Nicola da Urbino (1480–1537/8), who trained in the Urbino bottega of Guido Durantonio (Guido of Castel Durante). Nicola excelled in what is known as *istoriate* ware, dishes with a narrative depicted on them (such as the famous plate of St Cecilia, 1528, in the Bargello, Florence, or the *Calumny of Apelles* dish of *c.*1522, now in the Ashmolean Museum, Oxford). 'Istoriate' ware, in the hands of a lesser master, can be crude and strident; but in Nicola's it is subtle and delightful – the *Calumny of Apelles* design, for instance, with its delicate range of pale blues, is especially lovely. In 1524 Nicola executed a service for Isabella d'Este, and in 1531 worked on a table service for Federico Gonzaga, Duke of Mantua, to celebrate his marriage with Margherita

LEFT: The *Venus of Urbino*, Titian (Uffizi, Florence).
ABOVE: Maiolica dish *The Calumny of Apelles* by Nicola da Urbino, *c.*1522 (Ashmolean Museum, Oxford).

Paleologo. (There are examples in the museum at Faenza, the Wallace Collection and the British Museum.)

Among other eminent names in the field of maiolica is that of Maestro Giorgio Andreoli of Gubbio. He was born in Lombardy in 1465/70 and by 1492 had set up a workshop in Gubbio along with his brother Salimbene. They excelled in lustre-wares; indeed there is a theory that dishes from workshops elsewhere used to be sent to Gubbio for this special finish. The very lively *Hercules and the Hydra* bowl of *c*.1520 at the Ashmolean was probably made in Maestro Giorgio's *bottega*.

Practising in the 1530s was Francesco Xanto Avelli, who came from Rovigo. A poet as well as a maiolica painter, he wrote a series of sonnets, *Il Rovere Vittorioso*, dedicated to Francesco Maria della Rovere. In 1531 he did an *istoriate* plate showing the flooding of the Tiber (now in the Museo del Castello, Milan) and in 1533 executed a great marriage plate of Alexander and Roxana, with Gonzaga-Paleologo-Monferrato heraldry (now in the British Museum, London), and another one the following year which is now in the Metropolitan Museum, New York. His work is highly coloured and his figures have a *découpage* appearance; many of his compositions are derived from the engravings of Marcantonio Raimondi.

Guido Durantino, who was also known as Guido Fontana, ran a workshop in Urbino together with his son Orazio Fontana for several decades from the 1530s onwards. From this workshop came a great table service for Anne de Montmorency, Constable of France, made in 1535. Most of the pieces are now in public collections in London and Paris. At the British Museum in London is a plate with Jove and Semele, and at the Ceramics Museum of Sèvres a dish with Joseph sold to Potiphar; both also date from 1535. By Orazio Fontana is a plate from 1541, which is now in the Victoria and Albert Museum in London, showing horsemen and a view of the city of Urbino. Orazio also worked for Cardinal della Rovere, and painted a stemmed dish with Raphael's *Triumph of Galatea* from the Farnesina (1542); and executed a design of the Prodigal Son (now in the Museo Civico, Bologna), based on a Dürer print. In 1565 Orazio Fontana

left his father's workshop but continued to work in the *istoriate* manner.

Most of the elaborate pieces had up to this time been executed in this tradition, with the designs essentially pictures, to be seen from one angle only. There were also simpler wares, including charming dishes (mainly from Castel Durante, rather than Urbino itself) with portraits of girls backed by curling ribbons inscribed 'Camilla Bella', 'Gentile Bella', 'Elisabetta Bella', 'Susanna Bella' and so forth; there are some delightful examples in the Arezzo Museum and in the Museo Civico, Pesaro. Meanwhile the *istoriate* tradition slowly gave way to designs based on the *grotteschi*, or arabesques, that had so impressed Raphael at the Golden House of Nero; these were often referred to as *raffaelleschi*. This new style, much used by the workshop of Alfonso Patanazzi which dominated Urbino maiolica towards the end of the sixteenth century, encouraged designs which reflected the circular shape of the plates rather than running horizontally across them. There are some excellent examples in the Civic Museum of Pesaro. The Patanazzi workshop also produced richly coloured figures in relief; a number of these are on display on the upper floor of the Ducal Palace in Urbino.

Splendid services of maiolica continued to be sent as gifts to foreign potentates. For instance, in 1586 Francesco Maria II sent a case of vases to the Duke of Bavaria, and in 1603 sent eight cases of Urbino wares to the King of France at Fontainebleau. In 1608 he also gave a set of drug jars from the Orazio Fontana workshop to the Sanctuary at Loreto. The production of maiolica did not cease with Urbino's fall from political importance. The Patanazzi workshop of Alfonso, together with his brother Antonio, continued until the early seventeenth century. (There is a plate of Romulus and the Sabines in the Victoria and Albert Museum, dating from 1606.) But the great tradition came to an end when in 1637, at the time of the marriage of Vittoria della Rovere with Ferdinand II, the famous workshop of Orazio Fontana packed up and transferred to Florence.

It had been a fine flowering, lasting over a century, when from the little city of Urbino came many of the most beautiful maiolica wares the world has ever seen.[11]

MUSIC

While the art of maiolica had hardly begun before the year 1500, the art of music flourished in Urbino throughout the Renaissance.

The great Duke Federico, we are informed by Vespasiano da Bisticci, 'delighted greatly in music, understanding vocal and instrumental alike, and maintained a fine choir with skilled musicians and many singing boys. He had every sort of instrument in his palace and delighted in their sound, also the most skilful players. He preferred delicate to loud instruments, caring little for trombones and the like.' Nevertheless he employed six *trombetti* and two *tamburini* as well as two organists. A finely produced songbook was among the volumes in the Ducal Library.

This strong interest in music is reflected in the remarkable intarsia designs of the Studiolo in the Ducal Palace. Not only do they display a well-known French song, *J'ay pris amours*, but also a representation of a clavichord with the strings not tuned in unison and varying in length according to the pitch, but tuned in pairs by keys, making it possible for the instrument to be far more compact. This is the earliest depiction of such a clavichord, in advance of anything else made at this time.[12] It is shown as having four octaves, starting with a low F, sounded from seventeen pairs of strings. This apparently set the pattern for clavichord design until the 1530s. Doubtless the real instrument actually existed among the furnishings of the palace, even though it is not immediately recognizable in the inventories.

The members of the chapel choir, according to Vespasiano da Bisticci, were Don Luchino di Magio, Don Giohanni Fiorentino and Don Perino; he also lists the singing boys –

Baldassare de Costacciano, Balbo de Genghe, Jacomo de Ugobbio, Domenichino Fiorentino, Don Checo and Bernardino d'Antonio Santicchia da Gobbio. The organists were Baldassare da Camerino, Pier Andrea da Ferrara and Maestro Pietro.

While there seems to have been no shortage of Italian singers and instrumentalists (even if some of them had to be brought in from Florence, Gubbio and Ferrara), with composers it was another matter. They were mainly French or Flemish, such as Guillaume Dufay (c. 1400–74) and Josquin Desprez (c. 1440–1521). They had been reared in the cathedral choir schools of Cambrai and Liège, and came south seeking the more generous patronage of Italian courts. While neither of these composers (as far as we know) came nearer than, say, Rimini, Pesaro and Ferrara – the city being somewhat remote – there is no doubt that their work was well known in Urbino.

Guidobaldo founded the Cappella Musicale of Urbino, and his wife Elisabetta Gonzaga was an accomplished musician, both as a singer and a lutenist. Since it was she, rather than the Duke, with his fading health, who became the central figure of the court, it followed that around her gathered some of the greatest talents of the day (see Chapter 11).

DANCE

Popular dance and court dance existed alongside each other, but during the Renaissance period the difference between them widened. Court dancing became more elegant, more defined and precise. Duke Federico in his time kept two dancing masters: Guglielmo Ebreo of Pesaro (presumably a

A clavichord shown in the intarsia decoration of Federico's Studiolo. Though the actual instrument has not survived, it is a fair assumption that the Duke had one like this, a design some fifty years ahead of its time.

Jew) and his son Pierpaolo. It was Guglielmo, who died some time after 1481, who taught Isabella d'Este to dance. He was also a poet, and described how the art of dancing comforts and refines the noble mind.

The most common form of dance at court was the *bassadanza* (low dance), with its slow tempo in four-time, stately rather than exciting. It was said of Queen Elizabeth I of England that she preferred to 'dance high, after the Italian fashion'. This refers to the *saltarello*, from the word *saltare*, to leap, a high jump into the air being a feature of the dance. A German form of the *salterello*, with four-beat rhythm, was known as the *quatemaria*. Then there was the popular *moresca*, a vigorous dance of Arabian origin. The stately pavane and the brisker galliard were dances of international renown, performed in almost every European court.

The *piva* (meaning pipe or bagpipe) was originally a popular dance, but one which was adopted by the court. It allowed for a degree of improvisation; while the ladies had to keep decorously to the basic steps, the men could leap and twist and gambol about. It was this dance, Giuseppe Magaletta maintains, which was the origin of all the rest.[13]

POETRY

Poetry, music and dance tended to go together in Renaissance culture, but especially if the reigning prince were a poet himself. This was the case in Florence in the court of Lorenzo de' Medici (1449–92); himself an accomplished poet, composing the lyrics of songs for dancing, he gathered round him writers of the quality of Angelo Poliziano. In Urbino meanwhile, although he had many other attributes, Duke Federico was not known to be a poet, nor was his son Guidobaldo. So while the encouragement may have been there, poetry tended to be a secondary activity undertaken by people principally known for something else: as painters, like Giovanni Santi, or as maiolica artists, like Francesco Xanto Avelli.

In any case poetry was usually a private affair and depended less on courtly patronage than almost any other art. It is generally a matter of accident where a poet is born, is brought up and

spends his adult life. But in the case of the great Torquato Tasso (1544–95), Urbino may claim to have been a formative influence in his youth, and a city to which he returned thankfully in the turbulent wanderings of his later life. In the Piazza Rinascimento in the centre of the city, there is a tablet which reads:

COMFORTED IN HIS SORROWS
BY THE AFFECTION OF HIS COMPASSIONATE FRIENDS
HERE LIVED IN THE YEAR 1578
TORQUATO TASSO
GUEST OF FEDERICO BONAVENTURA

Torquato Tasso was born in Sorrento, the son of a less well-known poet Bernardo Tasso, who was made secretary to the Prince of Salerno. Torquato at first remained with his father and went to school in Naples. In 1552 Bernardo followed his prince into exile, and at the age of ten Torquato joined his father (he was never to see his mother again) and in 1557 went with him to Urbino, where he was educated at the court for almost two years, together with the Duke's son. His subsequent career took him to Padua, where he wrote his romantic poem *Rinaldo* in 1562. After continuing his studies there and in Bologna, he spent some twenty years at the court of Ferrara. He fell in love with Laura Perperara and wrote a number of exquisite lyrical poems to her. His pastoral poem *Aminta* dates from 1573, and his chief work, *Gerusalemme Liberata*, from two years later. But it was at this time that he began to suffer from some undiagnosed mental complaint that led him to wander apparently aimlessly around Italy; sometimes he was violent and this led to his being imprisoned for seven years in the Hospital of St Anne at Ferrara. He died in Rome, where Pope Clement VIII was about to crown him Poet Laureate.

The stay with his friend Federico Bonaventura must have provided a pleasant respite in the city where he had spent two relatively tranquil years in his youth. Perhaps he had Urbino in mind when he wrote these lines in *Aminta*:

O lovely age of gold
Not that the rivers rolled

CONFORTATO NEI SUOI DOLORI
DALL'AFFETTO DI PIETOSI AMICI
QUI DIMORO NEL MDLXXVIII.
TORQUATO TASSO
OSPITE DI FEDERICO BONAVENTURA

IL FORTUNATO EVENTO
SCRITTO NEI FASTI DELLA PATRIA
E NEL CUORE DEL POPOLO
GLI URBINATI COMMEMORARONO CON SOLENNITÀ
NEL MDCCCLXXXXV.
COMPIENDOSI VIII. SECOLI DALLA PRIMA CROCIATA
III. DALLA MORTE
DEL GRANDE ED INFELICE POETA

T. TASSO

With milk, or that the woods wept honeydew;

Not that the ready ground

Produced without a wound,

Or the mild serpent had not tooth that slew;

Not that a cloudless blue

Forever was in sight,

Or that the heaven, which burns

And now is cold by turns,

Looked out in glad and everlasting light . . .

. . . But that law of god,

That glad and golden law, all free, all fitted,

Which Nature's own hand wrote – What pleases is permitted.[14]

Another poet, years after the Renaissance period, but continuing the creative tradition, was Giovanni Pascoli (1855–1912). He spent part of his boyhood in Urbino and his poem 'L'Aquilone' ('The Kite') appears as a tailpiece on page 189.

Urbino in the Renaissance had a cultured and intellectual ambience, a nursery for scholars. The Collegio dei Dottori, founded in 1502, was established as a university by Pope Julius II in 1507.

The historian Polydore Vergil (Polidorio Vergilio) was born in the city in about 1470, and died there in 1555. He was educated in Padua and Bologna, and was at first, it seems, secretary to Duke Guidobaldo. After ordination, he became chamberlain to the Borgia Pope Alexander VI, who sent him to England to collect 'Peter's Pence' (an ecclesiastical tax levied in England until it was abolished by Henry VIII in 1534). In this country he was given various church preferments, including being made Archdeacon of Wells (1508), and in 1510 he adopted English nationality. He became an enemy of Cardinal Wolsey and in 1515 he was imprisoned for the letters he wrote about him. He was accepted as a historian into the London humanist circle of Sir Thomas More, John Colet and William Grocyn. He

ABOVE LEFT: Bust of Torquato Tasso, Piazzale Roma.
ABOVE RIGHT: Tablet recording that the poet Torquato Tasso took refuge in Urbino, staying with his friend Federico Bonaventura.

QVI NACQVE E QVI VOLLE TORNARE IN TARDA ETÀ
POLIDORO VIRGILI
1471? — 1555
IN INGHILTERRA IN MISSIONE APOSTOLICA
DIVENVTO ARCIDIACONO DI WELLS
E STORICO INSIGNE
IN DOTTO LATINO
PER PRIMO
STESE VNA STORIA VERACE DELLA NAZIONE INGLESE
CRITICAMENTE FONDATA
AMICO DI ERASMO E DI TOMMASO MORO
VMANISTA POLITICO MORALISTA
AVTORE DI OPERE CELEBRI
NELL'EVROPA DEL RINASCIMENTO

THEATRE

The Italian Renaissance revival of drama was in the first place based on a rediscovery of the plays of classical antiquity, particularly the Latin works of Plautus, Seneca and Terence. Terence's plays first appeared in print in 1471. Plautus's *Menaechmi* (later to be the basis for Shakespeare's *Comedy of Errors*) was performed in Ferrara in 1487. Directly inspired by ancient mythology, Angelo Poliziano's *Orfeo*, a highly original and lyrical work (to some extent prefiguring opera) was performed in Mantua, probably in 1480.

These will have been known of, even though not directly experienced, in Urbino. There, as in most great cities, they had a tradition of religious drama that went back to the Middle Ages, performances often being linked with particular church festivals. These involved much poetry and music and at first were staged in the churches themselves. There was a growing use of scenic effects.

At the same time there were court performances of allegorical dramas, probably on much the same lines as the masques of sixteenth- and seventeenth-century England. The first that we know about is *Amore al Tribunale della Pudicizia*, which was presented in honour of Prince Federigo of Aragon on the occasion of his visit to Urbino in September 1474. It is uncertain who the author was; it may have been Raphael's father Giovanni Santi.

The plot is that Venus's son Cupid is accused by six famous women, including Cleopatra, of having encouraged them in their incestuous love; they say he should have put a limit to their unbridled passions. Penelope (the wife of Ulysses) enters to plead the case for the women; then Cleopatra announces the arrival of certain famous queens who will judge the matter. After this the performance which continues is mainly musical: Cleopatra playing on various instruments, silken-clad nymphs dancing, and Penelope followed by Pudicizia (Chastity) singing *J'ay pris amours* (the French song the score to which was featured in the intarsia in Duke Federico's

also knew Erasmus. Apart from a book on inventions (*De inventoribus rerum*, 1499), his principal work was his history of the English people in twenty-seven volumes, *Historiae Anglicae libri viginti septem*, published in Basle in 1534. An immensely influential book, it was made required reading in all English schools by order of the Privy Council in 1582. It was also the basis for the chronicles of Edward Hall and Raphael Holinshed – on which Shakespeare based most of his history plays.

Polydore Vergil is therefore a figure who should be regarded even more in the context of English culture than in Italian; yet he never totally abandoned his native soil and made occasional visits home. Then in 1550 he obtained permission to return (without however losing his Church preferments in England) and he died in Urbino on 18 April 1555. Writing in Latin gave Polydore Vergil international status in his day. He represents a unique link between Urbino and England.

ABOVE: Tablet on the house of the historian Polydore Vergil, who was a notable link between Urbino and England in the sixteenth century. RIGHT: The court theatre of the Gonzaga family at Sabbioneta, near Mantua. There would have been a theatre similar to this in the Ducal Palace in Urbino.

Studiolo). Then follow the six queens, and the performance finishes with a dance and a song by Nicostrata Carmenta (one of the queens) extolling the virtues of the House of Aragon in general and Prince Federigo in particular.

It was hardly gripping drama perhaps, but certainly a synthesis of the arts.

The most memorable production in Renaissance Urbino was of the play *La Calandria* by Bernardo Dovizzi (Cardinal Bibbiena) in 1513. It was staged in the Ducal Palace.

The rooms used for this and other theatrical productions were on the ground floor, one level below the principal state rooms. They adjoined the Terrazza del Gallo on the south side of the *torricini*, and near them was a large banqueting room. (In Pasquale Rotondi's book on the Ducal Palace the rooms are numbered 61 and 62.)

La Calandria is a comedy. The prologue, spoken by Baldassare Castiglione, emphasizes that it is in prose not verse, in modern not antique language, and in the vernacular not Latin. He says why it is appropriate that this should be so, quoting Plautus as a precedent. This was followed by a mildly lascivious prologue spoken by the author.

The plot of *La Calandria* is rather like that of *Twelfth Night* in that it involves a pair of mixed twins so alike that they can only be told apart by their dress. Their names are Lidio and Santilla, and they are fleeing persecution by the Turks. They are separated, and in the course of the action, boy dresses as girl and girl as boy, with resultant confusion. However it all ends happily, with the twins, and everyone else, convinced that there is nowhere in the world as secure and civilized as Italy.

It is a racy play, and much of its humour derives from the dialogue between the servants. Written as it was nearly a century before *Twelfth Night*, *La Calandria* is significant as one of the very earliest Renaissance comedies.

What made *La Calandria* such a sensation at the time was not so much the plot as the scenery. Almost certainly this was designed by Girolamo Genga, and it was probably the first time a perspective setting had been used on the Renaissance stage, creating a vision of incredible depth and complexity. The whole scene was vividly described by Baldassare Castiglione in a letter written to Ludovico Canossa:

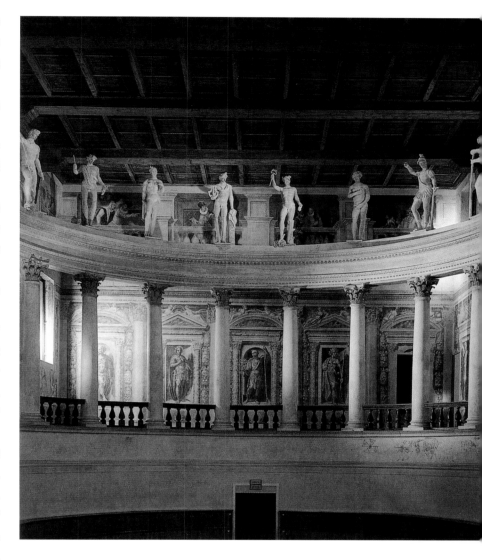

The scene represented was an outer street of the town, between the city wall and its last houses. The wall with its two towers was represented in the most natural way possible, rising from the floor of the stage to the top of the hall. One tower was occupied by the pipers, the other by the trumpeters, and between the two there was another finely constructed rampart. The hall itself, where the audience sat, occupied the place of the moat, and was crossed as it were by two aqueducts . . .

The scene was laid in a very fine city, with streets, palaces, churches and towers, all in relief, and looking as if they were real, the effect being completed by admirable paintings in scientific perspective. Among other objects there was an octagon temple in low relief, so well finished that, even if all the workmen in the duchy of

Urbino had been employed, it seemed hardly possible to think that all this had been done in four months! The temple was completely covered with beautiful stucco reliefs, the windows were made to imitate alabaster, the architraves and cornices were of fine gold and ultramarine blue, with glass jewels here and there, looking exactly like real gems; there were roundels of marble containing figures, carved pillars, and much more that would take me too long to describe. This temple stood in the centre of the stage. At one end there was a triumphal arch about two yards from the wall, marvellously executed. Between the architrave and the vault an admirable representation of the story of the two Horatii had been painted to imitate marble. The two niches above the pillars supporting the arch were filled with little Victories bearing trophies in their hands made of stucco. On the top of the arch stood a most beautiful equestrian statue of a figure in armour, striking a vanquished man at his feet with his spear. To right and left of this rider were two little altars with vases of burning flame that lasted to the end of the comedy.[15]

For the audience there were tiers of seats, and on the wall behind them were hung the famous tapestries of the Trojan War. Candelabra in the shape of letters spelling out DELICIAE POPULI, each of them holding between seven

Perspective drawing for Cardinal Bibbiena's *La Calandria*. This design was made by Baldassare Peruzzi for the play's repeat performance in Rome; Genga's highly original set for the Urbino production would have been on the same lines.

and ten torches, were strung across from between bunches of foliage; a highly dangerous lighting arrangement, one would think.

The evening's entertainment included *intermezzi* (interludes) as was the custom: first a *moresca* of Jason sowing the ground with dragon's teeth which spring up as armed warriors; they are slain, and Jason appears triumphantly with the Golden Fleece. The second interlude featured Venus drawn in a chariot by two doves, the third was of Neptune and sea monsters, then finally arrived Juno in her chariot 'drawn by two peacocks so beautiful and lifelike that I could not believe my eyes, and yet I had seen them before and had myself given directions how they were to be made'. In fact the poet and diplomat Castiglione (of whom more in the next chapter) had been closely involved with the whole production. He relates that his prologue was included because the actor who was to recite the original one arrived too late to learn the words.

La Calandria was such a success that it was repeated in Rome the following year, again with perspective settings (this time by Baldassare Peruzzi), for the delectation of Pope Leo X and of Isabella d'Este, who was visiting.

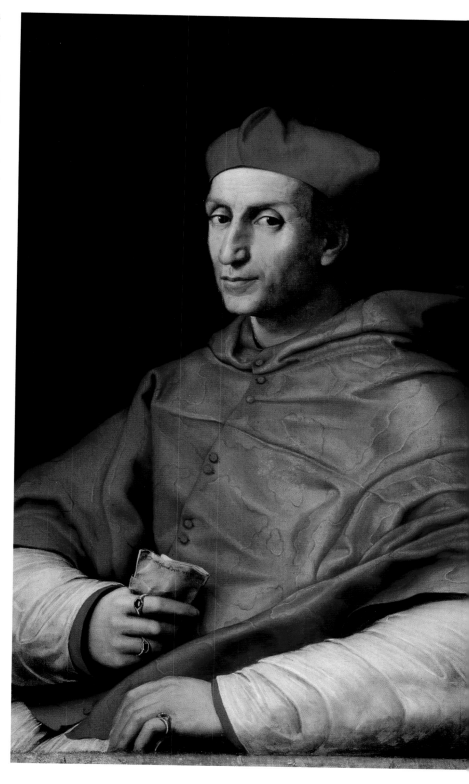

Portrait by Raphael of Cardinal Bibbiena, author of *La Calandria* and friend of Baldassare Castiglione (Galleria Palatina, Florence).

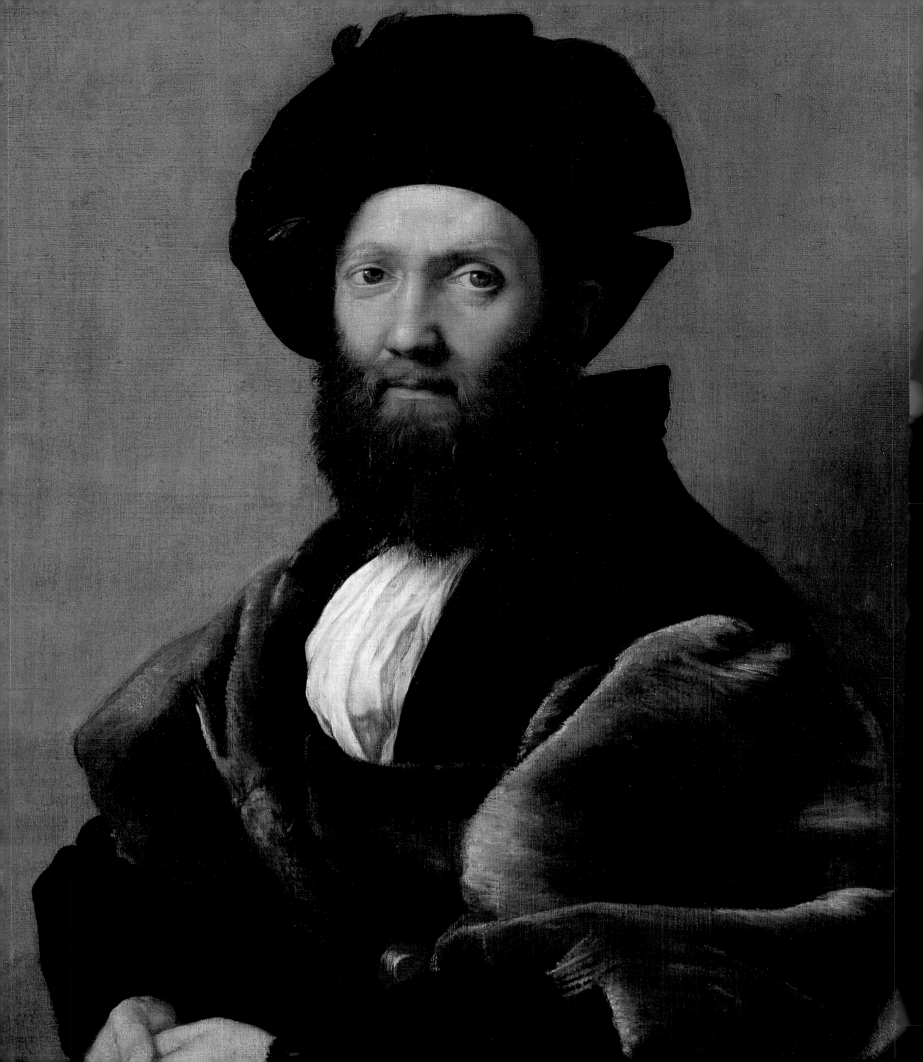

THE BOOK OF THE COURTIER

When Baldassare Castiglione breathed his last in Toledo, the Emperor Charles V declared, 'I tell you there has died one of the greatest gentlemen of the world.' He was not forgotten; his fame and influence survived in that best-selling publication of the sixteenth century, *Il Cortegiano*, or *The Book of the Courtier*.

The warrior pope Julius II arrived in Urbino in September 1506 (shortly after he had commissioned Bramante and Michelangelo to commence the rebuilding of St Peter's), and he was given an enthusiastic welcome by the citizens. In fact it was an uproarious scene as the Urbinati tried to grab hold of his mule, nearly unseating him and disturbing the composure of the cardinals. The Pope was well disposed towards Guidobaldo and Elisabetta and fond of his young nephew Francesco Maria; so his stay was amicable but necessarily short, as he was anxious to press on to Forlì and thence to see the subjugation of Bologna.

He returned victorious in the early spring, and once again broke his journey in Urbino. He himself stayed there only one day, but in his train there were a number of gentlemen, scholars, writers, artists and musicians, and some of these stayed on in the cultured ambience of Urbino. It was on their supposed discussions that *The Book of the Courtier* was based.

By this time it was a court essentially dominated by women. Duke Guidobaldo was in a state of premature decline, and barely had the use of his limbs; he could take little part in any festivities and was in the habit of retiring to bed immediately after supper. The unfortunate fellow, Castiglione remarked, seldom succeeded in anything he undertook. So while the fact that he was still alive and still titular head of state lent a certain stability to the situation, in

'THE MOST IMPORTANT SINGLE CONTRIBUTION TO A DIFFUSION OF ITALIAN VALUES.'

Denys Hay, 'On Italian and Barbarian Europe', 1960

I might have lived . . .
In the green shadow of Ferrara wall;
Or climbed among the images of the past
The unperturbed and courtly images
Evening and morning, the steep street of Urbino
To where the Duchess and her people talked
The stately midnight through until they stood
In their great window looking at the dawn.

W. B. Yeats, 'The People' from *The Wild Swans at Coole*, 1919

Portrait, by Raphael, of Baldassare Castiglione, author of *The Book of the Courtier* (Louvre, Paris).

social terms it was the Duchess who reigned. She set the tone, and Urbino became a Mecca for the intelligentsia of Italy. In providing a pleasant and sympathetic milieu for discussion, her court was in a way the precursor of the salons of those formidable literary ladies, Mme de Maintenant, Mme de Staël and Mrs Thrale, but unlike them she only took a minor part in the conversations – her role was gentle supervision rather than active participation.

Baldassare Castiglione professed to have taken no part in the discussions. He alleged that he was absent from Urbino at the time, having gone to England. Castiglione's absence may not make literal sense – for how could he possibly know who said what if he had not been there to hear it? – but it gives the narrative impartiality and so does make dramatic sense.

Castiglione was born in 1478 at Casatico near Mantua. His family was closely linked to the Gonzagas and held administrative posts under them; Baldassare was for the first twenty-five years of he life a protégé and faithful follower of the Marchese Francesco, Elisabetta's brother. He was educated first in Mantua and then at the University of Milan. In Milan he came under the further civilizing influence of the Sforza court, and having added military skills to a knowledge of classical literature, he entered the service of Lodovico il Moro.[1] Then from 1500 until 1504 he was employed by Francesco Gonzaga, and campaigned for him, unsuccessfully, against the Spanish. Meanwhile he had met the Duke and Duchess of Urbino while they were in exile and, recognizing a kindred spirit, Baldassare asked the Marchese if he might enter the service of Guidobaldo. Consent was given only reluctantly, and with the proviso that he should not return to Mantua, or it would be at the peril of his life. Baldassare agreed to these terms even though it meant that he could no longer visit his family or possessions in Mantua.

In 1506 Baldassare was sent to England to receive the Order of the Garter on behalf of Duke Guidobaldo, and to bear gifts to Henry VII in exchange: in addition to the Raphael painting of St George a fine Mantuan horse. Before he left he wrote to Francesco Gonzaga protesting his loyalty. But the Marchese criticized his choice of presents; the horse would not be welcomed since both the Duke of Ferrara and

the King of Spain had sent similar gifts. The Duchess Elisabetta was upset by her brother's unpleasantness, and asked that Castiglione should be allowed to visit his mother (Luigia Gonzaga) and other members of his family in Mantua; this was permitted, but only on the return journey.

Meanwhile King Henry gave Baldassare a magnificent gold collar as a present for himself.[2] While the Pope made his brief visit to Urbino, Castiglione was on this embassy to England; therefore he missed meeting him and, perhaps fortunately, missed meeting the Marchese Francesco as well. It was probably in the following year, 1507, that the first draft of *The Book of the Courtier* was made.

It may be said of Castiglione that he embodied all the attributes he looked for in an ideal courtier – or, we should say, in an ideal Renaissance man.[3] He was a soldier and a writer, composing poetry in both Latin and Italian; he numbered among his friends some of the most gifted people of his day, including Raphael. He was a considerable scholar, and the inventories of his library indicate his knowledge of Greek as well as Latin; he owned ten Greek classical texts, including three manuscripts: the tragedies of Euripides, a comedy by Aristophanes and a work by Emanuel Moscopulos. He was particularly anxious that his son Camillo should learn Greek, and he wrote to his mother in 1521, when the boy was only four, asking her to ensure that he did.

Castiglione was also an enthusiastic and discerning collector. The gold collar he had been given by Henry VII he treasured not only for its monetary value. He owned nine bronzes and a number of marble sculptures, all probably ancient Roman. The artist Giulio Romano seems to have acted as his agent and he trusted his judgment, avoiding paying for any works which Giulio regarded as second rate. He had a rich collection of artefacts in silver, gold and precious stones. He possessed no less than seven portraits by Raphael, whose work he especially admired. In valuing works of art as he did he was aware that he had a classical precedent; he wrote in *The Book of the Courtier*: 'The ancients held art and artists in high esteem, so that they reached the peak of excellence.'

To summarize his further career, when Francesco Maria della Rovere, who had succeeded Guidobaldo as Duke, was

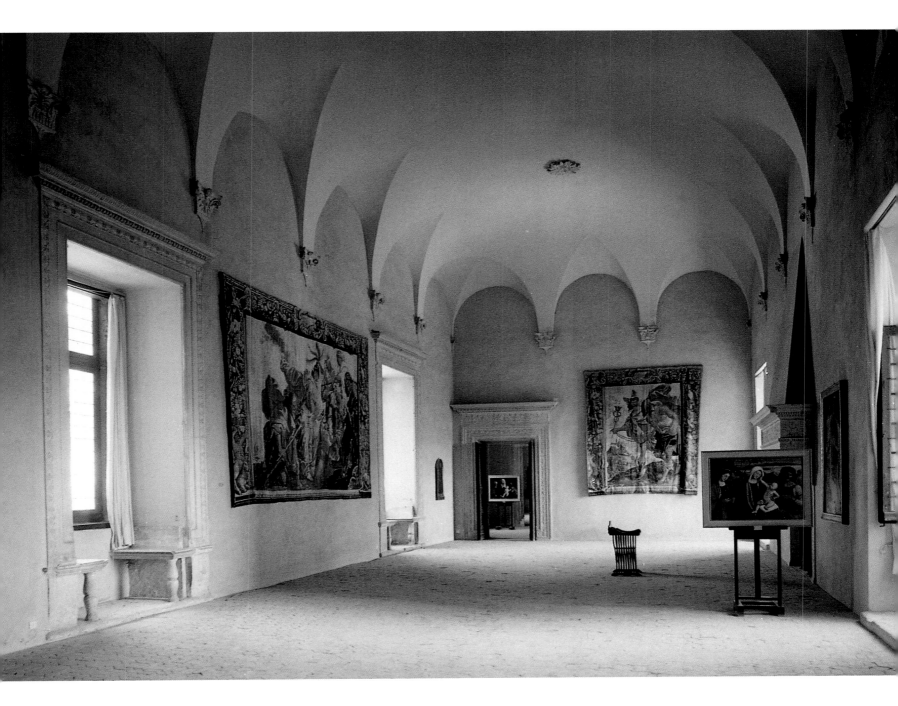

driven out by the forces of the Medici pope Leo X, Castiglione fled from Urbino to Mantua. He worked for the Gonzaga again from 1516 to 1524, during which period he was able to return to his estates and to marry. His wife was Ippolita Torelli, and they had one son, Camillo. The new Marchese, Federico (who had succeeded Francesco) sent him as Mantuan ambassador to Rome. It was at this stage that Raphael painted his portrait, now in the Louvre, as a

The Sala delle Veglie in the Duchess's suite, where the conversations that form the basis of *The Book of the Courtier* took place.

consolation present for Castiglione's wife.[4] Then in 1524 he was sent as papal nuncio to Spain, and it was in Spain that he died five years later.

It is interesting to compare Castiglione's *The Book of the Courtier*, which won him widespread renown, with Niccolò Machiavelli's *The Prince*, which, however much admired it was in Italy, won him centuries of vilification abroad.

Niccolò Machiavelli (1469–1527) was a Florentine who, as principal secretary to the committee responsible for war and foreign affairs, was sent on diplomatic missions to Louis XII and Emperor Maximilian. He wrote dispatches and fought for Cesare Borgia in the Romagna, and for Julius II. In 1506 he was responsible for the organization of an infantry force which was three years later to capture Pisa. He hoped that when the Medici returned to power he would hold office under them, but instead he was unjustly accused of conspiracy. He was imprisoned and tortured. Finally

he was allowed to return to his farm at San Casciano, and it was there that he wrote *The Prince*, which he described as 'a pamphlet on principalities, how they are acquired and maintained and why they are lost'.[5]

He had intended to present it to Giuliano de' Medici, but on his death in 1516 offered it to Lorenzo de' Medici; his aim was to give the prince practical and pragmatic advice on how to become a successful ruler. The times being corrupt, he was advising him to adopt methods which might result in a strong and effective government, and also free the state from foreign domination. The ruler may or may not be virtuous; but his

subjects should believe him so, for all must be subordinated to the good of the state, which should be his ultimate aim. What Machiavelli was setting down so unequivocally was only the policy adopted by most despots throughout the centuries; and his patriotism was unwavering.

The two works, *The Prince* and *The Book of the Courtier*, are almost contemporary but the attitudes expressed in them are completely different. While Machiavelli was concerned with the ultimate good of the state, the end justifying the means, Castiglione was writing in a nostalgic vein about the perfection of the individual, and delineating a civilization which he feared could never be achieved again.

Castiglione first thought of writing *The Book of the Courtier* while he was still in Urbino. After the death of Guidobaldo in 1508, aged only thirty-five, Castiglione continued at court in the service of his successor Francesco Maria della Rovere, while working on the first draft of his book.

Guidobaldo may have been an inadequate character, but Castiglione was never openly critical of him. He wrote in his introduction, 'Since my recollection of Duke Guido's great qualities and of the happiness I had known in the friendly company of those outstanding men and women who used to frequent the Court of Urbino was still fresh and vivid, I was encouraged to write these books on courtly life and behaviour.'

His greatest admiration was for the Duchess: 'She was of greater worth than all the others and I was even closer to her than to them.' Therefore, on hearing of her death in 1526, he resolved to complete, revise and publish the book 'as a

Stained glass panel designed by Timoteo Viti (see page 136) in the Duchess's suite.

portrait of the Court of Urbino, not indeed by the hand of Raphael or Michelangelo,' but, he says, 'by a worthless painter who knows only how to draw the outlines and cannot adorn the truth with pretty colours.'

He was also anxious to make a definitive edition of the book. It seems that through the treachery of Vittoria Colonna, Marchioness of Pescara, who had been entrusted with the manuscript, pirated and truncated versions had been appearing in Naples. Meanwhile he had also learnt of the deaths of several of the characters featured in the book – of Alfonso Ariosto, of Duke Giuliano de' Medici, of Bernardo Dovizi (Bibbiena), of Ottaviano Fregoso – all great men whom he felt deserved to be remembered. Then finally came the death of the Duchess herself.

The conversations that comprise *The Book of the Courtier* are said to have taken place during four successive evenings during March 1507. They were held in the Duchess's apartments after supper, when the Duke had retired to bed.

The Duchess **Elisabetta Gonzaga** is seen as an epitome of womanly virtue: patient, faithful, long-suffering, one who had 'lived with her husband for fifteen years like a widow', choosing 'to suffer exile, poverty and all kinds of hardship' rather than abandon him. As well as her unassailable goodness, Baldassare praised her beauty – rather exaggeratedly, to judge from Raphael's portrait in the Uffizi.

Elisabetta might have seemed a trifle sanctimonious if she had been the only dominant woman present, but with her was invariably the vivacious **Emilia Pia**. Castiglione avers that she was a lady 'gifted with such a lively wit and judgment . . . that she seemed to be the mistress of all and to endow everyone else with her own discernment and goodness'. Emilia was the daughter of Marco Pio of Carpi, and had married Federico's natural son Antonio da Montefeltro. On the death of her husband in 1500, she and her children Veronica and Ludovico had stayed on in Urbino. She died in 1528.

Pietro Bembo (1470–1547) was Venetian by birth. He was a champion of classical literature and classical values; nevertheless he supported the use of the Tuscan language. He was the author of the *Asolani* (*The People of the Sun*), on the theme of the nature of love; this dates from 1505. He had a strong though platonic passion for Lucrezia Borgia; from less platonic affairs, however, he fathered three children. From 1506 onwards he spent six years at the court of Urbino. Later he became a cardinal and lived in Rome. There is a portrait of him by Raphael in Budapest, which shows the Ducal Palace of Urbino in the background.

Bernardo Accolti (L'Unico Aretino) (1458–1535) enjoyed considerable success as an itinerant court poet. He is not to be confused with Pietro Aretino, whom Castiglione omits. **Calmeta** (Vincenzo Collo) was also a court poet.

Alfonso Ariosto (1475–1525) was a friend of Castiglione, and was related to the famous poet Ludovico Ariosto. He served with the Este family of Ferrara, and like them supported the French. *The Book of the Courtier* was originally dedicated to him; and Castiglione says that it was he who suggested the idea.

Lodovico da Canossa (1476–1532) came from Verona, He was a diplomat and a friend of Castiglione; he also knew Raphael and Erasmus. Later he was made Bishop of Bayeux.

Bernardo Dovizi (1470–1520), known as Bibbiena, was in the service of Giovanni de' Medici, who later became Pope Leo X and made Dovizi a cardinal. He was a humanist, diplomat, and playwright, the author of *La Calandria* (see pages 149–51); his portrait was painted by Raphael.

Ottaviano Fregoso (1470–1524), together with Federico Fregoso and their sister Costanza, were children of a natural daughter of Duke Federico. They were members of an exiled but once powerful Genoese family who had sought refuge in Urbino. Under Francesco Maria della Rovere, Ottaviano served as ambassador to France. Federico Fregosa was a great linguist, a friend of Castiglione and Bembo. Ottaviano Fregoso was murdered by order of the Marchese of Pescara (the husband of Michelangelo's friend Vittoria Colonna) and so the latter is not mentioned in Castiglione's book.

Gian Cristoforo Romano (*c.*1465–1512) was celebrated as sculptor, medallist and musician. **Cesare Gonzaga** (1475–1512) was both soldier and diplomat, a cousin of Castiglione. **Margherita Gonzaga** was the Duchess's niece.

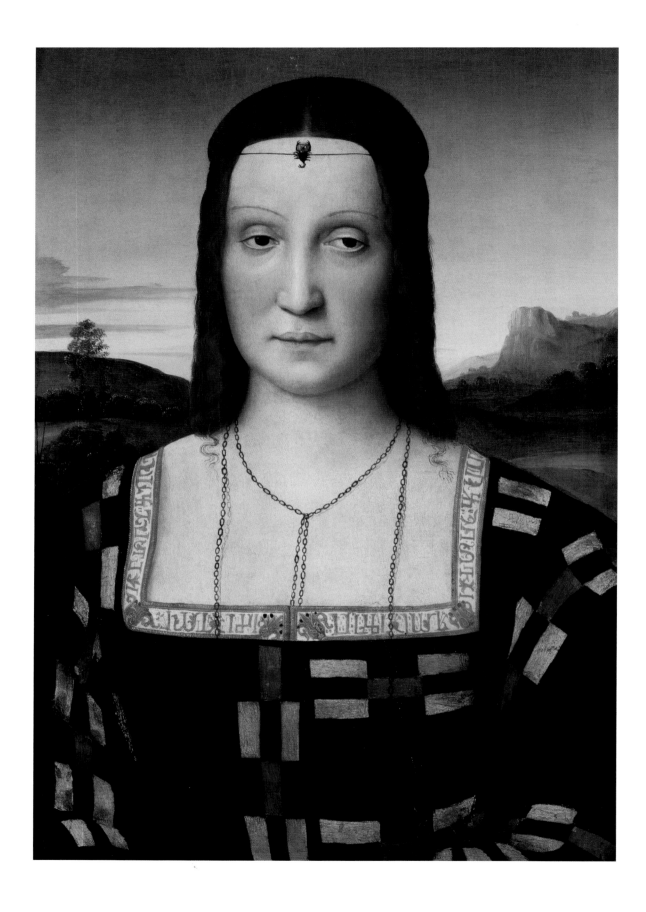

Giuliano de' Medici (1479–1516), Duke of Nemours, was the youngest son of the great Lorenzo de' Medici. His tomb, sculpted by Michelangelo, with his figure personifying 'Active Life' (flanked by figures of Night and Day) is in the Medici Chapels of S. Lorenzo, Florence. His brother Giovanni, although he too was a guest at the Court of Urbino, is not mentioned, because after he became Pope Leo X he expelled Francesco Maria della Rovere from Urbino, and installed his nephew Lorenzo as Duke in his place.

Morelio da Ortona was an old retainer of the Montefeltro family. The only spokesman of his generation in the conversations that comprise *The Book of the Courtier*, he is given a certain dry wit.

Gaspare Pallavicino (1486–1511) was a youthful misogynist from Lombardy. He takes a lively part in the discussions, and functions as a sparring partner, especially for Emilia Pia. He died young after almost constant illness.

Roberto da Bari was another elegant courtier, a friend of Baldassare's; he came from the Massimi family of Bari. He died in 1512.

Francesco Maria della Rovere (1490–1538) appears in *The Book of the Courtier* at the age of seventeen. He was only fourteen when he had been made Prefect of Rome (in the text he is referred to as 'My Lord Prefect'); he was commander of the papal forces. He was one of a succession of papal nephews, and consequently influential despite his youth.[6]

Among the other characters, **Fra Serafino** was probably from Mantua, and a frequent visitor to Urbino. **Michel de Silva**, or Dom Miguel da Silva, (*c.* 1480–1556), was a Portuguese nobleman and diplomat, whom Castiglione had met both in Rome and in Spain. Pope Paul III made him a cardinal.

Castiglione's general dedication of his book (to Miguel da Silva) outlines the circumstances which prompted him to complete and publish the work, and defends his decision to write it in the Tuscan language.

BOOK I

(dedicated to Alfonso Ariosto)

Defining the perfect courtier; his physical and intellectual accomplishments

The book begins with the famous description of the Ducal Palace of Federico da Montefeltro (see page 15).

All the company sit in a circle, alternating men and women as far as possible. It is Emilia Pia who is called upon to begin the discussions, and the Duchess, sensing disagreement between her and Gaspare Pallavicino, invests her with authority as her deputy. Throughout all the conversations, there is frequent sparring between Emilia and Gaspare, and this renders them animated and convincing.

What, asks Federico Fregoso, are the qualities that characterize the perfect courtier? Emilia chooses Count Lodovico da Canossa to be the principal speaker on this theme. He should, he says, be a man of noble birth, for such a man is likely to be well brought up, and so more may be expected of him; he should have good looks and graceful bearing.

At this point young Gaspare interrupts, expressing the opinion that nobility of birth is not necessary; sometimes fine qualities are to be found in men of humble origin. Lodovico, not fully convinced, stresses the importance of first impressions, and goes on to say that the ideal courtier must be a warrior, though not of course a professional soldier, and not a man for whom fighting is his only interest. Self-glorification is not to be endured, but self-esteem is another matter. Bibbiena remarks, for light relief, what a handsome face he has, and how many women fall in love with him; he is, however, not so sure about his legs. He asks Lodovico to describe the appearance of the ideal courtier, and is told he should be both manly and graceful, not in any way effeminate. The courtier, he says, should be of middle height and well proportioned. He should be expert with every kind of weapon, proficient in wrestling, horsemanship, hunting, swimming, jumping, throwing and tennis – almost every

The Duchess Elisabetta, portrait by Raphael, painted in tempera on wood about 1502–3 (Uffizi, Florence). Her black and gold dress is possibly the one that she wore for Lucrezia Borgia's third wedding (see page 130). Her scorpion jewel is likely to relate to the Scorpio sign of the zodiac.

athletic activity with the exception of tightrope walking. The courtier should execute everything with grace, including of course, dancing, but he should always avoid affectation.

The conversation turns to the subject of language and good writing. Count Lodovico praises the Tuscan language, as used by Petrarch, Dante and Boccaccio, preferring it to the archaic use of Latin (this was a favourite theme of Castiglione himself). In the same way, while antique works of art are to be admired, the finest paintings by contemporaries, such as Leonardo da Vinci, Mantegna, Raphael, Michelangelo and Giorgione, are all different and all outstanding.

The discussion veers to the use of language by classical authors, until Emilia Pia complains that it is getting tedious. Count Lodovico changes the subject to that of beauty in women: how much more attractive they are if they appear natural, avoid affectation and display their graces nonchalantly. But then he reverts to the subject of literature, declaring that letters are the chief adornment of the mind. Giuliano de' Medici refers to the neglect of scholarship in France in recent years, but says he has great hopes of Monsieur d'Angoulême of the House of Valois.[7] He goes on to quote classical precedents for the encouragement of letters, and predicts that this young man may reverse the trend. For it is of great importance that the ideal courtier should be a good scholar, should understand Greek as well as Latin, and should write at least sufficiently well to be able to appreciate the work of others.

At the same time he should be modest and diffident, and give the impression that all his accomplishments are mere ornaments to his main profession as a man-at-arms. Pietro Bembo, however, questions this attitude, and asks why everything else should be subordinated to soldiering? He quotes classical precedents: Homer, Alexander and Achilles.

The subject of music is introduced. The Count says that the ideal courtier must be able to read music and play several instruments. Gaspare, however, suggests that music is effeminate. This view is hotly countered by Lodovico, who speaks of harmony in the universe, and the wisdom of ancient philosophers in their belief that the heavens themselves were moved by music. Giuliano agrees; for the courtier, music is not just an ornament but a necessity, and he stresses the part that music plays in the lives of men of all walks of life.

Equally important, continues Count Lodovico, are the visual arts:

> Anyone who does not esteem the art of painting seems to me to be quite wrong-headed. For when all is said and done, the very fabric of the universe, which we can contemplate in the vast spaces of heaven, so resplendent with their shining stars, in the earth at its centre, girdled by the seas, varied with mountains, rivers and valleys, and adorned with so many different varieties of trees, lovely flowers and grasses, can be said to be a great and noble painting, composed by Nature and the hand of God. And, in my opinion, whoever can imitate it deserves the highest praise.[8]

Gian Cristoforo Romano has been sitting with them, as representative of the visual arts. Emilia Pia now turns to him and asks his opinion: does he think that painting requires greater artistry than sculpture? As a sculptor, he is bound to disagree. Sculpture, he says, requires more effort and skill, and it has greater dignity. Lodovico agrees that sculpture is more durable, but thinks that painting, while it lasts, has the greater beauty. Cristoforo rejoins that he is only saying this on account of his admiration of Raphael; working in stone is far more difficult. But the Count continues his argument:

> Does it then seem of little importance to you that Nature's colours can be reproduced in flesh tints, in clothing and in all other objects that are coloured in life? This is something the sculptor cannot do. Still less can he depict the love-light in a person's eyes . . . the colour of blonde hair; the gleam of weapons; the darkness of night; a tempest at sea; thunder and lightning; a city in conflagration; or the break of a rosy dawn with its rays of gold and red.[9]

Francesco Maria della Rovere, portrait by Raphael (Uffizi, Florence). Painted in 1503–4, this shows the future Duke of Urbino as a very young man, done perhaps at the time when he was made Prefect of Rome.

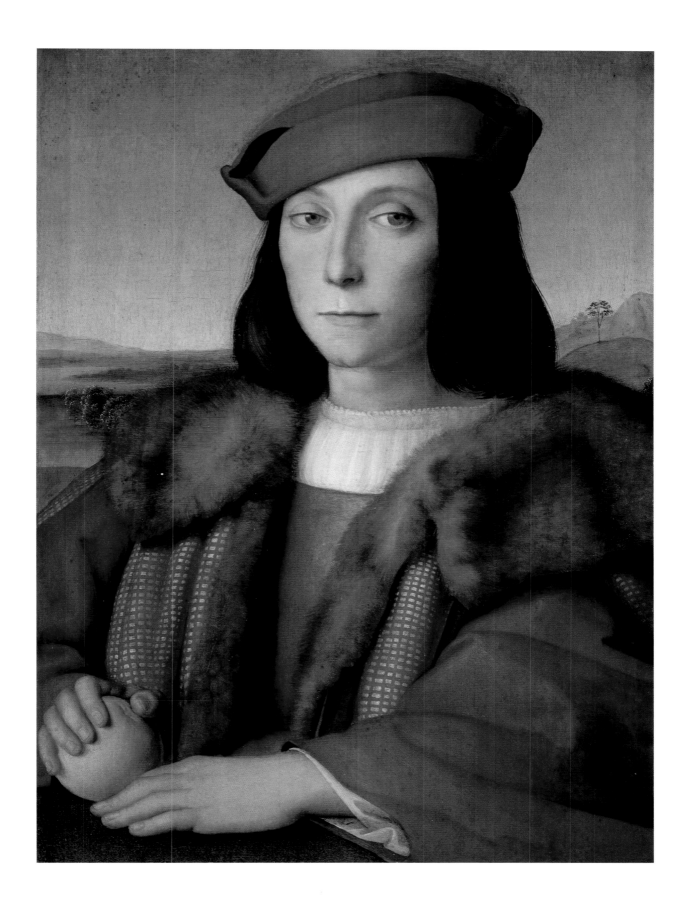

Cesare Gonzaga takes a more earthy view; he would rather see a fine woman than any work of art, and for him it is living beauty, which has the power to move to love.

The discussion is then interrupted by the arrival of Francesco Maria della Rovere (the Lord Prefect), along with others of his suite. As it is getting late, it is decided to end the evening's entertainment with dancing (accompanied by Barletta, the court musician), which continues until the Duchess decides it is time for bed.

BOOK II
(dedicated to Alfonso Ariosto)
Definition of the perfect courtier continued; humorous stories

Old men praise times past and are critical of present-day customs, but Castiglione thinks they are mistaken in finding no good in contemporary society.

Bernardo Accolti attempts to sum up the previous day's debate; all that needs to be said, he avers, is that the courtier should have good judgment and know what is appropriate to the time and place.

Federico Fregoso emphasizes that he should achieve balance and gentleness, and should avoid ostentation. He should be modest, well dressed, not seeking for false glory, and always behaving decorously. Gaspare Pallavicino, however, says that in Lombardy young noblemen happily take part in outdoor activities, such as dancing and athletics, alongside the ordinary people. But Federico does not approve, and thinks it undignified; the courtier should indulge in athletics and dancing, but only as an amateur. He should not appear too proficient. The same is the case in music; the solo voice is the purest form, accompanied by the lute or keyboard instruments; but the courtier should avoid performing in public. He criticizes old men who sing love songs. The courtier's chief duty, says Federico, is to make himself agreeable to his prince. He must not seem arrogant; he must never show himself to be ill-tempered nor be the bearer of bad tidings. He must always treat his prince with respect, and not enter into his private apartments uninvited.

He should always appear a little more humble than his standing requires. He should avoid the arrogance shown by some French and some Spanish nobles.

Lodovico Pio then raises a tricky question: should the courtier obey his prince even when urged to do wrong? Federico replies that he should not do anything that will shame his honour. Ultimately he must use his own discretion. Concerning how he should dress, Federico recommends that he should follow his own inclinations; nevertheless he expresses a preference for black or dark clothes, except for festivals. Pietro Bembo makes fun of the extravagant fashions of Lombardy, and Federico adds that men are largely judged by their habits and gestures, and by their choice of friends. He expands on the value of true friendship in men's lives.

They go on to discuss gaming. Federico says that it is fine for the courtier to play cards and dice and chess, as long as he does not attach too much time and importance to these pursuits. He must try and ensure that his good reputation precedes him; but Bibbiena says there is a danger in this – people who have too high a reputation in the event sometimes disappoint. Gaspare, always the misogynist, disparages women as irrational creatures, until he is rebuked by the Duchess. Federico warns of the dangers of basing one's judgements on hearsay, and cites a musical example: the occasion when a motet was sung and was thought to be worthless until it was revealed that it was a work by Josquin des Près.

Reverting to the ideal courtier's bearing, he says that he must not swear or show off in front of ladies, and must not indulge in horseplay, but always try to create a good impression. A gift for languages is an advantage. The courtier must not appear superior or scornful of other people's efforts; in all things he must seek the golden mean. The art of light conversation is to be encouraged. Federico says that Count Lodovico and Bibbiena are masters of this, though Lodovico protests they are being made fun of. Emilia then gives Bibbiena the task of teaching the company all he knows on the subject of pleasantries (his talk being, according to Federico, like 'the gentle murmuring of a flowing spring'). Bibbiena speaks on the importance of light entertainment.

'Everything which promotes laughter exalts a man's spirit.' But care should be taken in choosing whom to mock. Nevertheless he hazards jokes about popes; then he tells the story of a peasant who had a donkey that looked like Cicero, and the delightful tale of Duke Federico and the abbot (see page 76). Jokes are made about the Venetians and the Florentines, and about a Brescian who had gone to Venice for the feast of the Ascension and watched a trumpeter whom he thought was swallowing part of his instrument.

Then comes a tall story related by Giuliano about a merchant from Lucca and his unsuccessful dealing for furs with some Muscovites, whose words allegedly hung in the air over the frozen river until, an hour later, a fire was lit on the ice, and then the words could be heard quite clearly.

Bibbiena caps this with the story of a clever monkey who could play chess and performed before the King of Portugal. Then he goes on to talk about puns; the examples he quotes rest on the words *aver letto*, which can mean either 'to have read' or 'to have a bed', and *mattonata* meaning a brick floor and 'matto nato' meaning a born fool. There are also plays on words, including one on Emilia's name being changed from 'Pia' to 'Impia'.

After a number of scurrilous stories, Bernardo comments that the courtier should avoid irreligious jokes, and vulgar witticisms in the presence of ladies. Gaspare says that women rejoice in such things. Bernardo is about to protest, but Emilia declares, 'Women have no need of a defender against a critic of so little authority.'

Then Bibbiena quotes examples of ironic humour and cutting jokes, many of them directed against clerics. For instance, the story of the two cardinals who complained to Raphael that his painting of St Peter and St Paul showed them too red in the face; Raphael retorted that he had done this deliberately as the saints in heaven 'were blushing that the Church should be governed by men like you'.

On the whole Bernardo recommends wit without malice; the courtier should be careful not to make his humour cruel and biting. He says to Federico that he has given such poor entertainment in his discourse that he must have thought he had wandered by mistake into the Montefiore inn (which was notoriously bad). But as Federico assures him he is still enjoying himself, Bernardo continues and turns to the theme of practical jokes. The stories he tells are full of broad humour and many of them not altogether kind. Still, he maintains, the courtier should always show respect for women.

Characteristically Gaspare rises at this and questions why men should show more respect to women than women do to men. Bernardo replies that it is less damaging for men for it to be implied that they are leading a dissolute life than it is for women – for once a woman's honour is impugned, she is disgraced for ever.

Ottaviano Fregoso appears to join forces with Gaspare in disparaging women, who are, he says, very imperfect creatures. Therefore it is necessary that some curb be put on their behaviour, and that curb is chastity. The Duchess remarks that it is no wonder women don't love him if he has such a low opinion of them. However Bernardo resumes his theme; he cannot pretend that it is right for women to deceive their husbands, but the means by which they do so, as related by Boccaccio, are very clever and ingenious. Gaspare argues that a man who wins a woman's body also wins her soul. All the same, he protests, he is no enemy of women.

Bernardo is thinking of springing to their defence, but decides he has spoken long enough. The ladies rise and threaten Gaspare, and Emilia turns to Giuliano asking him to be their champion and speak in their defence. She reminds him that in Italian the word for 'virtue' is feminine and the word for vice is masculine. But they have talked long enough, and the Duchess decides that their discussions should be adjourned to the next day, when Giuliano the Magnificent is required to define what constitutes the ideal court lady.

BOOK III
(dedicated to Alfonso Ariosto)
The court lady

Castiglione says in his preface, 'My dear Alfonso . . . you can clearly understand from this small part of the whole how greatly superior was Urbino to all the other courts of Italy,

considering the superiority of these games (designed to refresh minds wearied by more demanding activities) to those practised elsewhere.'

Cesare Gonzaga says that women are essential to court life; it is their presence that inspires deeds of chivalry. Giuliano undertakes to define the perfect court lady; he flatters the Duchess by saying that if he were to describe her, he would be describing the ideal queen. But she calls him to order and he goes on to say that virtues of the mind are just as important in a woman as they are in a man. Added to which, she should have beauty and affability. She should avoid gossip and be a good conversationalist.

Gaspare Pallavicino asks what recreations are suitable for a court lady; Giuliano replies that certain pastimes are inappropriate: she should not handle arms, wrestle, ride or play tennis.[10] Aretino remarks that among the ancients, women used to wrestle naked with men, and Cesare Gonzaga adds that he has seen women ride, hunt, play tennis and even handle weapons. But Giuliano does not consider such mannish exercises fitting for a woman; he looks for greater delicacy. She should dress appropriately, and when she makes music she should play on suitable instruments, not drums and trumpets. She should have an understanding of literature and painting. She should appear graceful in everything she does, and she should be adorned with all the virtues, such as magnanimity, temperance, fortitude and prudence.

If Giuliano is investing her with all these fine qualities, remarks Gaspare, perhaps he would like her to lead armies and govern cities, while the men stay at home? Giuliano replies that that might not be so bad a plan, except that he is trying to fashion a court lady, not a queen, to which Gaspare retorts that he has been exaggerating; he is not to be swayed from his antifeminism, and declares, 'When Nature fashions a woman it is a mistake.' On the contrary, as Giuliano points out, it would be an imperfection if Nature produced only males. He goes on to expand on the achievements of women, how some are versed in philosophy, some are poets, some are eloquent orators. Others have successfully waged war and governed kingdoms.

Gaspare is still not convinced; he asks why women should want to be men, as he says they all do, if it were not that the male is a higher order of being? Giuliano replies at once that they desire this in order to 'gain their freedom and shake off the tyranny that men have imposed on them by their one-sided authority'. And he adds that women have the additional virtue of being more constant than men. He dilates on the subject of matter and form until Emilia, exasperated, rebukes him: 'Speak in a way that you can be understood.'

Gaspare still thinks that men are superior to women. Because women are cold in temperament, he says, they are cowardly and timid. Giuliano's opinion is that they are more temperate than men; they enjoy longer life and better fulfil the intention of Nature. Moreover, while aware of dangers, they show courage and resolve in setting honour and duty above all else.

He now digresses in order to criticize unprincipled friars until Emilia brings him back to the point. Giuliano lists the heroines of classical times, and in particular tells the story of Camma, who suffered death rather than dishonour, of Tommaso's wife Argentina, who died from joy at her husband's restoration to liberty, and of the Sabine women and the founding of Rome. Then coming to more recent times, he praises women of the Montefeltro, Gonzaga, Este and Pio families, also Queen Anne of France, Margherita daughter of Emperor Maximilian, and in particular Queen Isabella of Spain. Then he mentions the Queen of Hungary, Isabella of Aragon, Isabella d'Este, Eleonora Duchess of Ferrara, and the heroism of the women of Pisa in defending their territory against the Florentines.

Gaspare still insists that 'women bring no benefit to the world, save the bearing of children'; he quotes the continence of Alexander, Scipio and Xenocrates. In reply, Cesare Gonzaga tells the story of a contemporary 'Patience on a Monument' girl, whose wicked father was insisting she should marry a rich man she did not love. He goes on to quote more examples of women who preferred death to dishonour, and then he speaks daringly of the Duchess Elisabetta:

And now I must say a word about our Duchess, who has lived with her husband for fifteen years like a widow, and chose rather to suffer exile, poverty and all sorts of hardship rather than to accept what seemed to everyone else a great favour and indulgence of Fortune.

But one swallow, comments Castiglione's friend Niccolò Frisio, does not make a summer.

Cesare goes on to speak of the temptations put in the way of girls, to which they refuse to yield, and of the general civilizing effect of women. Isabella of Spain is praised for her bravery against the King of Granada; and where, he asks, would Petrarch have been without his Laura, and King Solomon without his beloved? Gaspare finally gives up the struggle.

Changing the subject slightly, Federico Fregoso asks how a woman should deal with declarations of love. Giuliano says she should either refuse to believe them, or treat them as a joke. But what if they are sincere, asks Federico. Then she must use her judgment.

Federico asks if women who are unhappily married may be permitted extramarital love. Giuliano won't allow this; he thinks women should fall in love only with those they can marry, and should be reticent in their treatment of would-be lovers.

Gaspare queries whether the ideal court lady does in fact exist, to which Emilia replies, 'I will guarantee to discover her, if you will find the courtier.' Roberto da Bari remarks that this impeccable lady Giuliano has fashioned has been made too hard and unyielding; but Giuliano says she is so only if she is approached with dishonourable intent. Aretino says he has seldom encountered ladies who do not know how to love; but in order that this love should not be thrown away on worthless men, he suggests that the ideal courtier should study how to make himself loved. He asks Emilia to say what pleases women. If a man is to be loved, she replies, he must first make himself lovable. She goes on to accuse Arentino of insincerity, and of making advances to too many women. He counters that all too often he is disbelieved when he is telling the truth, while she is believed even when she is lying.

They then debate how the man should declare his love. Giuliano says it should be done with respect; let his eyes declare it. Lodovico discourses on the use of hearsay, but Giuliano thinks it is dangerous to make his love too public, better to keep it secret. He warns against the use of 'Poliphian words' (extravagant language, derived from Franceso Colonna's romance *Hypnerotomachia Poliphili*) which leave women totally bewildered. Cesare Gonzaga tells the story of a man loved by a great lady, who came secretly to stay at an inn in the town where she lived; but then he insisted she should pay his bill at the inn, so he would not be put to any expense. Gaspare criticizes the vanity and cruelty he sees in women; he says they enjoy their lovers' torments.

But Ottaviano Fregoso wants them to discuss more about the perfect courtier. The Duchess, however, suggests that this is left to the next day as it is getting late. They all retire to bed.

BOOK IV
(dedicated to Alfonso Ariosto)
The courtier in the service of his prince; platonic love

By the time Castiglione came to write this last book, three of the participants in the discussions (Gaspare Pallavicino, Cesare Gonzaga and Roberto da Bari) had in fact died. Meanwhile, Federico Fregoso had been made Archbishop of Salerno, Lodovico was now Bishop of Bayeux, Ottaviano was Doge of Genoa, Bibbiena had been made a cardinal and Pietro Bembo secretary to Pope Leo X. Giuliano was now Duke of Nemours and Francesco Maria della Rovere had succeeded Guidobaldo as Duke of Urbino. His good qualities, Castiglione declares, were nurtured by the company he knew at the court of that city:

It seems to me that the cause . . . that has so long given outstanding rulers to Urbino still endures and produces the same results: and it is to be hoped that good fortune should so continue to foster these brilliant achievements that, far from failing, the happiness of the Court and of the State will rather increase swiftly from day to day.

He goes on to praise Eleonora Gonzaga, Francesco Maria's wife and the new Duchess. But although Book IV is clearly a reminiscence, the dead are allowed to speak.

On this fourth day, little has been seen of Ottaviano Fregoso; therefore, thinking that the discussions may not take place, the company turns to dancing. Then Ottaviano turns up, and seeing Gaspare dancing with the Duchess, thinks perhaps the latter has revised his opinions on women. The Duchess requires the discussions to continue.

The theme is to define the functions of the perfect courtier. Firstly, he must win the confidence of his lord, so that he can risk telling him the truth, even if it is unpalatable. He must try and deter him from unworthy acts and bring him back to the paths of virtue, persuading him that this will gain him honour.

Ottaviano maintains, 'Just as music, festivities, games and other agreeable accomplishments are, so to speak, the flower of courtship, so its real fruit is to encourage and help his prince to be virtuous and to deter him from evil.'

He must try and ensure that he is not led astray by flatterers and liars, the worst faults of the rulers of the day being ignorance and conceit. Princes need someone to tell them the truth, for they can become drunk with power and think they can do no wrong. The courtier should try to gain the goodwill of his lord by emphasizing his best points, it being necessary to sugar the pill.

Gaspare points out that wicked rulers are not prepared to admit their faults; he says that virtues are the gift of God, and cannot be learnt. However Ottaviano is convinced that man *is* capable of learning and improving, of cultivating his better qualities. Gaspare argues that there are some men who do evil deliberately; but there are others, says Pietro Bembo, who are capable of remorse when they have done wrong. Ottaviano believes that there are some who allow their judgment to be overcome by emotion, but this will not happen if they are really strong-minded. He believes that moderation is preferable to abstinence.

Then the company turns to discussing which is preferable: the rule of a good prince or a republic. Ottaviano prefers the former, 'since this kind of dominion is more in accord with nature', more similar to the dominion of God. But Bembo's view is that, since God has given us all the gift of freedom, why should one man have more power than another? There are, in Ottaviano's opinion, three forms of good government: monarchy, rule of the good (the 'optimates') and rule by the citizens; of these he prefers the 'gentle government of a constitutional monarch', for he believes that it is easier to find one good leader than many such. And the prince should not only be virtuous himself, but should encourage others to follow his example. The test of a man's character is how he performs in office. Corrupt men reveal all their faults when they are given power. Good rulers do not fear assassination,

Pietro Bembo (1470–1547). Cardinal, scholar and poet, he is a major contributor to the discussions in *The Book of the Courtier*, which ends with Bembo's 'Hymn to Love'.

but tyrants live in fear; he instances Clearchus who slept in a chest, and Aristodemus who had a bedroom suspended in mid-air, reached only by a ladder which was taken away at night.

The Duchess asks Ottaviano to define what the courtier should teach his prince once he has gained his favour. Ottaviano says that the prince should be encouraged to lead both an active and a contemplative life. Clearly he has in mind the late Duke Federico; his view had been that 'the man who knows how to command is always obeyed'. The duty of a good ruler is to give the people enduring laws so that they can live in peace. Military skills are to be encouraged, but primarily for self-defence, so that lasting peace may result; thus his rule will be happy.

Gaspare asks him to define the practical virtues useful first in war, and then in peace. In war, Ottaviano replies, fortitude, and in peace, temperance and justice. He stresses the importance of both moral and intellectual virtues. Gaspare recommends that one should first look after the body and then the soul. He refers to the idea in Plato's *Republic* that both wives and children should be held in common, i.e. in the public ownership of the state. But the Duchess turns to Ottaviano and asks him to outline how a prince should be instructed. His suggestion is: choose the right counsellors and encourage them to speak the truth and have, in addition, a people's council. The most important of his concerns is the administration of justice; added to this is reverence for God and love of his country and people. There should be a fair distribution of wealth; citizens should be neither very rich nor very poor. Their love and allegiance will foster peace and prosperity (though Gaspare believes that the wicked outnumber the good). Cesare Gonzaga wants the prince to have greatness of spirit and regality, combined with humanity and gentleness. He should live splendidly (after the manner of the Marquess Federico Gonzaga of Mantua); he should seem more like a king than just the ruler of a city. He should erect noble buildings, just as the late Duke Federico did and as Pope Julius was now doing in Rome. Ottaviano says that he should rid the world of tyrants, and argues that the victories of Alexander brought advantages to the conquered.

But turning to the contemporary world, he says that there are bright prospects for France if it should come to be governed by Monsieur d'Angoulême (the future François I), and also in England if Henry, Prince of Wales (the future Henry VIII) who is 'growing up in all virtue under his great father, like a tender shoot beneath the shade of a noble and fruitful tree,' should live to succeed to the throne. Bibbiena speaks of the great promise also shown by Don Carlos, Prince of Spain (later Emperor Charles V) although he is only nine years old.

Ottaviano says that these princes were sent by God, and Lodovico remarks that the one who shows most promise is Federico Gonzaga, the Duchess's nephew (who was to become the first Duke of Mantua). Giuliano says he has finished all he has to say on the subject; the Duchess comments that it is getting late, but adds that Ottaviano will also make an excellent prince. The discussion continues.

Giuliano remarks that Ottaviano has set the courtier above the prince; Ottaviano disagrees. Giuliano observes that if the courtier is old and the prince is young, he can always give him good advice; he is unlikely to be able to join in the games and merrymaking, yet can still understand the pleasures of youth. On the other hand if the prince is older than the courtier, he is likely to be the more knowledgeable. But if the prince should prove to be a tyrant, then the courtier should resign his position. Aristotle and Plato are quoted as precedents; Gaspare wonders whether either of them ever danced, played music or performed acts of chivalry. Ottaviano says that these accomplishments are not to be despised.

The company takes up again its discussions on love and beauty. Gaspare questions whether it is fitting for the old to fall in love. Why not, asks Ottaviano. Gaspare thinks they might be happier without it. Bembo believes that love is for the old as well as the young, not that he wants to be thought old, he adds. The Duchess says he must speak, for though young in years, he is old in wisdom. So Bembo collects his thoughts and begins. The philosophers of the ancient world, he says, defined love as a longing to possess beauty, which may be appreciated through the senses, through natural choice and intellect. Can beauty be enjoyed without

possessing? Mature men, he says, are more able to control their emotions.

Morelio da Ortona remarks that beautiful women are often evil, and Bembo agrees that they sometimes are. Yet beauty itself is a sacred thing; it 'springs from God and is like a circle, the centre of which is goodness'. Outward beauty is often a sign of inner virtue and character may be expressed in appearance. He turns to cosmography and how the earth (as was believed) was the centre of the universe, how the stars keep their courses, and how man, supreme among created beings, may be regarded 'a little universe in himself'.

He turns to the relationship between beauty and chastity; if some women are unchaste, it is not their beauty that makes them so. For his part, Bembo says, he has dedicated his life to love since boyhood. Rational love, he maintains, is happier than merely sensual love. A kiss, he says is 'a union of body and soul'. In his opinion, man should not limit himself to the contemplation of one being only, but 'by uniting all possible forms of beauty in his mind, form a universal concept'.[11]

Bembo goes on to consider the divine nature of love and how it refines man's nature. He then breaks into his sublime hymn to love, which he believes is the father of 'true pleasures, of all blessings, of peace, of gentleness and of good will; the enemy of rough savagery and vileness.'

Emilia says, 'Take care, Pietro, that with these thoughts of yours you do not cause your soul to leave your body.' Cesare Gonzaga remarks that the road to happiness is so steep he thinks hardly anyone can travel it. 'Difficult for men,' comments Gaspare, 'but impossible for women.' Emilia says she will not forgive him if he insults women once more, and Giuliano rises to the defence of women, quoting the examples of saints Diotima and Mary Magdalene.

The argument could go on too long, says the Duchess, and it would be better to postpone it till tomorrow. But they have been talking all night, and it is already day.

The Book of the Courtier has been accused of superficiality and with some slight justification. That is to say, its aim is always to entertain; the courtier must never be boring. Much praised are the qualities of *sprezzatura*, that is to say, spontaneity and the avoidance of affectation, and *grazia*, or ease of accomplishment. A gentleman is defined in Moliere's *Le Bourgeois Gentilhomme* as 'one who knows everything without ever having had to learn anything'; there is something of this elegant nonchalance in Castiglione's *Courtier*. George Bull, in the introduction to his excellent translation, slates it as the most shameless opportunism under the cloak of a tiresome refinement.

Yet at the same time it was, in the words of Denys Hay, 'the most important single contribution to a diffusion of Italian values' throughout Europe.[12]

The book was written mainly between 1513 and 1518, when Castiglione was in Mantua. It first appeared in print in 1528, brought out by that most distinguished of publishers, the Aldine Press of Venice. Castiglione ordered 1030 copies to be printed; 500 of which (on the finest paper) were for himself.

Although he had spent so much of his life away from it, Baldassare Castiglione was greatly loved and respected in his native city. After his death in 1529, his tomb or monument was erected in the Santuario of Sta Maria delle Grazie, a little outside Mantua. It was designed by Giulio Romano; a set of steps rises to a pyramid, and above it is a figure of Christ of the Resurrection. The inscription, in Latin, is by Pietro Bembo. Translated it reads:

Baldassare Castiglione of Mantua, endowed by nature with every gift and the knowledge of many disciplines, learned in Greek and Latin literature, and a poet in the Italian (Tuscan) language, was given a castle in Pisauro on account of his military prowess, after he had conducted embassies to both Great Britain and Rome. While he was working at the Spanish court on behalf of Clement VII, there he drew up *The Book of the Courtier* for the education of the nobility; and in short, after Emperor Charles V had elected him Bishop of Avila, he died at Toledo much honoured by all the people. He lived fifty years, two months and a day. His mother Luigia Gonzaga, who to her own sorrow outlived her son, placed this memorial to him in 1529.

By the time his book was published, as Castiglione himself well knew, the days of the small Italian independent principalities were over. The French had overcome Venice in 1509 and in 1515 the troops of François I had ransacked Milan (using Leonardo's model for an equestrian Sforza monument for target practice). Then in 1527 came the Sack of Rome by the German and Spanish troops of Charles V, an act of appalling savagery and vandalism, in which the Pope himself was imprisoned. A far cry from the well-ordered state of *The Book of the Courtier.*

In those circumstances, *The Book of the Courtier* could have little direct impact in Italy; it was abroad that it had its greatest influence. In fact it was fortunate that the book emerged at the time it did, when printing had become a potent means of disseminating ideas. For as Italy declined politically, and became a battlefield between the Germans and the French, at the same time she grew as a cultural force.

The Book of the Courtier appeared in nearly sixty editions in its original Italian, and was translated into all the main European languages, as well as into Latin (understood by all scholars everywhere). The first translation into French was made by Jacques Colin in 1537. In his essay 'What Parisians read in the Sixteenth Century', H. J. Martin lists Castiglione's *Courtier*, together with Petrarch's *Trionfi*, Boccaccio's *Decameron*, Bembo's *Asolani* and, later, Ariosto's *Orlando Furioso* among the most popular books to be found.[13]

Castiglione had met Monsieur d'Angoulême before he became François I, and found him a handsome and personable young man who was 'highly loved and esteemed letters, and had in very great reputation all learned men'. François spoke fluent Italian.

It was above all *The Book of the Courtier* that inspired him to add to his martial skills an appreciation of culture; he formed a great library and was a discerning collector as well as a lively patron of the visual arts. He employed Andrea del Sarto as Court Painter. Later the Italians Rosso Fiorentino and Primaticcio came to his court, establishing the School of Fontainebleau. For François, Benvenuto Cellini made his incomparable salt-cellar (the most famous piece of Renaissance goldwork), and he gave refuge to the aged Leonardo da Vinci, housing him with a handsome annuity near his château at Amboise; for, he said, 'no one in this world knows as much as Leonardo'. Indeed it may be said that it was with the influence of *The Book of the Courtier* that the High Renaissance was transferred to France.

In England the influence was equally profound, not so much in the visual arts as in the fields of literature, music, learning and chivalry.

Thomas Hoby's translation of *The Book of the Courtier* came out in 1561. It was prefaced by a sonnet by Sir Thomas Sackville, who rated it of more value than any royal palace,

> A rarer worke and richer far in worth
> Castilio's hand presenteth here to thee.
> No proude, ne golden Court doth he set forth,
> But what in Court a Courtier ought to be.

Thomas Sackville was himself a poet, dramatist, statesman, and a trusted counsellor at the court of Elizabeth I.

The young queen received her education chiefly from Roger Ascham, author of *The Scholemaster*. In this book he not only emphasizes the importance of athletic activities, 'to vault lustily, to run, to leap, to wrestle, to swim, to dance comely, to hawk, hunt and play tennis, but also to sing, and play of instruments cunningly', which is not only 'comely and decent, but also very necessary for a courtly gentleman to use'. He also says that in order to appreciate literature, the courtier must have some knowledge of literary techniques.

Ascham acknowledges his debt: 'To join learning with comely exercises Conto Baldassare Castiglione in his book, *Cortegiano*, doth timely teach; which book, advisedly read and diligently followed but one year at home in England, would do a young gentleman more good, I wiss, than three years travel abroad spent in Italy.' Then he goes on to point out to the 'young gentlemen of England' that to their shame they are every one of them excelled in learning and diligence by the Queen herself:

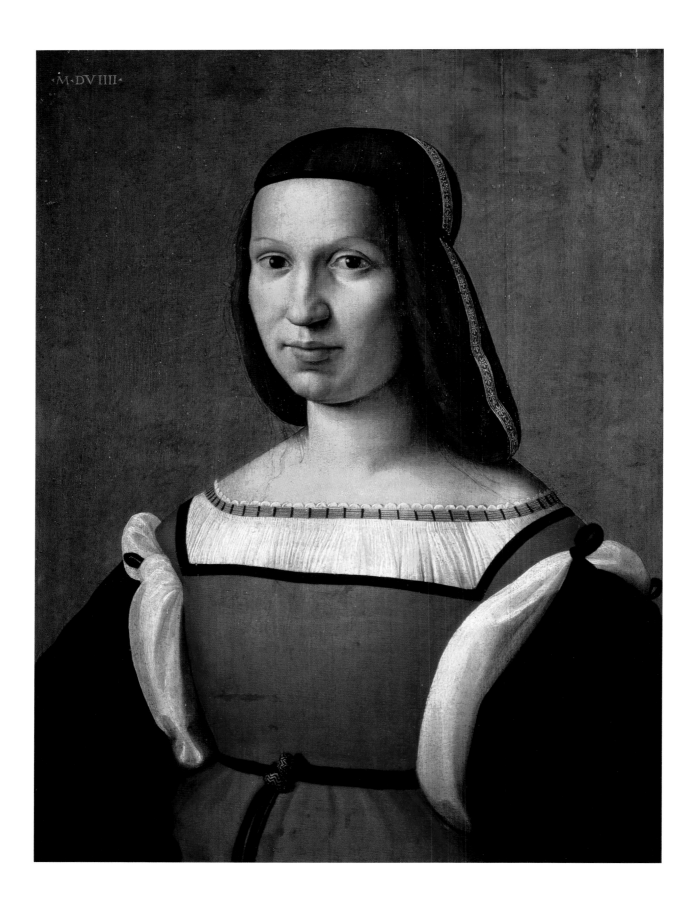

I believe that, beside her perfect readiness in Latin, Italian, French and Spanish, she readeth here now at Windsor more Greek every day than some prebendary of this church doth read Latin in a whole week. . . . She hath obtained that excellence of learning, to understand, speak and write, both wittily with the head and fair with the hand as is hardly equalled by any scholar at either Oxford or Cambridge.

The budding feminism in *The Book of the Courtier* comes here to fruition. And in the court of such a monarch the same code of values will be observed.

Sir Philip Sidney, poet, soldier and ambassador, epitomized these ideals. His father was Lord Deputy in Ireland, and young Philip wrote to plead his cause when he was out of favour. In his youth he travelled extensively on the Continent, including Italy. His literary work was done mainly between the years 1578 and 1582, notably the 'Arcadia' and the series of sonnets 'Astrophel and Stella'.

At this time he was somewhat out of favour himself, having opposed the Queen's projected marriage with the Duc d'Anjou. But in 1583 he returned to court, married, and was knighted. Always sober and elegant in his dress, he favoured the dark colours recommended in the *Courtier* (as, for centuries, did the Spanish nobility, the French, however, preferring something more flamboyant).

He had an ambition, albeit thwarted by Sir Francis and the Queen, to sail with Drake to America. He died miserably but heroically at Zutphen; wounded and racked with thirst, he allegedly refused a drink of water and passed it to a wounded colleague with the words, 'Thy necessity is greater than mine.' Such a man could hardly have existed without the blueprint outlined in *The Book of the Courtier*. The entry in *Chamber's Encyclopedia* reads: 'There is no doubt that he deliberately set out to exemplify the ideal gentleman of such courtesy books as Castiglione's *Courtier.'*

Sir Philip's literary counterpart is *Hamlet*. Here again we find the ideal Renaissance man. He is caught in the struggle between the active and the contemplative life, yet always presents himself elegantly to the world.

> The expectancy and rose of the fair state,
> The glass of fashion and the mould of form,
> The observed of all observers.
> (*Hamlet* III, i,159)

Castiglione's book stems from an assured world, a world where it was believed that the earth was the centre of the universe, where man the measure of all things was 'a little universe in himself'.

This is the final expression of the Renaissance in Urbino. The pleasant conversations of civilized and intelligent men and women had made the Ducal Palace seem 'the very inn of happiness'. Castiglione writes: 'The delight and enjoyment to be had from loving and devoted companionship were never experienced elsewhere as they were in Urbino.' Too happy, too engrossed to go to bed, they went on talking till dawn.

Cesare said, 'it is already day'; and he showed her the light that was beginning to come in through the clefts of the windows. Then they rose to their feet, greatly astonished, because it did not seem that the discussion had lasted longer than usual, but as they had started far later and taken greater pleasure in it, those gentlemen had been so absorbed that they had not noticed the way time was passing; nor did anyone feel at all tired; and this often happens when the accustomed time of sleep is spent in wakefulness. So when the windows on the side of the palace that faces the lofty peak of Mount Catria had been opened, they saw that dawn had already come to the east, with the beauty and colour of a rose, and all the stars had been scattered, save only the lovely mistress of heaven, Venus, who guards the confines of night and day. From there, there seemed to come a delicate breeze, filling the air with biting cold, and among the murmuring woods on neighbouring hills wakening the birds into joyous song. Then all, having taken their respectful leave of the Duchess, went to their rooms, without torches, for the light of day was sufficient.

Emilia Pia, portrait by Ridolfo Ghirlandaio (Galleria Palatina, Florence). Emilia takes a memorable and lively part in the discussions in *The Book of the Courtier*. Ridolfo Ghirlandaio (1483–1561), a friend of Raphael, was the son of the more famous Domenico Ghirlandaio and, like Michelangelo, had been his pupil.

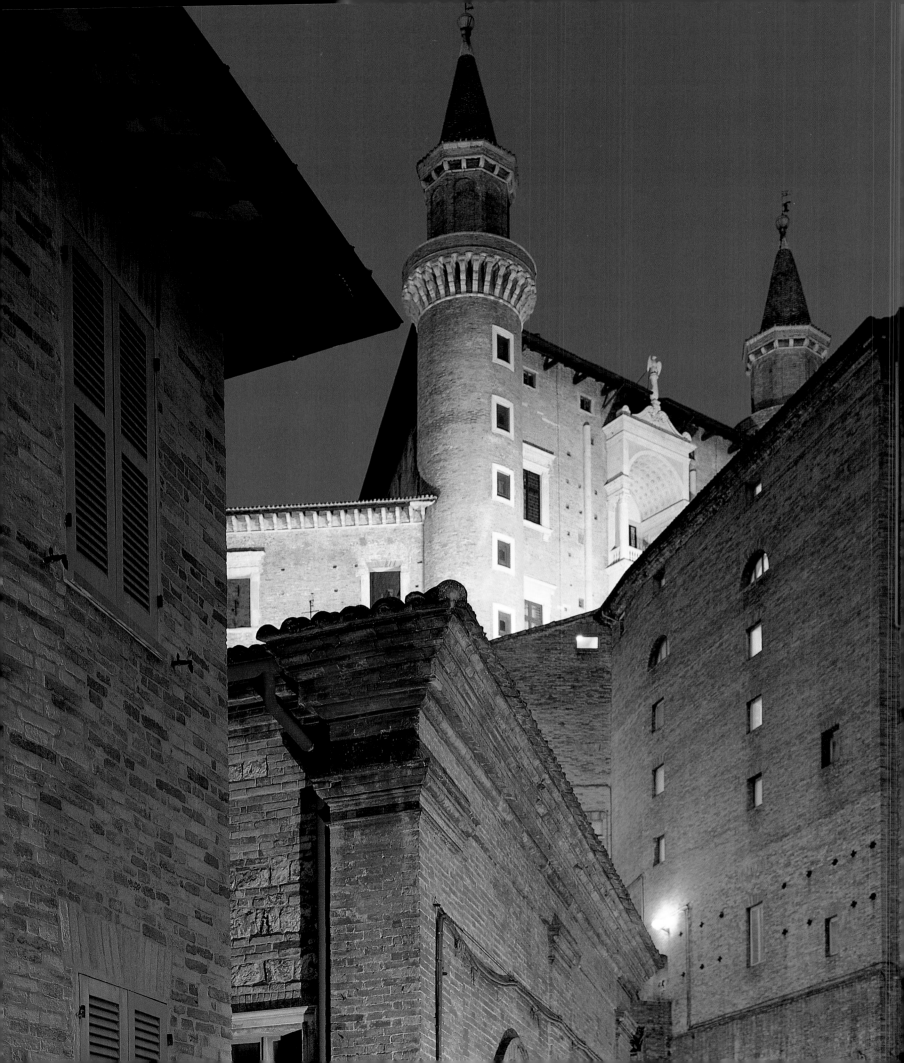

OVER THE HILL

Even while he was writing *The Book of the Courtier*, Castiglione knew that he was describing a civilization that no longer existed.

Duke Guidobaldo died young and childless in 1508 and was succeeded by Francesco Maria della Rovere (1490–1538), the son of his sister Giovanna. (Raphael's portrait of Francesco Maria is on page 161, Titian's is on page 176.) Being also the nephew of Pope Julius II, Francesco Maria was in an influential position, so for the time being Urbino continued to enjoy some prosperity and a degree of international recognition. But everything changed when the warrior pope died and was succeeded by Leo X of the Medici family. On the grounds that, five years earlier, Francesco Maria (always a hot-tempered man) had killed a cardinal, Francesco Alidosi, Leo X had him excommunicated.[1] An excommunicated duke, it was argued, could hardly be left in charge of a papal fief. On this pretext, Lorenzo de' Medici entered the city in May 1517. Although the dispossessed Francesco Maria enlisted the aid of Spanish troops, and the campaigns left Lorenzo seriously wounded, he was created Duke of Urbino and Lord of Pesaro and the city was in the hands of the Medici. In 1521 it was then regained for the della Rovere, but a diminution of power followed. Francesco Maria and his descendants Guidobaldo II (1538–74) and Francesco Maria II (1574–1631) enjoyed only limited autonomy and tended to be dominated by Spain or by the Church.

In 1523 the ducal court moved to Pesaro. This led to a decline in the fortunes and relative importance of Urbino. During its years as an independent city state, it had been an important centre for commerce and craftsmanship. It had been full of busy workshops: masons, carpenters, cabinet-makers, cloth-workers and dyers, intarsia-makers, engravers,

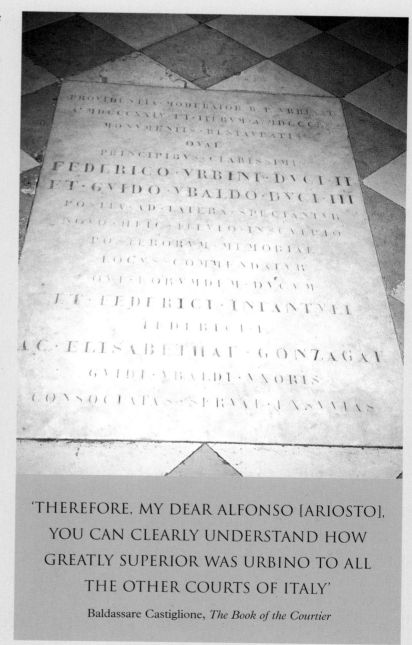

'THEREFORE, MY DEAR ALFONSO [ARIOSTO], YOU CAN CLEARLY UNDERSTAND HOW GREATLY SUPERIOR WAS URBINO TO ALL THE OTHER COURTS OF ITALY'

Baldassare Castiglione, *The Book of the Courtier*

LEFT: The façade of the Ducal Palace at night, from the corner of the Via Stretta. The building in the foreground is the synagogue.
RIGHT: Tomb slab commemorating Dukes Federico and Guidobaldo and Duchess Elisabetta, church of S. Bernardino.

calligraphers and illuminators, potters and maiolica painters, and artists of every kind. With the removal of ducal patronage, however, there was less employment to be had, leading in turn to a fall in the city's population. Those who remained were heavily taxed to support the absent Duke and his entourage.

Thus the grandeur of the city diminished. Only the Palazzo Passionei-Paciotti (its unassuming entrance is in Via Valerio) retained its former splendour.[2] It dates from the late fifteenth century and its first floor commands a fine view towards S. Bernardino. Originally it belonged to Federico da Montefeltro, who sold it or gave it to the Passionei family. The Passionei had held office as standard-bearers and treasurers to the dukes. Their elegant *salone* (great hall) is adorned with a blue and gold frieze and the inscription 'Maneat domus donec formica aequor bibat et lent testudo perambulet orbem' (Let this house remain until the ant drinks the ocean and the slow tortoise walks round the world). In 1568, Giovanni Francesco Passionei sold the palace to Francesco Paciotti. With its painted wooden ceilings, and elegant courtyard with Corinthian columns, it remains one of the lesser-known glories of Urbino. Appropriately enough, the Palazzo Passionei-Paciotti now belongs to the University of Urbino, which was inaugurated by Duke Guidobaldo in 1506, and which, despite all the vicissitudes of the city's history, has managed to survive the centuries.

In general, the city was no longer the centre of culture that it had once been. However, certain crafts continued to flourish. As we have seen, Urbino was the finest centre in the world for the making of maiolica, even though many of the best pieces were now commissioned for the court at Pesaro, and elsewhere. The city was renowned, too, for the making of chamber-clocks (one of which can be seen in the painting on page 177) and scientific instruments such as compasses and astrolabes.[3] Eminent in these fields were the Barocci family, especially Simone (the irascible but talented brother of the painter Federico Barocci) and his cousin Giovanni Maria. Simone is also credited with the design for a basin sundial for the Secret Garden of the Ducal Palace. With a fine understanding of refractive angles, it was made so that the shadow would only show the exact time when the basin was full of water. There were other occasional showpieces – for instance, the oratory of S. Giuseppe, in what is now Via Barocci, where Federico Brandani created in stucco a charming Nativity scene (1545–59) – but traditional trades of silk and wool fell into decline, and the guilds were disbanded.

Most public works undertaken at this time were for defence, sections of the massive city walls being repeatedly destroyed and rebuilt. In 1502, Leonardo da Vinci was employed by Cesare Borgia to make a plan of them; then Guidobaldo had them re-erected when he regained power the following year. The proceeds of a wine tax were spent on constructing the stretch between the Porta Valbona and the battlements of the Mercatale. The walls were pulled down again in 1517 by the troops of the invading Medici. Then on regaining power Francesco Maria renewed the same stretch over again.

In short, while money for defensive purposes could usually be found, it was not until later in the sixteenth century, under the rule of Guidobaldo II and Francesco Maria II, that improvements were made inside the city. The Ducal Palace was heightened and enlarged, and the houses opposite were demolished (1562–64) to make room for a spacious square. The Hospital of Santa Maria della Bella, on the Poggio, was enlarged to incorporate the monastery of Buon Gesù. The dome, which apparently had long been envisaged, was finally raised on the cathedral (it was designed by Muzio Oddi of Urbino), and ten years later a portico was built to celebrate the marriage of Federico Ubaldo to Claudia Medici.

If all this suggests renewed civic prosperity, it is a false impression. Federico Ubaldo died shortly after his wedding and never became duke. By 1590 there were fewer than five thousand inhabitants (barely a quarter of the population of the city today) and in that year the crops failed, causing a further exodus. There was misery and impoverishment within the city, reflected in the writings of the time. The great chronicler Bernaldo Baldi (1553–1617) wrote nostalgically of the great dukes, Federico and Guidobaldo, and did not expect to see such times again.

This was, however, a time for taking stock as far as the furnishings and works of art that remained in the Ducal Collection were concerned. Under the della Rovere, careful

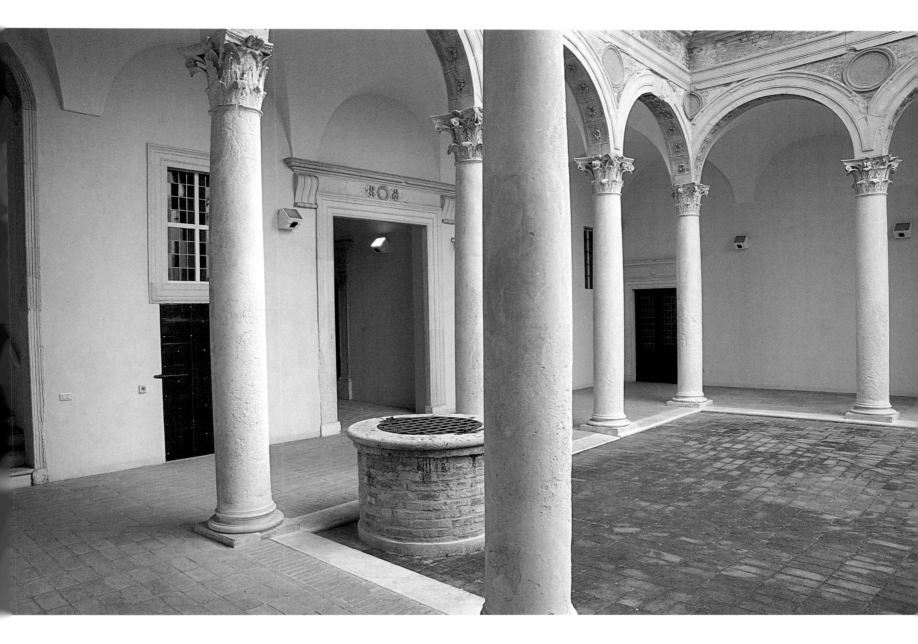

The elegant Renaissance courtyard of the Palazzo Passionei-Paciotti.

inventories were drawn up.[4] The first of these dates from April 1599. Among the lists of trestle-tables, mattresses and gilded leather hangings, we suddenly discover the celebrated double portrait by Piero della Francesco of Federico and his wife Battista (now in the Uffizi, Florence), together with other pictures of the ducal family: Jacopo de' Barbari's painting of Guidobaldo with the mathematician Luca Pacioli (now in the Capodimonte Museum, Naples) and Bronzino's portrait of Guidobaldo della Rovere (now in the Palazzo Pitti, Florence). Together with them is listed the famous painting of the *Ideal City*, which encapsulates to such a degree the aspirations of Renaissance Urbino.

A further inventory is dated 16 July 1609, and here we discover a full-length portrait by Vittore Carpaccio of

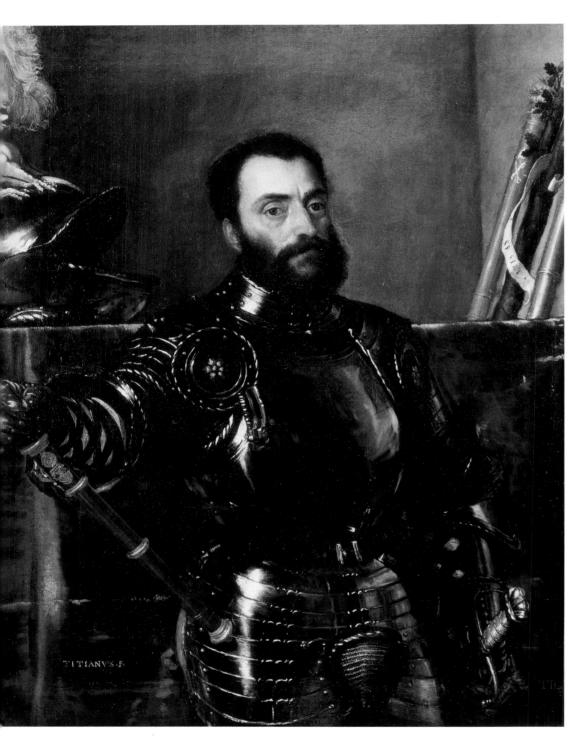

Portrait of Duke Francesco Maria della Rovere in his maturity, painted by Titian (Uffizi, Florence). It is interesting to compare this portrait with the much earlier one done by Raphael (see page 161).

Francesco Maria della Rovere (now in the Thyssen Collection, Lugano). Most notably of all, we see Raphael's masterpiece *The Madonna of the Chair* (now in the Palazzo Pitti, Florence), the circular painting that in the dukes' time adorned the tiny round-arched Capella del Perdono.

After the ducal court moved to Pesaro, many of the paintings were understandably either transferred there or commissioned there. A list of works at Pesaro was drawn up in 1624; among them was Raphael's portrait of Duke Guidobaldo (now in the Uffizi) and the painting (attributed to Justus of Ghent) of Federico and his son listening to a lecture. Commissioned for the court while at Pesaro were a number of celebrated works by Titian, including *The Venus of Urbino* (now in the Uffizi), the Mary Magdalen (Palazzo Pitti) as well as his portrait of Francesco Maria della Rovere (Uffizi). Also in Pesaro was Raphael's portrait of Duke Guidobaldo, whereas the picture of his wife Elisabetta seems to have been left behind in Urbino (both are now in the Uffizi).

A final inventory was drawn up in 1631, listing what was left in the Ducal Palace after the last duke died. There are some tantalizing things in it: for instance, Raphael's portrait of Pope Julius II (now in the Galleria Corsini, Florence, which also houses the paintings of the Muses from the now empty Temple of the Muses), and the magnificent Titian, *Girl in a Fur Wrap* (now in the Kunsthistorisches Museum, Vienna). From these inventories, these bare lists, we can judge the richness of the Renaissance palace and the magnificent patronage being offered to artists by the ducal court.

However, Urbino soon became a civilization of the élite. Little of the prosperity

of the court was now shared by the ordinary people of the city, and the death of Francesco Maria della Rovere II in 1631 marked the end of an era. Urbino was taken into the direct control of the papacy and a papal legate was appointed, the first being Cardinal Antonio Barberini. He was welcomed into the city with a fountain of wine and a ceremonial arch in the market place. Under the legate, there was a Council of Forty; this was composed of the nobility, the heads of surviving guilds, and the citizens; of these, the most influential were certainly the nobility. But Urbino had lost its autonomy, and power was now centralized in Rome; the Ducal Palace of Urbino was stripped of its furnishings. The largest part of the art collection had been left by the last Duke to his niece Vittoria. She had married Ferdinando de' Medici and lived in Florence; thus some of the most celebrated works are still to be found there today. It seems, though, that she did not inherit all that she was supposed to, and much of the rest – including tapestries, silver and jewels, as well as paintings – was disposed of by public auction in Urbino. Meanwhile, the paintings from the Studiolo and the Temple of the Muses were sent by Cardinal Barberini as a gift to his brother the Pope. As for Federico's wonderful collection of manuscripts (although they had in fact been bequeathed by the last Duke to the people of Urbino), in 1657 they were sent to the Vatican Library – where they mostly still are. Francesco Maria II had also been a collector of books and manuscripts; these had been gathered together at Castel Durante (present-day Urbania), but in 1667 these too were sent to Rome.

Under the administration of the cardinal legate, the Ducal Palace was leased out to

Duchess Eleonora Gonzaga della Rovere, painted by Titian (Uffizi, Florence). Behind the Duchess's lapdog the fine table-clock is likely to have been made in Urbino by the Barocci family (see page 174).

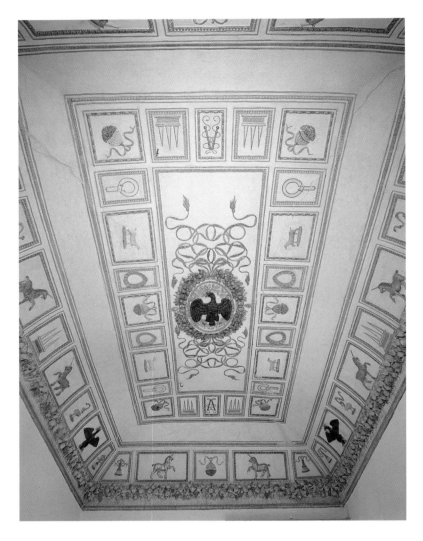

splendid tradition of caring for the welfare of the people. It will be remembered how when Federico took over the rule of Urbino, he undertook that two doctors should be employed at public expense to provide a health service for the citizens.

Urbino was gently falling into decay until, in 1700, a man who had been born there was chosen as pope. This was Gian Francesco Albani; on his election he took the name of Clement XI. This heralded a new era for Urbino. The Pope never forgot his native city. He had a new edition of Baldi's 1587 description published, and in 1703 he commissioned two clerics, Monsignors Origo and Lancisi (who were going to Urbino for the graduation of the Pope's nephew Annibale) to make a careful survey of the city.[5] This took them ten days, and their account was written up, making a remarkable early guidebook. Their visit was characterized by a certain humanity; on the fourth day they went to see a shopkeeper who had been a friend of the Albani family, and brought him the Pope's blessing; he was so overcome with emotion that he burst into tears. What was produced was much more than a guidebook in the modern sense, because on the basis of it Clement XI set about a repair and rebuilding project for his native city. From Rome he sent the architect Carlo Fontana to oversee the restoration of the cathedral and the Ducal Palace. The underlying idea was to give the city unity and elegance, and to modernize it along Roman lines. Much of the city we see today reflects this early-eighteenth-century Romanizing.

Pope Clement ordered the restoration not only of the cathedral and the Ducal Palace, but also of S. Bernardino (1704) and in the same year ordered the construction of the Collegio dei Nobili and the Market Square; after which he set about restoring the Bishops' Palace and the Palazzo Communale (town hall).

Meanwhile, Urbino became – perhaps rather surprisingly – the seat of a royal court.

Visitors to the Ducal Palace today may be a little puzzled to come across the so-called 'King of England's Room'. The ceiling decoration has a magnificent black eagle festooned with ribbons,

various institutions, but with the dukes gone, there was little attempt to keep it in good repair; only the *torricini* were restored (in 1665). And in the city, few public works were undertaken. The exceptions were those that were financed by the local nobility, and the greatest example of this was the development of the university, whose foundation dated back to Guidobaldo and the Collegio dei Dottori. Between 1633 and 1636 the Bonaventura Palace on the Poggio was reconstructed, and this became what is still the heart of today's university.

At this time, too, medieval monasteries were being destroyed, and with them must have disappeared much of the

The ceiling of the 'King of England's Room' in the Ducal Palace, with emblems including the Montefeltro eagle and the unicorns of Scotland.

and around the cornice march golden unicorns, the emblems of Scotland. James Francis Edward Stuart, known as the Old Pretender (though still quite a young man at the time), kept court here for several months in 1717–18.[6]

He was in fact half-Italian, his mother being Mary of Modena (the second wife of James II). Since the death of his father James II in 1701, when he was thirteen, he had been regarded by many as 'the King over the Water' (James III and VIII) and virtually all his life had been spent in exile, mainly in France. The death of Queen Anne in 1714, and the fact that she had no surviving children, seemed to strengthen his claim, and prompted a Jacobite rising in the following year. But by the Treaty of Utrecht in 1713, France had undertaken to support the Hanoverian succession to the English throne, and therefore could not be seen to recognize the Stuart claim. The prince travelled south into Italy, but even in his mother's home city he was not allowed to stay long. The only potentate prepared to offer him any sort of permanent refuge was the Pope. The Chevalier arrived in Rome in 1717. For a month he stayed in the Palazzo Gualterio there, spending his time sightseeing, but without any real enthusiasm; then the Pope suggested that he should take up a more permanent residence in the Ducal Palace at Urbino. This was rapidly furnished and made ready to receive him, and the procession of carriages arrived there in July. At first, the Chevalier was delighted with the place, and the citizens of Urbino were certainly pleased to have him in their midst. For one thing, it brought them a new period of prosperity. They approved of the young man's sense of decorum and his love of ceremonial – on feast days insisting on riding to the cathedral in a coach-and-six, although it would have been much quicker to walk. It may have been absurd, but it generated employment, and at last, people felt, the Ducal Palace was being put to an appropriate use.

The Prince spent much of his time dreaming of his hoped-for succession, admiring the view, and when the weather was fine, going coursing with his 'clever little Danish doggies' down by the Capuchin monastery. In the summer he had little

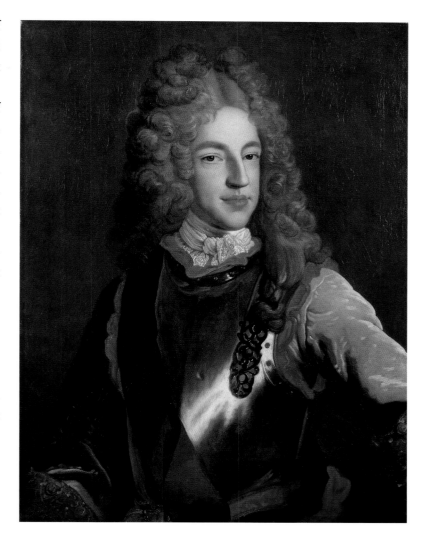

to complain about, except that he was easily bored, became increasingly melancholic and was, as ever, in exile. Winter was a different matter. James and the Scots lords who had accompanied him or joined him in Urbino were dismayed to find it so chilly a place.[7] The Earl of Mar remarked: 'I could not believe there was ever such winters in any place in this country and will think better of our own island afterwards.' And then – lacking for the most part any great intellectual resources or aesthetic appreciation – they were easily bored. In Mar's opinion, 'One day being like the other as two eggs, and those eaten without either pepper or salt', and 'I do not

Portrait of James Francis Edward Stuart, by an artist in the studio of Alexis Simon Belle (1674–1734), in the National Portrait Gallery, London.

In the following century the Metauro province was divided into two, with Urbino and Pesaro as its capitals. In 1859 the area ceased to be under papal jurisdiction, but became part of the Kingdom of Italy. Urbino had always been remote and difficult of access because of the nature of the terrain. New works had already been begun under Napoleon's rule. The aim was to have roads fit for carriages. Even today, exploring the streets of Urbino, one becomes aware that this was the criterion – roads paved with slabs, not impossibly steep for horses, and just wide enough for two carriages to pass. Originally the main road into the city was through the Porta Sta Lucia to the north, but in 1831 a new entrance was made at the Porta Nuova. A rail-link between Urbino, Pergols and Fermignano was opened in 1898. This existed for almost a century, and was closed in 1986. Looking down over the valley you can still see the site of the old station.

The Mercatale (originally a flat landfill site required for the earth dug out to accommodate the foundations of the Ducal Palace) was, as its name implies, an extensive market place. During the nineteenth and early twentieth centuries, busy cattle markets were held here. But with the increase of motor traffic it found a new function as a parking place; it has two levels, with the buses (an essential part of life in Urbino) and taxis stopping at ground level, and the cars in a subterranean car park down below. Inside the city walls motor traffic is very wisely discouraged – it is a place for people – and how could Urbino exist without its Mercatale?

The Renaissance might be over, yet the cultural life of Urbino was never entirely neglected. The Cappella Musicale del Santo Sacramento (which had been founded as early as the fourteenth century) was further endowed by the Albani pope in 1703. He brought in Scarlatti's young son Domenico (1685–1757) to be its Master Organist, and founded a printing press specifically for music.[11] An International Festival of Antique Music is now held in Urbino every July.

As for drama, we have seen how Urbino was at the forefront of stage design in the early sixteenth century, but this was, of course, court drama in the Ducal Palace, rather than something to be viewed by the general public. In the mid-nineteenth century (1845–53) the Teatro Sanzio was built by

LEFT: Landscape to the south of the city, showing the site of the former railway station.
ABOVE, LEFT: The Mercatale, once a cattle market, now a bus station and car park.
ABOVE, RIGHT: The interior of the Teatro Sanzio.

Vincenzo Ghinelli of Senigallia in a commanding position above the Mercatale. Its foundation is the ancient helicoidal ramp of a bastion tower; set within the defensive walls, it is therefore supremely integrated with the shape and structure of the city. With its classical entrance and richly glowing auditorium, the Teatro Sanzio has a certain magnificence.

Even during the early twentieth century, when it was somewhat decayed, much of its splendour gone and little restoration taking place, Urbino and its significance was still recognized by the *cognoscenti*. Clive Bell's essay on 'Civilization' (1927) was probably written with Urbino much in mind; he fully approved that an Italian Renaissance palace should be splendid rather than convenient, and Raphael and Castiglione were among his heroes. He visited the city in May 1913 together with his wife Vanessa, Roger Fry and Duncan Grant. Duncan Grant had, as a student, made a careful copy of the famous Piero portrait of Duke Federico (this can be seen on the walls of their farmhouse, Charleston, in Sussex).

But it was the academics who were especially enthusiastic. 'Roger,' wrote Vanessa, 'is up with the lark, does many sketches, sees all the sights, and he and Clive are indefatigable in their attributions and historical discoveries.'[12] She herself was rather less keen, the weather being wet and the hotel dirty, but she warmed to Piero's *Flagellation* and reported, 'We have seen today one of the best pictures in the world', and that in itself made the visit worthwhile. These words are echoed by Sir John Mortimer in his novel *Summer's Lease*, in which a Piero della Francesca trip to Urbino across the 'Mountains of the Moon' is the climax of the story.

The city, with its timeless serenity, has always attracted the discerning. In 1990 H.R.H. The Prince of Wales, who presumably had the choice of almost anywhere in the world, chose Raphael's birthplace in Urbino as the setting for an exhibition of his watercolours. They were displayed in the simple white-painted rooms that had been Giovanni Santi's workshop. But to describe Urbino as timeless is not to say that

LEFT: The former Capuchin monastery.
RIGHT: The Via Mazzini and the Porta Valbona, now the main entrance to the city.

it is static. It is full of life, hope, optimism, one feels, and there is a true sense of values, refreshing in this age. The vitality of the place is nowhere better expressed than in the University. We have seen how this started in a small way in the early sixteenth century as a Collegio dei Dottori. Then it was given university status by Pope Clement IX in 1671. It survived the Napoleonic era by adapting itself to the current democratic ideas, opening its doors to citizens regardless of rank, and introducing new disciplines such as languages. After the unification of Italy, it became known as a Libera Università Proviniciale. Gradually it enlarged its scope, and while retaining its autonomy grew from a small private concern to being now one of the finest universities in the country, with approximately 22,000 students. Unlike most Italian universities, it has – while retaining its traditional centres in the city – something of the nature of a campus university like York, with the spread of modern buildings over the hills by the Capuchin monastery. And since in Urbino the students

probably outnumber the population, an unusually high proportion must be living away from home. A fair number of them will be on scholarships. The range of courses available is remarkably wide, ranging from philosophy to fashion design, from oriental studies to geology; there are now few disciplines that cannot be studied here. There is, however, one that seems quite exceptional, and is singularly appropriate to Urbino and all that it stands for. This is the department of Beni Culturali, or 'cultural heritage'. There are two courses: one embracing art history, archaeology, archives and in general terms the care and preservation of beautiful things; the other is more technical, being directly concerned with their conservation and restoration.

What better insurance could there be for the continuance of all that is lovely in Urbino? And for the preservation of the city, not just its outer shell, but the survival of its very spirit. All these young and eager minds seeking, like Duke Federico, to learn some new thing every day.

LEFT: Roofs of the modern university.
RIGHT: Entrance to the traditional centre of the university in the Piazza Rinascimento (Palazzo Bonaventura).

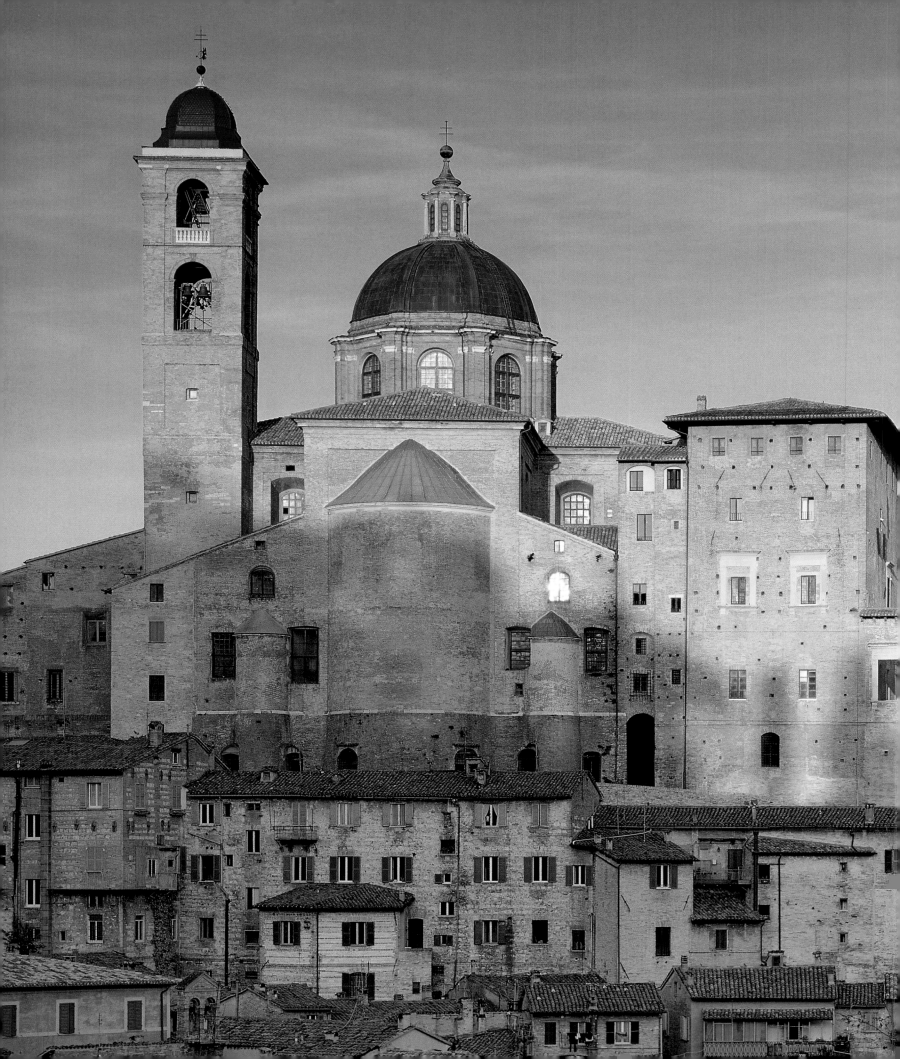

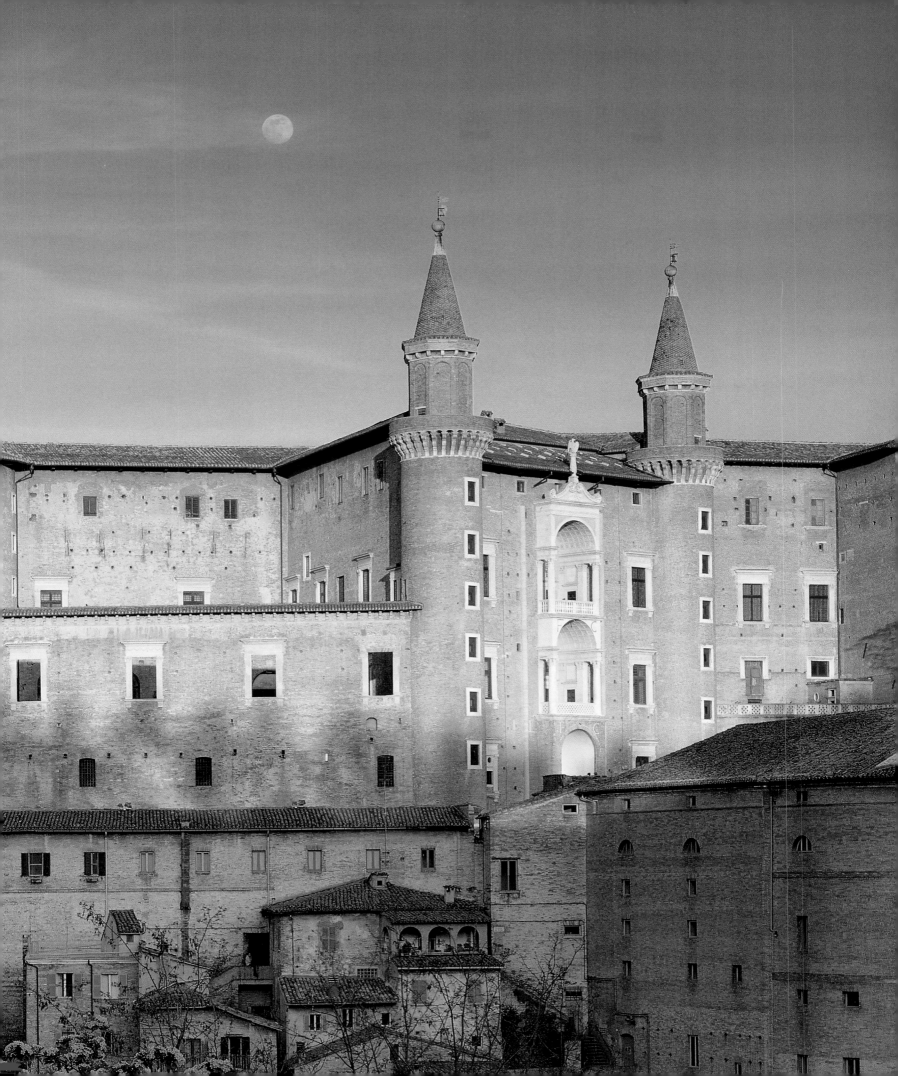

TAILPIECE: THE KITE

Giovanni Pascoli (1855–1912) was born in the Romagna, north-east of Rome. Losing both his parents while he was still a boy – his father, dramatically, was murdered – and then as a student being imprisoned on account of his pacifism, it is not surprising that Giovanni Pascoli grew into a melancholy man. He won acclaim, however, as a classical scholar, and held posts at the universities of Bologna, Messina and Pisa, spending his final years in Bologna as Professor of Italian Literature.

For part of his boyhood he was at school in Urbino, where this poem is set. His otherwise happy memories of a day in early spring spent scrambling through the woods by the Capuchin monastery and then flying kites from the city walls are overshadowed by recalling the death of one of his classmates. The boy, dressed in white, is seen to have an affinity with a kite fallen to the ground; and the whole poem is pervaded by an awareness of the vitality yet transience of the natural world.

L'AQUILONE

C'è qualcosa di nuovo oggi nel sole,
anzi d'antico: io vivo altrove, e sento
che sono intorno nate le viole.

Son nate nella selva del convento
dei cappuccini, tra le morte foglie
che al ceppo delle quercie agita il vento.

Si respira una dolce aria che scioglie
le dure zolle, e visita le chiese
di campagna, ch'erbose hanno le soglie:

un'aria d'altro luogo e d'altro mese
e d'altra vita: un'aria celestina
che regga molte bianche ali sospese . . .

sì, gli aquiloni! È questa una mattina
che non c'è scuola. Siamo usciti a schiera
tra le siepi di rovo e d'albaspina.

THE KITE

In the sun today there is something new,
or rather, something old; I live elsewhere, and feel
that violets are sprouting all around.

They are sprouting in the wood by
the Capuchin Convent, among the dead leaves
that the wind stirs at the foot of the oak trees.

There breathes a gentle breeze thawing
the hard turves, and visiting country churches
with their grass-grown lintels.

A breeze from another place, another time,
another life: a celestial breeze
which carries many white flecks aloft . . .

Yes, the kites! And on this morning
there was no school; we went out in a crowd
between the hedges of bramble and may.

Springtime in the woods by the Capuchin Monastery.

Le siepi erano brulle, irte; ma c'era
d'autunno ancora qualche mazzo rosso
di bacche, e qualche fior di primavera

bianco; e sui rami nudi il pettirosso
saltava, e la lucertola il capino
mostrava tra le foglie aspre del fosso.

Or siamo fermi: abbiamo in faccia Urbino
ventoso: ognuno manda da una balza
la sua cometa per il ciel turchino.

Ed ecco ondeggia, pencola, urta, sbalza,
risale, prende il vento; ecco pian piano
tra un lungo dei fanciulli urlo s'inalza.

S'inalza; e ruba il filo dalla mano,
come un fiore che fugga su lo stelo
esile, e vada a rifiorir lontano.

S'inalza; e i piedi trepidi e l'anelo
petto del bimbo e l'avida pupilla
e il viso e il cuore, porta tutto in cielo.

Più su, più su: già come un punto brilla
lassù lassù . . . Ma ecco una ventata
di sbieco, ecco uno strillo alto . . . – Chi strilla?

Sono le voci della camerata
mia: le conosco tutte all'improvviso,
una dolce, una acuta, una velata . . .

A uno a uno tutti vi ravviso,
o miei compagni! E te, sì, che abbondoni
su l'omero il pallor muto del viso.

The hedges were bare, thorny; but there were still some red
bunches left of autumn berries
and some white flowers of spring.

And on the bare branches the robin
perched, and the lizard's head peeked out
among the dry leaves in the ditch.

Or we stood still: windy Urbino
facing us: everyone sending from a cliff
his comet through a sky of indigo.

And there it is, waving, tottering, jostling, leaping,
backing, catching the wind; and after a while
slowly, slowly rises up amid the boys' shouts.

It rises, and steals the thread from the hand
like a flower which flies away on slender stem
and travels far away to flower again.

It rises, and the trembling feet and breathless
chest of the child and the keen eye,
the face, the heart, all are carried to the sky.

Higher, higher, already like a speck shining
up there, up there. . . . But here's a gust
of cross-wind, and a loud shriek . . . who is shrieking?

They are the voices of my classmates;
unexpectedly I know them all,
one soft, one shrill, one indistinct . . .

One by one I see them all again,
oh my schoolfriends! and you, who rested
on your shoulder the silent pallor of your face.

Si: dissi sopra te l'orazïoni,
e piansi: eppur, felice te che al vento
non vedesti cader che gli aquiloni!

Tu eri tutto bianco, io mi rammento:
solo avevi del rosso nei ginocchi,
per quel nostro pregar sul pavimento.

Oh! te felice che chiudesti gli occhi
persuaso, stringendoti sul cuore
il più caro dei tuoi cari balocchi!

Oh! dolcemente, so ben io, si muore
la sua stringendo fanciullezza al petto,
come i candidi suoi pètali un fiore

ancora in boccia! O morto giovinetto,
anch'io presto verrò sotto le zolle
là dove dormi placido e soletto . . .

Meglio venirci ansante, roseo, molle
di sudor, come dopo una gioconda
corsa di gara per salire un colle!

Meglio venirci con la testa bionda,
che poi che fredda giacque sul guanciale,
ti pettinò, co' bei capelli a onda

tua madre . . . adagio, per non farti male.

Giovanni Pascoli

Yes, I spoke prayers over you
and wept; and yet, you are happy who
do not see your kites fall to the ground.

You were all in white, as I remember;
only you had red upon your knees
with all our praying on the pavement.

Oh, happy you who close your eyes
in faith, serenely clasping to your heart
the dearest of your treasured playthings!

Oh gently, I know well, one dies
clasping one's childhood to one's breast
as still in bud the flower clasps its petals!

Oh dead youth, soon
I too shall see beneath the sod
where you sleep quietly all alone.

Better to come here gasping, damp
with sweat, as after a joyful
race to climb a hill!

Better to come with a fair head
that lies cold upon the pillow,
your mother combs your lovely hair in waves

slowly, so as not to hurt you.

trans. June Osborne

THE MONTEFELTRO DYNASTY

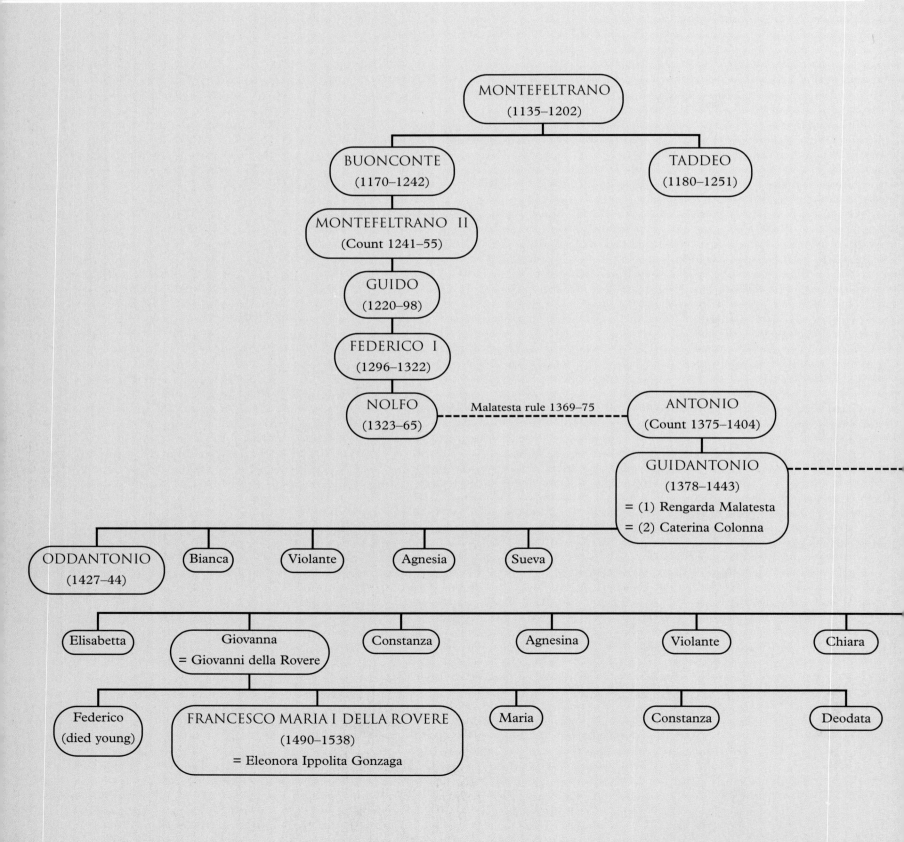

MONTEFELTRANO
(1135–1202)

BUONCONTE
(1170–1242)

TADDEO
(1180–1251)

MONTEFELTRANO II
(Count 1241–55)

GUIDO
(1220–98)

FEDERICO I
(1296–1322)

NOLFO
(1323–65)
— Malatesta rule 1369–75 —
ANTONIO
(Count 1375–1404)

GUIDANTONIO
(1378–1443)
= (1) Rengarda Malatesta
= (2) Caterina Colonna

ODDANTONIO
(1427–44)

Bianca

Violante

Agnesia

Sueva

Elisabetta

Giovanna
= Giovanni della Rovere

Constanza

Agnesina

Violante

Chiara

Federico
(died young)

FRANCESCO MARIA I DELLA ROVERE
(1490–1538)
= Eleonora Ippolita Gonzaga

Maria

Constanza

Deodata

Montefeltro eagles, traditional and modern: by the Porta Valbona (above)
and by the Accademia di Belle Arti (below).

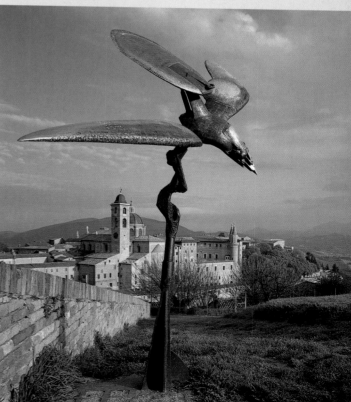

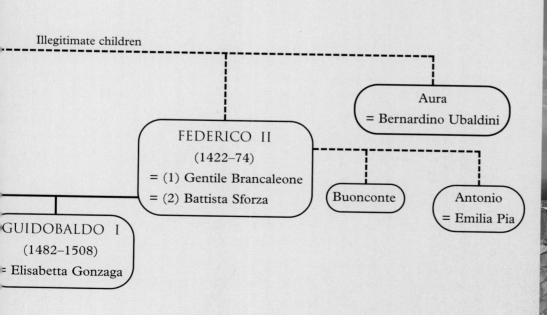

Illegitimate children

Aura
= Bernardino Ubaldini

FEDERICO II
(1422–74)
= (1) Gentile Brancaleone
= (2) Battista Sforza

Buonconte

Antonio
= Emilia Pia

GUIDOBALDO I
(1482–1508)
= Elisabetta Gonzaga

NOTES

CHAPTER 1

1. From *Oration on the Dignity of Man* by Pico della Mirandola (1463–94).

2. Marsilio Ficino (1433–99), scholar and humanist. He translated all the works of Plato into Latin at the request of Cosimo de' Medici, wrote his own philosophical work on the immortality of the soul and subsequently became a priest. This extract is from a letter to Paul of Middelburg, written in 1492.

3. Filarete was the pen name of Antonio Averlino (*c.*1400–69), a Florentine goldsmith and architect. This treatise, dating from *c.*1460–64, was circulated in manuscript form. It was described by Giorgio Vasari as 'mostly ridiculous'.

4. Roger Ascham (1515–68) was an English humanist. His work *The Scholemaster*, a treatise on classical education, was published in 1570, after his death.

5. Vespasiano da Bisticci (1421–98). His work *Uomini Illustri* dates from 1482 and was translated as *The Vespasiano Memoirs* by William George and Emily Waters in 1926.

CHAPTER 2

1. Procopius was a Greek historian and lawyer. He was born in Caesarea in Palestine in AD *c.*500. He became a counsellor to Emperor Justinian's redoutable general Belisarius. Books V–VII of his *History of the Wars of Justinian* deal with the campaigns against the Goths, and were probably written in AD 551.

2. Duke Federico da Montefeltro passed under this arch on the occasion of the marriage of his daughter Giovanna to the Duke of Rimini. See Mario Luni, Paolo Quiri, *La Via Flaminia nell'Ager Gallicus*.

3. See Mario Luni, *La Flaminia delle Gole del Furlo e del Burano*.

4. See Mario Luni, *Le Origini di Urvinum Mataurense*. Professor Luni also refers to the writings of G. Radke and G. B. Pellegrini.

5. See N. G. L. Hammond, H. H. Scullard (editors), *The Oxford Classical Dictionary*.

6. Mario Luni, *Le Origini di Urvinum Metaurense*.

7. More recently (1996) remains of Roman structure, as well as Roman, medieval and Renaissance potsherds, were found in excavations on the oldest of the Montefeltro houses by the Via Saffi.

8. By Pier Girolamo Vernaccia.

CHAPTER 3

1. Montefeltro was also the name of a diocese. In 715 Pope Gregory II granted a Roman cleric, Lupicino, the benefice of two monasteries, S. Leone and S. Severino, on rugged mountain peaks. The chief fortress was Montefeltro and in Carolingian times this also became the name of the bishopric.

2. A third brother became Bishop of Montefeltro.

3. Professor Luni dates this as mid-thirteenth century and notes that part of it survives today on the east side of the city, built of small white blocks. See his *Population in the Town and Territory of Urbino from Ancient Times to the Middle Ages*. Leonardo Benevolo and Paolo Buoninsegna think that the earliest medieval wall was twelfth century. See *Urbino* in the series *Le Città nella Storia d'Italia*.

4. The first Franciscan to become pope was Nicholas IV (1288–92). A compromise candidate, he was elected after a vacancy of nearly eleven months – during which six cardinals died in a heatwave – and accepted the office with reluctance.

5. I am much indebted to G. Franceschini's *I Montefeltro* for his account of these events.

CHAPTER 4

1. Twenty years later another monumental fresco was placed beside it of the *condottiere* Niccolò da Tolentino, by Andrea del Castagno.

2. He said that the Battle of Anghiari was so framed that there was only one casualty; in fact there seem to have been several hundred.

3. The present building was begun in 1340.

4. I am greatly indebted to the State Archives of Mantua for material on Vittorino da Feltre and the Ca' Zoiosa.

5. Each room had its own name – downstairs: a Gata, a Serpa, a Luna, a Griffono, a Serena, a Stella, a Cervetis, a Ciconia, Pissis; upstairs: Saraxini, a Corona, a Falchionis, Gally and Solis.

6. Now in the Louvre, Paris.

7. This is the theory of Alessandro Maganuti, 1947.

8. Bernardo Baldi *Vita e Fatti di Federico da Montefeltro duca d'Urbino* Vol. I, pages 161–2.

9. It was his son Gianciotto who killed his wife Francesca da Polenta and his brother Paolo for suspected adultery. They were the Paolo and Francesca of Dante's *Inferno*.

10. Verses composed for the death of Guidantonio, *Codex Vaticano Urb. Lat.* 1498.

11. From the anonymous *Cronaca Malatestiana*.

CHAPTER 5

1. *Codex Vaticano Urb. Lat.* 1765, f.3r, Sec. XVII.

2. Recognized by Pietro Zanopetti when the frescoes were restored in 1953. See Fert Sangiorgi *Iconographia Federiciana* Accademia Raffaello, 1982.

3. The inscription on the façade and sides of the church states: 'Sigismondo Pandolfo Malatesta, back from the Italian war, dedicated this temple to the city and to the immortal God who had helped him escaping a multitude of dangers, and performing great exploits, and raised it an willingly met all the expenses, thus leaving a noble and holy monument.'

4. According to the Peace of Cremona of 1441, the whole peninsula 'parere essere tucta in le mani sue et che lui podesse dare leggio a tucta Italia' (Ser Guerrriero, quoted in R. Mariotti's *Bandi da tregua fra: Malatesta, gli Sforza, e Fed. di Montefeltro*, Fano, 1892.

5. *Codex Ambrosiani O.* 71 f.35r–43v.

6. His *Commentaria della Vita e Gesti dell' Illustrissimo Federico Duca d'Urbino* was published by the Accademia Raffaello, Urbino, in 1966.

7. These were Giovanni di San Marino (counsellor to the dead Antonio), Francesco dei Prefetti di Vico and Messer Gian Paolo. See Graziani 'Cronaca di Perugia' in *Arch. Stor. Ital.* Vol. XVI, part 1, page 568.

8. Bartolomeo Colleoni (1400–76) was a famous *condottiere* who fought for Venice in the Republic's war against Milan in 1438–41 and under Sforza for Venice in 1448. The Venetians lavished enough wealth on him to persuade him not to fight for anyone else. He is chiefly remembered by Verrocchio's equestrian statue, which stands outside the church of SS Giovanni and Paolo in Venice.

9. See Vincent Cronin, *The Florentine Renaissance*.

10. The artist himself brought it to Urbino the following year.

11. Aura, natural daughter of Guidantonio, married Bernardino Ubaldini della Carda.

12. The list is based on *Vat. Urb.* 829, f.55, as well as No. 1248 and *Vat. Ottob.* 3141, f.144 and *Oliveriana* 384, f.1.

CHAPTER 6

1. Cecil Clough, in his essay 'Federico's Patronage of the Arts, 1468–1482' (London, 1973) estimated his income at 50,000 ducats a year, compared with the Doge of Venice,

who received 3,000 ducats a year.

2. *The Ten Books of Architecture* (Alberti), translated into English by the Venetian architect James Leoni, 1755 (published by Alec Tiranti, London, 1965).

3. *Ten Books on Architecture* (Vitruvius), Book 1.

4. *The Ten Books of Architecture* (Alberti), Book 2.

5. For details on the construction of the palace, see Pasquale Rotondi, *The Ducal Palace at Urbino*.

6. Iole, or Omphale, was Queen of Lydia. Hercules was sent to be her slave for three years because he had murdered his friend Iphitus. While in her service he became her lover, then took to wearing women's clothing and spinning yarn. The sculpture is probably by Michele di Giovanni of Fiescole.

7. Rotondi points out that the mullioned windows here are of a later date, being inscribed FD.

8. In his essay 'Federico da Montefeltro's Patronage', based on a paper given at the Society of Italian Studies Conference, Leeds, April 1971.

9. This is sometimes attributed to Piero della Francesca, sometimes to Laurana, sometimes left anonymous.

10. According to Bernardo Baldi's description.

11. This was in 1476, and they cost him 2,557 ducats. See Mary Hollingsworth *Patronage in Renaissance Italy* (Murray, London, 1994).

12. Published by the Accademia Raffaello, Urbino.

13. Under 'Nella Capella' the entry is: 'Un quatro de una Madonna con il putto e San Giovanno dentro a un tondo fatto a festone dorate.'

14. The definitive work on this is Luciano Cheles, *Lo Studiolo di Urbino*.

15. Frederick Hartt, *A History of Renaissance Art*, (Thames and Hudson, London, 1970).

CHAPTER 7

1. I am indebted to Mario Luni for his paper 'Ciriaco da Ancona e Flavio Biondo. La Rissoperta dell' Antica a Urbino nel Quattrocento'.

2. According to Cecil Clough, this painting may have been intended for Federico's studiolo at Gubbio. The panel was acquired by Queen Victoria in 1853, having been discovered, then in poor condition, in Tuscany. It is painted in oil on a chestnut panel.

3. Some of these were from England, including John Tiptoft Earl of Worcester, Willaym Gray Bishop of Ely, and the English pronotary Andrew Hollis. They were all much influenced by the lectures of Guarino of Verona. Tiptoft was a friend of William Caxton.

4. The *Disputationes Camaldulenses* consisted of a series of conversations between Lorenzo de' Medici and leading humanists of the age, including Alberti and Marsilio Ficino.

5. It is thought (by Albina de la Mare) that the book was made for the author and that after his death it was sold to Federico via Vespasiano da Bisticci. This and other manuscripts from Federico' library, is illustrated and discussed in *The Painted Page*, catalogue of an exhibtion of Italian Renaissance book illustration (Royal Academy, 1994–5).

6. Paintings of the Liberal Arts, by Justus of Ghent, were also to be seen in the studiolo at Gubbio. Of these, Rhetoric and Music are in the National Gallery, London. Dialectics and Astronomy were in the Kaiser Freidrich Museum, Berlin, but were destroyed during the Second World War.

CHAPTER 8

1. Cennino d'Andrea Cennini was born in Florence in about 1730; his master was Agnolo Gaddi, a pupil of Taddeo Gaddi, who was a pupil of Giotto. *The Craftsman's Handbook* (*Il libro dell'arte*) was published in translation by Yale University Press in 1933.

2. Volume 1305 of the *Ottoboniana* manuscript, Vatican Library. Written for Duke Guidobaldo, it appears in translation in Dennistoun's *Memoirs of the Dukes of Urbino*.

3. The painting was bought for the Royal Collection in June 1853, and used to hang in the corridor at Windsor, but after a more expert cleaning carried out by John Brealy in 1953–4, it was transferred to Hampton Court on 24 October 1955. I have had the opportunity to inspect the back of this painting, and it is quite clear where the table legs were to be joined on.

4. The *Christ at the Column*, a figure of great power and solemnity, stands against a pilaster which is ornamented with a design of leaves very similar to that which adorns the painted upright divisions of Mantegna's Camera degli Sposi in Mantua. But in the poignancy of the figure we may perhaps detect the influence of Leonardo, who was also in Milan at the time.

5. The ghetto with its synagogue was within the heart of the city, in the area of the Via Stretta, which runs parallel to the main street, the Via Mazzini. The first bank in Urbino was a Jewish one, opened in 1433. See Mazzini, *I Mattoni e le Pietre di Urbino*.

6. See the article by Martin Kemp and Ann Massing in the *Burlington Magazine*, March 1991.

7. Dr Catherine Whistler, Assistant Keeper of the Ashmolean Museum, has expressed the opinion that 'there is not enough to prove or disprove an argument either way' (November 1991).

8. See Luciano Berti *Paolo Uccello* (Fratelli Fabri, 1976–7)

9. The fresco is now detached and, sensitively restored, hangs in its own museum.

10. A smaller and much simpler version of the subject is included in the Misericordia polyptych in San Sepolcro; Christ is tied to a classical column, his assailants in red and brown raise their whips on either side.

11. This is in the Kunsthistorischie Museum, Vienna, part of the Ambras portrait collection of Archduke Ferdinand II.

12. See *Bolletino d'Arte* No. 65, 1991, pages 1–28.

13. This is also the opinion of Cecil Clough. The painting came to Florence with the bequest of Vittoria della Rovere to the Medici collection, and has been in the Uffizi since 1773.

14. See Philip Hendy, *Piero della Francesca and the Early Renaissance*, Weidenfeld & Nicolson, 1968.

15. By Luca Pacioli, mathematician (*c*.1445–1517).

16. An international convention, making a full assessment of the work of Giovanni Santi, was held at the Convent of Sta Chiara in Urbino on 17–19 March 1995.

17. The house is now the centre of the Accademia Raffaello, which does so much to further Urbino Renaissance studies.

CHAPTER 9

1. *Vita e Fatti di Federico da Montefeltro Duca di Urbino* Vol. III (Rome, 1824).

2. For the life of Elisabetta, see Maria Luisa Mariotti Masi *Elisabetta Gonzaga Duchesa d'Urbino* (Mursia, 1983).

3. Bought by Charles I from the bankrupt Gonzagas, the *Triumph of Caesar* paintings were sent to Hampton Court Palace, where they are now displayed in the Orangery.

4. Elisabetta wrote to ask her not to stay on her way to Loreto because it was Lent, and in Urbino, being inland, there was naturally a shortage of fish.

5. He had, however, contracted the *mal francese* as a result of his amorous adventures.

6. He died in the castle of Laches, near Tours, in 1508.

7. Leonardo da Vinci (1452–1519) entered Cesare Borgia's service in 1502 as a military engineer, but was back in Florence by spring 1503, working mainly as a painter. He was commissioned to paint *The Battle of Anghiari* for the Council Chamber, but never completed it.

8. Emilia Pia (d. 1528), daughter of Marco Pio of Carpi. By Antonio da Montefeltro she had two children, Veronica and Lodovico.

9. A year later, his body, with a stone tied round the neck, was dragged from the Tiber. Caterina Sforza was also imprisoned, but after eighteen months was liberated by order of the French. She retired to Florence and died there in 1509. Her youngest son was the notable Giovanni dalle Bande Nere.

10. Burchard describes a supper party given by Cesare with naked prostitutes picking up chestnuts, the mating of stallions and mares (watched with delight by the Pope and his daughter), a race run by Jews, a race of wild boars, and a race between Barbary horses – all held in the middle of Rome. An English translation of Burchard, by Geoffrey Park, was published by the Folio Society in 1963.

11. *The Sleeping Cupid*, a very early work by Michelangelo (*c*.1496) was sold as an antique sculpture by the Roman dealer Baldassare del Milanese to Cardinal Riario, nephew of Sixtus IV. How it came to be in Urbino seems unclear. It seems to be one of three cupids, one by

Sansovino, one antique and one by Michelangelo, which came into the collection of Charles I; all have now disappeared. See L. Goldscheider, *Michelangelo* (Phaidon, 1953).

12. Louis XII, who had been Duke of Orleans, succeeded Charles VIII in 1498, as he had died without a direct heir.

13. Giovanna had married Giovanni della Rovere and was the mother of Francesco Maria.

14. This was probably in 1503. Henry VIII did not marry Catherine until 1509, seven weeks after his father's death and his own accession to the throne. When Catherine failed to give him the longed-for male heir, he began to have doubts about the legitimacy of this marriage, and whether the Pope had been entitled to set aside the prohibition aginst a man marrying his brother's wife, as stated in the Book of Leviticus.

CHAPTER 10

1. There is a preparatory drawing which seems to relate to this painting, in the Uffizi Gallery, Florence. Another version of *St George and the Dragon* by Raphael is in the National Gallery, Washington. Cecil Clough in his article 'Il San Giorgio di Washington: Fonti e Fortuna' dates this 1506 and suggests it was given to Henry VIII's emissary Sir Gilbert Talbot. In the Washington painting, St George is wearing the Order of the Garter; in the Louvre painting he is not. This helps to confirm the earlier date of the latter. I am much indebted to David Alan Brown of the Washington Gallery for pointing this out.

2. Seven of the paintings are in the Galleria Orsini, Florence.

3. Petrucci was also famed for stage design.

4. Raphael's self-portrait is possibly the one listed as number 141 in the 1599 inventory of the palace. A drawing in the Ashmolean Museum, Oxford, almost certainly a self portrati, seems to be of not much earlier a date.

5. 'Grotesque' designs came to be used to decorate maiolica plates (see pages 142–4) and in the eighteenth century became a feature of Rococo and Neo-classical ornament.

6. Barberini Gallery, Rome. The sitter may possibly be Beatrice of Ferrara, a courtesan. (See G. Masson, *Courtesans of the Italian Renaissance*.)

7. The painting of Duke Guidobaldo is probably that listed as no. 142 in the 1599 inventory. Raphael's portrait of Pope Julius also hung in the palace, no. 231 in the 1582 inventory. The *Madonna della Seggiola* seems to be no. 43 in the 1609 list.

8. The *Venus of Urbino* was the second in a long sequence of reclining nudes spanning the centuries and including Goya's *Maja Desnuda* and Manet's *L'Olympe*.

9. One of Raphael's designs was shown in the exhibition 'Roma e lo stile classice di Raffaello' in the Palazzo Té, Mantua, March–May 1999.

10. I am most grateful to Grazia Maria Fachechi of the Urbino University Isitituto di Storia dell'Arte e di Estetica for her assistance with my studies, especially in the field of maiolica and for making available to me *L'Arte della Maiolica in Italia*.

11. In writing this section, I have been helped by being allowed to borrow books from the extensive library of Lady Kate Davson.

12. See *The New Grove Dictionary of Music and Musicians*, ed. Sadie Stanley and John Tyrell.

13. Giuseppe Magaletta *Teatro, Musica, e Danza a Urbino nel Rinascimento*.

14. Translated by Leigh Hunt. See Denys Hay, *Polydore Vergil, Renaissance Historian and Man of Letters*.

15. Quoted in Julia Cartwright, *The Perfect Courtier: Balassare Castiglione, His Life and Letters*.

CHAPTER 11

1. Ludovico Sforza 1451–1508, who assumed the title of Duke of Milan in 1494, is especially remembered as the patron of Leonardo da Vinci.

2. See Guido Rebbechini's article 'The Book Collection and other possessions of Baldassare Castiglione' *Journal of the Courtauld & Warburg Institutes*. There were times when he was forced to pawn the collar, or parts of it, but he was always anxious to get it back.

3. See Julia Cartwright *The Perfect Courtier*. Guido Rebecchini's article further reveals him as a scholar and collector.

4. As well as the famous Raphael painting, there is another portrait of Baldassare Castiglione, this one by Titian. An oil painting measuring 124 x 97 cm, it is in the National Gallery of Ireland, Dublin. It seems to have been acquired through Queen Christina of Sweden from the Imperiali family of Genoa. In the nineteenth century it was in England, the property of Lord Mansfield; Sir Hugh Lane bought it from his descendants. (I am indebted to Sergio Benedetti, Keeper of the Collection, National Gallery of Ireland, for this information.)

5. He was also a fine playwright, best remembered for his satire *La Mandragola* (*The Mandrake*).

6. Francesco della Rovere had been elected pope as Sixtus IV and his nephew Giuliano became Julius II. Julius II's nephew Giovanni married the daughter of Duke Federico of Urbino. Francesco Maria was their son, and was adopted as heir by the childless Guidobaldo. Francesco Maria appears as a young man in white in Raphael's *School of Athens* fresco in the Vatican Stanze.

7. He was to succeed as François I in 1515.

8. All these quotations are taken from George Bull's translation.

9. This was a famous argument among artists of the Italian Renaissance. See Leonardo's *Paragone* and the rivalry between Michelangelo and Raphael.

10. Royal tennis, or *jeu de paume*, was played with much harder balls than lawn tennis.

11. This is similar to Raphael's view that ideal beauty is not to be found in any one woman, but in the fusion of the loveliest features of many women. See his 1514 letter to Castiglione quoted on page 138.

12. Denys Hay, 'On Italian and Barbarian Europe' from *Italian Renaissance Studies*, ed. E. F. Jacob (Faber & Faber, 1960).

13. *French Humanism 1470–1600*, ed. Werner L. Gundersheimer.

CHAPTER 12

1. Many regarded this as justifiable homicide, Alidosi being widely disliked.

2. See Vera Valletta and Mario Luni, *Palazzo Passionei-Paciotti di Urbino* (Universita degli Studi di Urbino, 1994).

3. See Roberto Panicali, *Sixteenth Century Italian Chamber Clocks and the Urbino School*. Barocci clocks are said to figure in certain portraits by Titian, for example that of Eleonora Gonzaga (see page 177).

4. Edited by Fert Sangiorgi (Accademia Raffaello, Urbino, 1976).

5. *Un Guida Settecentesca d'Urbino*, ed. Fert Sangiorgi.

6. See James Lees-Milne *The Last Stuarts* (Chatto & Windus, 1993).

7. Jacobites in Urbino included John Erskine Earl of Mar, with his secretary Robert Creagh and his interpreter William Erskine, James Livingstone Linlithgow, David Nairne, William Maxwell Nithsdale, James Edward Oglethorpe (soldier), James Drummond Earl of Perth, Sir Peter Richmond, Charles Wogan and a surgeon Dr James Hay. (I am grateful to Susan Scullino for information on this.)

8. In fact, a German bride was unlikely, as it would have been opposed by the Hanoverian King George I.

9. They had two sons, Charles Edward (Bonnie Prince Charlie) and Henry Benedict, who became a cardinal. For details of Clementina's adventures, see Peggy Miller, *A Wife for the Pretender* (Allen & Unwin, 1965).

10. An architect involved in this work was Giuseppe Tosi (1712–93), who came from Urbino. He also worked in Fermignano and Urbania.

11. This was the Stampieria della Venerabile Capella del SS Sacramento.

12. From a letter to her sister Virginia, quoted in Frances Spalding, *Vanessa Bell* (Weidenfeld & Nicolson).

Alberti, Leon Battista *The Ten Books of Architecture: The 1755 Leoni Edition* Dover, New York, 1986.

Ascham, Roger *The Scholemaster* (1570) Constable, London, 1903.

Baldi, Bernardo *Vita e Fatti di Federico da Montefeltro* (Rome, 1824).

Benevolo, L. and Buoninsegna, P. *Urbino (le Città nella storia d'Italia)* Laterza, Rome, 1986.

Betti, Luciano *Paolo Uccello* Fabri, Milan, 1976.

Burchard, Johann *At the Court of the Borgia* Folio Society, London, 1963.

Burckhardt, Jacob *The Civilization of the Renaissance in Italy* 3rd edition, Allen & Unwin, London, 1950.

Cartwright, Julia *Baldassare Castiglione, His Life and Letters* Dutton, New York, 1908.

Castiglione, Baldassare *The Book of the Courtier* trans. George Bull, Penguin, London, 1967.

Cennino d'Andrea Cennini *The Craftsman's Handbook* trans. D. V. Thompson, Yale University Press, 1933.

Cheles, Luciano *Lo Studiolo di Urbino* Franco Cosimo Panini, Modena, 1986.

Clark, Kenneth *Civilization* BBC Books, London, 1979.

Clough, Cecil *The Duchy of Urbino in the Renaissance* Variorum Reprints, London, 1981.

Cole, Alison *Art of the Renaissance Courts* Weidenfeld & Nicolson, London, 1995.

Conti, Giovanni *L'Arte della Maiolica in Italia* Bramante Editrice, Milano, 1973.

Cronin, Vincent *The Florentine Renaissance* Collins, London, 1972.

_____ *The Flowering of the Renaissance* Fontana, London, 1972.

Dante Alighieri, *The Divine Comedy: The Inferno* trans. Mark Musa, Penguin, London, 1994.

Dennistoun, James, *Memoirs of the Dukes of Urbino* Longman Brown, London, 1851.

Dovizzi, Bernardo *La Calandria* in Luigi Russo *Commedie Fiorentine del '500* Sansoni, Firenze, 1939.

Franceschini, Gino *I Montefeltro* Dall'Oglio, 1970.

Graham-Dixon, A. *Renaissance* BBC Books, London, 1999.

Graves, Robert *Count Belisarius* Penguin, London, 1955.

Hale, J. R. *Civilization of Europe in the Renaissance* Harper Collins, London, 1993.

_____ (ed.) *Concise Encyclopedia of the Italian Renaissance* Thames & Hudson, London, 1981.

_____ *War and Society in Renaissance Europe 1450–1628* Fontana, London, 1985.

Hammond, N. G. L. and Scullard, H. H. (eds) *The Oxford Classical Dictionary* Clarendon Press, Oxford, 1970.

Hay, Denys *Polydore Vergil, Renaissance Historian and Man of Letters* Clarendon Press, Oxford, 1952.

Hazan, Fernand (ed.) *A Dictionary of Italian Painting* Tudor Publishing, New York, 1965.

Hendy, Philip *Piero della Francesca and the Early Renaissance* Weidenfeld & Nicolson, London, 1968.

Hollingsworth, Mary *Patronage in Renaissance Italy* John Murray, London, 1994.

Holt, Elizabeth G. (ed.) *A Documentary History of Art* Vol. 1, Princeton University Press, 1982.

Kay, George R. (ed.) *The Penguin Book of Italian Verse* Penguin, London, 1958.

Kelly, J. N. D. *The Oxford Dictionary of Popes* Oxford University Press, 1952.

Klein, R. & Zerner, H. *Italian Art, Sources and Documents 1500–1600* Prentice Hall, New Jersey, 1966.

Lucas, John (ed.) *The Oxford Book of Italian Verse* Oxford University Press, 1952.

Luni, Mario *Le Origini di Urvinum Metaurense* Ancona, 1993.

_____ *La Via Flaminia nell'Ager Gallicus* Urbania, 1993.

_____ *La Flaminia delle Gole del Furlo e del Burano* Urbino, 1993.

_____ *Il Restauro della Fortezza Albornoz* Urbino, 1989.

_____ *Francesco di Giorgio Martini e l'Antico nel palazzo Ducale di Urbino* Marsilio, 1992.

_____ *Population in the Town and Territory of Urbino from Ancient Times to the Middle Ages* Urbino, 1992.

Magaletta, Giuseppe *Teatro, Musica e Danza a Urbino nel Rinascimento* Montefeltro, Urbino, 1992.

Machievelli, Niccolò *The Prince* trans. George Bull, Penguin, London, 1961.

Martin, H. J. *French Humanism 1470–1600* Macmillan, London, 1969.

Masi, Maria Luisa Mariotti *Elisabetta Gonzaga, Duchessa di Urbino 1471–1526* Mursia, 1983.

Mazzini, Franco *I Mattoni e le Pietre di Urbino* Argalia, Urbino, 1982.

Moranti, M. and L. (eds) *Il Transferimento del 'Codices Urbinates' alla Biblioteca Vaticana* Accademia Raffaello, Urbino, 1981.

Mortimer, John *Summer's Lease* Viking, London, 1988.

Murray, Peter *Architecture of the Italian Renaissance* Thames & Hudson, London, 1969.

Naglet, A. M. *A Source Book in Theatrical History* Dover, New York, 1952.

Nicoll, Allardyce *Development of the Theatre* George G. Harrap, London, 1927.

Notestein, Lucy L. *Hill Towns of Italy* Hutchinson, London, 1963.

Paltroni, Pierantonio *Commentaria della vita e gesti di Federico, Duca d'Urbino* Accademia Raffaello, Urbino, 1966.

Panicali, Roberto *Orologi e Orologiai del Rinascimento Italiano, La Scuola Urbinate* Quattroventi, Urbino, 1988.

Procopius *Secret History* trans. G. A. Williamson, Viking, London, 1966.

Prendilacqua, Francesco *La Vita di Vittorino da Feltre* (1774)

Rebecchini, G. 'The book collection and other possessions of Baldassare Castiglione' *Journal of the Courtauld and Warburg Institutes* LXI, 1998.

Rosenau, Helen *The Ideal City* Routledge & Kegan Paul, London, 1959.

Ross, James B. and McLaughlin, Mary M. (eds.) *The Portable Renaissance Reader*, Penguin, London 1977.

Rotondi, Pasquale *The Ducal Palace of Urbino* Tiranti, London, 1969.

Sadie, Stanley and Tyrell, John (editors) *The New Grove Dictionary of Music and Musicians* Grove Publications, London, 2001.

Sangiorgi, Fert (ed.) *Una Guida Settecentesca d'Urbino* Accademia Raffaello, Urbino, 1992.

_____ *Documenti Urbinati, Inventari del Palazzo Ducale, 1585–1631* Accademia Raffaello, Urbino, 1976.

_____ *Iconografia Federiciana* Accademia Raffaello, Urbino, 1982.

Stewart, A. *Philip Sidney, A Double Life* Chatto & Windus, London, 2000.

Vasari, Giorgio *Lives of the Artists* trans. Peter Bondanella, Oxford University Press, 1998.

Vespasiano da Bisticci *The Vespasiano Memoirs* trans. W. G. and E. Waters, Routledge, London, 1926.

Wilson, Timothy, *Maiolica* Ashmolean Museum, Oxford, 1989.

Vitruvius *Ten Books on Architecture* trans. M. H. Morgan, Dover, New York, 1960.

INDEX

Entries in *Italics* refer to artworks in the text.

Page numbers in *Italics* refer to artworks and photographs.

Titles of books are in inverted commas.

A

Accolti, Bernardo ('L'Unico Arentino', poet) 157, 162–3, 164

Agapito (Greek scholar) 98

Albani, Cardinal Annibale 180

Albani, Gian Francesco (later Pope Clement XI) 178

Alberti, Antonio (painter) 49

Alberti, Leon Battista (architect) 13, 59, 61, 73, 75–6

 Tempio Malatestiano *61*

 'Ten Books of Architecture' 75–6

Albornoz, Cardinal 38

Alexander VI (Rodrigo Borgia), Pope 126–7, 132

Alexander VII (Fabio Chigi), Pope 100

Alfonso, Duke of Bisceglie 128–9

Alfonso, King of Naples 64, 65, 97

Alidosi, Cardinal Francesco

 killed by Francesco Maria della Rovere 173

Alidosi, Gentile *see* Brancaleone, Gentile

Alidosi, Giovanna 59

'Amore al Tribunale della Pudicizia' (play) 148–9

Andreoli of Gubbio, Giorgio (maiolica artist) 144

Angelo, Tommaso di Guido dell' 54

Anghiari, Battle of 52

Aragona, Ferdinando d', King of Naples 65

Aragona, Federico d' 130

Aragona, Lucrezia d' 124

Aragona, Maria d' 54

Aretino, L'Unico *see* Accolti, Bernardo

Ariosto, Alfonso (courtier)

 'Book of the Courtier' 157, 159, 162, 163, 165

 death of 157

B

Ascham, Roger (schoolmaster) 18, 169

Astemio, Lorenzo (Latin scholar) 98

Atti, Isotta degli (wife of Sigismondo Malatesta) 116

Augusto, Porta di (Rimini and Fano) 22

Avelli, Francesco Xanto (maiolica artist) 144

B

Baldassare Castiglione *see* Castiglione, Baldassare

Baldi, Bernardo (biographer of Federico da Montefeltro) 59, 123, 174, 178

Barbara of Brandenburg (bride of Ludovico Gonzaga) 49

Barbari, Jacopo di (painter) 126, 175

Barberini, Cardinal Antonio (Papal Legate in Urbino) 177–8

Barbiano, Alberico da (*condottiere*) 45

Bari, Roberto da

 'Book of the Courtier' 159, 165

 death of 165

Barocci, Federico (Federico Fiori, painter) 142, 174

 The Institution of the Eucharist 141

Barocci family (clockmakers) 174

Bartiferro, Maestro (physician) 64

Bartolomeo, Maso di (architect) 78

Bartolomeo, Michelozzo di (architect) 78

Belisarius (Byzantine general) 26–7

Bell, Clive (art critic) 184

Bell, Vanessa (artist) 184

Bembo, Pietro (poet, literary theorist, cardinal) 124, 157

 'The Book of the Courtier' 157, 160, 165, 166–7, 168

 portrait 166

Benigni, Giorgio (teacher) 124

Berruguete, Pedro (artist) 107

Bertelli, Carlo (art historian) 113

Bessarion, Cardinal (scholar) 97

Bibbiena, Cardinal *see* Dovizi, Bernardo

Bisticci, Vespasiano da (author and dealer in manuscripts) 60, 62–3, 65, 67, 73, 104

 biographer of Duke Federico 18, 60, 62–3, 69, 97–8, 145

 'Life of Federico' 59, 93

 'Lives of the Illustrious Men of the Fifteenth Century' 97

 workshop in Florence 98

Bocca Trabaria Pass 22

'Book of the Courtier' (Il Cortegiano), by Baladassare Castiglione 14, 17, 18, 153–71

 Book I (The Perfect Courtier) 159–62

 Book II (Humour) 162–3

 Book III (The Court Lady) 163–5

 Book IV (Service and Platonic Love) 165–8

 impact abroad 169, 171

Borgia, Cesare (military leader) 100, 126, 129, 174

 death of 132

 legitimized 126

 warfare 130–32

Borgia, Lucrezia 124, 126–7, 129, 130, 131, 157

 marriage to Alfonso of Bisceglie 128

 marriage to Alfonso d'Este 130

 portrait (from a fresco by Pinturicchio) *129*

Borgia, Rodrigo (later Pope Alexander VI) 126–7, 132

Bracciolini, Poggio (humanist)

 page from collected works 98

Bramante, Donato (Donato di Angelo, architect and painter) 17, 108, 138, 153
 Christ at the Column 107
 modern bust of *107*
Brancaleone, Gentile
 death 64
 marriage to Federico da Montefeltro 50, 59
Brancaleoni, Alerigo dei 52
Brandani, Federico (artist) 174
Bronzino, Agnolo (painter) 175
Brunelleschi, Filippo (architect) 13
Bruni, Leonardo (historian) 98
Bull, George 168
Burchard, Johann (chronicler) 130
Burckhardt, Jacob (historian) 44

C

'Calandria, La' (play by Bibbiena) 149–151
Callisto III (Alfonso Borgia), Pope 65
Candigliano, River 22
Canossa, Ludovico 149
 'Book of the Courtier' 157, 159–60, 162, 165
Carpaccio, Vittore (painter) 175–6
Carpi, Emilia Pia da *see* Pia da Carpi, Emilia
Castel Durante *see* Urbania
Castiglione, Baldassare (diplomat and writer) 14–16, 132, 138, 149–51, 153–4
 background 154
 'Book of the Courtier' 14, 17, 18, 100, 153–71
 death 153, 168
 portrait by Raphael *152*
Castiglione, Camillo 154–5
Catherine of Aragon 133
Catria, Mount 171
Celestine IV (Gofredo da Castiglione), Pope 31
Cellini, Benvenuto (artist) 169

Cennini, Cennino (artist)
 'The Craftsman's Handbook' 103
chamber clocks 174, *177*
Charlemagne, Emperor 29
Charles VIII, King of France 127
Cheles, Luciano 89
Ciriaco di Pizzicolli, 96
Clement V, Pope 35
Clement XI (Gian Francesco Albani), Pope 178, 180
cloth trade 66
Clough, Cecil 97, 116
Colbordolo 22
Colet, John (humanist) 148
Colin, Jacques 169
Colleoni, Bartolomeo (*condottiere*) 66
Colonna, Caterina 50, 61
 marriage to Guidantonio da Montefeltro 45–6
Colonna, Vittoria (poet)
 pirated version of 'The Book of the Courtier' 157
condottieri (mercinaries) 43–45
Constantine the Great 29
Contugi, Matteo (calligrapher) 98

D

dance 145–6
Dante Alighieri 6, 29, 30, 32, 89, 95, 98, 160
Dati, Agostino (humanist) 54
Dennistoun, James
 'Memoirs of the Counts of Urbino' 67
'Donation of Constantine' (Donatio Constantini) 29
Donato, Andrea 46
Dovizi, Bernardo (Cardinal Bibbiena, writer and diplomat) 76, 149
 'Book of the Courtier' 157, 162–63, 165, 167
 portrait by Raphael *151*
 set design for La Calandria (Peruzzi) 150

Drake, Sir Francis 171
Ducal Collection, inventories 174–6
Ducal Palace
 architects involved with 78–80
 basement floor 80–82
 books and manuscripts sent to Rome 177
 Capella del Perdono 87, 139
 character and building of 16, 77–78, 80
 contents sold by auction 177
 contract of Luciano Laurana 78
 Cortile d'Onore 62, *63, 74*, 76, *76*
 inscription 62
 enlargement 174
 inventories 175, 176
 King of England's Room 178–9
 library 97–100 *101*
 military academy 66
 piano nobile (state rooms) 83, 84
 restoration by Pope Clement 178
 Sala delle Veglie 155
 Secret Garden 80–82
 Studiolo 87, 89, 91
 details of intarsia work and arrangement of portraits 88–9
 portraits 93–96
 Temple of the Muses, 87, 91
 torricini 80, 90 178

E

Edward IV, King 66
Elizabeth I, Queen 169, 171
Erasmus of Rotterdam (humanist) 148
ESTE family of FERRARA
 Este, Alfonso d' 130
 Este, Beatrice d' 124
 Este, Isabella d' 124, 126, 131, 151
 Este, Isotta d' 54
 Este, Lionello d' 54, 113
Eugene IV, Pope 46, 52, 53, 61, 63
 death of 64

F

Fabretti, Raffaele (collector of antiques) 181

Fano 21

Feltre, Vittorino da (schoolmaster) 48–9

Ferdinand, King of Aragon 132

Ferdinando of Naples 64

Ferrante I of Aragon 66

feudal system 30

Ficino, Marsilio (humanist) 13–14

Filarete (architect and architectural theorist) 16

Filelfo, Francesco (humanist) 97

Filelfo, Gianmario 97, 124

Fiorentino, Rosso (artist) 169

Flaminia, Via (Roman road) 22

Folgia, River 21

Fontana, Carlo (architect) 178

Fontana, Guido (Guido Durantino, maiolica artist) 144

Fontana, Orazio 144

Forli, Melozzo da (painter) 100

Fortebraccio, Braccio (*condottiere*) 45, 52

Fossombrone 22

Francesca, Piero della (painter) 55, 60, 67, 80, 100, 111–13, 175
 blindness 119
 Brera altarpiece *102*
 The Flagellation of Christ 112
 An Ideal City 14–15
 The Madonna of Senigallia 119
 Portrait of Battista Sforza 114
 Portrait of Federico da Montefeltro 115
 Triumph of Battista Sforza 117
 Triumph of Federico da Montefeltro 116

Francesco, Bishop of Rimini 36

Francesco Maria della Rovere *see* Rovere, Francesco Maria della

Francia, Francesco (painter) 136

Franciscan order 33

François I, King of France 169

Frederick I , Emperor 30

Frederick II, Emperor 30–31

Frederico, Marquis of Mantua 124

Frederico d'Aragona 130

Federico da Montefeltro *see* Montefeltro, Federico da

Fregoso, Federico
 'Book of the Courtier' 157, 159, 162–3, 165

Fregoso, Ottaviano 157, 163, 165, 166–7

Frisio, Niccolò 165

Furlo Gorge 22

G

Galli, Angelo (poet) 67

Gatta, Bartolomeo della 100

Genga, Girolamo (artist) 136, 143

Ghibellines *see* Ghelfs

Ghiberti, Lorenzo (artist) 108

Ghirlandaio, Ridolfo (painter)
 Portrait of Emilia Pia 170

Giorgione (painter) 140, 160

Giraldi, Giugliemo (illuminator) 98

Goes, Hugo van der (painter) 104

Gombrich, Ernst (art historian) 8

GONZAGA family of MANTUA
 Gonzaga, Cecilia 49, 50
 Gonzaga, Cesare
 'Book of the Courtier' 157, 162, 164–5, 167–8
 death of 165
 Gonzaga, Elisabetta *see* Montefeltro, Elisabetta Gonzaga
 Gonzaga, Francesco 16
 Gonzaga, Gianfrancesco 48
 Gonzaga, Ludovico 48 , 78, 104
 Gonzaga, Maddalena 124
 Gonzaga, Margherita 158

Grant, Duncan (artist) 184

Graves, Robert 26–7

Gregory IX, Pope 30–31

Grenier, Jean
 tapestries 84

Grocyn, William (humanist) 148

Gubbio 66, 76

Guelfs and Ghibellines 30, 31

H

Hall, Edward (chronicler) 148

Hasdrubal Barca (Roman general) 24

Hawkwood, Sir John (Giovanni Acuto, *condottiere*) 44, 109
 painted memorial by Uccello *43*

Hendy, Philip (art historian) 119

Henry VII of England 133, 154
 received Raphael painting 135

Hoby, Sir Thomas
 translation of 'The Book of the Courtier' 18, 169

Holinshed, Raphael (chronicler) 148

Honorius III, Pope 30

I

Innocent III, Pope 30

Innocent IV, Pope 31–2

Innocent VII, Pope 45

J

Jacobite cause 179

John XXII, Pope 39

Julius II, Pope (Cardinal della Rovere) 17, 132, 133, 153, 173
 anonymous portrait 133
 portrait by Raphael 176

Justus of Ghent (painter) 49, 97, 104, 106–7, 108–09
 The Communion of the Apostles 105
 Federico and his Son Listening to a Lecture 17, 97, 106, 108
 modern bust of *104*

L

Landino, Cristoforo (humanist) 97, 98, 126

Laurana, Luciano (architect) 78,80

Leo X, Pope (Giovanni de' Medici) 138, 151, 155, 173

Leonardo da Vinci 16, 104, 129, 138, 160, 169, 174

Lollini, Fabrizio (art historian) 113

Lorenzetti, Ambrogio (painter) 15

Lorenzo the Magnificent *see* Medici, Lorenzo de'

Louis XII, King of France 132

M

Machiavelli (political theorist and dramatist) 126, 156
 'The Prince' 136

maiolica 142–44, 174

The Calumny of Apelles (Nicola da Urbino) *143*
technique 142–3
MALATESTA family of RIMINI
Malatesta, Domenico 52
Malatesta, Galeazzo 62
Malatesta, Pandolfo 35–6, 38
Malatesta, Roberto 66–7
Malatesta, Sigismondo Pandolfo (*condottiere*) 52, 53, 54, 61–2, 63–4, 116, 119
character of 61
death of 66
medallion *60*
Manfred (son of Frederick II) 30
Manfredi, Astorre, Lord of Faenza 130
Manfredi, Bartolomeo (astrologer) 49
Mantegna, Andrea (painter) 48, 49, 104, 160
Court of the Gonzaga in Mantua 47
manuscripts, illuminated
frontispiece with Federico 98
page from works of Poggio Bracciolini 98
Mar, Earl of 179–80
Martin V (Oddo Colonna), Pope 45, 55
Martini, Francesco di Giorgio (architect) 80
Masaccio (painter) 13
Maximilian I, Emperor 130
MEDICI family of FLORENCE
Medici, Cosimo de' 78
Medici, Vittoria de'
inherited Urbino art collection 177
Medici, Ferdinando de' 177
Medici, Giovanni de' (later Pope Leo X) 157
Medici, Guiliano de'
'Book of the Courtier' 157, 160, 163, 164–5, 167–8
Medici, Lorenzo de' 66, 126, 156, 173
Medici, Piero de' 16, 127
mercenaries (*condottieri*) 43–5
merlons (Ghibelline battlements) 31, 33
Metauro, River 21
Metauro Province 183
Michelangelo 131, 138, 153, 160

Middelburg, Paul of 87
Mirandola, Pico della (humanist) 13
Mondaino, Brother Lorenzo da 36
MONTEFELTRO family of URBINO
castles outside Urbino 36
chart of Dynasty *192–3*
condottieri 43–5
family origins 30–46
Montefeltrano II, Count 32
Montefeltro, Antonio da (Count) 38, 45
Montefeltrano, Antonio da (illegitimate son of Federico da Montefeltro) 69
death of 129
legitimized 64
marriage to Emilia Pia de Carpi 129
Montefeltro, Battista Sforza da 60, 65, 83
death of 115, 119
marriage 65
Montefeltro, Bernardino
death of 65
Montefeltro, Buonconte
legitimized 64
Montefeltro, Elisabetta Gonzaga
'The Book of the Courtier' 157, 159, 162, 164, 166–8
marriage to Guidobaldo 125–8
portrait by Raphael *158*
Montefeltro, Federico I da 35
Montefeltro, Federico II da 15–18, 46–55
accessibility to his subjects 60
accident in a tournament 60, 64
appearance of 59, 60
architecture, understanding of 73
betrothal to Battista Sforza 65
betrothal to Gentile Brancaleone 46
birth 46
character of 62
childhood 46, 48
'Concessions' 56–7
Court 67–70
death of 123
death of Battista Sforza 115, 119
Duke Federico and his Son Listening to a Lecture (Justus of Ghent) *17*, 97, 106

education 48–50
hostage in Venice 46–8
household, number in 67, 68
humanity of 73
leadership 59–71
library 97–100
marble bust 123
marriage to Battista Sforza 65
marriage to Gentile Brancaleone 50
Order of the Garter 66
signature 78
way of life 69
Montefeltro, Giovanna da
marriage to Giovanni della Rovere 128
Montefeltro, Guidantonio da 45, 50, 53
marriages 45–6
Montefeltro, Guido da 30, 32–3, 35
Montefeltro, Guidobaldo I da 16–17, 67, 69, 100, 124, 126–9, 132, 140, 153
education 69
marriage to Elisabetta Gonzaga 125–28
Order of the Garter 135
portrait by Raphael *125*
Montefeltro, Nolfo da 36, 38, 39
Montefeltro, Oddantonio da 46, 50
character 53–4
death of 55
Montefeltro, Taddeo da 31
death of 32
Montefeltro, Violante da 52, 61, 123
More, Sir Thomas 148
Mortimer, John
'Summer's Lease' 114, 184
Murray, Earl of 180
music 145
Capella Musicale of Urbino 145
chapel choir, members of Duke Federico's 145

N
Nelli, Ottaviano (painter) 50
Nicola de Urbino (maiolica artist) 143
Nicholas V, Pope 97

O

Odasi, Ludovico (tutor) 124
Oddi, Muzio (maiolica artist) 174
Oliva, Carlo, Count of Pignano 120
Orsini, Matteo Rosso 31
Orsini, Orsino 127
Orso, Antonio, Bishop 36
Ortona, Morelio da 159, 168
Otto IV, Pope 30·

P

Pacioli, Luca (mathematician) 126
Paciotti, Francesco 174
Pagannuccio, Mount 22
painting 103–121
Pallavicino, Gaspare
 'Book of the Courtier' 159–60, 162–3,
 164–5, 166–8
Paltroni, Pierantonio 62
Papacy, political power of 29–30, 38
Parma, Battle of 32
Pascoli, Giovanni 147
 poem – 'The Kite' 189–91
Passionei, Francesco 174
Pasti, Matteo de' (artist) 116
Patanazzi (maiolica workshop) 144
Pentapoli 29
Perperara, Laura 146
Perugia, Treaty of 65
Perugino, Pietro (painter) 104, 136, 138
Peruzzi, Baldassare (artist)
 set design for La Calandria 150
Pesaro (Pisaurum) 21, 24
 ducal court moves to 173, 174
 list of paintings at (1624) 176
Pesaro, Giovanni da 128
Petrucci, Pandolfo 136
Photographs
 architectural details 5, 12, 25, 33–4, 49,
 55, 73, 76, 80–81, 147–148, 173, 175,
 183
 city buildings 2–3, 4, 9, 13, 18–19, 24,
 28–9, 36–8, 48, 53, 58, 61, 70, 103, 135,
 138, 149, 181, 184–5
 Ducal Palace 1, 63, 71–2, 74–7, 82–4,
 86–7, 90–94, 100, 145, 155, 172, 178,
 186–7

excavations 26
landscapes 6, 10, 20–21, 23, 40, 42, 50,
 122, 182–3, 188
photographic acknowledgments 208
Pia da Carpi, Emilia
 'Book of the Courtier' 157, 159–60, 162,
 165, 167, 168
 marriage to Antonio da Montefeltro 129
 portrait by Ghirlandaio 170
Piccinino, Jacopo 65
Piccinino, Niccolò (condottiere) 52, 54
Piccolomini, Aeneas Silvio see Pius II,
 Pope
Picenum (Iron age settlement) 22, 24
Piero della Francesca see Francesca, Piero
 della
Pietrolata, Mount 22
Pii, Manfredo dei 54
Pinturicchio (painter)
 Coronation of Pope Pius II 65
 Lucrezia Borgia (from a fresco) 129
Pio, Lodovico
 'Book of the Courtier' 162
Pisanello (artist) 49
Pius II (Piccolomini, Aeneas Silvio), Pope
 65, 66, 85, 95
 Coronation of Pope Pius II (Pinturicchio)
 65
Plautus (Roman playwright) 148
poetry 146–8
Poggetto, Maria del (art historian) 114
Poggio (mound) 21
Poliziano, Angelo (poet) 146, 148
Pollaiuolo, Antonio de (painter) 66
Prendilacqua, Francesco 4
 'La Vita di Vittorino da Feltre' 48
Primaticcio (painter) 169
Procopius of Caesarea (Greek historian)
 21, 26

R

Ranieri, Guidangelo de' 64
Raphael (Raffaello Sanzio) 13, 17, 87,
 121, 136, 138, 140, 143, 154, 160, 163
 La Muta 140
 Madonna and Child 136
 Madonna della Seggiola 138

Portrait of Baldassare Castiglione 152, 156
Portrait of Cardinal Bibbiena 151
Portrait of Duchess Elisabetta 158
Portrait of Francesco Maria della Rovere
 161
Portrait of Guidobaldo da Montefeltro 124
Self Portrait 137
St George and the Dragon 134, 135
stone for grinding paints 121
works transferred to Pesaro 176
Rimini (Ariminum) 22, 24
Romano, Guilio (painter and architect)
 154, 168
Romano, Giovan, Cristoforo (artist) 157,
 160
Rossano, Monte 24
Rovere, Cardinal della 131
 see also Julius II, Pope
Rovere, Francesco Maria I della
 91, 100, 131, 144, 154–6
 adopted by Guidobaldo 128
 betrothed to Eleonora Gonzaga 133
 'Book of the Courtier' 159, 162
 death 177
 excommunicated 173
 portrait by Raphael 161
Rovere, Giovanni della 128
Rovere, Guidobaldo II della 174

S

Sackville, Sir Thomas (poet and statesman)
 169
San Leo (fortress) 50, 51, 131
Santi, Giovanni (artist and poet) 67, 104,
 119, 120–21, 136, 146, 148
 modern bust of 121
 St Roch, 120
Sarto, Andrea del (painter) 169
Scarlatti, Domenico (musician) 183
scientific instruments 174
Scottish lords in Urbino 179, 180
Senigallia 24
 capture by Cesare Borgia 132
 surrender to Federico of 66
Sentino, Battle of 24
Serafina, Fra of Mantua 159
Serrungarina (Roman settlement) 22

SFORZA family of MILAN
 Sforza, Alessandro 52, 78
 Sforza, Battista
 see under Montefeltro, Battista Sforza
 Sforza, Caterina 128–9
 Sforza, Francesco 45, 46, 52, 54, 61–2
 death of 66
 Sforza, Galeazzo 67
 Sforza, Gian Galeazzo 127
 Sforza, Giovanni 124
 Sforza, Lodovico 16
 Sforza, Ludovico il Moro 127–9
 married Beatrice d'Este 124
Silva, Michel de (Dom Miguel da Silva)
 159
Sixtus IV, Pope 80, 95, 96, 124
Sobieski, Maria Clementina 180
Speranza, Count 36
Stuart, James Francis Edward (The Old
 Pretender)
 portrait, studio of Alexis Simon Belle
 179
 search for bride 180–81
 took up residence in Urbino 179
Sylvester, Pope 29
 'Life of Saint Sylvester' 29

T
Tasso Torquato (poet) 146
Terence (Roman playwright) 148
theatre 148–51
 'Amore al Tribunale della Pudicizia'
 148–9
 'La Calandria ' 149
Timoteo of Urbino (Timoteo Viti, artist)
 87, 136
Titian (Tiziano Vecellio, painter) 140–41
 Portrait of Duke Francesco Maria della
 Rovere 176
 Portrait of Duchess Eleonora Gonzaga della
 Rovere 177
 Venus of Urbino 143
Tivoli, Vitale de' 108
Tolfa 66
Tommaso, Abbey of 22
Torelli, Ippolita (wife of Baldassare
 Castiglione) 155

U
Ubaldini, Ottaviano 67, 100, 124, 126,
 127
Ubaldo, Federico 174
Uberti, Fazio degli (poet) 41
Uccello, Paolo 47, 107–9, 111
 The Hunt in the Forest 110
 painted memorial 43, 44
 The Profanation of the Host 108–09
Ugolino, Bishop 32, 33
Urbania (Castel Durante) 177
Urbino (Urvinum Metaurense)
 Bernardino, church of San 53, 89, 103,
 173
 cathedral 89, 174, 181
 ceded to the Church 30
 chequered early years 31–8
 Collegio dei Dottori 178
 comune (civic authority) 38, 39
 confraternities 39
 consiglio degli ottimati 38
 control passed to Counts of Montefeltro
 31
 court moved to Pesaro 173
 destruction 36
 Ducal collection, inventories 174–6
 earthquakes 181
 expansion 33, 35
 Fortezza Albornoz 38, 76
 Franciscan order in 33, 95
 gateways 35, 58–9, 183
 growth 33, 35
 Hospital of Santa Maria della Bella 174
 Iron Age settlement 24
 location 21–7
 map (1708) 27
 Mercatale 76, 183
 Mercato, Pian di 35, 39
 monastic foundations 32–3
 music 183
 Napoleonic invasion 181
 name 22
 Palazzo Passionei-Paciotti 174, 175
 Papal control 177
 Piazza della Repubblica 13, 35
 population of 174
 power of the people, growing 38–9
 Roman remains 22–7
 Romanization of city 180–81
 survey of city 178
 Teatro Sanzio 183–4
 University 174, 178, 185
 walls of the city 35, 174
 see also Ducal Palace, photographs
Urbino, Nicola da
 The Calumny of Apelles (maiolica dish)
 143

V
Valla, Lorenzo (scholar) 29
Vasari, Giorgio (painter and art historian)
 103, 109, 119, 121, 136
 'Lives of the Artists' 119
Vatican struck by lightning 129
Venice 46–8
Vergil, Polydore (Polidorio Vergilio,
 historian) 147
Vespasian, Emperor 22
Vespasiano da Bisticci
 see under Bisticci
Veterani, Frederico (chronicler) 36
Viamaggio 21
Villani, Giovani (chronicler) 32
Visconti, Filippo Maria, Duke of Milan 54
Viti, Timateo (Timateo of Urbino) 87,
 136
 Stained glass panel 156
Vitruvius (Roman architect) 22, 75
Volterra, Battle of 66

W–Z
Wogan, Charles 180
Yeats, William Butler (poet) 135, 153
Zampetti, Pietro (art critic) 120

ACKNOWLEDGMENTS

Extracts from Baldassare Castiglione's *The Book of the Courtier* translated by George Bull (Penguin, London, 1967) on pages 17, 160, 165 and 171 are copyright © George Bull and are reproduced by kind permission of Penguin Books Ltd. The extract from *Count Belisarius* by Robert Graves on pages 26–7 is reproduced by permission of Carcanet Press Limited. Extracts from *The Vespasiano Memoirs* translated by William George and Emily Waters (University of Toronto Press, 1997) on pages 40, 69 and 97 are reproduced with the permission of The Renaissance Society of America. Extracts from W. B. Yeats, 'To a wealthy man who promised a second subscription to the Dublin Municipal Gallery if it were proved the People wanted Pictures' on page 135 and 'The People' from *The Wild Swans at Coole* on page 153, from *The Complete Poems of W. B. Yeats* (Wordsworth Poetry Library, 2000), are reproduced by kind permission of A. P. Watt Ltd on behalf of Michael B Yeats. The Publishers have made every effort to contact holders of all copyright works. Any copyright holders we have been unable to reach are invited to contact the Publishers so that a full acknowledgment may be given in subsequent editions.

PHOTOGRAPHIC ACKNOWLEDGMENTS

With the exception of those listed below, all the photographs in this book are by Joe Cornish.
For permission to reproduce the images on the following pages and for supplying photographs, the Publishers would like to thank:

BRIDGEMAN ART LIBRARY
108–9 below, 109 above, 110–11, 120, 138, 143

BY COURTESY OF THE NATIONAL PORTRAIT GALLERY, LONDON
179

JUNE OSBORNE
13, 25, 26, 29, 36, 38, 48, 49, 53, 70, 71, 73, 104, 107 left, 121 left, 136, 147 left, 148, 155, 156, 173, 185 right, 188

PRIVATE COLLECTION
4, 27, 55, 59, 60, 61, 85 below, 123, 133, 149, 150, 166, 181

THE ROYAL COLLECTION © 2003, HER MAJESTY QUEEN ELIZABETH II
106, 137

SCALA, FLORENCE
14–15, 17, 43, 47, 65, 102, 105, 107 right, 112, 114, 115, 116, 117, 118, 125, 129, 134, 140, 141, 142, 151, 152, 158, 161, 170, 176, 177

© BIBLIOTECA APOSTOLICA VATICANA (VATICAN)
98 (URB.Lat.508), 99 (URB.Lat.224, folio 2r)

V&A PICTURE LIBRARY
85 above

EDITOR Michael Brunström
DESIGNER Becky Clarke
PICTURE RESEARCH Sue Gladstone
PRODUCTION Caterina Favaretto
INDEX Anne Coles/June Osborne